MADE IN NEWARK

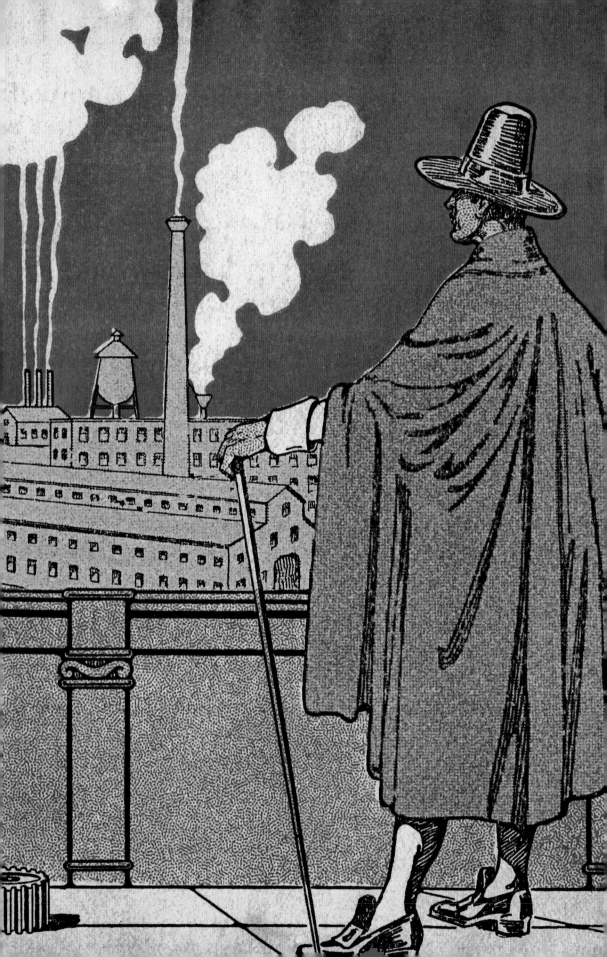

MADE IN **NEWARK**

CULTIVATING
INDUSTRIAL ARTS
AND CIVIC IDENTITY
IN THE
PROGRESSIVE ERA

Ezra Shales

Rivergate Books

AN IMPRINT OF

Rutgers University Press

New Brunswick, New Jersey, and London

Library of Congress Cataloging-in-Publication Data

Shales, Ezra.
 Made in Newark : cultivating industrial arts and civic identity in the progressive era / Ezra Shales.
 p. cm.
 Includes bibliographical references and index.
 ISBN 978–0–8135–4769–5 (alk. paper)
 1. Newark Public Library—History. 2. Public libraries—New Jersey—Newark—History.
 3. Newark Museum—History. 4. Museums—New Jersey—Newark—History. 5. Dana,
 John Cotton, 1856–1929—Political and social views. 6. Librarians—New Jersey—Newark—
 Biography. 7. Museum directors—New Jersey—Newark—Biography. 8. Libraries and
 community. 9. Museums and community. 10. Arts and crafts movement—United States. I.
 Title. II. Title: Cultivating industrial arts and civic identity in the progressive era.
 Z733.N414S53 2010
 027.4749′32—dc22
 2009036265

A British Cataloging-in-Publication record for this book is available from the British Library.

FE 14 '11

Visit our Web site: http://rutgerspress.rutgers.edu
Manufactured in the United States of America

image, page ii: Program for *Newark's Anniversary Industrial Exposition, May 13–June 3, 1916.*
See figure 58.

image, page xii: Newark Free Public Library, circa 1902–1905. See figure 2.

image, page xvii: Anonymous (signed with monogram, MC or CM), "Home Sweet Home."
See figure 8.

To Agnes Russell and Henry Amos,
for sharing their delight in peering
down the alleyways and byways

CONTENTS

ILLUSTRATIONS

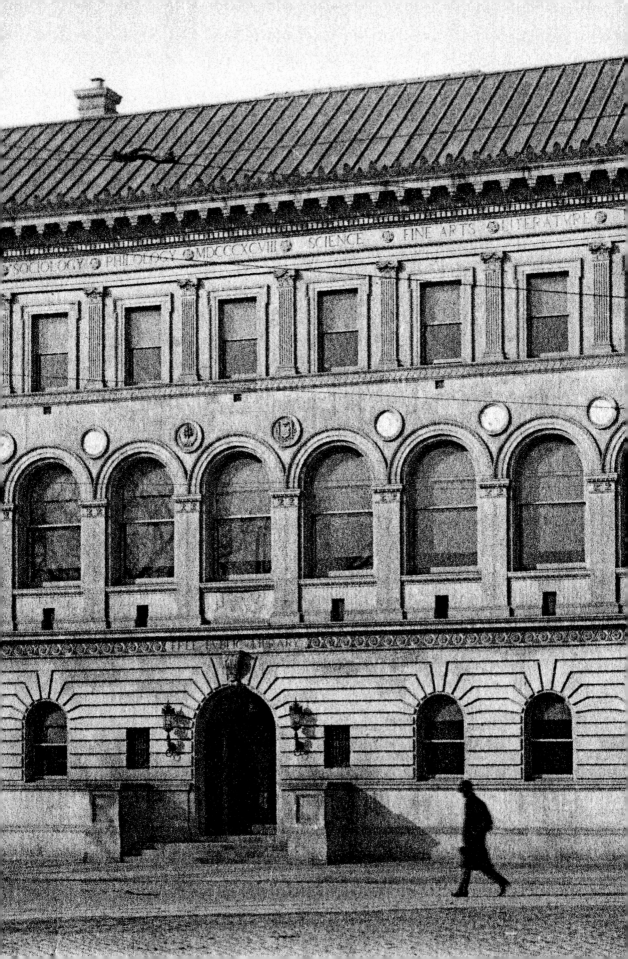

ACKNOWLEDGMENTS

This inquiry began while I was working as an educator in the Brooklyn Museum, where talented and generous curators, conservators, volunteers, and colleagues taught me to appreciate the rich historical layers of that cultural institution. I focused my research while in pursuit of a degree at the Bard Graduate Center, where my advisors, Kenneth Ames, Pat Kirkham, and Amy Ogata, improved my wordsmithing immeasurably and expanded my appreciation for artifacts as evidence. In particular, Amy Ogata's exemplary scholarship and focused criticisms have been invaluable. I count myself very fortunate to be the benefactor of her generosity in mentoring and her commitment to high standards. I also thank the visiting lecturers who passed through the BGC, especially Juliet Kinchin, Paul Stirton, Kevin Stayton, Tim Benton, Barbara Kirshenblatt-Gimblett, Harvey Green, and Ellen Paul Denker and my fellow students, especially Lee Talbot, Sarah Lichtman, and Doug Clouse. For study sessions during graduate school and time spent with Richard Guy Wilson, Ian Cox, and Alan Crawford, I thank the Victorian Society in America. Charmed hours spent grazing through storage in the Newark Museum and Brooklyn Museum pot by pot with the erudite and munificent curators Ulysses Dietz and Kevin Stayton inform much of this project, and I thank them for their tutelage.

Parts of these chapters were tested out as papers at the Cooper-Hewitt graduate student symposium, a Winterthur symposium on American material culture, a College Art Association session organized by Malcolm Baker in 2006, and another CAA panel chaired by Glenn Adamson in 2008. Presentations I gave at the Newark Library, Newark Museum, and the Woodstock Historical Society were of immense value. At each venue, participants aided the development of my work with thoughtful comments. At Winterthur, Gretchen Buggeln, Amelia Peck, Michael Prokopow, Arlette Klaric, Cheryl Robertson, and Paul Greenhalgh were generous. Following up

with Amelia afterward, I also incurred debts to her colleagues Morrison Heckscher and Alice Cooney Frelinghuysen. In Newark, Steven Diner gave me excellent advice and tolerated my blind spots. At "Handmade Utopias," co-panelists Elissa Auther, Nicholas Maffei, Jonathan Clancy, and Julia Bryan-Wilson posed important questions, and the audience of Catherine Whalen, Namita Gupta Wiggers, David Raizman, and Jennifer Mikulay responded thoughtfully. I am especially grateful to Glenn Adamson, David Raizman, and Susan F. Rossen for encouraging me to publish my research, and keeping on doing so. Before and after my presentation in Woodstock, Betty Emmons and Margaret Dana Emmons brought some of J. C. Dana to life for me in very tangible and important ways. Betty summered with her uncle John as a child and reminisced about a breakfast conversation when he regaled her on the beauty of an egg. Margaret Dana took me tramping through Dana's overgrown golf course on Togo Hill and rummaging through his furniture in the Historical Society; sadly, she passed away two years ago. Bruce Ford, formerly of the Newark Library, kindly shared his scholarship with me on B.W. I also thank Carol Duncan for a critical unscheduled second defense of my dissertation at her breakfast table. Informal conversations with Kelly L'Ecuyer, Elisabeth Agro, Alan Elder, Neil Brownsword, Neil Forrest, Lydia Matthews, and Love Jönsson have added much. Randolph Starn's critique of museums and willingness to correspond with me has also enriched my perspective. Most recently, Edward S. Cooke Jr. was a reader of the penultimate manuscript, and his keen criticism and willingness to engage in follow-up questions improved its maturation by leaps and bounds. I also thank my editor, Leslie Mitchner, for prodding the project forward, as well as Margaret Case, and the staff of Rutgers University Press.

This is a book about a librarian, but one who wanted the books off the shelf, and it is to that sort of industry that I owe my largest debt. Numerous archivists, librarians, and curators have provided time, expertise, and endured my extended visits. In Newark, I have been the beneficiary of expertise and much good will. Ulysses Dietz, curator of decorative arts of The Newark Museum; William Peniston, librarian of the Newark Museum, and Jeffrey Moy, archivist of the Newark Museum; William J. Dane, Jared Ash, and Chad Leinaweaver in the Newark Public Library's Special Collections; James Lewis and James Osbourne in the New Jersey Room; and Maureen O'Rourke, reference associate in the New Jersey Historical Society, each was heroically generous over the course of many years. Numerous others dedicated their professional skill and time: Elisabeth R. Baldwin, archivist at the Metropolitan Museum; Jane Rodgers Siegel, in Rare Books at Columbia University Library; Fernando Peña, curator of the Grolier Club; Madelyn Kent, curator of the Seymour B. Durst Old York Library, Graduate Center, City University of New York; David Kuzma, in Special Collections and University Archives, Rutgers, the State University of New Jersey. I also thank the

staff of the Science and Business Library and the Main Branch of the New York Public Library, the Library of Congress, the New-York Historical Society, Avery Library of Columbia University, the Summit New Jersey Public Library, the Summit Historical Society, the library of the Brooklyn Museum, the Brooklyn Public Library, the Bard Graduate Center, and Scholes and Herrick Libraries of Alfred University.

It has been my pleasure to meet and work with Wilma Dane and Mary Sue Sweeney Price, current and able stewards of the Newark Free Public Library and Newark Museum, respectively. They and numerous administrators at other institutions were supportive and welcomed me. Jack Anderson at the Woodstock Historical Society spent days with me, conducting fieldwork and sharing information. All the aforementioned understood the value of visual evidence in this publication. In addition, for securing images I thank Tim Decker of the New Jersey Historical Society, Olivia Arnone and Rebecca Buck of the Newark Museum, and treble my appreciation to William Peniston, Jeffrey Moy, William J. Dane, Jared Ash, Chad Leinaweaver, James Lewis, James Osbourne, and Maureen O'Rourke.

At Alfred University, several students have been wonderful teachers, and I have benefited from supportive colleagues. In particular, I thank Linda Sikora, Barbara Lattanzi, and Dean Joseph Lewis for their intellectual curiosity. I also extend my appreciation to Don Weinhart and John Hosford for their good humor in helping me keep my images in sharp focus.

The generosity of the Craft Research Fund of the University of North Carolina Center for Craft, Creativity and Design facilitated the completion of this work and I thank the staff and the board. The Windgate Foundation generously lent support to the book's production and I thank Robyn Horn and John Brown III for encouraging me to apply. I also thank the Society for the Preservation of American Modernists and the Marcianne Mapel Miller Fund for Ceramic Art, Alfred University, for aiding research and production.

Several friends and family gave me criticism of the first caliber before this project took the shape of a dissertation, especially Rachel Brownstein, Daniel Brownstein, and Gabriel Brownstein, my mother and two older brothers. I grew up reading my mother's paperback copy of "Made in America," listening to stories about John Kouwenhoven over dinner, and looking hard at the George Washington Bridge: to my mother I owe my title as well as my education. But not only family directed me into this business: Susan Edwards was the best type of boss, who hired me to work at the Katonah Museum of Art, taught me much, and then encouraged me to leave in order to enroll in graduate school. Leon Waller is a colleague who was the first to make museum education interesting to discuss. Bill Barrette, Diana and Lawrence Fane, Linda Cohn, Mark Silberman, Ajay Chaudry, James Leggio, and Elaine Koss all

enriched my incidental education. And as we have logged hundreds of thousands of miles in our cars together, Charlotte Rice continues to enlighten me, broadening my horizons in the best ways, and I thank her for encouraging this eccentric task to grow over the past decade and not tiring of Newark meandering in and out of our discussions as we navigated broken windshields, bumps, and babies.

Emerging from this project in the wee hours of the night, I know there are others who deserve to be noted for their good tips, undue praise, or productive friction. Tracing back these lines of sustenance, I have had scores of patient teachers in flea markets, classrooms, and archives, and I thank you for sharing your knowledge, cultivating my eye, and tolerating my curiosity. It has been a pleasure to return to the scholarship of Joseph Siry and Richard Ohmann, and finally understand what excited me about their work in college. I particularly regret that two people, artist Lawrence Fane and librarian Charles Cummings, died before I could level out my sentences and reap the rewards of having them as readers. One introduced me to take delight in craft and the other in Newark. Both were selfless educators. I hope that this cold type and damp paper preserve some of their thoughtfulness and consideration, convey their spirit.

Lastly, it would be a suppression of my autobiography if I did not admit that my interest in the virtue of making things was prompted by my grandmother, Rose Mayer, a milliner whose knitting, quilts, and baking were once much more real to me than the occupations of bookish grownups. As we kneaded dough and peeled apples she taught me to take pleasure in being industrious and enticed me into the "Romance of Labor" long before I knew of the book of that name by John Cotton Dana and Frances Doane Twombly.

MADE IN NEWARK

1. Newark Free Public Library bookplate, circa 1903. Collection of Special Collections Division, Newark Public Library. An iconography of the cultured industrial city emerges.

Cultivating the Industrial City

Characterizing the city of Newark, the director of its Free Public Library, John Cotton Dana (1856–1929), called it an "industrial suburb" of New York City, "our great metropolis."[1] His ambivalent description was both apology and boast. In exhibitions and bookplates, he represented the industrious city in grand mythical terms that were antithetical to its actual chaos: he made the gritty colossus picturesque (figure 1). Revering Newark's factory chimneys, he depicted their plumes of smoke as organic growth.[2] However, even as he bragged of its prowess in production, he regularly beseeched the city to improve, uplift, and ennoble itself.

Like other late nineteenth-century manufacturing capitals, such as Buffalo, Glasgow, and Budapest, Newark is littered with façades and mottoes once designed to reconcile cultivation and industrialization and to forge an image of civic progress. Newark posed two vexing questions to Dana: How should a cultural institution be tailored to an industrial city, and what civic goals should it strive for? He stood on the shoulders of an earlier generation of reform-minded librarians who argued that he needed to respond to his specific community and that books and art had to be defined pragmatically to keep up with society's changes.[3] His library grew in national importance as it modeled methods to boost local manufacturing and conduct social work. The ambitious head librarian and his able coworkers esteemed the "industrial arts" as both a method and a metaphor for individual and collective self-improvement, and built an alliance of school educators, shopkeepers, and manufacturers around allegories of civic enrichment.

When the stately Free Public Library opened in 1901, electric cables strung along Washington Street interrupted views of the façade (figure 2). Set in a

landscape of overcrowded dwellings, bustling retail shops, and busy factories, the limestone monument contrasted sharply with neighboring wood clapboard and brick shops. Early photographs record the uneven mix of hurried enterprise and high aspirations. Its pretentious architecture was borrowed from sixteenth-century Renaissance Italy and was emblematic of the City Beautiful movement, while its basement generators and self-reliant illumination, designed to ensure evening hours for factory workers, were characteristic of the City Practical. In America's manufacturing hubs such as Cleveland, Pittsburgh, and St. Louis, the addition of a library or museum stirred public debate over whether a temple lined with marble halls, grand gilt frames, and European treasures subsidized with taxpayers' money improved the indigenous environment or was an impractical luxury. The Newark Public Library's priority, to develop the city's distinctive identity and encourage municipal patriotism, navigated the dialectic of art and industry by showing both oil paintings and local jewelry and leather production.[4] Its director, Dana, sought to increase the fame of Newark, once called the "Birmingham of America," and frowned upon the acquisition of expensive rarities.[5] It was an era of civic boasts, some still legible today, like the remnant on the Delaware River bridge proclaiming "Trenton Makes, the World Takes." Newark's librarians, as well as its captains of industry, undertook such propaganda. The visual program of the library, and later the museum, redeemed the city's status by dignifying its capital and celebrating its artisans.

Beginning in 1902, with Dana's arrival, the public library won notoriety for live demonstrations of New Jersey skilled labor's "good workmanship," spectacles intended to exhibit and enrich the skills of its mechanics.[6] In 1909, exhibitions on its upper floors were formally organized under the aegis of the Newark Museum Association. Library and museum functions, personnel, and trustees became intermeshed, and a stew of cultural literacy and civics lessons lavished praise on local artifacts and landmarks. By tying its mission to contemporary consumption and production, the institution disavowed conventional notions of cultural absolutes.

The library epitomizes an attitude of isolationist progressive industrialism.[7] It sought engagement with local capital, entrepreneurship, and consumption as benevolent factors in civic improvement. Newark tried to revive "municipal mercantilism" just as America was becoming predominantly urban and, across the nation, alliances made under the banner of Progressive reform cried for "home rule" and "home spirit."[8] Dana upheld regional applied art as a lesson in good citizenship and collaborated with nearby retail

2. Postcard of Newark Free Public Library, circa 1902–1905. Collection of the author. The new library was a sight worth seeing and sending. An import like the Renaissance Revival style of the façade, which came to the United States from Europe, this postcard was manufactured in Germany and retailed locally in Newark.

stores to moralize goods. But the result was that distinctions between serving citizens, the municipality, and industrial capitalists blurred. Commodity production became a metonym for the city-state. Dana's odes idealizing the captain of industry were remarkable because he merged them with the trope of the self-reliant and inventive entrepreneurial artisan, the clichéd hero in Horatio Alger stories. Skilled work was a metaphorical solution to the perceived central issues of the day, including the threats posed by "the masses," the "woman question," and what was referred to as the "alien element." The library's praise for free competition, civic incorporation, and artistic production preserved the city's hegemony more than it challenged the ruling elite.

A period description of the library's mission as "a means of elevating and refining the taste for giving greater efficiency to every worker" preserves Newark's confusing characteristic approach to culture, which elided scientific labor management with older paternalistic terms conceived in the Enlightenment.[9] Developing in a distinctly capitalist and consumerist fashion that was unseemly to aesthetic connoisseurs, stately art museums, and libraries, Newark emphasized outreach, and included an extensive library branch system; a magazine; school exhibitions; industrial, scientific and children's

3

museums; billboard advertising; and the manufacture and sales of goods directly to the public. Boldly and innovatively integrating modern entrepreneurial and managerial tools into the library and museum, Newark willfully defied what historian Lawrence Levine characterizes as the era's tendency toward the "sacralization of culture" by becoming an instrument for civic betterment and by putting vernacular products on a museum pedestal.[10] Its notion of democratic culture was hierarchical but still radical. A hundred years ago, the "live museum" was one of Newark's exhilarating and dramatic inventions.[11]

NEWARK, CITY OF INDUSTRY

In 1900, Newark was one of America's twenty most populous cities, a conurbation of three hundred thousand people. Factories made the state one of the wealthiest in the nation. In 1907, when Edward Stokes, New Jersey's governor, declared Newark a "beehive of industry," he admitted the state's failure to spawn a metropolis, and cast the city's productivity as its strength.[12] The city thrived in manufacture and transportation. Like nearby Jersey City, Newark was indeed an "industrial suburb" tied to Gotham's population of nearly four million people ten miles away. In Benjamin Franklin's day, New Jersey had been a breadbasket supplying New York City and Philadelphia—a keg from which beer flowed from both ends. In 1900, it maintained this subservient role but was now an industrial, not an agricultural, cornucopia.

Cosmopolitan culture was not readily apparent in Newark at the turn of the century. Factories were centrally located in the city, clustered along railroads and canals, as a map made by the Newark Public Library in 1911 attested. Residential housing was a secondary consideration and parks and public amenities were given little thought (figure 3). Before 1850, Newark exported thousands of David Alling's assembly-made "fancy" chairs and Moses Combs's shoes.[13] In 1872, Horace Greeley recalled that it was "a smart, rather straggling but busy village" which became a prosperous rail depot overnight to meet the demands of the Civil War.[14] Newark's manufacturers, especially

3. Map of factories in Newark, *Newarker* 1, no. 2 (December 1911): 25, drawn by John Cotton Dana, Sarah Ball, and FBS. Collection of the author. Shaping the citizens' self-awareness through this map, Dana and Ball combined visual marks and numerical information to show a bird's-eye view of Newark's two thousand factories. Large versions of the map were made and shown at municipal industrial exhibitions and Dana, a member of the City Plan Commission, reprinted the map as visual evidence that Newark was a "progressive city" in the commission's 1913 report.

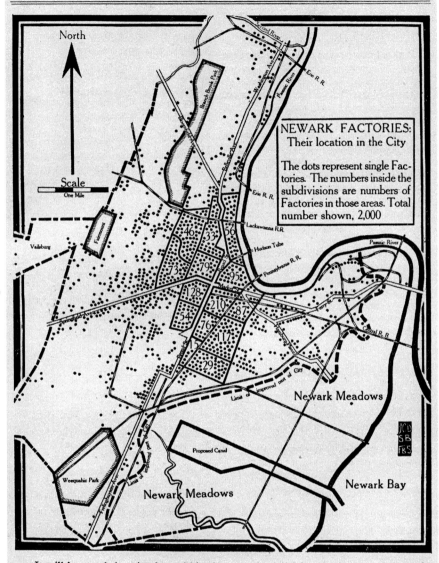

NEWARK FACTORIES:
Their location in the City

The dots represent single Factories. The numbers inside the subdivisions are numbers of Factories in those areas. Total number shown, 2,000

It will be noted that the dots within the several subdivisions in the center of the city do not correspond with the number of factories in those subdivisions. The dots simply give one the proper idea of where Newark's factories are situated. Within each of the areas marked out by the black lines, there are as many factories as the number in the center of the area indicates.

The dots do not represent separate factory buildings. In some cases they represent several factories in the same building. It is not possible on so small a map to show differences in the number of hands employed in the factories. The map does show, however that the factories have kept close to the trolley and business center of the city at Broad and Market Streets, and close to the railway lines that cross the city, and close also to the water transportation facilities afforded by the Passaic River.

metal refineries and leather goods firms, swelled with wartime expenditures, but their factories, rail lines, and industrial waste sprawled out. There had been no thought to planning an infrastructure. Prior to tapping the Delaware watershed and building sewers in the 1880s and 1890s, toxic byproducts from Paterson flowed through the Passaic River, and Newark's mortality rate was one of the nation's highest.[15] When advocacy for clean water, sanitation, schools, streets, and street lighting gained momentum at the century's end, it was a sign that the city had reached a new phase of maturity.

As New York City grew, so did Newark, its population doubling every twenty years. In the late nineteenth century, the production of celluloid and electrical hardware were added to a diversified economy, and the voluminous export of goods surged: luggage, lamps, and all types of jewelry, from novelty pins to watch fobs and buttons. The commercial transportation networks that dominated the cityscape were only beginning to be regarded as an integrated system in 1911, when the business branch of the Public Library mapped it as such to show that Newark was in need of capital improvements.

Newark's Board of Trade was formed in 1868, and this alliance of manufacturers drove improvements more than any single political party or mayor. They considered public works good investments. The Board of Trade was the first to try to turn the city's profile as an "industrial suburb" into a selling point for businesses to relocate from Brooklyn, and they, more than politicians, reformed its infrastructure.[16] In 1872, Newark's industrial exposition gave the city national attention. It was narrow and self-promoting, designed to boost the city's own goods, and was dwarfed by the scale and internationalism of the Centennial Exposition in Philadelphia in 1876. Municipal trade shows were revived in fits and starts, and goods finally began to be stamped "Newark Made"—signs of genuine civic pride—in the twentieth century. "Newark enjoys the distinction of having a greater diversity of industries and a greater output in value of manufacture than other city in this country," the board boasted in 1902, a partly truthful bit of municipal salesmanship.[17]

By 1900, manufacturing began to drift westward to Detroit and Cleveland, and Newark's economy shifted toward retailing and distribution, but the idealization of skilled craft pervaded the city's identity.[18] Despite the proliferation of moving assembly lines, the Board of Trade's publications romanticized the skilled hand in the factory, rhapsodizing about the "whirr of spindles, clack of machinery, purr of dynamos, pound of forges, bang of hammers, and rasp of files, as the best artisans of the world turn out [our] products."[19] In a similar vein, the Public Library's map enumerated "the numbers

of hands" employed by each factory. Labor historian Susan Hirsch points out
the irony that most of Newark's artisans and mechanics were wage-earning
operatives and its workforce was transient. Declaring that "the wonderful
inventive genius of our mechanics . . . gives promise of stability that insures
a permanency without question," the Board of Trade sketched an important
early-twentieth-century myth—that local industry would reward the diligent
worker and commit capital to local human resources.[20]

Trying to establish its genius loci, the city celebrated manual invention. In
1890, a memorial statue to Seth Boyden (1788–1870), the father of Newark's
multimillion-dollar patent leather and malleable iron industries, was erected
in Washington Park (figure 4). The sculptor, Karl Gerhardt (1853–1940),
originally a machinist himself, depicted Boyden as a tradesman in a leather
apron, flanked by an anvil and hammer, head bent down to study a piece of
handiwork. A nineteenth-century Hephaestus in rolled-up shirtsleeves,
the bronze figure was among the earliest of American public monuments to
celebrate industry as a civic virtue; more typical was Manhattan's statue of
Robert Fulton—a designer of the steam engine—as a gentleman. The round-
shouldered Boyden expresses humility, not hubris. Private subscriptions for
the monument to Boyden commenced in 1872, but completion was far from
certain until the Board of Trade took over the task of financing it in 1883. In its
annual yearbooks and municipal exposition publicity, the organization por-
trayed the statue of the inventor as the embodiment of the city's work ethic.[21]

In 1900, the library arose across the street from Boyden, as if to give the
laborer an uplifting destination. And in 1926, Newark built its first museum at
the southern end of the green. Between 1909 and 1926, when the museum was
a small venture housed on the library's top floors, Dana's project to cultivate
Newark relied on Boyden as a metaphor. The library saluted him as the city's
foremost industrious citizen, placing his portrait on the cover of its booklet
"Newark: the Story of Its Awakening, 1790–1840" (1905). He became an icon
of civic virtue.

Newark's entrepreneurs and socially minded reformers expected the
public library to influence civic fortunes. A citizens' referendum chartered
public funding for it in 1888, and it succeeded because the city held the con-
viction that culture could be profitable.[22] Newark's manufacturing context
and industrialist trustees gave the cultural institution its character from
its inception. "The benefit mechanics and their children derive from a free
library" were eagerly anticipated in an era when opportunities for schooling
were still limited.[23] This notion that public education should abet commerce

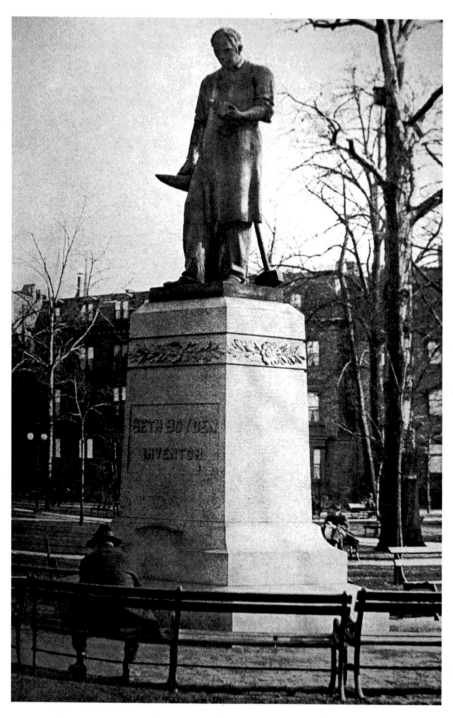

4. Statue of Seth Boyden reproduced in David Lawrence Pierson, *Narratives of Newark (in New Jersey) from the Days of Its Founding* (Newark: Pierson, 1917). Karl Gerhardt modeled the statue by 1880, and it was erected in 1890 near the site of Boyden's first shop.

only increased under Dana's tenure, when the *New York Sun* exclaimed that "if Newark's population does not attain intellectual supremacy over all the other people in the United States, its failure cannot fairly be laid at the door of the public library."[24] The library was conceived to make the city more competitive.

Located three-quarters of a mile from Newark's main commercial intersection, the library was part of an impressive constellation of turn-of-the-century civic structures. The Philadelphia architectural firm of Rankin and Kellogg designed the façade to resemble a sixteenth-century Florentine palazzo. By 1900, the style, derived from the École des Beaux-Arts, was already a conventional vehicle of the City Beautiful movement. A smaller version of McKim, Mead, and White's much emulated 1895 design for the Boston Public Library, the interior plan accommodated such modern amenities as a spacious auditorium, museum, art gallery, and a designated children's room, in response to librarians' demands for increased educational activities. Progressive librarians, part of a national professional organization since 1876 that advocated reform, saw the library as "a factor in industrial progress" and a "living organism" that grew in response to the developing city.[25] Describing the coincidence of the library's opening and the departure of its director, Frank E. Hill, the *New York Times* called the library "splendid" and "one of the most potent centres of the intellectual life of that city."[26]

The library was soon joined by a host of other municipal buildings of even greater extravagance. In 1907, the Essex County Courthouse, designed by Cass Gilbert, opened; it was adorned with murals by Kenyon Cox and Howard Pyle and skylights by Louis Comfort Tiffany's firm. In 1908, the city's most majestic classical monument arose, a granite and marble Newark City Hall designed by local architect John H. Ely and his son, Wilson C. Ely. The elder Ely had served as a member of the city council, and was celebrated as "enterprising and public-spirited" in a 1916 publication; the cost of the City Hall, more than two million dollars, was considered by its admirers and detractors either excessive or apt.[27] In comparison, the library's construction required over three hundred thousand dollars.

Considering the late arrival of these emblems of municipal order, it is not surprising that commercial establishments dominated Newark's identity. Insurance companies built new skyscrapers at the mercantile hub of the "Four Corners," the downtown intersection of Broad and Market streets, which towered above the governmental edifices. The spiked silhouette of George Post's hulking fortress designed for the Prudential

Insurance Company in 1892 was visible from miles away. In 1912, Newark's L. Bamberger & Co., the fifth largest department store in the nation, built a new flagship store on Market Street at a cost of two million dollars. This eight-story structure, clothed in luminous creamy terracotta and studded with electric bulbs, was feted in advertisements as "the Great White Store." Its architect, Jarvis Hunt, was the nephew of Richard Morris Hunt, the seasoned artificer of pomp. Jarvis Hunt would later design Newark's 1926 museum building, paid for by Louis Bamberger himself—an indication of how local patronage seamlessly integrated the spheres of business and culture. Prudential's turrets and Bamberger's immense plate glass windows had greater influence in shaping Newark's skyline and streetscape than all its temples of justice or culture.

When the Hudson and Manhattan Railroad "tubes" opened in 1911, the flow of consumers and workers commuting between Newark and New York City increased. Bamberger's and Hahne's (Newark's other premier department store), were economic anchors and tourist destinations, competing with Manhattan's Macy's and Gimbel's. Their large auditoriums, restaurants and other luxurious amenities hosted commercialized mass leisure and gave Newark citizens their first rides on elevators and escalators. Bamberger's advertised itself as a "civic" venue, "almost a community center."[28] Such assertions had validity because of the extensive philanthropy of Louis Bamberger and Felix Fuld, his co-owner and brother-in-law. Their advertisements promised that "the Bamberger store is continually evolving new ways of serving the interests of the community."[29] This confounding of business interests and civic welfare also characterized Newark's City Plan Commission in 1912. The development of a better urban transport system, sewage, and vocational high schools were social improvements to reach an economic objective.[30]

Slow to establish a public cultural institution, Newark was eager to catch up in the early twentieth century and was therefore inclined to experiment. If the public library began as a popular mandate, it only blossomed after Dana arrived in 1902, and gathered businessmen and headlines to his cause. When the *New York Times* noted, "A state of progress always seems to be characteristic of Newark," it used the term in relation to speculative construction and entrepreneurial risk taking, an atmosphere Dana turned to his advantage.[31] He facilitated the intimacy between industry and the library and museum, but the institution's identity would also emerge from the trustees' working knowledge of capital and production and the city's pace.[32]

In 1909, a small coterie of library trustees created the Newark Museum Association. Although they unanimously aimed at civic enrichment, they disagreed on a plan of action. Richard C. Jenkinson's 1902 gift of technical and mechanical books was motivated by a vision of the institution in relation to Newark's economy. The bookplate Dana mounted in his donations was among those that articulated a beatific vision of industry; chimney smoke culminated in fruit-bearing trees. Jenkinson too spoke of the library as a mechanics' aid despite other characterizations of its primary constituency as women readers of fiction. The museum's two "benefactors in perpetuity," Franklin Murphy and Louis Bamberger, were opposites. One had national stature in the Republican Party and served as the state's governor, enacting child labor laws but protecting corporations from taxation; the other quietly sculpted the city's parks and endowed hospitals. Bamberger was always an outsider because of his origins as a peddler, immigrant, and Jew. Both men hung their academic French oil paintings in the museum, but they disagreed on the institution's value as a social instrument. Bamberger supported acculturation and funded political activism. He donated goods to the suffrage bazaars conducted by the Women's Political Union. Murphy demurred in a letter to Jenkinson: "I have the highest respect for the ladies except on the single question of female suffrage."[33]

The two trustees diverged openly in 1916, when Murphy advocated a colossal palace specifically for fine art designed by McKim, Mead, and White, and Bamberger quietly seconded Dana's plan for a more modest museum of industry that would still be close to the library's mission of public education. Murphy's grand aspirations for Newark were derailed, and the fracas meant that the museum building was postponed by a decade. After World War I, with Murphy dead, Bamberger paid for the museum building that stands today, but thereafter his interest shifted to other efforts, such as establishing Princeton's Institute for Advanced Study, perhaps because he foresaw that the university would be a more dynamic tool than the museum to activate economic and intellectual changes in American life.

While the library and the museum remained all male in their governance, several trustees' wives headed Newark's Young Women's Christian Association (YWCA). This division, like that between Bamberger and Murphy, meant that abstractions like industry and culture were qualified in distinctly gendered ways and that the city's complex philanthropic ecology operated as a small micro-climate. Mrs. Jenkinson, a president of the YWCA and The Contemporary, a women's club intent on civic improvement, supported the polarizing movement of women's suffrage.[34] A city that had no

tradition of citizenship was trying to design its civic ideals while also negotiating a contentious political and social landscape.

The library's public included a vast number of non-English-speaking immigrants, predominantly from southern, central, and eastern Europe. In 1912, a fearful headline in the *Newark Star* exclaimed, "City Is Foreign!" because more than two-thirds of the city's population of 355,000 was considered to be of "alien" culture.[35] Turn-of-the-century immigrants were esteemed less than their predecessors and considered especially in need of "Americanization" if labor strikes were to be subdued. In general, they came from rural backgrounds, unlike the earlier waves of German artisans of the mid-nineteenth century, and suffered greater bouts of unemployment in less prestigious work. Employee turnover in these years averaged 115 percent annually for most factories.[36] Even the most socially minded trustee used the flow of human labor as if it were fuel, following turbulent market demands.[37] Many workers in Newark's factories were younger than twenty and, as in other northeastern cities, were most visibly subject to industrialization's disruptive patterns. The education of Newark's children, 64 percent foreign-language speakers in 1912, was considered a reform of paramount importance in order to secure the city's future.[38] The library took aim at this population in particular.

Initiatives to enrich the city and its citizens coalesced in a benevolent paternalism in which civic boosterism was often a greater priority than social reform. In 1904, a "business man's branch" was opened, the first such public library in America dedicated to this special constituency. Eight years later, in 1912, the library created a "foreign branch" near Springfield Avenue to serve the immigrants living in the area. The institution reached out to capital and businessmen first, the working poor second. The concept of the business branch was utilitarian: it advertised a Remington typewriter available for complimentary use to serve the entrepreneurial individual, thereby democratizing the Internet station of the era. The aim of the foreign branch, where the majority of the books were in languages other than English, was also practical—a bid to educate and "improve" the poor. In 1912, the business library had twelve thousand books and the "foreign" library ten thousand, and these were by far the largest of the seven branches. Library publicity records these as analogous and reciprocal, not antithetical, endeavors. Businessmen were encouraged to read both nonfiction and fiction to gain "increase of intelligence and sympathy," and books on modern plumbing and electricity were ordered in Russian and Italian.[39] Moreover, the library also printed its own pamphlets

and posters to bring commerce and industry, literally and metaphorically, inside its walls. If Newark was a "hive of industry," the makeshift colony of stratified social networks and diverse agenda was anything but orderly.

MODELS FOR NEWARK'S THEATRICAL
USE OF INDUSTRIAL ART

Traditionally, scholars attribute the innovative aspects of the Newark Library and Museum to the leadership of Dana, who served as the director of the library between 1902 and 1929, and was a cofounder of the Museum Association in 1909 (where he was the secretary for the first five years). A polymath with a national reputation in his day, Dana opened book stacks to the public and created specialized public libraries focused on children, business, and medicine. He also served important roles on Newark's 1912 City Plan Commission and as an argumentative member of its Board of Education. His legacy of civic activism defies easy generalization or political labels. A truly idiosyncratic and pragmatic thinker, he became a reactionary progressive or anti-institutional and anti-bureaucratic radical, depending on context. Mirroring his institution's hybrid identity, he expanded the traditional role of the librarian to advocate public welfare as a social scientist, businessman, teacher, preacher, interior decorator, and craftsman.

Dana insisted that his staff see their vocation as a handicraft, and by focusing on his own cultivation of industrial arts, the reciprocity of his museum and library can be appreciated. He argued that librarians should be able to handle a printing press and set type, bind books, and nimbly identify the technical differences, for instance, between engravings and lithography. His 1905 study of bookbinding was intricately and fastidiously practical, and listed "paper, leather, cloth, sewing, joints, gold, and many other things the librarian must know."[40] In January 1904, he acquired a printing press to demonstrate the "magic of Gutenberg" to the public. Skillful in the craft since his teenage years, he instructed his staff. He authored a set of guidelines on the proper ways to display lecturers to best educational effect, as if a harmoniously colored background was as important to live communication as it was for museum objects.[41] His praise for the aesthetic "charm of the uncluttered" has rightly been interpreted as a rejection of Victorian taste, but his citation of "the imperative demand of good taste" and of "art-in-industry" sprang from nineteenth-century educational ideals.

Dana's vision of education as a process conducted by industrious hands was mocked, looked on with skepticism in his own day. Cartoons ridiculed

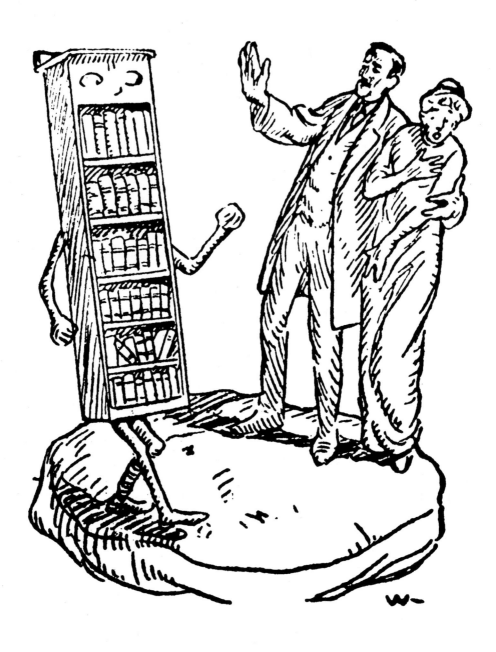

5. Cartoon of Dana defending woman in *Newark Evening News*, 12 November 1912, NPL Scrapbook, 1906–1912. Collection of the Charles F. Cummings New Jersey Information Center, Newark Public Library. Here Dana was being pilloried as a librarian who lacked a proper appreciation for classical learning and who was serving the whimsies of women for fiction.

his idea that library patrons need not study the classics and that children should spend more time at playgrounds than reading books. A 1912 satire proposed that a bronze statue of the heroic librarian "protecting a [frightened female] figure representing suffering humanity from a threatening five-foot shelf of books" be erected in Washington Park alongside that of Boyden (figure 5). The aggressive bookcase of bound classics represented the idea that "average" Americans self-educate themselves by dedicating fifteen minutes a day to working through a "five-foot shelf" of books. (Harvard President Charles W. Eliot had proposed this as a modern system of self-education and publisher Collier and Son retailed "Dr. Eliot's Five Foot Shelf.") The *Newark Evening News* published the drawing to criticize Dana and quoted a Chicago newspaper that his boosting of contemporary fiction was a "damnable perversion of the functions of a public library."[42] Multiple copies of the news item were carefully preserved in the library's scrapbooks, evidence that his idiosyncratic "reforms" caused controversy and won him the publicity he sought. His desire to dethrone "book learning" and the classics divided librarians, who considered his tactics to increase relevance either condescending or democratic.

In 1903, the Newark Public Library's *Annual Report* noted that the institution intended to get "in touch with the Art-and-Crafts' movement and with village industries," a sign that the leaders of the industrial city considered the revival of handicraft relevant to their aim.[43] The Enlightenment project fused with this more recent creed that sought to revitalize the city by cultivating rural taproots. The industrial arts, especially crafts such as bookbinding and jewelry, were considered pragmatic vehicles to further civic betterment and self-improvement. In contrast to wealthy metropolitan libraries and museums that kept vocational education at an arm's length, Newark argued that the regional museum should match its methods to its local economic and social context.

To label the Newark Library and Museum forward-thinking or innovative because it sought to influence the production and consumption of applied art obscures how deeply its idealism poured old wines, nineteenth-century "rational recreation" and design reform, into a new century's wineskin.[44] Newark's emphasis on industrial education and commerce amounted to a cultural arrhythmia. Industrial art was old-fashioned in 1900, but it had been modern in 1875 and would become so again in the late 1920s, when "industrial design" took on its current meaning. Like the Pennsylvania Museum and School of Industrial Art, established in the aftermath of that city's world's

fair, Newark's museum hoped to influence directly living ideals of industry and simultaneously to preserve the past. In the 1870s, a generation of American museums wrote the educational mission of applied art into their charters in emulation of the South Kensington Museums (now the Victoria & Albert).[45] The Newark library held onto that institution's utilitarian goal to influence the artisan and mechanic and guide the artistic quality of middle-class consumption.

When Dana told the Board of Trade to fund vocational high schools because "a city which makes things must see to it that it also makes good men," he resorted to a mechanical logic and a solution suggestive of Frederick Winslow Taylor's "scientific management."[46] Advocating artistic shop work as a means of forging civic solidarity, he delivered a speech on the subject on the same stage as John Dewey at a convention for teachers of art and manual training. Both valued "industrial education" in order to reform new Americans, in Dana's case primarily by molding their taste and homes.[47] The educators hoped to ready students for the journey from the home to the factory by giving them an intellectual appreciation for machine-made goods. Their aim was to revive handicraft as a moral engagement, to integrate the spiritual and mechanical—what Dewey called "the running machinery of the individual."[48] In *The School and Society* (1899), the philosopher pictured the "industrial museum" as the great unrealized modern educational rite that was needed to stabilize society.[49] Dana grafted this vision onto Newark's library and tailored it to his city. Whereas William Morris disdained the term "industrial art" for its implied conditions of production, Dana and Dewey valued the commercial connotation as a desirable and most modern ambition.[50]

Dana's attempts to fashion Newark's exhibitions of industrial art into an effective civic curriculum relied on precedents set by the Labor Museum in Chicago, a component of Jane Addams's Hull-House, and the Commercial Museum in Philadelphia, to which he sent inquiries. To Hull-House went his questions concerning bookbinding classes, and to the Commercial Museum his queries on boosting entrepreneurship. In 1900, Addams was known internationally for her work in "industrial amelioration."[51] She founded the American settlement house movement around what she called "lines of activity," developing a lecture hall, daycare center, theater, and craft workshop in one complex.[52] In 1891, Hull-House's picture gallery brought "art to poor people."[53] Its Labor Museum, in which Addams and her staff selectively adapted a view of manual industry from the British Arts and Crafts movement to use in outreach programs, mainly for local children and women, opened in 1899.

Hull-House's newsletter advertised the Labor Museum as a place where live craftwork preserved "ancient knowledge." Craft demonstrations were a staple there because Addams noted "the spot which attracts most people at any exhibition or fair is the one where something is being done."[54] It was women-centered and immigrant-oriented, and encouraged the preservation of "domestic industries" rendered obsolete by modern factories. Strolling into the Labor Museum, visitors witnessed the "primitive arts" of "Irish spinnin [sic]": immigrant handicrafts in particular were thought to demonstrate that there was "no break in orderly evolution if we look at history from the industrial standpoint."[55] The Newark Museum also showed "old customs of new Americans," and although some scholars see this move as proto-multicultural, at the time it related to G. Stanley Hall's theories of graduated mental development.[56] To ascribe an evolutionary stage of civilization in relation to handicraft was both a scholarly and popular leitmotif.[57] Women in Hull-House and in Newark's public schools learned to sew a shirtwaist as a "way up" in social advancement and character. Handiwork was conceived as condensing the steps of the civilizing process, although it is often anachronistically interpreted to have been a countercultural or anti-commercial tactic.[58]

The Labor Museum and Philadelphia's Commercial Museum were leading examples of experimentation, and both were featured in Gustav Stickley's popular home furnishings magazine, *The Craftsman*, in the years when the Newark Museum commenced.[59] The Commercial Museum, established in 1893 by William Powell Wilson (1844–1926), staged trade shows and published statistical data to aid business.[60] Members of Newark's Board of Trade visited the museum in 1898; thus several of Dana's trustees already appreciated the concept of an industrial museum.[61] It was intent on aiding the American businessman identify global markets and sustain an interest in exploiting resources. First assembling specimens from the World's Columbian Exposition held in Chicago in 1893, Wilson, a botanist turned showman, created taxonomies and tableaux that conveyed economic stories. The museum sought to combat isolationism in trade by teaching the small businessman to have a global outlook. In fact, Wilson described the rise and fall of civilizations in relation to the failures and successes of trade routes. Internationalism in the service of commerce would be one of Dana's consistent themes.

In Newark, Dana collated these visions of "uplift" and attempted to integrate gendered notions of productive labor. Exhibitions were both ethical and commercial injunctions, attempts to domesticate citizens and foster faith in modernization. He wrote to Wilson to see if he was interested in breaking

precedent with his mission to show solely American goods by exhibiting Germany applied art.[62] Although Hull-House is often considered an oppositional force to capitalism, Addams saw factory manufacturing in a positive light, as "more exhilarating than the work of the old tailor, as playing in a baseball nine gives more pleasure than that afforded by a solitary game of handball on the side of the barn."[63] Her institution of social and economic urban reform had multiple aspects: it was a charity to give succor to the less fortunate, a vocational resource, an ethics lesson, and a pep rally. But when she called on the "spirit of 'team work'" to transform alienated workers into modern athletes, Addams's call for unity resembled Wilson's patriotism. Newark's hybrid cultural institution was a combination of the Commercial Museum and Labor Museum, hall of science, art museum, and modern public library; to reduce it to only one of these types is to lose sight of the complexity of its ambitions and the regional varieties of progressivisms.

Like Addams and Dewey, Dana and his largely female staff of librarians had left behind a rural birthplace to pursue urban crusades. They were attracted to culture as an agent of change. Without becoming members of the clergy or striving for elected office, these missionaries sought to influence civic life and private morality. Paradoxically, they sought to reform and even to modernize the city through preindustrial handicrafts, ethical injunctions, and collaboration with industrialists, and saw their own work as sophisticated and altruistic, and therefore a morally superior form of industry.

The hands-on contribution of Dana's staff in articulating the metaphor of the industrious citizen should not be overlooked and is evident in archived exhibition records, correspondence, and newspaper clippings. Newark's librarians eagerly promoted industrial art as both a mode of economic advancement and a transcendent force, but their democratic aspirations of suffrage resided quietly within a habitual renunciation of the self. The library and museum became a stage for these culture workers to perform their own ideal of industrious citizenship although they had inherited the more obscure role of maternal nurturer.

Most of Newark's librarians were among the first generation of women to attend college; the profession had only recently been feminized. They were in search of a calling, driven by a moral agenda to reform public life. The contributions of Addams, in establishing the urban settlement, and of her colleague Florence Kelley, in policing of factory conditions, were their exemplars. Most librarians were new to urban life. Although they are often overlooked, considered to be passive and deferential participants, these "apostles of culture"

preached social advancement even though they were not yet emancipated by suffrage reform.[64] The Newark Library's most prominent female staff members, Louise Connolly (1862–1927) and Beatrice Winser (1869–1947), were active in the Women's Political Union, zealous soldiers in the ill-fated battle to pass New Jersey's 1915 suffrage referendum. Connolly told the newspapers, "there is no profession which demands so fine a quality of self-abnegation as that of the librarian."[65] Female librarians were expected to be models of self-discipline. While celebrated for their social skills, they were also derided in the debate over the declining birthrate of native-born Americans avoiding their "natural" duties of motherhood.

The idealism and self-effacing roles of these women—particularly their evangelical espousal of industry and culture—are archaic by modern standards and difficult to appreciate.[66] Winser maintained self-deprecation after Dana's death, stating, "He was a creator, I am just a worker."[67] But in 1905, when the entire staff penned satirical tributes to Dana upon his departure for an American Library Association conference in Portland, Oregon, she bestowed the same praise with more comic wit. Her droll pictorial portrait bore the caption, "Is this man DANA-gerous? Oh! Yes, he is having IDEAS," in spidery letters. Undercutting these words was the image of a dimwit, much like one of the illustrator McNamara's slapstick characters in the *New York Journal*'s and the *World*'s pioneering and scandalous comics (figure 6). She deftly paid homage to Dana's inventive leadership and simultaneously called into question his tendency to devote himself to penning philosophical arguments. In fact, her fastidious memos and diligent management kept the institution running smoothly so that he could benignly neglect mundane issues. Dana regularly praised Winser in the press as the embodiment of civic virtue, but a bookplate he designed for her reveals a more playful admiration. He transformed her name into a rebus, using an insect, a bee, to signify her first initial (figure 7). She became an ancient symbol of apiary cooperation, the inverse of her depiction of him as a man of repose. Her name was turned into metaphor for industry, as well as organization.

Most of the tributes in Dana's 1905 festschrift gently prodded his hubris, but a few also mocked Newark, an indication that some co-workers shared his ambivalence toward their mission of cultivating the "industrial suburb." One, "Home Sweet Home," lampooned the library's own bookplate and revolted against nineteenth-century sentimentality (figure 8).[68] The image depicting the black Passaic fouled by factory waste parodies the conventional Victorian invocation of nostalgia. In the drawing, the feisty modern librarian claimed a

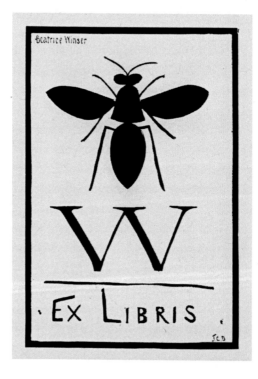

I s this Man DANA-
Gerous?
Oh! Yes he is having IDEAS
Why Does he have
IDEAS?
Because he is a GENIUS
What is a GENIUS?
One who has ORIGIN
AL IDEAS
And has them FIRST

6. Beatrice Winser, "Is this man DANA-Gerous?" in John Cotton Dana, "The Far Northwest" mss. 1905, p. 90. Collection of the John Cotton Dana Papers, Charles F. Cummings New Jersey Information Center, Newark Public Library. Winser's memoranda document her strictness in managing the hemlines and attire of her employees, but this image, while reverent of Dana, suggests she also recognized the role of the radical librarian. Her drawing seems both to applaud Dana's efforts to change institutionalized conventions and imply the difficulty in enacting reform.

Beatrice Winser

W

· EX LIBRIS ·

7. John Cotton Dana, bookplate designed for "[Bee] W[inser]," undated. Collection of Special Collections Division, Newark Public Library. The bookplate is now regarded as an obsolete accessory but once provided a space for self-invention and identity fashioning that is curiously liminal, between public and private spaces. Each graduating museum apprentice in the 1920s needed to compose and print a bookplate, a rite of passage that was a competition to express wit more often than beauty. When Dana made this for Winser, he drew on the metaphor of a "hive of industry," and thereby blended eulogy and jest.

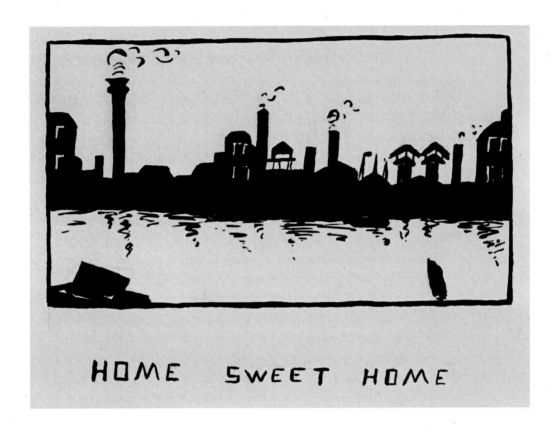

HOME SWEET HOME

8. Anonymous (signed with monogram, MC or CM), "Home Sweet Home," in Dana, "The Far Northwest" mss. 1905, p. 98. Collection of the John Cotton Dana Papers, Charles F. Cummings New Jersey Information Center, Newark Public Library. This motto was commonplace in the late-nineteenth-century ornamented home, a recurring recitation of sentimental domesticity, but reconfigured in Newark it was satire. Store-bought perforated cardboard texts were individuated by needlework, and the repetitive injunctions, from our contemporary perspective, communicate orthodoxies and prescriptive behaviors. By replacing the nineteenth-century ideal of a pastoral cottage with a gritty urban vista, this drawing subverts the cultural constraints of the middle-class ideal.

right to public engagement and expressed a self-awareness that her work was cordoned off as a pseudo-industry of a domestic type. On the one hand, the librarians forsook individuality in the workplace, willingly serving as worker bees on behalf of the institution, but on the other hand, in Dana's unconventional library, they enacted the metaphor of "live" industry when they worked a printing press.[69] They changed the city's character in significant ways by expanding the visible representations of industry and inhabiting a new niche in the city's consciousness. If not the radical or New Woman, the librarian was still an important new arrival who upended conventions.

When the volunteers, staff, trustees, and director spoke of industry, they bridged the ideals of social and entrepreneurial uplift, as well as the relationship between individual ambition and urban progress. In the Newark Library and Museum, an artisan, such as a weaver, might signify diverse political and aesthetic ideals—both homespun patriotism and private aesthetic enrichment. Similarly, a librarian using a printing press might symbolize both the emancipated suffragist and a modern civil servant.

VERNACULAR REPRESENTATIONS OF INDUSTRY: MADE IN NEWARK

When the Newark Museum opened in 1926, the words "Science, Art, Industry" were chiseled into the façade (figure 9). Manufacturing was worthy of respect, a fundamental bond of unification that sustained the community. Furthering commerce was the social contract in the city industrial.[70] In 1928, the museum installed a stained glass memorial window dedicated to the deceased director of manual arts of Newark's public school system, Hugo B. Froehlich (1862–1925) (plate 1). The window marked the museum as an accessory to modern methods in "manual training" and idealized Froehlich's work in "industrial education" in ecclesiastical terms. Applied art and industrial art, handmade and factory-made goods, were emblems of civic fortune and good citizenship.

The window's iconography—a celestial full-length robed male deity, holding a lamp and laurel wreath to symbolize education and enlightenment—self-consciously reaffirmed Newark's identity as a forger of goods but departed from the realism and individuality of the Boyden monument. Designed by Katharine Lamb Tait (1895–1981) and manufactured by her family's firm, J. and R. Lamb Studios, the ethereal effigy was supported by six vignettes illustrating students working in Newark's industrial arts curriculum, using hand tools.[71] The design praised the artisan with a hammer,

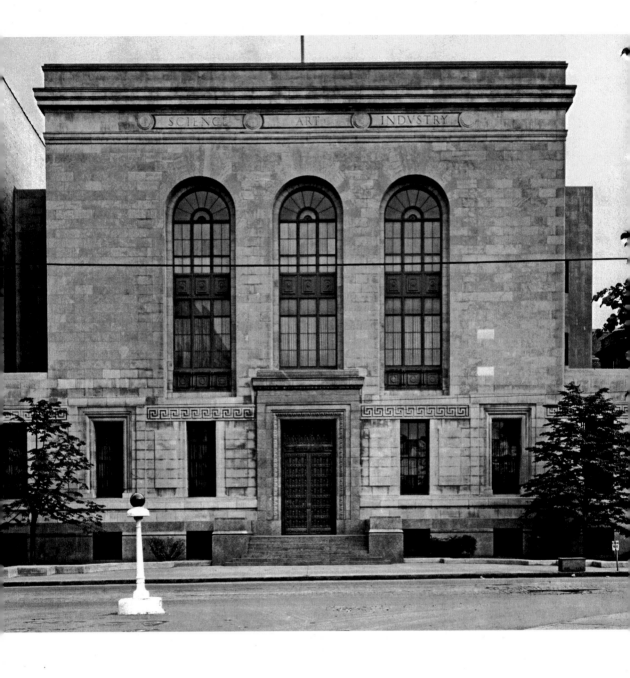

9. The Newark Museum building façade, 17 June 1929. Koenig, photographer. Collection of the Newark Museum. Jarvis Hunt's design for the museum was a restrained classicism, and the words at its top, "art, science, and industry," reflected the desire to be encyclopedic and relevant to commerce and other aspects of everyday life.

turning a blind eye to the reality of the annual U.S. production of two million radio receivers and more than ten million automobiles, which conveyed a very different message. In the larger context of cultural drift, while Ford's management was implementing "progressive obsolescence," the federal census still listed the occupation of blacksmith. The window's representation of culture being made in Newark complicates the concept of the American industrial vernacular that John Kouwenhoven identified in *Made in America* (1948), and that lingers in so many histories of design in the form of a celebration of steel, speed, and men.

Tait's design balanced mythical, historical, and contemporary references. Modernity sat in abeyance, residing in a gothic syntax. Like tapestries and murals, stained glass was a vehicle to broadcast sermons, a medium popularized by late-nineteenth-century British design reformers and secularized by the Americans Louis Comfort Tiffany and John LaFarge. In "Sewing," the short-skirted flapper is a modern young woman in industrial education, an overt attempt to update the historicist medieval genre (figure 10). The stained glass acknowledged select demographic shifts and ignored others. Opposite the scissor-wielding seamstress, a young man in a leather apron, holding a hammer aloft, echoed the statue of Boyden outside, as if "shop work" trained boys for a position of enduring status (figure 11). The craftswomen in the window corresponded to the 25 percent of Newark's manufacturing force that had become female, largely employed in garment production. The images of both "sewing" and "shop work" were integrated into the design after the first draft, which originally favored the fine arts in its depictions and included toddlers playing with alphabet blocks. The finished window was more attuned to the concept of industrial arts on display in the Newark Museum's 1915 and 1916 exhibitions of ceramics and textiles. Whereas the statue of Boyden celebrated a specific heroic individual, the Froehlich window praised self-sublimation to the collective city. The choice of the museum as the proper location for this memorial reveals a zeitgeist in which industrial education was an ideological project shared by both the museum and school.

These two memorials to manual genius—the bronze of Boyden and the stained glass dedicated to Froehlich—demarcate the chronological limits of this book as well as the cultural geography of Newark, where images of work implied social advancement and civic virtue. The window's prominent location expressed the important role of industrial education, and is a reminder that applied art was central to the mission of late-nineteenth-century public museums.[72] "Industrial art" was a meaningful phrase that connected the

spheres of public education, museums, and department stores. In the decade before Modernist doctrine polarized design and manual crafts, displays of seventeenth-century French furniture in the Metropolitan Museum of Art, contemporary glass made by Tiffany Studios, and sewing in Newark's vocational high schools were all labeled as industrial art. The Newark Museum regularly exhibited the handiwork of clubs and schools alongside that of experts, and its mission situated industrial education as a pursuit wherein municipal and individual benefit was reciprocal. Like each of these institutional frameworks, Newark's library and museum grew in relation to a specific vernacular urban milieu.[73] This history rekindles the sights of Newark that inspired the cultural institution and its staff: it seeks to recuperate the thrill of the industrious city.

In the early twentieth century, representations of Boyden and Froehlich tied self-improvement to civic improvement, and suggested that citizenship required subordination to the collective. The assumption was that industry was rational. Handicrafts educators, hobbyists, and sociologists, such as Max Weber and the satirical Thorstein Veblen, maintained that there was innate virtue in skilled hands. Design reformers demonstrated utility as an institutional response to Social Darwinism. Stickley's *Craftsman* and the publications of academic William Graham Sumner connected the "survival of the fittest" to "fitness for purpose," the slogan espoused by the Deutscher Werkbund, an association of industrialists, designers, and merchants.[74] Part of the confusing nature of American Progressives' political rhetoric was the narrowness of so many invocations of the industrious citizen as an athletic, ethical Christian. Speaking in Newark in 1916, Theodore Roosevelt espoused industrial cooperation as a bulwark against "race suicide" and "hyphenates."[75] According to Woodrow Wilson, individual enterprise and autonomy was the essential New Freedom.[76] Championing "honest labor," they reconciled both the vogue of the Arts and Crafts movement and the ethos of capitalist competition. The most fervent believers in Morris's declaration of the inalienable right to beauty could sidestep his socialism to maintain moralistic praise for handicraft and embrace free-market enterprise as an innate right.

Exhibitions of industrial art in the Newark Public Library and Museum developed in relation to a notion of civic welfare pioneered by local businesses. Newark museum trustee Frederick Keer quoted John Ruskin's eulogies to "workmanship" in the promotional literature for his art gallery on Broad Street and promoted Tiffany Studios' lamps and glass, Rookwood pottery, and Stickley's chairs as edifying. He encouraged shoppers to value commodities

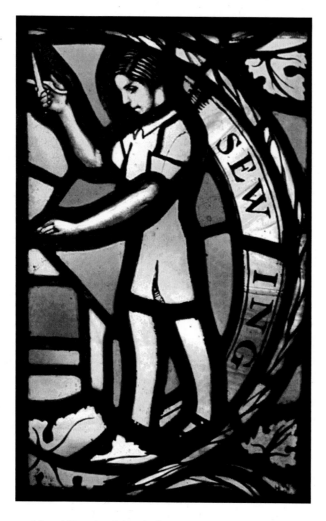

10. (above) "Sewing," detail of Hugo B. Froehlich Memorial Art Education Window, 1927, Newark Museum. Manufactured by J. and R. Lamb Studios, designed by Katharine Lamb Tait, New York, N.Y. Glass, lead; 64 × 35 in. Gift of the Manual Training Teachers of Newark, 1927. Collection of the Newark Museum (27.1451). The designer's original watercolor sketch, now preserved in the Library of Congress with the firm's business records, has in it nothing as modern as this woman with short hair, Mary Janes, and exposed leg. The change suggests that the Manual Training Teachers or the Museum had an active hand in selecting an image that suited their city and their ideals.

11. (opposite) "Shop work," detail of Hugo B. Froehlich Memorial Art Education Window, 1927, Newark Museum. Manufactured by J. and R. Lamb Studios, designed by Katharine Lamb Tait, New York, N.Y. Glass, lead; 64 × 35 in. Gift of the Manual Training Teachers of Newark, 1927. Collection of the Newark Museum (27.1451). By 1927, shop work often involved lathes and electrified machinery, but this image turns to the archaic blacksmith for inspiration, and seems consciously to echo the statue of Boyden outside.

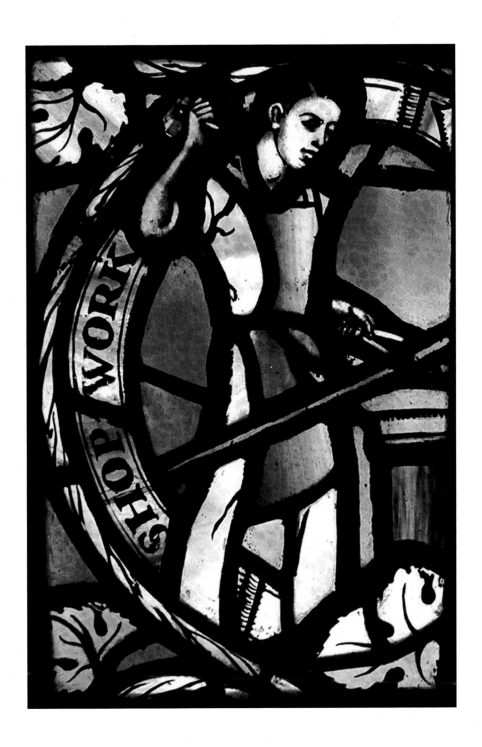

as having ethical properties that could rub off on them.[77] Whereas the Newark Museum's annual attendance crested in 1916 at fifty thousand, Bamberger's Made in Newark expositions in 1913 and 1914, which showed "the cogs of industry" on view "humming merrily," attracted five hundred thousand visitors in ten days, a number greater than the city's population.[78] Dana traveled in the wake of these pioneering entrepreneurial institutions. Visiting the show in 1913, Dana proclaimed "A similar exhibit should be given somewhere every year and our young people should see it and learn what it means."[79] The Newark Museum fulfilled Dana's goal for the first time in 1915, and in that exhibition and a subsequent one in 1916 featured many of the same manufacturers as Bamberger's. Both institutions sought to organize local production in order to stimulate consumption and further Newark's welfare.[80]

Industrial art also emerged in the Board of Trade, school, and municipal pageant; the museum's 1915 and 1916 exhibitions would not have occurred without this local context. Commodities in the library and museum and store sustained a dual operation, as agents of both individual and civic autonomy. Goods expressed regional affiliation so that consumption was a performance, an affective experience. Susan Porter Benson has persuasively suggested that the department store was a glamorous stage where sales staff and consumers climbed social ladders, and industrial art similarly transformed the cultural institution into a nexus where librarians and visitors fashioned new identities.[81] The demonstrations and idealization of craftsmanship in the Newark Museum complicate our assumptions of what was modern and what Progressive, as well as the conventional notions of center and periphery in art history's master narratives. Newark constitutes an alternative to tracing Modernism to Manhattan, or even more narrowly, to the arrival of Duchamp's art in 1913 (in the International Exhibition of Modern Art). The library and museum do not fit into the paradigmatic story of avant-garde culture as a series of transgressions against mores or as a left-wing agenda; Dana formulated culture in regional and ethical as well as participatory terms. Exhibitions were focused on the therapeutic and recuperative potential of artifacts, both historically and socially.

Walking out of the Metropolitan Museum of Art or the American Museum of Natural History in New York City in 1915, one understood that the virtue of industry was abstractly connected to the robber barons' mansions of Fifth Avenue and the sacrosanct leafy precinct of Central Park, its material conditions suppressed. Ten miles away, on the steps of Newark's Free Public Library and Museum, Seth Boyden was pitted against a horizon of belching

smokestacks. In museum exhibitions, a toilet or tapestry on display was a new commodity, a marvel and also a mundane fixture to be found only in the city's most elegant hotel. Viewers witnessed the spectacle of an "old Greek woman" demonstrating spinning yarn, and were told that such an obsolete tool was still of value. They saw role models and were told that certain goods on exhibit were ethical. The production told them what to aspire to buy, what types of citizen to become, and what their city aspired to transform them into. The young librarians carefully mounted Japanese prints, printed labels for exhibitions, and demonstrated the work of a printing press. Neither the public nor the librarians had the expectation that their own identity would be magnified through their association with the cultural institution. Art, like industry, was conceptualized as a means of civic engagement.

The Library and the Printing Press.

Books came before Printers; Wisdom before Newspapers. But only with the Printer came books by millions for all mankind and only through the Printing Press could Wisdom knock at every man's door. Who makes the newspaper, the sign, the circular; the note, the card, the check; the etching, engraving, lithograph; the brief, the bill, the writ; and the book and all and everything we read? The printer makes them, and about and through and by his Art our daily life, in its every aspect now revolves. The Library is above most the Printer's debtor. The man of books, the lover of beautiful books,—and all who go about libraries are such—they surely wish to know a little of the printers' craft, its trials, difficulties, growth, and fine accomplishments. Here therefore in this library, we have set up a press—rather, a friendly Printer has done this for us—from which comes, by the magic of Gutenburg, Faust, Schoeffer, Koster, and those other Wizards of the 15th Century —this little leaf. It bids you welcome to Newark's Library; it urges you to concern yourself over the beauty of the Printer's skill here displayed; and to make it a moment's task to learn more of, and hence to esteem more highly, this marvellous craft—This Master of All Arts, the Art of Printing.

THE FREE PUBLIC LIBRARY.

January 25, 1904.

The Engine of Culture

> The invention of printing was the greatest event in history. It was the
> first great machine, after the great city. The wide white band streams
> into the marvel of the multiple press, receiving unerringly the indelible
> impression of the human hopes, joys, and fears throbbing in the pulse
> of this great activity, as infallibly as the gray matter of the human brain
> receives the impression of the senses, to come forth millions of neatly
> folded, perfected news sheets, teeming with vivid appeals to passions,
> good or evil; weaving a web of intercommunication so far-reaching
> that distance becomes as nothing, the thought of one man in one cor-
> ner of the earth one day visible to the naked eye of all men the next;
> . . . so marvelously sensitive this wide white band streaming endlessly
> from day to day.
>
> — Frank Lloyd Wright, "The Art and Craft of the Machine" (1901)

The Newark Public Library celebrated mechanized newspaper production
in terms similar to those of Frank Lloyd Wright's rhapsodic lecture, decree-
ing the press the modern paradigm of social engineering if not control.[1] Dana
played a central role in romanticizing the press, its seemingly limitless reach
and its powers of persuasion, and saw it similarly as a reformer's tool—a way
to bring about the "democracy of art."[2] Like Hull-House, where Wright first
gave the address which would later be transcribed as "The Art and Craft of
the Machine," the library was struggling to assert its influence and define new
terms of engagement in public education. Complicating this vision of uplift,
however, Dana also embraced Newark's commercial ethos and logic, claiming

12. Handbill, "The Library and the Printing Press," 25 January 1904, in Newark Public
Library Bound Miscellaneous Pamphlets. Collection of the Charles F. Cummings New
Jersey Information Center, Newark Public Library. The top image, the type of cylinder
press that Robert Hoe patented in 1834, which could print eight thousand sheets an hour,
spoke of mechanization. At the bottom of the page, a more bucolic image, and one used
in library print jobs prior to Dana's arrival, depicted the library's classical façade. Both
images were readymade cuts, not custom-made. The small handbill is characteristically
packed with text and references to fifteenth-century printers. Dana was rarely concise, and
preferred long-winded poetic entreaties with multiple historical references.

that the library was an "educational engine" and that modern advertising was "the essence of public service."[3] Focused on municipal unification, Newark's librarian regarded industrial and mercantile methods as compatible with democratic aims and progressive politics.

Adopting the printing press as his tool, Dana posed as an engineer, businessman, and mechanic cultivating literacy in the industrial city. The "white band streaming endlessly," even in the guise of handicraft production of posters and leaflets, aimed to contribute to civic reform. In the library, printing was a theatrical hobby and a craft to engineer civic solidarity, and loudly in support of capitalism. This machine production guided by hand embodied Dana's notion of democratic culture. Presswork also nurtured the impulse to exhibit. His self-fashioning as a printer was important because his own handiwork became a metaphorical performance and imbued his institution with a transformative capacity. He enabled his staff, trustees, and audience to develop a theater of craft on which they could stage their own industry. The image of Boyden dilated into an accessible metaphor: recreation afforded the re-creation of self and civic identity. Dana, and his co-workers demonstrated the democracy of art convincingly within the public library.[4] But the symbol of communication remained more of a pleasant and picturesque fiction than a tangible achievement.

THE MACHINE IN THE LIBRARY

Visitors walking into the lobby of the Newark Free Public Library in 1904 encountered a working printing press and received a handbill asking them to "esteem more highly this marvelous craft" (figure 12).[5] The machine, a tool that could just have easily been housed out of sight, made manifest the cultural institution's ambitious aim to depart from staid conventions. It suggested, simultaneously, that mechanization was compatible with the liberal arts and that the library was an extension of the city's manufacturing. Seeking to upend "old aristocratic educational ideals" that catered to the leisure class, the institution was "especially helpful to the industrial man of to-day."[6] Many urban public libraries of the time reinvented themselves similarly as annexes of the public education system. They taught children civics, and municipal improvement associations convened in their halls. Newark's library went one step further and claimed to be an extension of municipal productivity. The printing press was redolent of vocational as well as spiritual advancement. To that end, Dana celebrated the "magic" of Gutenberg as a cathartic spectacle and a tool for collective self-improvement. The odor of ink and the sight and

sounds of printing in the three-story atrium made industry present literally and metaphorically. The press collapsed the distinctions between fine art and mass production, literacy and recreation, mundane advertising and lofty cultural ambitions, and permitted the library to cast itself as an intermediary between production and consumption. Making posters that were exemplary advertisements was a means to conduct economic and aesthetic uplift.

The press enabled the librarian to situate himself (and herself) as a corollary to Newark's captain of industry. A photograph taken about 1920 documents Dana's managerial involvement with the manual press in the Newark Public Library's print shop, but only hints at the immense energy the institution dedicated to the work (figure 13). Dana identified himself as a printer as

13. The Library Print Shop, undated photograph, circa 1918–1928. Collection of the Charles F. Cummings New Jersey Information Center, Newark Public Library. The Taylor Press, if obsolete in 1907 at its date of purchase, was a fossil by the 1920s, when this picture was taken. In a similar photograph, Dana posed with Thomas Raymond, who served as mayor 1915–1917 and again 1925–1928, and who was an ardent bibliophile. Dana and Raymond were both members of the Carteret Club, a group of like-minded Newark booklovers who commissioned private presswork and limited editions. In this image, however, Dana exhibits his interest in printing as "the democracy of art," not an elite pastime. The original purpose of these photographs is unknown, but they show continuity in the cultural institution's commitment to the hand press over three decades.

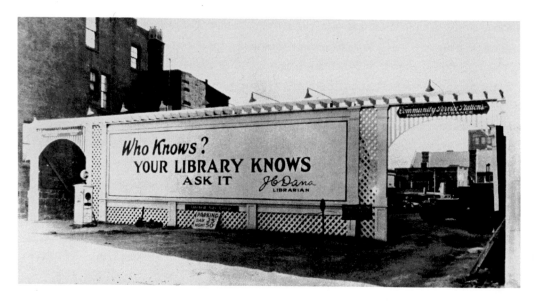

14. Newark Public Library billboard, circa 1923. Labeled "16–18 Park Place." Collection of the Charles F. Cummings New Jersey Information Center, Newark Public Library. The sign was opposite Military Park, beside what was then the Newark Athletic Club. The United Advertising Corporation operated the billboard; its president, Leonard Dreyfuss, was a museum trustee who also endowed the planetarium. The billboard was not unique, but one of at least three attempts at this sort of street-level outreach.

well as a librarian. His training as a librarian had been on the job, beginning in 1889 in Denver, but his career as a printer and publisher had begun much earlier, in the 1870s, when he was a teenager. The library acquired a press on loan in 1904. In 1907, it purchased a hand press in order to demonstrate that the handicraft of printing was educational.[7] In the photograph, Dana scrutinizes one of the thousands of posters the library made each year to prod citizens to borrow and read books. The acquisition of the printing press suggested that the public library was a trade. While most museums and libraries of the era composed their public face through genteel speeches and annual reports, Newark's hustled pedestrians: Dana himself called out and promised uplift from newspapers, billboards, and handbills (figure 14). The printer performed an educational crusade both by distributing free presswork and by acting as a business entrepreneur to drum up an audience.

Dana applied his expertise as a letterpress printer and connoisseur of the modern lithographic process to reinvent the public library as an engine of culture. Trustee Franklin Murphy knew varnish production, Christian Feigenspan knew brewing, Louis Bamberger and Moses Plaut knew dry

goods, and Dana knew printing. His view of the library as a trade was radical. Under his guidance, Newark plied its wares to other libraries, selling versions of an exhibition about book making and printing to the University of Chicago Library, Brown University Library, the Cleveland Museum of Art, the New York Public Library, and the Library of Congress.[8]

Newark's exhibition, The Printed Book, received positive reviews in trade journals. It toured forty-three libraries across America.[9] A part of a broader discourse about culture and commerce, The Printed Book contended that it was important to patronize all printing—from the highbrow fine art book to the lowbrow advertisement for plumbing accessories—if the art was "to give pleasure, to make manners seem more important, to promote skill, to exalt hand-work and to increase the zest of life."[10] Contrasting specimens were mounted on sheets of cardboard sized fourteen by sixteen inches. In one typical lesson, nine bookplates revealed a range of labels used by private and public libraries. Included were two of the Newark Public Library's own designs (figure 15). The compilation's range, including Egyptian motifs and art nouveau ornament, revealed an expanse of aesthetic ferment. The range of styles was typical of commercial printing of the period but unusual for a library, let alone an advocate of handicraft, to sanction. The larger lesson (thinly veiled) was Newark's own skill at fashioning publicity and belief that advertising was an art worthy of proper study.

One of the first librarians and museum directors to acquire a printing press or champion advertising, Dana believed that a cultural institution needed the instrument in order to be competitive. He saw these two activities—advertising and printing—as connected. His flagrant use of the printing press for promotional uses flummoxed institutions like the Metropolitan Museum of Art, whose trustees thought machinery would taint their temple. The secretary there, Henry Watson Kent, confided to Dana that he himself needed to smuggle in even a typewriter. Gradually Kent persuaded his trustees to emulate Newark and to install a printing facility in its basement.[11] Librarians and museum directors adopted printing as a means of publicly giving their organizations a graphic identity, a necessary move because Americans did not immediately grasp the purpose of their cultural institutions or embrace the habit of visiting them. In stages, museums and libraries began to ape business practices by printing monthly periodicals and paying for advertisements. Catalogues, labels, and newsletters blurred the differences between education and self-promotion, information and persuasion. But even if they adopted the use of printing presses, most museums maintained a separation between

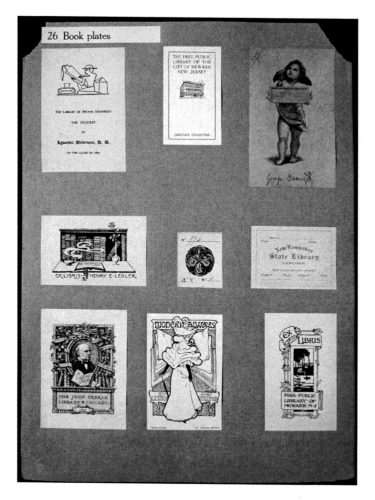

15. "#26 Bookplates," in Newark Public Library's The Printed Book exhibition, 1909. Collection of the New York Public Library. Dana included more than ten examples of printing from his own library as good models, and also included specimens from his own books published by the Elm Tree Press, which he and his brothers owned and operated.

lofty culture and the mechanics of daily life. The Newark Library, by contrast, made radical use of the press as both a tool of aesthetic reform and commercial self-invention.

The tendency during the early twentieth century was to value printing in compartmentalized ways—either as an economic, technological, or cultural activity. The Commercial Museum in Philadelphia boasted that its educational goals were dependent upon its "printing plant," a phrase that naturalized the machine.[12] In 1908, in Jersey City, American Type Founders, then the nation's largest foundry of metal slugs, opened a library and museum inside

its factory to display typographic specimens to educate the public and to promote consumption of its wares. In Newark, Trenton, and Jersey City, new technical schools taught printing. Meanwhile, in New York City, the Grolier Club as well as the New York Public Library exhibited books, but only fine limited editions and ancient manuscripts.

Unlike other institutions, the Newark Public Library attempted to bridge diverse audiences and criteria. It exhibited fine vellum pages produced by William Morris's Kelmscott Press and Daniel Berkeley Updike's Merrymount Press of Boston, and also displayed advertisements and student exercises in typesetting. In 1904 and 1907, two exhibitions of student work drew forty thousand citizens to admire handicraft in printing in addition to sewing and jewelry: avant-garde quality or rare treasures never guaranteed an audience—sometimes quite the contrary. When Dana pledged his allegiance to printing as the democracy of art, he valued its economic powers, but he remained pragmatic and relativistic when it came to aesthetics.[13] At the time, the power of the public library was dependent on publishing houses, but the Newark Library suggested an alternative role whereby the institution actively forged standards.

THE WORKSHOP AND THE PRINTER

Dana spoke of his profession in materialist and utilitarian terms, claiming that "a library after all is but a workshop with books as its tools." When he bought his hand-powered cast iron press in 1907, he admitted that a "foreman with a quadruple or octuple press might scoff at the machine."[14] He himself selected the typeface to buy from the American Type Founders Company in Jersey City and described his work in the third person, confessing that he "was the only person then on the staff who knew even the elements of typography, and for a time all printing was done by him or under his immediate direction."[15] Staying at the library evenings, he demonstrated the craft to his assistants, largely young women. He was proud to purchase a tool with local roots, patented fifty years earlier by Newark blacksmith Alva Burr Taylor.[16] Local newspapers applauded the recuperation of local history. Deliberately and stubbornly, Dana revered the "old fashioned press [as] still useful and as accurate as ever."[17] His use of the relic was an "innovative nostalgia," to use historian Robert Crunden's term.[18] He showcased the press to leverage civic pride through romance as much as material production. In 1920, his library still distributed posters from the outmoded press, an act of showmanship with serious didactic intentions and more than a dash of self-righteousness.

In an age dominated by stocks and trusts, the librarian saw virtue in the production of tangible goods, and asserted that "skilled labor in a town helps to make the town peaceful, progressive, and prosperous." His homily echoed Timothy Dwight's pastoral epic poem of 1794, "Greenfield Hill," which had idealized the industrious and self-reliant colony whereby "every town / [was] A world within itself, with order, peace / And harmony."[19] Dana reiterated Dwight's emphasis on the virtue of remunerative production.[20] "The hand is the handmaiden of the brain," he wrote, the "hand-worker" needed by the "brain-worker."[21] "To take a long shaving off the edge of a soft pine board, with a plane, is to this day one of the greatest pleasures of all intelligent men," enthused his "Yankee mind."[22]

Printing Dana deemed the most valuable art, providing more stimulation to "the eye and brain than do all other crafts combined."[23] His idealism was driven by both firsthand experience and the nineteenth-century printer's penchant for calling his trade "the mother of all the arts." "Fond of types and of the smell of printer's ink" and "slightly typographic, from the days [of] our village printer's shop," he described himself making things as if he had worked as a boy alongside blacksmiths, tanners, and carpenters.[24] All around him since his Civil War–era childhood in Woodstock, Vermont, the quickening pace of industrialization had increasingly dislocated artisans' crafts, categorizing the skill sets as either factory labor or amateur hobby. He held onto his own handicraft, especially to printing, as a virtuous activity and outlet for a curious mixture of poetry, pranks, and pomp.

As a teenager printing a periodical, he had aped the voice of the preacher, salesman, and raconteur, presaging his project to champion moral and civic recreation in Newark. In 1872, he began to print an eight-page octavo-sized newspaper, the *Acorn*, serializing fictionalized accounts of the Civil War, advertising the local businesses (especially his father's) and pondering the nobility of civilization (figure 16). Neatly set in diminutive nonpareil type, the editorials blended idealism and materialism and characterized the work of printing itself as moral rite. A profile he wrote of Dartmouth leader and abolitionist preacher Asa Dodge Smith argued that he was "a little better President for having been a printer."[25] The evangelical crusade included selling style. The rural adolescent used three different typefaces for the masthead in the course of the paper's seventeen-month existence, which represented a significant investment of care and money.[26] A boy's version of the embroidered sampler, the *Acorn* demonstrated learning and up-to-date aesthetics by reporting on the invention of fiberglass clothing in Vienna, which was

16. *The Acorn* (Woodstock, Vermont, 1872–1873). Collection of the Woodstock Historical Society. Dana's teenage hobby prepared him to teach "rational recreation" and reveals his ambitions, recording that he ran for office in a national amateur newspaper election.

considered an omen of future improvements in winter coats for Vermonters, as well as advice on dressing for photographs. Decoding technology for the layman, the *Acorn* advised, "it is useful to know that dark-brown, dark-green, maroon, and plain black goods without gloss will take a rich drab color; silks ... should be avoided."

Unlike the quaint and verdant Vermont town of today, Woodstock in 1850 was overtly industrialized. Every nearby mountain or hill had been deforested. Mills harnessing the Quechee River's water power processed merino wool. A hulking stone linseed oil factory hugged the river, but the town held several contrasts. The numerous stately brick residences of the town's many lawyers exhibited symmetry and order. Dana's grandfather surveyed Elm Street in 1806, planted its trees, built a general store and home there, and helped construct the First Congregationalist Church. In 1840, the town's population peaked at 3,500. Over the course of his life, Dana watched Woodstock and its manufacturers steadily diminish.[27]

To the store he inherited, Dana's father added a large sign proclaiming "New York Dry Goods," the gilt letters heralding the advent of railroad distribution and the postwar economy. On his receipts he called it the New York Cash Store (figure 17). The advertising invoked metropolitan aspirations and a degree of pretension. While his grandfather's colonial-era inventory included dried cod and sperm oil, his father regularly traveled to Boston and bought elegant fabrics such as red silk damask. The more refined "dry goods" store still sold perishables but made money on exotic commodities. To invoke historian Richard Bushman's shorthand for generational change, whereas Dana's grandfather maintained Puritan asceticism, his father was a prosperous Yankee entrepreneur with railroad stock.[28]

Waiting on customers in his father's store, J. C., as friends and family knew Dana, unloaded crates from Boston and New York. English and French silk, domestic and foreign goods signified social distinctions. He charged twice as much for "Japanese" tea as for the ordinary variety and grasped an implicit cultural hierarchy in the prices of earthenware and china teapots. The consumer revolution of the nineteenth century changed Woodstock, and the country store inducted it to new cultures and new emblems of status, such as thirty-dollar shawls. Methods of display taught Dana craftsmanship in commerce. Arguably these experiences in his father's store later equipped him to challenge the orthodoxy of fine art and to stipulate that "household objects ... [should] receive the same recognition as do now the genius and skill of painting in oils."[29] "The educational value of all these precious relics of the general

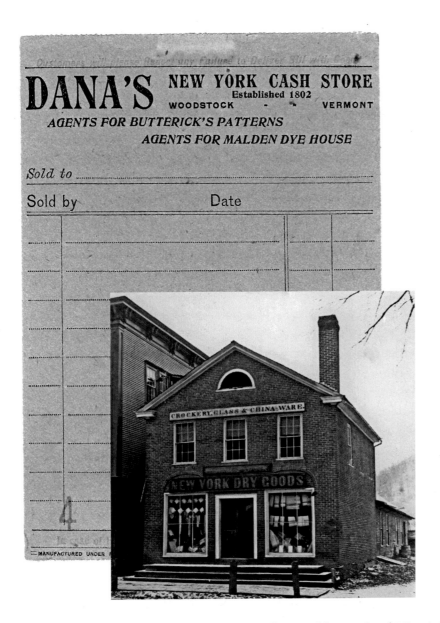

17. Dana store, Woodstock, Vermont, circa 1880. Collection of the Woodstock Historical Society. The returns of the Greek Revival cornice, fashionable in Woodstock in 1802 when the building was built and business founded, neatly point to the sign advertising crockery, glass, and china. Dana's father inherited the store without this or the sign below with gilt lettering. This change in generational acceptance of advertising and the pretensions of refinement continued to operate in Dana's own professional career as a library and museum director. The store's receipt was labeled "Dana's New York Cash Store," a premonition of the museum director's penchant to juggle numerous titles for exhibitions simultaneously, and a sign that the librarian's instincts to methodically categorize never curtailed his enthusiasm to advertise.

country store of sixty years ago needs no telling," he later reminisced.[30] Crates "of clean straw and china ware" taught him tactile intelligence and a sense of how culture was something that might be both imported and self-fashioned.

Studying at Dartmouth in the 1870s, Dana was exposed to the widespread enthusiasm for British idealists John Ruskin and Matthew Arnold, who called for spiritual renewal and individual autonomy through handicraft. Arnold's pledge to "sweetness and light" may have resonated with his strict Congregationalist upbringing and connected to Timothy Dwight's lesson heeding the "conscience sweet of useful life."[31] Dana emerged from his evangelical childhood revering capitalism, and reiterating a puritanical condemnation of European luxuries. He celebrated "honest" commerce, much as Dwight had. In the hands of his American followers, Ruskin's remonstrance, "Life without industry is sin; and industry without art is brutality" literally became a framed twentieth-century domestic accessory. Like Elbert Hubbard and Gustav Stickley, Dana would accommodate Arts and Crafts spiritual creeds to Andrew Carnegie's "Gospel of Wealth."[32]

In Woodstock, Dana's manual skills were pastimes once removed from vocational use and had a cultivated aesthetic sensibility. His great-uncle John Clark Dana (1737–1818) had been a skilled carpenter and local builder, and one of his neoclassical sideboards stood in the Dana parlor. Its tapered legs and inlaid garlands had pretensions to high culture, despite the provincial location. The reflective surface, rich complexion, and sinuous strength of imported mahogany evinced refinement. Noting this intriguing aspect of high ambitions in New England's educated rural families, Edward S. Cooke Jr. and William N. Hosley describe such furniture as vernacular forms of cosmopolitan high style. This eclecticism, an admixture of sophisticated and rough taste, helps explain Dana's ability to savor both the Kelmscott Press and comic strips like Little Nemo as good-quality printing.[33] Working in Colorado for a decade, then a few years in Springfield, Massachusetts, Dana always returned periodically to New York City to visit his older brother, and maintained a worldly outlook.

In 1902, when Dana relocated to Newark, he came to America's capital of jewelry, patent leather, and celluloid production, and held onto his vision that a city's and a society's healthy was rooted in manual skill and trade. He deliberately addressed Newark as a "city of mechanics" at a time when the average citizen was likely to be employed in unskilled work.[34] Outdated in the twentieth-century economy, his terminology was rooted in his own childhood. In the 1860s, in Woodstock and also in Newark, 80 percent of the

citizens had described themselves as mechanics in the census. And Dana was not alone in reaching for the antiquated expression: Newark's politicians of the period, Democrat and Republican, called out to "mechanics." Like the statue of Seth Boyden, the city's great inventor, standing outside the public library, idealization of industry was a prominent feature of life in Newark.

The craft of printing bridged Dana's far-ranging interests. Through the press he proselytized on the value of maintaining hygienic water, told adults to plant shade trees, and advised adolescent boys to whittle. As a member of the Boston-based Society of Printers, established in 1905 by America's preeminent fine-art type and book designers such as Daniel Updike, Bruce Rogers, Thomas Cleland, and Carl Rollins, he maintained close ties to bibliophiles and a reputation in their world.[35] He socialized with Henry Watson Kent when the latter was secretary of the Grolier Club (before he joined the staff of the Metropolitan Museum). Over the course of three decades they coauthored several volumes on library history as well as perpetuated hoaxes on stodgy colleagues.[36] With his brother, Charles Loomis Dana, a Manhattan neurologist (best known to the public for his testimony against Stanford White's murderer), John Cotton Dana established and maintained the Elm Tree Press, a business that was set up in what had been their father's store. They published their own limited edition of Horace's satires and numerous books of poetry and nonfiction alike. Advertising his translation of Horace in the *New York Times* or hawking poems in the library, Dana reconciled social reform with entrepreneurial gain in his use of the press.[37] Bridging the worlds of Boston's Brahmins, New York City literati, and Newark's trustees, he retained membership in many spheres but also cultivated the appearance of being independent of any tribe or creed. His use of a learned and ribald quotation from Henry Peacham's *Compleat Gentleman* (1634) featured in Newark's Printed Book exhibition, "there is no booke so bad but some commodity may be gotten by it," is emblematic of Dana's way of balancing levity, antiquarianism, and modernity.[38]

The Newark Library lent support to the trade of printing by drawing on the language of the Enlightenment and the ethos of mechanics' institutes. The library's press, magazine, and exhibitions of print constituted a value system that emphasized that public culture was interdependent with commerce. Printing was made to be sold or to sell another commodity: the library sanctioned remunerative artisanal skill, and the reform librarian composed civic sermons urging mercantile ambition. He expected his library publications to "bind the people of a city into a civic whole," an aspiration that is lost if his

presswork is reductively assessed as graphic design.[39] Printing was not a private craft but rather a skill in the service of municipal statecraft.[40]

References in the Newark Public Library to Benjamin Franklin as a printer illuminate the ways progressive antiquarianism resounded within the institution. Franklin's name was emblazoned on the ceiling of the reading room alongside those of European printers Gutenberg and Caslon (and the Printed Book exhibition reproduced his image in the same historic company). A bronze bust portrayed Franklin the elder ambassador, while a marble statue depicted the child of humble origins. Through each version, the library modeled a moral lesson to multiple audiences. The ten-year-old Ben, shown smarting from the purchase of a useless, costly toy, warned of the vice of profligacy. The image of the printer who signed the Declaration of Independence suggested that artisans, not only the leisure class, built the country.

At the turn of the century, from across the Atlantic, sociologist Max Weber also looked to Franklin as the exemplar "capitalist" and "craftsman" of Enlightenment in whom the virtue of industry and the vision of industrialism coalesced.[41] In Weber's view, the printer joined the Protestant ethic to the modern spirit of capitalism. Printing was the catalyst that transformed commerce and turned individual entrepreneurs into corporations. To Weber, Franklin's management of the duties of postal service and governmental printing constituted the first vertically integrated business. Franklin was construed as a forerunner of the corporate trust but also regarded as a moral entrepreneur. Dana's commitment to the handicraft of printing paralleled his celebration of Franklin as both a virtuous past and exemplar for future generations.

THE LIBRARY'S "MASS OF PRINTED MATTER"

Antiquarian and progressive ideals intersected in Dana's methods of industrializing the library. He congratulated himself on using obsolete technology, a credential he cherished for its conservative and idiosyncratic nature, yet he demanded that public institutions keep up with the new inventions. Historian Dee Garrison labels him a "radical" because of his apparently unchecked enthusiasm for the market as an adjudicator, but warns that to call him a Progressive simplifies his complex politics and social maneuvering. This paradox extended to his idealization of materials.[42] He was an unusual librarian in that he considered the production and consumption of thirteen billion copies of newspapers and journals and two hundred million dollars of advertising revenue per year as "progress." He found the concept of a national market exciting, as were the syndicated periodicals, advertisements, brand

names, and typefaces that were amalgamating America's disparate markets.[43] He applauded the cheapest ephemera, even "printed transfer slips for trolley lines now issued by millions; telephone directories, now printed in thousands of tons," expressing awe for numbers that are quaint by today's standards.[44] At the time he wrote, merely one out of ten Americans had a telephone in their homes, and the *Ladies' Home Journal* had just reached a circulation of one million: his optimism for technology was prescient.

Instead of decrying industrialization and its effects, Dana radicalized the library by placing value in mass production as a means of providing affordable educational material. Unlike many later Modernists who saw new media as a rupture of conventional forms and a force toward obsolescence, Dana saw new technologies as cumulative. His use of modern commercial tactics to further the goals of his public cultural institution is symptomatic of the ambiguities of Progressivism and the reform movement within the profession of librarian. Supporting unprecedented levels of domestic consumption at the turn of the century were new national marketing techniques and complex integrated systems of brand recognition—a web of interrelated novelties such as posters, magazines, buttons, packaging, and trade cards.[45] Dana stood out for being receptive to these inventions. And although he spoke fondly of the unprecedented "mass of printed matter," he also maintained esteem for elite magazines.[46] Ten-cent magazines drew a mass audience to the public library; the pretentious thirty-five-cent ones he himself read. His institution subscribed to both. Weekly popular magazines—in their advertisements, contents, and covers—were swiftly displacing older cultural classifications and notions of gentility.[47] The library accepted a hierarchy of taste; it did not hide class distinctions in these products for commercialized leisure.

Although the results of reforms supported by Dana and his fellow radical librarians increased the popularity of the public library and furthered access to it, they were not always motivated by democratic ideals. A campaign for professionalization and efficiency drove librarian Melvil Dewey (of Dewey Decimal System fame) to tell his peers, "Look at your position as a high-grade business one, look after the working details, . . . know the whereabouts and classifications of books, and let people get their own meat or poison."[48] Seemingly in agreement, Dana patronizingly suggested that the undereducated might "be coaxed into reading by putting before them the sweetmeats of literature, like simple stories and picture papers."[49] He catered to requests for popular periodicals with some condescension, and ultimately was a pragmatic and autocratic manager.

45

Turn-of-the-century librarians intent on reform believed that the way to more democratic and truly public institutions lay in equipping reading rooms with periodicals and novels and applying new organizational techniques such as Frederick W. Taylor's scientific management to readers.[50] In 1895, when he was the director of the Denver Public Library (at the time merely a few rooms in the city's lone high school), Dana was elected president of the American Library Association (ALA) on a platform demanding that cultural institutions be run efficiently as a service. In a national publication, *Appletons' Popular Science Monthly*, he went so far as to demand that the library be managed like "the ready-made-clothing house or the bookstore."[51] His plea to "make your library at least as attractive as the most attractive retail store" was at first a minority view among professionals, but it gained momentum in his life-time.[52] By 1910, Arthur Bostwick, then ALA president, idealized the librarian who was the "successful distributor through trade" and treated "the whole community as a group of possible clients."[53] Dana's idealization of business as inherently progressive was widespread in his profession.

Newspapers, flourishing as never before, inspired Dana's idealization of printing and, like Frank Lloyd Wright, his vision of a cohesive society. "After formal education—perhaps before it—the most important instrument of education in the city is the newspapers," he wrote in 1917, seeing the mechanization of the press as the lubricant of Newark's economic engine.[54] In his childhood in Woodstock, the Democratic *Spirit of the Age* and the Republican *Vermont Standard* were the only options for citizens, and these papers focused on railroads, freight tax, and temperance; it is astonishing that he came to consider all newspapers, even the sensationalist Hearst's and Pulitzer's, useful. Because "the yellow journal caters all the time to the beginners in reading," it was maintained.[55] In 1897, Newark citizens had applauded when library director Frank Hill canceled subscriptions to the New York *World* and *Journal* and condemned them as "leprous," a "stench in the nostril of civilization."[56] But by 1903, the library subscribed to 27 dailies (including Hearst's and Pulitzer's "yellow journals"), 129 weeklies, and 250 monthlies, statistics that would impress any twenty-first-century librarian and an indicator that the medium was at its zenith.[57] Dana's faith in consumption as a natural cycle often trumped his moralistic concerns.

Seeing "print-capitalism" as seminal to nation building in the nineteenth century, historian Benedict Anderson has argued that at the height of their strength at the turn of the century, newspapers interconnected social rituals and created a sense of collective identity. The *Newark Evening News* was the

city's first daily newspaper not sponsored by a party's political machinery, and it created what Anderson calls an "imagined community" that Dana used to his advantage. Although staunchly Republican in its opinion, the newspaper had the guise of bringing in perspectives that were "untrammeled in politics and unhampered by corporate affiliations."[58] The paper shaped Newark citizenship and commerce into a respectable form, so much so that its competition called it "the little old lady of Market Street." The paper was as important as the library in dignifying the industrial city. Its daily circulation was over one hundred thousand in the first decades of the twentieth century; it made Newark's literate public independent of Gotham, and proudly so. In its role of marketing the city's goods, the paper was indispensable. Established in 1883 by Wallace M. Scudder, a thirty-year old attorney at the time, the paper promised crusading editorials and scientific objectivity. The family retained control of the paper for nearly a century, and Scudder served as one of Dana's trustees, so it is fair to see their partnership as an active collaboration and conscious attempt to mold civic identity. The library celebrated the city's prowess in the graphics and its independent newspaper, declaring it as important as the production of luxury goods or fine arts. And the newspaper kept the library in the public eye.

Like most urban American librarians, Dana was faced with large numbers of non-English-speaking immigrants, and he responded boldly by buying foreign-language books, advertising in foreign languages, and justifying the purchase of pictures and applied art as universally accessible resources. Paying keen attention to the numbers and types of publications in Newark, the library kept lists of the scores of newspapers that served the multitude of distinct communities, and praised these vehicles of publicity as essential to civic improvement.[59] His colleagues in the ALA also considered visual lessons necessary in view of the varying modes and degrees of literacy among immigrants. Librarians developed a less book-centered approach, orchestrating exhibitions and community events. In 1898, George Herbert Putnam, the director of the Library of Congress, proposed that the institution was undergoing reinvention and argued that "the library is no longer merely an aggregate of books, each passive within rigid limits; . . . it is an active agent. It moulds into incredibly varied shapes to suit incredibly varied needs."[60] He valued pictures but lacked Dana's aesthetic panache, perceiving them mainly as a tool "to render homogeneous the very heterogeneous elements of our population."[61] Advocacy for the public library as a means of acculturating immigrants drove the era's most famous library benefactor, Andrew Carnegie, as

well. Arthur Bostwick, then president of the ALA, too thought pictures and art "socialized"—by which he meant Americanized—people: the librarians' outlook was paternalistic and also practical.[62] Settlement houses like Hull-House articulated this agenda of "race progress" but, like Dana, they valued aesthetic uplift as well.[63]

Upon his arrival in Newark in 1902, Dana organized an open house to advertise and popularize the library. By inaugurating evening hours and art exhibitions, he gave it a new identity as civic center. "Instead of dealing primarily with books, as formerly," reformers like Dana "consider[ed] the library somewhat in the light of a community club."[64] On one Friday night between eight and ten o'clock, approximately two thousand citizens were greeted by Dana, his staff of thirty, and several trustees, and given a tour of the "brilliantly illuminated" building, the power generated by its own dynamos. The eclectic opening-night display included "a portion of Mr. Dana's collection of Japanese art prints" and plates from Owen Jones's and Jules Goury's *Alhambra* (1845).[65] It foreshadowed the medley of art exhibitions to come. Shortly thereafter the brand-new "assembly room" was converted into an exhibition space.[66]

By remaining open "after the whistle blows," the Newark Public Library courted the city's factory workers and countered widespread criticism that the taxpayers' dollars were frivolously supporting the reading of fiction by "bluestockings."[67] Explaining his hope that the library would be used during its new evening hours, Dana promised future exhibitions "for the hand-workers"—the local "workingmen, mechanics, [and] artisans."[68] In fact, adult males comprised less than one-third of the library's audience: young children and mature women were its most numerous patrons.[69] The disconnect between rhetoric and practice was characteristic of the era.

In Newark, Boston, New York, Chicago, and St. Louis—cities with ever-increasing immigrant populations—language barriers were severe in schools and social services and agencies. The Newark Library estimated the foreign born at 67 percent of the local population. Dana held an evolutionary view of intelligence, and regarded many Newark citizens as occupying a "pictorial stage" of the human mind.[70] This patronizing outlook was common in the practice of advertising. In 1918, Newark's United Advertising Corporation published a pamphlet that described how their outdoor billboards sent a "message *to all the people*: To the Foreigners and the Illiterates who cannot read the newspapers and have money to spend, and who can absorb a simple message told to them pictorially and in large size and color."[71] Other advertisers similarly described billboards, and other pictorial advertising, as tools to

make the nation more "homogeneous."[72] Turn-of-the-century librarians, like advertisers, were motivated by a fear of modern democracy's racial diversity.[73] For Dana and his peers, pictures and map collections were increasingly valued as tools to build "a wider tolerance, a wider sympathy."[74]

In a 1902 article titled "The Age of Pictures," Dana outlined the value of pictures and pictorial advertisements to instill a shared culture in the non-English-speaking immigrant, the illiterate, and those not inclined to book learning.[75] He wrote condescendingly, "Pictures seem to form the fundamental and universal language. They appeal to the dullest minds."[76] "By pictures," he wrote with missionary zeal, librarians "are going to increase man's ability to grasp the life that surrounds him, and make education more common and . . . more thorough."[77] Dana began to see his library as a tool to address a deficiency in civic literacy. Influenced by the work of the editor of the *New Republic*, Herbert Croly, whose *The Promise of American Life* (1909) urged the restoration of American "solidarity," or perhaps by Dwight's view that "On uniformity depends / All government," Dana conceived progressive education, and visual literacy in particular, as a regulating force.[78]

Dana's generation of reformers realized that exhibitions could increase a library's popularity, and he selected pictures to put on display in the same manner he acquired magazines of distinct tiers and types, from *The Studio* to *Ladies' Home Journal*. He heralded the "democracy of art" in the trade periodical *Printing Art*, and described his hope that the public library was making culture accessible. Adventurous librarians hung paintings by local artists or posters circulated by magazine publishers: Dana was even more audacious when he exhibiting his private collection of Japanese woodblock prints or *ukiyo-e*. His acquisition of the work of Katsushika Hokusai (1760–1849) and Utagawa Hiroshige (1797–1858) was prescient, and his personal trove numbered hundreds of prints. The inexpensive prints, to his way of thinking, were evidence that the Japanese had democratized art. He celebrated the exotic *ukiyo-e* as "plebeian" images "of gayety and bright beauty," and praised their creators as having produced "more beautiful things in their everyday life than any nation."[79] Local newspapers viewed his connoisseurship as enriching the city, and also valued the prints as a new and challenging aesthetic.[80] Naming his family's Vermont golf course Togo Hill after the admiral who had been victorious over the Russian navy, Dana's passionate interest in Japan extended beyond his romantic appreciation of its applied art to a belief that the prints were relevant to contemporary Newark.[81] He saw Hiroshige's 1833 images of merchants caught in a rainstorm as accessible to

Newark's citizens and the medium as a historical model worthy of emulation. Cheap printing might bring art into each of Newark's classrooms and homes. He implored the modern library to engage in the revolution in modern distribution, to send modern lithographs of "old masters" out into circulation in the thousands.[82] Further broadening the definition of culture, he recommended selectively transforming cheap periodicals into indexed clipping and picture collections.

When he began a picture collection and cofounded the Newark Educational Association in 1902, Dana was dedicated to placing art in the public schools as much as to building a museum and art gallery. In 1903, an exhibition of five hundred photographs of old master paintings hung in the library's art gallery attempted to rally the public to fund schoolroom decoration.[83] Ruskin had championed improving the appearance of walls inside British classrooms in his Arundel Society in the 1880s, and the idea spread to American cities such as Chicago, where Ellen Gates Starr of Hull-House became a leader in the cause.[84] Newark's new picture collection relied on getting schoolteachers to visit the library, an uphill task. The library loaned three hundred pictures a month in 1908, and the innovation prompted the *New York Tribune* to declare Newark "A Progressive Library" (figure 18).[85] By 1912, the collection had grown to 360,000 neatly labeled and indexed lithographs and engravings, from Kate Greenaway's children's books to blueprints for modern plumbing.[86]

Alphabetized according to topics the picture collection was earmarked for school curricula. One could look through a pictorial encyclopedia—images of birds, flowers, poets, and architectural wonders—that the library approved of. Selectively adapting mass culture to create an informative visual databank, Dana developed a new stream of material to loan. The practice exemplifies the librarian's vision of the most patently commercial goods as "democratic" culture. His criteria redefined quality in relation to cheapness and accessibility, mediated the contradictions inherent in reproduction, and reconciled the spheres of fine art and mass production. And despite low numbers of membership in the Newark Educational Association, a few schoolteachers did use the resource extensively. Never content, Dana lambasted the city's educators, writing in 1914 that only ten out of sixty-four principals habitually used the library, and out of sixteen hundred teachers only ninety-five were library card holders, of whom a mere twenty-five were readers "properly so called."[87] Although the library successfully provided the schools with educational models and specimens, Dana often stated dissatisfaction with its role as an influence on everyday life, and voiced his ambition to increase circulation.

18. Librarians managing the picture collection, 1918. Collection of the Charles F. Cummings New Jersey Information Center, Newark Public Library. The picture collection, which filled an entire room of boxes, was comprised of clippings carefully glued to manila boards. The collection boasted a circulation of 53,000 images in 1913. The filing system permitted users to locate images of architecture, animals, and famous citizens, so that teachers could better illustrate lessons on history, geography, and biology.

But what did the library communicate when it turned postcards, book-plates, and advertisements into institutional methods of extending visual literacy? Another way to regard his picture collection is to see it as an extension of the scrapbook, a middle-class individual's Victorian hobby thirty years earlier, where nostalgia and the attempt to stay up-to-date intersected. In the 1909 exhibition of The Printed Book, over one thousand examples of colophons and typefaces were pasted onto manila cardboard sheets. The compendium bridged all styles and technologies of the past century, savoring the Art Nouveau whiplash curve and Aesthetic spider web, a Pre-Raphaelite etching by George Woolliscroft Rhead, and photogravures by Goupil. Sunday comics

from the *New York Herald*, which had distinctively working-class associations because its characters spoke in street slang, were selected as an example of block printing, while Bruce Rogers's title page for the Riverside Press's *Life of Dante* by Boccaccio represented a new chapter in limited edition printing (and probably cost the equivalent of a month's earnings for the average family). The limited edition and the penny paper were on equal footing and both were freshly made. Diverse examples landed on the same page, such as whales alongside the latest furniture from Munich's Vereinegten Werkstätten.

One page of four motley clippings, purposely showing how different "half-tones" could be made or used, illuminates Dana's radical ideal of the democracy of art in action. A neoclassical couple in togas bearing scythes, a copper gate valve used by plumbers, a bonneted woman lit as if from stage footlights, and a set of earrings, cufflinks, and buttons square off on one cardboard sheet (plate 2). Charles Warde Travers, illustrator for the *Saturday Evening Post* and numerous advertising calendars for Prudential, had drawn the austere couple from antiquity. The smiling countenance of the stage performer was reminiscent of a Jules Chéret or Louis Rhead design, and deliberately emphasized the granular deterioration that might occur in mechanical reproduction. The only distinct link was the material common to both the plumbing fixture and the mid-market jewelry, both profitable local products. Dana exhibited both exuberance and indiscriminate loyalty in honoring manufacturing that was integral to Newark's identity economic.

The pictures conveyed Dana's view of the modern industrial city as both a romantic adventure and a force to reform mass culture. "There is as good material for poetizing in our city's factories as ever Hawthorne found in Salem's musty warehouses," he opined.[88] While the *ukiyo-e* he favored illustrated a foreign urban everyday life, many of the images in the pioneering exhibitions of photography held in the library in 1910 and 1912 depicted Newark. In 1917, he commissioned a portfolio of engravings of Newark from Rudolph Ruzicka, a printer trained at Hull-House who had recently moved to New York City. These were realist but generally celebratory representations of the modern city. "Last Sunday evening I walked along Mulberry Street among the tenements and factories beside the railway and canal," an enthusiastic Dana told Newark's Board of Trade in an appeal for technical high schools, and exclaimed "Here was industrial America. Here was the machine age."[89] His appreciation for the glory of urban production could be heard in his rhetoric. The librarian embraced his age of mechanical reproduction, and, like Walter Benjamin, optimistically envisioned photographic and lithographic representation

emancipating a new aesthetic sensibility. The librarian romantically expressed his empathy for the industrious city by speaking as a New Jersey *flaneur*, and by composing picturesque images of the city's manufacturing. In college, Dana had appreciated Charles Dickens for synthesizing sociological analysis, morality, storytelling, and urban reform, and he aimed for a similar fusion of realism and idealism. His exhibitions of printing sought to match the explosive pace of city life. Brokering culture as merchandise and celebrating the city, his institution addressed the dialectic of art and industry head on.

MARKETING THE LIBRARY

Dana's democratization of libraries and of printing derived from his faith in marketing as innovative and liberating. He boasted of the library as a "leveler" and saw it as "the most democratic, universal institution ever devised."[90] His exhibitions, he claimed, sought to make the public library into "the most elevating and the most popular place in the city."[91] He described the cultural institution as if it were a retail outlet, albeit a vender of morality. His promotion of the new commodity culture is epitomized by his remark that "good art is hitherto to be found in connection with an advertisement of nails or oatmeal," a sentiment that shocked his librarian colleagues.[92]

Dana's optimism about commercial advertising warrants examination. Discussing cultural literacy as a utilitarian process, he compared the "progress which advertisements have shown in recent years toward form, style, arrangement, design, and beauty" to the change in "the art of handling a [coal] shovel."[93] Dana's analogy would seem to refer to Taylor's much acclaimed system of scientific management developed at the Bethlehem Steel Company between 1898 and 1901. More specifically, it seems to refer to the managerial evaluation of and experimentation with different shovel sizes and handle lengths, which had resulted in a new science of industrial efficiency.[94] Dana hoped that legible advertising would spur America's minds to commercial greatness, just as Taylor's shovels unleashed new heights of productivity. His article about the "Scientific Management of Libraries" in 1913 pleaded with readers to think of the library more "in terms of commerce and industry" than literature.[95] The library developed cultural literacy to increase consumer education, with the ideal that citizens would "learn to criticize them wisely" and demand of manufacturers that "good taste and high skill be put into their production."[96]

Experiencing resistance among professional colleagues toward his promotion of his library, Dana took the stance that "advertising is a public service."[97] He accepted modern advertising as compatible with humanistic learning if

53

the former would enable him to sell the latter. In her study of American librar-
ies, Dee Garrison sees librarians as vacillating "between the censorship and
the consumership models" of stewardship, a result of the dualistic nature of
their intention being both "to elevate public thought and to meet demand."[98]
Dana justified as a pragmatic act the accosting of Newarkers with his posters
and thought advertising was "absolutely fundamental to [a library's] being
useful."[99] He argued that no one would go to libraries or museums if he did
not festoon the city with advertisements:

> Here is an educational engine, a library, set up and kept in motion by cash
> paid by all citizens. It can help them only if they use it. That engine—
> the library—should make its existence and all its special power known
> to every citizen. It cannot content itself with mere existence. The citi-
> zens who pay for it want it to be useful, and the act of advertising itself
> successfully is absolutely fundamental to its being useful.[100]

Adopting Newark as a model, he reinvented library work and made the arts
of persuasion a focus. For two decades, Dana campaigned unsuccessfully
for the ALA to create a "bureau for the promotion of libraries in the business
world."[101] While those involved in the printing trade valued his intentions,
fellow librarians objected, seeing advertising as irremediably tainted by com-
merce. His use of billboards and posters in Newark was unrepresentative of
his profession, and other librarians generally scorned the practice as vulgar.

Dana's faith in advertising as a constructive method of enlightening a
city sounds disingenuous today. Even his greatest admirers rarely quote his
claim that "advertising is a great instrument for the promotion of education
and of general welfare."[102] But Dana was genuinely intrigued with new appli-
cations of printing as a solution to social problems. He tracked his annual
production of posters to measure his gains in improving Newark. The thou-
sands of posters made in the library print shop were material evidence that
Newark's literacy and well-being were on the rise. His enthusiasm for bill-
boards, posters, and periodicals as new devices in mass communication was
bolstered by his conviction that these media targeted reason. His optimism
was not baseless: he read the latest studies on the "science" of advertising,
such as Walter Dill Scott's *The Psychology of Advertising* (1910).[103] He con-
sidered the library's advertisements vehicles of honest persuasion, aimed to
improve civic health and social cohesion, a counterweight to the tide of emo-
tionally manipulative misinformation.

Juggling his authority as a printer and librarian enabled Dana to keep toeholds in distinct worlds and use advertising as he wished in either. He lectured to rare book clubs on German type design, argued the value of vocational education in town hall debates, and served as a judge in Vermont county fairs. In 1911, Harvard Business School invited Dana to lecture on printing, he emphasized that the "dawn of reading" wrought by mechanization was a new age of money-making in printing.[104] And he exhibited a dizzying knack to win his library and museum newspaper coverage wherever he went. His idea that the commercial practice of persuasion could be used to further moral and educational ends was prescient, only generally accepted during World War I, when national campaigns to sell bonds galvanized morale. But contemporary pejorative associations with the word propaganda also date to that cataclysmic event.

Since Dana did not describe the sequence of cause and effect in advertising in more detailed or theoretical terms, one must extrapolate his affinity for marketing from his personal use of the press. Like the proximity between his own taste for *ukiyo-e* and his institutional use of them, Dana seemed to believe that his small editions printed on his family press "makes for the democratization of art."[105] When he published translations of Horace's letters and satires in contemporary language, and marketed the limited edition through advertisements and at department stores such as Wanamaker's, Dana created yet another persona of the modern reform librarian.[106] He saw himself as carrying out the democratization of art by making limited editions of the Roman writer. Bypassing the author's lyrical poetry, he elected to find modern readers for satire. Immodestly, he thought he improved upon translations that were "correct and scholarly, but almost entirely spiritless and uninteresting."[107] While his choice of classical texts reflected Dana's college education, his selection of Horace's social criticism mirrored his own ambivalence toward the classics. Moreover, his reiteration of the poet's contempt for the country bumpkin and city slicker corresponded to his own dislocation and alienation from small-town Woodstock and Newark the industrial suburb. Considering that he advertised his own edition of Horace in the *New York Times*, Dana's ambitious uses of the press to overcome displacement become more evident.

NEWARK AND THE PEDAGOGY OF PRINTING

In 1906, speaking on the same stage as John Dewey to teachers of art and manual training at the Pratt Institute, Dana proposed cautious engagement with

the new mass culture. Valuing images as the tools essential to grab the attention of schoolchildren and adults, he voted in favor of using the Sunday comics in the classroom. "The thing for the reformer to do is obvious; he should not damn the comic supplement and all who enjoy it," he argued again in 1912. The educator's real task was to "understand why it exists, examine the conditions which produce it and then, if he can, lend a hand at improving the conditions and also at improving the product."[108] This was the view of a missionary devoted to continual improvement. His appreciation of "cheap" printed material should not be construed as simply democratic idealism: he held severe opinions about quality and hoped to reform mass culture even as he promoted it:

> Why not tie the brief moments of your influence to things as they are? Give a few lessons on our Sunday cartoons. Don't affect to ignore what countless thousands of children every day delight in, but preach from them, as texts against them where you must, with them where you can. The children are living with the houses and the furniture and the wall-paper (God help them!) and the Buster Browns and Nervy Nats of today, and the ever-present influence of these will not be overcome by ignoring them and summoning Giotto and Velasquez for 10 minutes from the past. You can point a drawing lesson . . . far better from a cartoon . . . than from most of the shadowy prints of paintings.[109]

Simultaneously expressing low esteem for mass culture and a willingness to accommodate it, he lent support to new commodities only as a means to an end. He did not suggest that comics were desirable to teach drawing; rather, he argued that they were accessible raw material from which to build a moral sermon. Relevant object lessons were needed in the classroom, and ones that had "good workmanship" could be coopted. Ultimately, the reform librarian was more a pragmatic and zealous crusader than a democratizer.

As previously mentioned, Dana included Winsor McCay's pioneering cartoon, Little Nemo, as an exemplary piece of block printing in his Printed Book exhibition of 1909 (plate 3). Magazines like *The Outlook*, *Lippincott's*, and *The Nation* debated the merits and pitfalls of comics and often excluded them from their pages as appropriate solely for the "yellow press": thus, Dana stepped into a vitriolic debate when he exhibited the comic as an example of a good block print.[110] By labeling the comic strip as a technical model, he celebrated the risqué novelty (which portrayed a latchkey kid) for its technique— a quietly subversive move. To place Dana's decision to use Little Nemo in a

broader social context, in 1911 the settlement house movement leader Lillian Wald issued a plea to "Make Comics Educational."[111] The Committee for the Suppression of the Comic Supplement renamed itself the more conciliatory-sounding League for the Improvement of Comic Supplement and sought to temper the resilient new commodity.[112] Buster Brown, initially a prankster invented by Richard Outcault for the *New York Herald* in 1902 to mock the innocent child, reformed when he was transformed into a licensed brand for shoe retailers. The *Herald*, which published the strip for eleven years, reinvented Outcault's miscreant as part of an "uplift theme" in 1913 by distributing three million buttons on which the character pledged honesty and respect.[113] The intersection of mass culture and reform was not simple or without contradiction, and Dana's selection of McCay's comics reveal that he was prescient in finding high-quality mass culture, and talented at appropriating it for his own use.

Dana's lecture at Pratt, titled "The Relation of Art to American Life," can be easily interpreted as a rejection of "the masterpiece" in art, but in fact it vigorously focuses on commercial printing and advertisements as the American arts worthy of an educator's attention.[114] Dana averred that the library taught the importance of "the common everyday . . . picture in the Sunday paper, in the magazine, on the bill-boards." The speech is also noteworthy for an early oblique reference to Thorstein Veblen's notion of conspicuous consumption.[115] Cultural production, Dana suggested, should not be a luxury but a moral force. He selectively interpreted Veblen's *Theory of the Leisure Class* (1899) to suit his own needs. Veblen provided Dana with artillery to lob at libraries and museums engaged in the sacralization of culture, and gave him a basis to argue that consumer education furthered his institution's objective of democratic art. Moreover, Dana stated that his concern to fulfill Dewey's mandate of socialization was more urgent than culture. He told the audience of industrial arts teachers at Pratt that "when you compare the manual training [of drawing] with that of the base-ball field, it becomes in most cases quite negligible."

In comparison to the other presentations in the 1906 conference, Dana's emphasis on consumption of the commonplace in everyday life was not unique, but it was by far the most specific in its references to mass culture. Participants discussed the enigmas of occupational training, the Americanization of immigrants, improving taste, and America's "industrial democracy" in terms of social science and pedagogy, but few analyzed specific comic strips as aesthetic phenomena. Several presentations assessed American art education and museums in relation to those in Britain, Japan, and Germany, and to economic

and spiritual pressures. Ernest Fenollosa (1853–1908), America's leading expert on Japanese art, argued in favor of craftsmanship as an essential skill transferable to all aspects of citizenship. The educator spoke of the redemptive quality of Japanese craft processes, much like Gustav Stickley's lifestyle magazine *The Craftsman*, which ran such articles as "The Japanese Print as a Reformer: Its Power to Influence Home Decoration."[116]

Conveying their expectations for more tangible results than the previous generation, several of the conference participants ambitiously hoped that artistic self-improvement would spur on economic empowerment. The abstract social goals of the Arts and Crafts movement, which historian Cheryl Robertson characterizes as "moral education through artistic appreciation," were increasingly specific and nationalistic.[117] Dewey claimed that the introduction of "occupations" into education would make the school an "embryonic society."[118] James Parton Haney (1869–1923), the director of manual arts and manual training in the public schools of New York City, praised Japanese woodblock prints and modern German curricula as exemplary for America, as did Arthur Wesley Dow (1857–1922), author of the influential *Composition* (1899) and the eminent professor at Teachers College who presided over the conference. Each participant proposed slightly different ways to realign primary school education, home, and national interest into greater intimacy. Dana was one of the few to suggest that America did not need more artists or more skilled designers, claiming instead that citizens needed only to exercise their taste. Acquiring skill in reading the pictures featured in advertisements was more important than learning to draw. The latter, Dana maintained, was too specialized.

LIBRARY PLACARDS

The library's posters—broadsides of plain text through the 1920s—defied library conventions against advertising but indulged in none of the visual techniques popularized at the end of the nineteenth century, especially in color lithography. For his texts, Dana chose Cheltenham Wide, a stocky typeface designed by an American to emulate William Morris's gothic-roman. Cheltenham's serifs, like Morris's, were blunted to achieve a calligraphic horizontal weight. The type had been designed in 1896 by Bertram Grosvenor Goodhue to express ideals of unique handcraftsmanship; Goodhue designed it specifically to advertise the first exhibition of Boston's Society of Arts and Crafts in 1897. Like many Arts and Crafts inventions, the typeface became an "artistic style" that mainstream industry eagerly absorbed.[119] Goodhue

repudiated this "commercialization" and was unhappy that Cheltenham was a "most popular font for advertising," believing that such applications "debased" and "degraded" his design.[120] By 1907, when Dana bought it from the American Type Founders, the widely available Cheltenham was a stylish approximation of handicraft, more distinctive esthetically than ideologically. He called it the most legible type ever created.[121]

Taking pleasure in using a commercial type in the library, Dana dismissed claims that it was undignified. His description of Cheltenham Wide as "a face which exalted students of types decry" indicates he knowingly disregarded the views of purists who dominated the Arts and Crafts societies and the Society of Printers.[122] In his eyes, Cheltenham was an estimable design precisely because of its commercial success and American origin. Like Dewey and Veblen, who publicly deplored applications of medievalist ornament to academic architecture and books, Dana scorned extreme historicism and dogmatic aesthetics.[123] His type selection is representative of his tendency to champion incremental innovation and local patronage. He saw Cheltenham type as a tool for persuasion and communication, an artistic hybrid of Arts and Crafts handicraft and mass culture.

The Newark Library printed posters aimed to adorn its own walls and those of its patrons. Poems were printed in large format to post in homes and classrooms. The library's annual reports catalogued the number of posters made and distributed as expenditures. Some signs were earnest, others droll. For example, one declared "Listening has done the World so much harm," a roundabout way to discourage patrons from chatting (figure 19).[124] The message balanced authority and wit.

In 1912, the Newark Library mounted large, simple posters, printed in Cheltenham, on the building façade. Each sheet conveyed a pithy fact about the practical value of reading, described a pivotal achievement in the history of printing, or praised the historic role of the press in enlightening societies. The *Newark Evening News* printed the reaction of "A Disgusted Newarker" who thought Dana aimed to "cheapen the whole institution."[125] The paper's editor, museum trustee Wallace Scudder, defended the library's publicity: "Perhaps if the whole front of the handsome building at the head of Washington Street were covered with placards the city would be the gainer. The announcements which appear there now are not eyesores, by any means."[126] If Dana "had to sacrifice the beauty of the building to make it useful he would probably do so, and, no doubt, be perfectly right," the city's newspaper declared. The library's placards advertising the institution as a practical resource seem

Reading is often Better than
Hearing

It is Listening that has done
the World so much Harm,
not Talking.

J.C.D.

19. Broadside, "Reading is often better than hearing," undated, Newark Library Print
Shop poster. Collection of Special Collections, Newark Public Library. The typeface
can be identified as a part of the Cheltenham family by, among other idiosyncrasies, the
descender of the lower-case g. Dana, like Dewey, bemoaned passive learning, and often
despaired of education that was based on the lecture mode. He maintained an individual
presence in the library as J.C.D., a signature that was self-consciously unpretentious and
avoided honorifics. However, after his death in 1929 the pithy injunctions must have
looked mysteriously autocratic.

remarkably tame by today's standards. However, the placement of advertise-
ments in public space was a contentious issue, a dilemma that advocates of the
City Beautiful especially lamented.[127]

Dana favored the "editorial style" technique—lean didactic text, and no
images—popularized by freelance copywriter John E. Powers in his adver-
tising. Although a large amount of publicity achieved power through the
use of a picture or elaborate lettering, Powers only used text. and himself
described his work as achieving "honesty in advertising," a sentiment that
Dana probably appreciated and sincerely believed.[128] The choice was signifi-
cant because trustees also used this type of marketing. Newark's Murphy
Varnish Company, owned by library trustee Franklin Murphy, had employed
Powers, and Bamberger's in-house copywriter Walter Moler also used text
in the Powers manner.[129] Murphy Varnish advertisements directly compared

their spirits to the human spirit. A pithy saying of Boston's noted abolitionist minister Phillips Brooks was one source, and the nineteenth-century poem "Maud" another: "Fine varnish on stout oak is like Tennyson's delicate rhyming of great emotions."[130] Varnish, a material like veneer often associated with artifice, was given new poetic luster and moral virtue. It was an "Age of Pictures," but advertising was a complex game of signifying class, urbane sophistication, and authority in the industrial city.

The spare, text-laden style of the Newark Library's posters drew upon this particular style of advertising because Dana considered his own posters "honest" tactics. Addressing the audience in an intimate tone that assumed familiarity with the consumer was an early affectation of "simplicity" in mass marketing techniques. The Newark Library's adages, quotations, and exhortations echoed the temperament of Christian missionary work, just as did the words of many purportedly secular Progressive reformers, such as Dewey and Addams. Dana himself described his work as "preaching through exhibits the gospel of good will!"[131] His words of inspiration extended the religious metaphor, connecting manual labor to spiritual goodness as well as patriotism and other moral sentiments. In the Printed Book exhibition of 1909, he included homilies by Abraham Lincoln and ministers such as Phillips Brooks. Alongside these was an aphorism that celebrated both the Protestant work ethic and manual craft: "The world has no use for a weakling with a ready tongue for excuses but unwilling hands for work" (figure 20). This message was common among Progressive reformers and Arts and Crafts enthusiasts. Theodore Roosevelt often lamented the "weakling" when speaking of individuals or nations. Elbert Hubbard, in his capitalist utopia in East Aurora, New York, published similar praise of work, big business, and corporate titans in his Roycroft Shop.[132]

The motto fused civic republican ideals, nineteenth-century meliorism, Arts and Crafts idealism, and the gospel of industry.[133] For Dana, as for Timothy Dwight, industry was a commandment: this type of adage, to their way of thinking, satiated Americans' desire for affordable and accessible myths. Hubbard's and Dana's blend of overt moral irascibility and entrepreneurial ambition was appealing to early-twentieth-century consumers. Such advertising was an amalgamation of didactic social, moral, and economic sentiments. It was sophisticated kitsch *avant la lettre* and truly representative as a moral tone that gave succor to consumers by reaffirming their intentions. Readers were assured that their consumption promoted honest labor in America.

20. "#39 Mottoes" in The Printed Book, 1909. Collection of the New York Public Library. Theodore Roosevelt excoriated "weakling" nations and individuals. The drama of the lesson lay in its balance of two modes of Christian oratory, the "Gospel of Work" and trust in "Deeds, not Words." Richard Hofstadter and others have viewed this categorical mandate for doing, framed in opposition to thinking, as constituting part of a long tradition of anti-intellectualism in American culture.

In addition to advocating self-help, the Newark Library also advertised itself as a resource to assist individual entrepreneurs and small businesses.[134] In the 1919 leaflet "You Have the Will—We Have the Way," the library claimed it was "the best machine on the market" to write copy, investigate business data, and design publications, as if equating its expertise and service with those of an advertising agency (figure 21). The *Newark News* reported on the new availability of paid research to aid local businesses as a first by a public library.[135] The iconography of the pamphlet maintained the semblance of Arts and Crafts reform while simultaneously advocating advertising as

a constructive process. The cover featured an iconic representation of the Washington hand press, thus associating the library with physical methods of self-enlightenment. The title's "can do" spirit built upon William Morris's French motto *si je puis* and Gustav Stickley's slogan, "Als Ik Kan," but it also mocked popular get-rich-quick schemes. The cultural institution asserted that it was an engine as important and efficient and productive as any other factory in Newark. By combining an icon of manual trade with the verbal analogy, it suggested that honest artisanal work was compatible with modern salesmanship. Library billboards and broadsides were conceived as morally superior publicity. In terms of the local context of Newark and the national American Arts and Crafts movement, the printing press was a technology susceptible to romanticization and idealization. In Dana's hands, handicraft reconciled morality and commerce.

PERFORMATIVE PRINTING

The Newark Library presented the press as a demonstration in which self-employment and autonomy were preserved alongside mechanization and modernization. Production was a tangible metaphor for imposing collective order. On the one hand, bookplates composed by the public library constructed an institutional identity for citizen patrons and, via the Printed Book exhibition, for the nation; on the other hand, the live press suggested the library itself was a vertically organized business. In its theatrical performances of production, the library, transcending its role as a facility for storage and distribution, appeared to forge culture on an anvil.

The working press optimistically suggested that its function built community. The labor of printing was considered primarily a collective and collaborative engagement, and divided labor was not a problematic issue. Printing was a commercial imperative, a means of spiritual improvement, and an educational tool. It was art, handicraft, and propaganda all rolled into one. The handiwork of setting type and pulling wet sheets redefined culture as a local everyday occurrence or commonplace object, not an elite, rare, or awesome commodity. Although many tastemakers declared industrialization a force that was degrading aesthetics, the Newark Library emphatically declared that skill and taste were improving. The resilience of manual craft was visibly demonstrated amid mechanization. Handicraft was a metaphor for autonomy as much as a demonstration of skill.

There is a twenty-first-century tendency to consider museums are good if they own the best things money can buy, but Newark's institution was

You Have the Will—
We Have the Way

The Public Library
Newark, N. J.

21. Detail, pamphlet, "You Have the Will—We Have the Way" (Newark: Free Public Library, 1919). Collection of the John Cotton Dana Papers, Charles F. Cummings New Jersey Information Center, Newark Public Library. Here the library hit upon a clear slogan, but the message is communicated visually, by the image of the press, more clearly than in words. In 1904, the library depicted its work in relation to the cylinder press, a harbinger of industrialization, but here an archaic manual press was both more legible to the novice and also in line with the institution's commitment to handicraft as an icon and metaphor.

imagined in relation to a society that made things. The concern was that American art would not develop without manual skills and craftsmanship. Dana derided art that was, in his view, tied to convention and fashion; without educational or ethical moorings a piece of pottery or painting was meaningless, a hollow possession. By celebrating industry rather than masking it, he repudiated the idea that beauty was found in repose. The sight of the printing press in Dana's "workshop with books" was a radical move because the requirements of heavy industry had increasingly differentiated separate spaces for work and leisure.[136] Exhibiting the industry of the press as a daily activity demystified printing and made plain a connection between the production of culture and commodities. In Dana's eyes, the press proved his institution was not a passive reservoir of culture but focused on displays of "living industries."

The Newark Library and Museum showed "fine art," but it received national newspaper coverage for its exhibitions of "live industries" and demonstrations of handicraft. These displays assured visitors that individuals still had roles in commodity production and that the making of goods was necessary for municipal independence and growth. Idealizing handicraft in a theatrical spectacle was intended to foster social uplift and economic improvement, Dana's two main goals. The aspiring immigrant laborer or benevolent employer could view their participation as both producers and consumers in a civic light.

Standing beside his press, Dana fashioned a new concept of the public librarian. He dared ask why "the printer's products occupy no high place among 'museum pieces.' Is this because printing is an industry? Or of today?"[137] He perceived the multiple roles of printing—its ability to signify romantic and technological aspirations, artistic and educational processes, social and economic solutions, simultaneously—and he identified with it as a craftsman. Outside, the fiery, prospering city was home to more than a quarter of a million citizens who spoke a multitude of languages. Inside, the industrious librarian labored as a craftsman.

His hobby gave Dana a way to relate to the meaning of work and Newark's vital essence, he thought. He perceived himself to be in touch with the workers of the city, transcending class boundaries through his involvement with the press, much as Theodore Roosevelt placed himself outside of historical social hierarchies and labels by his involvement with the "strenuous life." Perceiving the "incorporation of America" and a city of foreigners, he held onto crafts as a common denominator, a virtue.[138] Flanked by increasingly impersonal corporations and alienated urban poor that were disconnected not only linguistically but also religiously and ethnically from his own Protestant Yankee roots, Dana hoped to forge consensus through ink and paper. Prior to 1909, the year the city chartered a formal museum entity, he had successfully transformed the library into a spectacle of handicrafts and dynamic exhibitions, and won national renown. The viability of the library's function as a cultivator and its role as a business catalyst in the industrial city, however, were still in question and fundamentally unproven.

The Newarker

Published Monthly by the Free Public Library of the City of
Newark New Jersey

One dollar per year Ten cents per copy

Volume 1 November 1911 Number 1

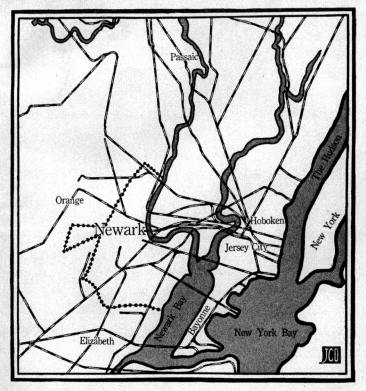

Newark's Strategic Position for Commerce and Manufactures. It is on the Lines of
Half the Great Railway Systems of the United States as they Reach the Seaboard at
the Port of New York and is itself a Seaport of Increasing and Unlimited Possibilities

John Cotton Dana, cover design of the first issue of *The Newarker* 1, no. 1 (November 1911).
See plate 4.

The Business of Culture

Literature and business found nothing in common a little while back in history. The poet and the merchant regarded each other with mutual distrust, dislike and disdain. One of the most important sections of the modern library is that devoted to business and technical books. Especially should this be true in a great manufacturing city. Especially should this be true in Newark's Library. And as the library of the business city devotes a large part of its effort to supplying the book wants of the modern business man, so should the library magazine make of itself a reflection of the thought of the business man, and a mouthpiece of the wider business interests.

— *The Newarker*, November 1911

The Newark Library created its own magazine to fill the breach between poetry and industry. The pages were a business-to-business forum and a research center connecting the city's tiers and types of entrepreneurs and manufacturers: all of Newark's publications and production statistics were filed in an index. To abet the reform of industry, the institution created this objective and nonpartisan system and developed it across branch libraries and museum exhibitions as well as the periodical. The library colonized interstitial urban spaces by becoming a clearinghouse for information. Its emphasis on circulation was unconventional and resulted in the physical building playing a reduced role in the overall system. By 1908, the central branch on Washington Street was no longer the main conduit of book distribution, and Dana praised his network that adhered to Taylor's ideal of productivity in which "the system must be first."[1] The librarian's new management paradigm purposely tried to compete with mass culture. In 1911 the library created *The Newarker*, a magazine presented as the city's "brain-worker" which transmitted "utilitarian literature" "to the industrial man of to-day."[2] Historically, the library had distributed fiction and political tracts: now it strove to engage mechanization and mass culture and editorialize as a civic "mouthpiece." However, Dana's ambitions outpaced his clarity of purpose. Striving to influence the city's major power brokers, its capitalists, the library engaged in a type of reform in which its librarians, exhibitions, and publications came to reflect "the wider business interests."[3]

QUANTIFYING THE LIBRARY'S PRODUCTION

At the turn of the century, librarians summarized their careers in terms of the use of their institutions. In newspaper editorials and articles, the library reported its recent advances in serving an ever-expanding audience. The city's dailies and weeklies offered complimentary space to the library to advertise its impressive accomplishments in loaning and buying books. Circulation statistics quantified civic betterment in graphs and consistently cast the present as a state of progress.

Dana quantified his success at the Newark Library in this empirical manner, too. He measured the volume of his trade as if cultural work could be tallied on a ledger like the one in his father's dry goods business. Between 1902 and 1929, under his direction, Newark's book collection increased from 79,000 to 414,000 volumes. The number of borrowers grew from 1,900 to 90,000, so that one in five Newark citizens used the system, an improvement over one in ten.[4] Circulation increased from 314,000 annual loans to almost two million.[5] All these figures suggest that the library did become more "democratic," as Dana hoped.

The library's regular notices of numerical data were akin to commercial audits and municipal bond valuations. Statistics seemingly proved the library's response to swelling urban populations and mass leisure. Dana particularly was attentive to publicize the percentage of library books loaned from the "Useful Arts." This collection epitomized the ideological shift in the library's identity from a private club. The active distributive network supported his claims for the democratization of information, comparable to debates in the twenty-first century about Internet use.[6] Dana and his city interpreted the marked rise in circulating volumes as a positive sign of uplift. However, the increase in these numbers can also be seen as the result of his application of preexisting technological and commercial innovations to what had been a static institutional infrastructure. The changes were keenly pragmatic, attempts to appeal to diverse constituencies.

The decentralization of the library coincided with new ideals of industrial paternalism. The creation of branch systems and circulating libraries had started in New York City in the 1880s. Public libraries in Cleveland and St. Louis had pioneered the system of locating a few bookshelves in factories. By 1905 there were a dozen such outreach ventures in Newark's businesses. The library was selective about which neighborhoods and communities it would serve. It did not rush to serve immigrants, and catered first to businessmen. A foreign branch opened in Newark in 1912, and even then received much

less funding annually than the business branch, begun in 1904. Establishing branches in factories and retail stores, the library appropriated spaces where public and entrepreneurial welfare overlapped.

In 1906, Dana boasted that there were "branches"—shelves of a couple hundred books—in the factories of Weston Electrical Supply, Clark Thread, and Roberts Rubber Company. A few years later, the system grew to include the three of the city's largest department stores—L. Bamberger and Company, Hahne and Company, and L. and S. Plaut and Company—in addition to fifteen fire stations, ten police stations, and the main post office. Book return boxes were placed in select pharmacies.[7] Significantly, the owners of most of the largest of these commercial establishments were on the library's Board of Trustees. The initiatives in "industrial betterment," if paternalistic, held real educational value: they were applauded by most Progressives, including Jane Addams.[8] Using fire stations and pharmacies to circulate books was opportunistic and shrewdly interwove private and public institutions into a new type of civic network.

The Newark Library carefully tracked and reported its statistical growth in the *Newark Evening News* as well as in its annual reports. By 1907, there were almost five hundred sites for returning books, a tremendous increase from thirty in 1902.[9] The numbers of loans at each station were considered newsworthy if efficiency could be demonstrated, as in 1905, when the branch in Bamberger's department store circulated more than six thousand books per month.[10] By 1908, branches accounted for most of the library's circulation, and the main building became an organizational hub for the busy satellites.[11] *The Newarker* published graphs to prove its branch system was incontrovertibly successful. Not content with simply collaborating with private establishments, the public library also adapted commercial delivery systems and technologies. Patrons could use the postal or telephone service to request home delivery. The cultural institution was becoming more like the retail stores of the city, ferrying books to patrons who no longer needed to visit in person.

The library's integrated educational network operated as a civic business. When the *Newark News* reproduced a photograph of Dana in the Newark Library in 1902, it showed him at his desk with the decade's cutting-edge technology, the telephone, front and center (figure 22). He was portrayed as a virile businessman: the stage prop asserted the transformation of the librarian's identity into a practitioner of Taylor's scientific management. The telephone, not yet recreational or commonplace, at that time signaled a radical new mode of conducting the business of culture. The library also took advantage

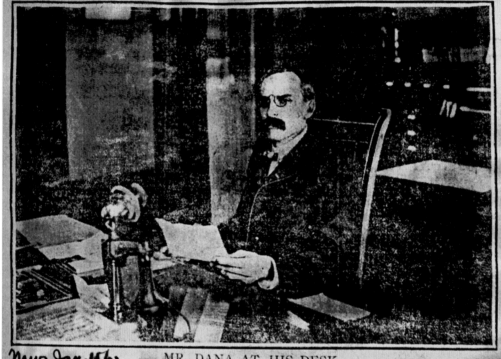

MR. DANA' ASSUMES HIS DUTIES AS LIBRARIAN.

News. Jan. 16/02 MR. DANA AT HIS DESK.

22. Dana at his desk in the Newark Free Public Library, *Newark Evening News*, 15 January 1902, NPL Scrapbook, 1901–1903. Collection of the Charles F. Cummings New Jersey Information Center, Newark Public Library. Few images of Dana date from this period, when he was eager to prove his worth to Newark and emphasized a businesslike appearance. Archival images reveal him as a teenage dandy, and a shaggy postgraduate surveyor in Colorado. The most reproduced images depict him as an older man in the last decade of his life.

of other commercial mechanisms of distribution that were giving Newark a sense of municipal sovereignty. It fed news stories to Wallace Scudder, the owner of the city's stately daily, the *Newark Evening News*, and also to the largest weekend paper, the *Sunday Call*, whose editor, Frank Urquhart, was Dana's personal friend. Scudder declared the *News* a source of "municipal journalism" and a means to assert Newark's independence. The paper was widely respected in the medium's heyday, both for its vigorous reporting and its growing readership. Urquhart, a minister, also saw his paper as a platform for civic improvement. They were editorially independent of political parties, but relied on the advertising revenue generated by the growing retail

center—"print capitalism," to use Benedict Anderson's expression. The full back page that Bamberger's ads regularly occupied was an important financial foundation upon which the *Newark News* could afford to develop independent journalism. The library was dependent on the papers for flattering descriptions of Dana's aims, such as his creation of a telephone delivery system to serve businessmen.

Most of his professional peers saw Dana's invention of the business branch as his most important contribution to the field of library economy, as the field was called. There, files of facts were organized and made public. The library became an agency to serve capital, a new concept. When the library began to compile information about local and international commerce, comparative trade statistics detailing the cost of raw materials and finished goods across the globe were still in their infancy. The U.S. federal government created the Department of Commerce in 1903, and there were few systematic efforts to conserve or organize the ever-expanding volumes of catalogs, trade journals, and annual reports in most libraries. Dana invented new methods of indexing and cataloguing pamphlets, maps, periodicals, and directories related to commerce, materials previously outside the purview of the librarian.

The business branch was located downtown, only three thousand yards away from the main library. By inviting entrepreneurs to use its staff as researchers, it revolutionized the library's reputation as a civic ornament or leisure venue. In cartoons and statistical summaries, newspapers helped Dana advertise the library as a practical municipal entity, and as a suitable destination for industrious men (figure 23). The service-oriented librarian was caricatured as a Gibson girl in the *Sunday Call*, and Newark's businessman comically rendered as a dapper Wall Street speculator sporting a silk top hat. In contrast, the conventional library reader was depicted as a woman of leisure browsing fiction. Entrepreneurship was clearly gendered. The business library designed its filing system to assist the Newark manufacturer looking for new markets for products or information about their competitors. The Board of Trade had previously collected statistical information about limited areas of municipal progress; Dana's real innovation was to cross-index such data organized by material and business name. Although acclaimed, his notion of a business library was not replicated elsewhere until 1928 in Boston.[12] There, a department store owner, not a librarian, propelled the development.[13]

The organizational innovation redefined the library according to the contours of modern commerce. Dana's interest in categorizing information according to modern commercial practices departed from humanistic notions

71

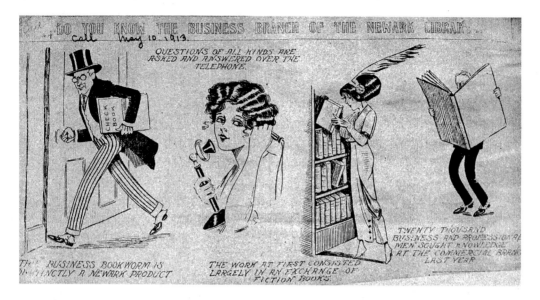

23. "Do You Know the Business Branch of the Newark Public Library?" *Sunday Call*, 10 May 1913, NPL Scrapbook, 1906–1913. Collection of the Charles F. Cummings New Jersey Information Center, Newark Public Library. In this illustration, the local paper praises the public library but resorts to period clichés to designate roles, status, and gender. Like the image of Dana at his desk, the telephone is an example of technology to demonstrate the modernity of the library and its work. The woman adorned with a dangerously long plume is explained as a reader of fiction, and the patron of the past. This was untrue; fiction remained a bulwark in the circulation.

of organizing books according to fields of study. He favored the rise of new specialized technologies, and categorized books according to types of work and material. For instance, Newark's rubber and electric manufacturing concerns were indexed according to inventions that had not been in the lexicon or home thirty years earlier. These innovative methods of library science are not easily labeled according to political ideals. Whereas the contests over fiction and censorship and the admission of children are often considered triumphs of Progressive politics, the creation of open stack systems and the emergence of telephone distribution hybridized civic welfare and entrepreneurship.[14]

A MUNICIPAL HOUSE ORGAN

By declaring the monthly *The Newarker* a "house organ," a late-nineteenth-century term for a company periodical, the library indicated its dedication to entrepreneurial ends as much as social goals. Between the autumn of 1911 and June 1916, it claimed its readership grew from more than twenty thousand to

two hundred and fifty thousand.[15] Even if this was hyperbole, it began to suggest how swiftly the magazine had developed. Its mission was defined as the "city's welfare," but here too, civic uplift and public welfare were unevenly folded together. The very title of the publication suggested the city was a business or an athletic team in which citizens had an investment. *The Newarker* commented on all aspects of modern life: it touted the virtues of personal hygiene, draining the swamplands of the Passaic, street sanitation, pure milk, and the increase of sympathy and understanding among citizens (the latter accomplished by reading fiction and nonfiction).

The aim of the magazine was to create a new community spirit focused on incorporation and to instill an ideal of collective improvement. Dana believed that such a house organ could "pull ... the city together, ... like any well organized business corporation."[16] His focus on municipal infrastructure was shared by new publications such as *American City*, on whose editorial board he served, and *Survey Graphic*, a "journal of constructive philanthropy" published by the Charity Organization Society of the City of New York and the Russell Sage Foundation.[17] But *The Newarker* addressed civic uplift in distinctly local and economic terms, more like house organs of department stores and factories. Dana and his collaborators, especially Louise Connolly, wrote as moralists and crafters of public opinion. They asked citizens to pick up trash, for example, and to plant shade trees and to tend their yards. "When the citizens take a keen interest in their town the town prospers, and becomes each year a better place to live in," *The Newarker* stated.[18] Although the periodical suggested a wide-ranging reading list, from the autobiography of Cleveland's Mayor Tom Johnson to a volume on Munich's city planning, civic action on national and international matters was never its intent. Its pages tallied Newark's own achievements and shortcomings, evaluating both schools and streetlights.

The decision to establish a municipal periodical was perhaps the library's most extreme attempt to transcend the physical limitations of its building and join the effort toward "municipalization." This keyword spread among urban reformers becoming increasingly intent on unifying the city along the lines of a corporate model. It was an umbrella for a "shared language of germs and sewage, gas prices and streetcar fares."[19] In the 1890s, Albert Shaw, a reporter trained in economics at Johns Hopkins University, produced influential studies of the European city as a model for American reform and coined the term "municipal housekeeping"—later appropriated by Jane Addams, Florence Kelley, and among others, the women's suffrage movement—to describe

civic ethics as an extension of maternal duties.[20] Didactic, moralistic, and condescending, the magazine listed the steps to assure "improvement in the character and intelligence of the citizens."[21] *The Newarker* published arguments celebrating the "Captain of Industry," a markedly virile expression of reform, as well as articles about tuberculosis prevention and personal hygiene as a maternal duty. The municipal housekeeping encouraged took shape as distinctly gendered types of activities.

In *The Newarker*, new social science and business theories coalesced with civics and fiction. The novel technocratic solutions that the magazine encouraged Newarkers to consider included Henry Gantt's charts of collective and individual productivity evaluations, the Gilbreths' motion studies of factory workers, and Taylor's scientific management. All this "science" aimed at greater efficiency was deemed applicable to schools, hospitals, and home. Readers were exposed to Mayor Johnson's story of a "self-made man and typical American" and to Mary Antin's account of her journey to America, *The Promised Land*. The latter was interpreted as "a study in race personality and character."[22] Dana celebrated Upton Sinclair's *The Jungle* (1906) as a story of human perseverance, calling it a romance in which individualism and rationality triumphed over the evils of "wage-earning dependency."[23] The characterization was not uncommon—the book was also made into an entertaining, emotional motion picture in 1914—but it illustrates Dana's emphasis on the responsibility of reform. He identified individual personality as the source of social crises and their solution. He advised self-regulation and decried regulatory legislation. Developing "character" was one of his favorite solutions. The Chicago Public Library suppressed *The Jungle* because it indicted the city's politics as prone to corruption, and the difference sheds light on Newark's independence and Dana's apparent radicalism.[24] As numerous variations of Progressive politics emerged, they were differentiated regionally and in relation to specific municipal identities.

The Newark Library's magazine drew a relationship between economic efficiency and civic morale with articles such as "How to Get the Best Work out of Yourself and Others."[25] Dana related municipal infrastructure to social psychology along the same lines as Charles Horton Cooley's *Human Nature and the Social Order* (1902), if in less theoretical terms. Cooley, who wrote for the *Survey Graphic* and whose texts were on the shelf of the Newark Library, described the city's units of infrastructure as "social organs."[26] He viewed a municipal transportation system as a defining aspect of modern community, and as an opportunity for social engineering. Optimistic like Dana, he

proposed that twentieth-century capitalism would "foster new values that transcended the competitive pursuit of self-interest and that would 'human-ize' the corporate order in turn."[27] Environmental and biological determinism were given equal room on the library shelf.

Criticism that he and the Newark Library were paternalistic or "commer-cial" was directed at Dana during his lifetime. His description of a reading room full of newspapers and magazines as "the only real people's college" appalled several librarian colleagues.[28] Lindsay Swift, director of the Boston Public Library, deplored the Newark library's decentralization and won-dered if Dana was dangerously close to obliterating its institutional identity.[29] Dana's critics rejected his adaptation of commercial methods and technologi-cal tools as adulterating the library's mission. His emphasis on distribution upset conventional definitions of culture. After Dana's death, his friend Carl Purington Rollins, the celebrated Yale University printer, complained, "John Cotton Dana once suggested that every museum ought to have a penny-in-the-slot machine in front of every exhibit, from which the visitor could extract a printed description of what he was looking at. Clever as this idea is, one winces at the probable typographic result!"[30] Although the two men met as connoisseurs in the Boston Society of Printers, Dana saw machines as a paradigm for printing that was educating the masses.

The Newarker did better define the city, but at the cost of obscuring the library. The pictorial lessons were overtly propagandistic. The journal's ser-monlike tone charged readers to act on multiple linked social problems, and the graphs, before-and-after photographs, and maps encouraged these practi-cal undertakings and solutions. The cover of the first issue was a map drawn by Dana, and its design is a testament to the librarian's interest in visual cul-ture and his faith in modern methods of pictorial suasion, as well as his devo-tion to his adoptive city (plate 4). Initialed JCD in thick capital letters at the corner, the map was intended to infect readers with the author's enthusiasm and optimism about Newark's future. In Dana's composition, Manhattan became a secondary landmass, an appendage to the Passaic harbor. He trans-formed Newark from an industrial suburb into a hub. Like Saul Steinberg's 1978 *New Yorker* cover, in which New Jersey and the entire world ring an egocentric Manhattan, Dana's design seems absurd; the two are quite alike.[31] *The Newarker* tried to inflate its readers' self-confidence: it asked them to see themselves as citizens of Newark first and foremost. The goal was to invent a civic identity. If the map did succeed in its aim to unlock the city's "unlimited possibilities," the library's role in this was not clear.

The Newarker declared itself a technological means to support civic self-confidence, but it became a platform for the interests of the Board of Trade. In its pages, Dana applauded the papers and department stores as models of growth much more insistently than he praised his own institution. He intoned pithy, vague, and optimistic solutions to the problems of capital and labor: "As Business grows, the world civilizes itself; asks for peace; gives up race prejudice; ties people together with the bond of mutual profit; discovers and rewards talent; awards prizes to genius; marks the lazy and deceitful for failure in the long run."[32] His demand, "Gentlemen, let us attend to business," however, promised a corporatist municipal culture for Newark that was not inclusive. Neither The Newarker nor the library spoke for the dispossessed. Although the magazine desperately tried to influence the morale of the rank and file, it spoke of civic order in the language of capitalism.

The cliché that Progressive reformers saw industrialization as alienating does not apply to the Newark Public Library. Dana, like Wright, Dewey, and Addams, saw beauty in the "white band streaming endlessly" and spreading information.[33] Dana's answer to sweatshops and labor unrest was "industrial efficiency" and "industrial intelligence," a combination of technocratic managerial solutions and a civic-based Protestant work ethic. Dewey, too, in his article on the "Need of Industrial Education in an Industrial Democracy" emphasized increasing rationality and morality in industry; he did not express antipathy toward industrialization itself.[34] In 1912, Ida Tarbell and Louis Brandeis similarly argued for Taylorism and agreed with Secretary of Labor William C. Redfield, writing in the Atlantic Monthly, that "The Moral Value of Scientific Management" was "the restoration of individuality."[35] The Newark Library implied that if the Board of Trade were given a free hand, local industry would build the modern enlightened "daylight factory."[36] Dana and his trustees saw themselves as moderates tempering capitalists and workers alike by increasing their sympathy and rationality.[37]

Serving on the City Plan Commission of 1912, Dana made this, too, the business of The Newarker. At a time when labor relations in the city were fraught with problems, the magazine's tone never became angry, nor did it engage in muckraking. Despite the fact that fires in Newark factories in 1910 and 1911 were reported nationally, there was no information about tragic local labor conditions in its pages. On March 25, 1911, eyewitness tabloid photographs and the firsthand testimony of Frances Perkins (then the secretary of the New York branch of the National Consumers' League, and later Franklin Delano Roosevelt's secretary of labor) related the gravity and tragic causes of

the Triangle Shirtwaist factory, but *The Newarker* avoided mentioning the tragedy in its commentary on fair labor practices in its first issue in the fall of 1911.[38] In 1912, the International Ladies' Garment Workers' Union condemned New Jersey and Newark in particular as a "paradise" for sweatshops and non-union labor, but Dana clearly represented the interests of manufacturers when *The Newarker* advocated "modification of the Employers' Liability Act, and amendments to factory and workshop laws which are burdensome to Manufacturers."[39] Dana's response to the acute problems of labor was indirect. He advocated sympathy and palliatives. *The Newarker* never called the industrial system itself into question.

EXHIBITING LIVE INDUSTRY

As early as 1902, Dana told the *Newark News* that the museum and art gallery on the top floors of the new library might be "employed for loan shows of pictures or collections which would illustrate the principal manufacturing interests of the city."[40] Although the formal founding of the Newark Museum Association occurred in 1909, the institution had been a venue for the exhibition of "industrial arts" years earlier. The development of a "live museum" was rooted in the notion of admiring depictions and demonstrations of work. Library exhibitions were connected to schools and charity organizations and local manufacturing at an early date.

For instance, Dana's initiative in 1902 to establish *Buchkunst*, book art, began with the library's own function and requirements. He dedicated a room on the ground floor of the building to serve as the bindery. During his first decade as director, from eight to ten thousand pieces of the collection were bound each year at a cost of from three to six thousand dollars, almost as much money as was spent on purchasing books and periodicals. To handle the bulk of the work, various professional binding firms won an annual large-scale contract until 1905, when Dana hired William Rademaekers, a German American, to conduct the bookbinding and also begin an apprenticeship system within the library (figure 24).[41] Celebrating the trade as a manual skill and also an industry, the library established an in-house bindery with a staff of three. Vocational education, practical need, and municipal enrichment coincided, resulting in exhibitions that gave the craft increased visibility. A 1905 library show contained approximately one hundred examples of different types of binding materials, including duck cloth, calfskin, goatskin, and pigskin covers. The exhibition toured a dozen other libraries as well as Teachers College and Pratt Institute.[42] Newspapers presented

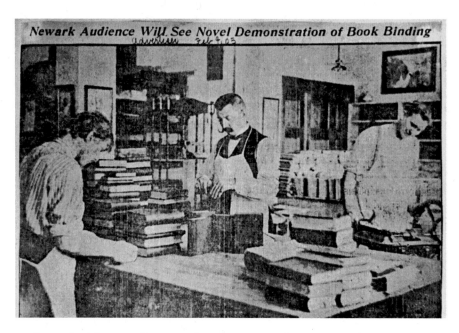

Newark Audience Will See Novel Demonstration of Book Binding

24. "Newark Audience Will See Novel Demonstration of Book Binding," *Newark Advertiser*, 4 February 1905, NPL Scrapbook, 1903–1905. Collection of the Charles F. Cummings New Jersey Information Center, Newark Public Library. The binder, William Rademaekers, was a professional recruited by Dana from Philadelphia, who established a bindery business inside the library, developed it into a school, and then relocated to a different building when the business outgrew the library.

Rademaeker as a virile artisan transforming the library so that it resembled the city's other businesses.

In 1910, when the binding business had over one hundred students completing contracts for libraries across the state, the firm relocated outside of the library building. Dana had advertised the business in librarians' periodicals, and its growth can be attributed directly to his work as a liaison. He approached Newark tanneries to develop new types of pigskin leather in order to facilitate the local production of proper supplies. The "non-acid tanned pig's skin" specially fabricated for Rademaekers by the Lincoln Leather Company "attracted the attention of the Bureau of Chemistry of the United States Department of Agriculture as well as of the best library bookbinder in the world, an Englishman," a reference to either Douglas Cockerell or T. J. Cobden-Sanderson, who both rose to prominence through William Morris's commitment to revive the craft.[43] The introduction of this new branch of skilled craftsmanship to Newark's population was lauded in newspapers as

a success that had social and economic implications, for children and the city. Dana hailed it as an art especially suited to women and one due to steadily grow because the machine could never supplant the hand. The artistic business was cultivated as an effort to "improve" the city and make it competitive in another dimension of its specialization in leather. As Dana's library exhibitions developed to fuel production and consumption, the cultural institution turned into a seedbed for industry.

In 1907, the library held its first exhibition of Industrial Art.[44] The topic, jewelry design, included mostly drawings and photographs culled from magazines and historical books. Byzantine, Roman, Korean, and "antique jewelry from British Columbia" were presented as exemplary for Newark's artisans. The enterprise illustrates Dana's idea of collaboration because he juxtaposed modern and ancient examples, and sponsored a series of public programs that involved local artisans and educators. The caption of a *Sunday Call* article, "Jewelers and Educators Striving to Raise Standards of Workmanship," suggests the degree of cooperation that Dana hoped his institution would engender between local business and schools. One of the related public events was a lecture given by Henry Turner Bailey, editor of the largest national publication on elementary school handicrafts, *School Arts Book* (1903–1912; continued as *School Arts Magazine* 1912–1935). Bailey was the former state agent for the Promotion of Industrial Drawing of Massachusetts. Newspapers advertised his talk in connection with the exhibition, and reported that Charles A. Colton, principal of the Newark Technical School, and Albert R. Lache, principal of the Free Drawing School, attended.[45] Dana won the participation of the Manufacturing Jewelers' Association, which announced that it would fund scholarships for students to attend the Newark Technical School, a thirty-dollar yearly tuition. The jewelers hoped that industrial education would solve the "dearth of apprentices" in the jewelry business. In reality, the small compensation of the apprentice system was the real problem. It was impractical to expect teenagers in desperate straits to think in terms of long-term career prospects and forgo the opportunities for higher wages that Newark's less skilled jobs offered. The Industrial Art exhibit tried to inspire Newark's young to be industrious citizens, and to convince them to value skilled labor that held the promise of social advancement.

When the Newark Museum Association was chartered in the spring of 1909, the mission to further "the exhibition of articles of art, science, history, and technology" formalized the library's habit of holding displays on its third and fourth floors, in four large rooms and the auditorium.[46] The fifty founding

museum trustees were drawn from the ranks of the library's benefactors. Associate membership, offered at a rate of five dollars per year, reached three hundred by 1913, but the number of museum members remained fewer than five hundred throughout the 1920s. Of the fifty major patrons, a small circle of no more than twenty men supervised the project. Dana was the association's secretary, volunteering his services until he became the director in 1914. The association employed two part-time staff members who split their time with the library, Louise Connolly and Marjary Gilson.

This formal entity was a coalition of factions marred by dissension, as Dana openly admitted in 1914: "The Newark Museum Association . . . has a composite ideal of what a museum should be. Some of its members think of a museum always in terms of marble corridors adorned with great white statues, and . . . paintings in oil. But there are others who see in the museum an opportunity to glorify and make articulate the everyday work of the everyday people of the everyday city."[47] Dana's use of repetition indicated that he considered himself a part of the latter, clearly superior, crowd and suggested that he wanted to dethrone the "white statues" and place modern goods made in Newark on the museum pedestal. However, in essays for schoolchildren, he also lovingly celebrated plaster casts and encouraged loaning them to beautify public school classrooms and serve as objects in drawing lessons.[48] He considered both applied and fine art "stimulating and helpful to our workers."[49]

The formation of the Museum Association in 1909 coalesced around the decision to exhibit and then purchase a collection of Japanese decorative arts and handicraft, and the consensus extended to viewing the assortment of woodblock prints and lacquer and brass objets d'art as relevant to modern industrial production. The artifacts, which were first borrowed from local pharmacist George T. Rockwell, attracted three thousand visitors in one month, no more than had the previous exhibition of magazine clippings in two weeks' time. But the objects also attracted the attention of Caspar Purdon Clarke, the British director of the Metropolitan Museum of Art. He visited the show and applauded it, provoking excitement that culminated in Newark's appropriating ten thousand dollars to purchase the collection and mark the formal beginning of a proper museum. The artifacts of personal and domestic adornment, especially lacquer *inros*, were described as pertinent to Newark's jewelry industries, and the collection expanded upon the previous two exhibitions of Dana's own *ukiyo-e*. Japonisme, an infatuation with and fetishization of the East, temporarily unified trustees polarized over the issue of marble corridors versus everyday life. The purchase rallied the city's

elite and sated their desire for deluxe objects, while it satisfied Dana's own for useful aesthetic lessons. Interestingly, these early exhibitions emphasized teaching preindustrial ornament to applied artists who worked in contemporary mechanized production in Newark, following precedents established by Clarke in his previous position as director of the South Kensington Museum in London and of colonial museums in India.[50] Continuing these projects of economic uplift characteristic of European imperialism, Dana specified that "peasant art" would invigorate Newark's mechanics aesthetic sensibilities.[51]

Dana heeded his own instructions to Newark that its artisans would do well to seek inspiration in "the work of the peasant." He designed a woodblock print with pretensions to emulate the planar color and exotic imagery of *ukiyo-e* (plate 5). Crudely cutting the letters of his name and an epigram in Latin, "Ex incisis japonicas," Dana explained that the print was to be applied to his own *ukiyo-e* as a way to label them. He was prescient that posterity might misconstrue the image of the surly samurai as a self-portrait. Giving away prints as gifts to proselytize, his ludic handicraft displayed sophistication. It is another instance of his desire to modernize art with Japonisme. He presented the connoisseurship of both Anglo and exotic handicraft as a robust, invigorating habit, and diverse types of handicraft as worth recuperating in contemporary Newark.

After this brief, seemingly unanimous moment in museum management, dissension followed over the next six years. Trustees chafed at giving too much space to scientific displays, and Dana considered their expenditures of large sums of money on oil paintings to be wanton and lacking frugality. (The Disbrow Science Collection of geology and botany specimens began to enter the museum in 1901, and was installed in 1912 as the first permanent collection in roughly one-third of the museum's eight thousand square feet.) Whatever the reason, the Newark Museum Association did not hold full-blown "industrial art" exhibitions of local products: the word "museum" inhibited the governing body, and the association, for a time, seems to have diminished the autonomy Dana had wielded in library exhibitions. Several trustees, especially Dr. Archibald Mercer, considered Newark's own industrial production an unsuitable subject. Franklin Murphy, a collector of oil paintings that the librarian dismissed as receiving "undue reverence" in his 1913 essay "The Gloom of the Museum," supported Dana, but numerous long-winded letters suggest he and the librarian found each other exasperating. Dana was stubborn and sustained the idea of a museum of industrial arts in publicity more than in practice for the next three years.

In May 1912, the Public Library participated in the Newark Industrial Exposition, but not the museum. At the event, held in the city's armory, the library displayed a printing machine made by the American Multigraph Company. The multigraph, a machine of movable type, printed lists as you watched. The printed matter emphasized the work of the business branch, not its immigrant outreach. Librarians distributed to the public more than fifty thousand leaflets featuring lists of facts about local industry. These lists included bibliographies on efficiency and scientific management, women in factories, and jewelry and silversmithing (figure 25). "Participation in such an Exposition," Dana noted, "is exactly in line with the policy of the Library, which believes in making itself known, and especially to the business men."[52] The library stall did not sell anything but merely exhibited posters, books, and pamphlets. The library was particularly proud to show off its recently compiled Made in Newark index, a catalog of over two thousand businesses. The Exposition Committee published a brochure of participants titled *Newark Made Goods*, and the library proudly noted that in comparison, its own work was more flexible and accessible, as it was cross-indexed.

Featured in the small stall was the library's map of factories in Newark drawn by Dana and Sarah Ball (see figure 3), while off to the side were two large plates depicting the propagation of ferns and flowers, perhaps from Christopher Dresser's 1862 primer on design.[53] But probably the most provocative images are not visible in the photograph of the stall: two speculative maps of a "Greater Newark" graphically represented a plan to annex outlying lands and incorporate them into the city proper. The expansion, which was debated for decades without success, aimed to grow the tax base beyond Newark's paltry thirteen square miles and would have sustained long-term urban development. In *The Newarker* and the 1912 industrial exposition booth, trustee Jenkinson tried to foster interest in this plan, of which he was a major architect.[54] He ambitiously predicted a city of more than two million by the middle of the twentieth century if Newark continued on the pace it had set in the 1870s, a statistic that in hindsight is both absurd and endearingly optimistic. In presenting Jenkinson's speculative maps for Greater Newark, the library supported trade.

Work on the Made in Newark index had begun in 1905, when a "catalog of manufacturers' catalogs" was established.[55] The idea of saving house organs, annual reports, and trade fliers—publications considered ephemeral and therefore outside the domain of the library—is indicative that Dana saw commerce as the library's prime partner. The statistics gathered in the

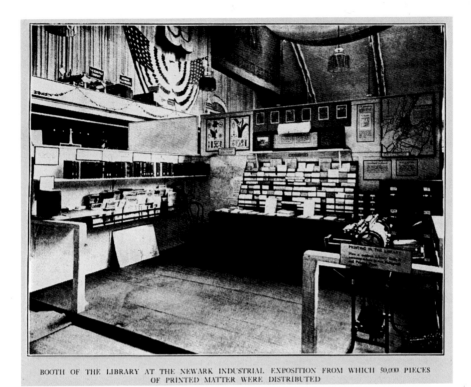

BOOTH OF THE LIBRARY AT THE NEWARK INDUSTRIAL EXPOSITION FROM WHICH 50,000 PIECES
OF PRINTED MATTER WERE DISTRIBUTED

25. Newark Public Library's booth in the Newark Industrial Exposition, reproduced in
The Newarker 1, no. 8 (June 1912): 125. At the right is the library' multigraph, a machine
that used moveable type and permitted form letters to be generated that resembled hand-
typed ones. Also visible is the library's map of the locations of Newark's two thousand
factories and what appear to be plates documenting the growth and reproduction of
plants—as if the mechanics of botany and cities shared a common logic.

index supported the Newark Board of Trade's notion of progress. The library
showed that between 1900 and 1910, the number of factories in Newark fell
from 3,300 to 1,800, a 44 percent decrease. The tendency was not consid-
ered worrisome, the library argued, as the workforce in manufacturing had
grown by ten thousand and the annual increase in the value of products made
by Newark industries rose 59 percent to more than two hundred million dol-
lars.[56] The Newark Library did not criticize the tendency to amalgamate pro-
duction, a loss of diversity that arguably improved the city's economy only in
the short term. The index was also a novelty that is difficult to fathom today:
the library's method of cross-referencing specific products and names of
manufacturers anticipated the form that telephone directories would use in
years to come.

In the municipal exposition of 1912, printing constituted the central and largest display; it was the only trade to organize as a collective outside of corporate identities. The display was a rare sight: express collaboration between labor and capital. The "Master Printers of Newark" installed colossal new machinery—the latest rotary presses and Linotype machines. One thousand workers produced a newspaper, *The Exposition News,* before the eyes of the public every day, "from the setting of type to the stitching and cutting of the paper."[57] The Mergenthaler Linotype was considered one of the more remarkable sights of this display, operating twenty-four hours a day.[58] Here, the spiritual powers of printing were on display.

Strolling through another civic industrial exposition two years later, in 1914, a visitor would have found the library printer churning out sheets of statistics on a mimeograph machine, but the museum was still absent. The library's Made in Newark index was once again a prominent feature in 1914, as well as the city's manufacturers' thousands of catalogs and house organs. These exhibitions emphasized that the business branch was Dana's great innovation and showed it off as a product of intimacy with Newark's businesses. When the public library handed out reading lists about "efficiency and scientific management" at the municipal exposition, explaining that "business civilizes" and "gives to the industrious and fair dealing a sure reward," it articulated a businessman's vision of Progressive reform.[59] In both the magazine and the exhibition, the library had become an overt advocate for the interests and aspirations of the Board of Trade. It was innovative in that it used visual arguments—maps and graphs—to influence popular opinion, and political insofar as it furthered an industrial progressivism. The business of culture and the culture of business were increasingly hard to tell apart in Newark.

CIVIL SERVANTS AND CIVIC IDEALS

The photograph of Dana by his printing press inside the library in the second decade of the twentieth century includes a woman with her back to the camera, whose significance is subtle but important: she signals Dana's radical institutionalization of a woman librarian in charge of printing (see figure 13). While the librarian assisting Dana might appear deferential in her body language, seemingly waiting upon the approval of her supervisor, she was on view running the press at a time when librarians were expected to be bookish.[60] The voices of the women in the library are barely audible in the historical record but warrant inclusion here to recreate a sense of the institution's daily inner workings. Women were considered especially suited to library

work because it was a moral calling and service-oriented. Even if her identity as an individual was suppressed in the photograph, the woman's presence challenged the conventional views of the desk-bound librarian and the gendered division of labor in the printing trade.

Librarian Marguerite L. Gates (1884–1965), educated at Mount Holyoke College near her native Springfield, Massachusetts, was placed in charge of publicity and printing; this was one of the anomalies that Dana foisted upon Newark. He trained her in presswork after her arrival in 1907 and, seeing her ability in manual craft, gradually entrusted her with greater responsibilities. Dana valued diligent craftsmanship as proof of a superior intellect. Unlike Gates, most women employed in the printing industry were subordinates—type compositors, copy editors, press feeders, and bindery workers.[61] The spectacle of a librarian at the press was uncommon in the printing trade, let alone in a library. Several women were trained to work the manual press, mimeograph, and multigraph in the library, and they gave live demonstrations of their work at municipal fairs, where they cranked out informational fliers in the thousands. When the library modeled its work at city fairs, the librarian herself became an exemplary industrious citizen.

The woman printer occupied a complex crossroads. While the profession of librarian had been feminized in the last half of the nineteenth century, the printing and advertising industries remained dominated by a masculine workforce. In 1920, Newark's smaller printing shops had jobbing presses for small runs that were similar to the library's Washington-style model, but women were considered less suited to the work of operating the press than to that of composing metal type, due to its physical demands. By 1910, Newark's four daily English-language newspapers had morning and evening editions and were printed on much larger rotary presses, which in general were manned, while copyediting employed a workforce of women. In Arts and Crafts colonies and schools, the reinvention of an upper class of printing tradesmen and craftsmen was also dominated by men. Bookbinding was acceptably feminine, gendered by its relationship to sewing.[62]

In many ways, the librarian Gates was a representative unconventional New Woman at the turn of the century, a member of a generation that rebelled against social expectations of marriage and domesticity.[63] It was radical for a woman to enjoy presswork or even to seek a career as a librarian. Dislocated by choice from her place of birth, Gates attended college and then sought an independent life, in a city. Her generation found few remunerative electives for women.[64] Marguerite and her sister, Pauline, attended Mount Holyoke

two years after Frances Perkins had graduated, and they were exposed to urban uplift in the curriculum. The school's president, Mary Woolley, was a board member of Florence Kelley's National Consumers' League, and there was a student Consumers' League Club as well as a conduit sending students to work in the hundreds of new urban settlement houses that emulated Addams's Hull-House.[65] Woolley described the aim of the college as "preparation for service, the development of a woman physically, mentally, spiritually."[66] These turn-of-the-century graduates of Mount Holyoke fought to make it morally acceptable to opt out of married life, and Addams's notion of "municipal housekeeping," which included librarianship, was a novel and acceptable avenue for the woman aspiring to become a professional.

Gates and her colleagues altered the topography of labor in the city. The librarian took part in the American phenomenon that historian Ann Douglas calls the "feminization of culture."[67] Leaving Springfield in 1907 for the much larger and more diverse urban frontier of Newark, in all likelihood Gate self-consciously followed the example pioneered by Addams twenty years before. In the 1850s, the first female librarians were hired at the Boston Public Library, and by 1900 the profession was thoroughly feminized.[68] But women in managerial positions were rare.

As an intermediary in this sea change, Dana argued on behalf of women and championed his assistants as worthy to serve on city councils and committees, but he still characterized them as especially good at the profession because of their purported innate skills in social work. His statement that "in almost every community, large or small today, it will be easier to find a woman than a man who is fitted to the director's task and is willing to take it" has been interpreted as an example of enlightened liberation by historian Marjorie Schwarzer, among others, but his assessment was largely built upon an essentialist view that the female gender was predisposed to sympathy and cooperation.[69] Dana's "apprentice" program—the term was taken from ancient guild systems of training—is similarly usually characterized as a step toward the professionalization of women, but it also reinforced the feminization of the cultural institution. As Garrison notes, the realization of these opportunities coincided with the devaluation of options that were open to women. In 1905, only two of Newark's twenty librarians were male. By 1911, the staff had grown to forty-four librarians and yet included only one man, William Morningstern, in the reference department.

In terms of class and status, Newark's librarians occupied a new liminal space, claiming a professional status but a minimal salary, and they are

interesting to locate in relation to the rest of the city's economy. Most were boarders for decades, considered nobler than barmaids but just as marginalized. Most of the women remained single, and several, such as Gates, came from New England. Their college educations were incommensurate with their financial status. The average librarian's salary ranged from a mere fifty dollars a month to a paltry sixty-eight, terms surpassed by women in retail positions.[70] These wages indicate the radical upheaval in class and status during the Progressive era. Women did not receive equal pay or responsibilities in Newark. At Dana's arrival, his annual compensation of four thousand dollars dwarfed his employees' salaries. To place the cultural institution in Newark's commercial context, Bamberger's hired Harry A. Hatry as their women's-wear buyer at a salary of six thousand dollars in 1906.[71] Employee attrition was remarkably low in the library, unlike that in Newark's factories. One exception was Sarah Ball, the head of the business branch, who left in 1917 to direct a library for the United Rubber Company, surely for better compensation and status.[72]

Dana's assistant director, Beatrice Winser, was employed at the Newark Library for a decade before he arrived, and her salary, while it rose, remained a quarter of his for decades. The daughter of a *New York Times* journalist who became an ambassador, Winser was worldly, having grown up in Germany. Her language skills elevated her above her colleagues; she built a French and German catalog file in the 1890s. But in terms of class, her position was still precarious, and the census records show that she and her widowed mother lived as boarders. Beatrice Winser only purchased a home around 1920, when she was over fifty, most likely because of her low salary. The selflessness and bold missionary zeal of these librarians were the fundamental attributes that enabled the cultural institution to grow so quickly and mercurially under Dana's rule. They were crusading reformers and retiring at the same time.

Gates was one of the women groomed by Dana's to become his protégée.[73] He taught her to work the press and encouraged her to grasp its larger managerial applications. In 1917, she signed publications in the journal *The Museum* as librarian "In Charge of Printing" at the Newark Library.[74] In a 1918 letter marked "Publicity Plan," Dana asked Gates to think of herself as the library's in-house advertising agent and to "begin the year on your return, with nothing save publicity on your hands."[75] She accepted the task of shaping the morale inside the library in addition to representing its public face by conducting newspaper interviews. It is important to note that Dana saw his library printer as the staff member most able to understand the power of

publicity and propaganda. It seemed to him that tactile appreciation of the press led directly to a conceptual understanding of the craft. His description of Gates's job shows the extent to which Dana believed that print could influence appearances and behavior; it also suggests the level of responsibility he delegated his female staff.

Dana wrote to ask Gates to accept the position as publicist when he was on his annual summer vacation in Vermont, and dating the letter "midnight" testifies to his urgency. The dispatch is an intimate record of his faith in advertising and his belief that it could engender a community spirit. It is as much of a sermon a speech. The note also illustrates the tone he used in delegating library business to his female employees. He hastily typed a "Publicity Plan" hoping to reassign Gates to public relations work within and without the museum, and urged her to no longer think of printing work "as printing per se, but also watch it as publicity, noting its effects, etc., etc."[76] She was to act as an intermediary and informational force within the museum and also to "have [conversations with] reporter cronies from local papers, of course, and here again you will begrudge the time-consuming talk—but on the other hand even the dull ones can help you and will be glad to talk over with you the whole publicity problem."[77] Considering manipulation an essential duty of publicity and advertising was remarkably modern and prescient.

When Dana "promoted" Gates he also expressed frustration about the public's limited use of the library. He was determined that advertising could build a larger audience:

> I am sure that libraries do not get the use they should—that the communities do not know their value and that they are not as effective agencies of information and suggestion as they can be. But most of them do not at the same time discover that the failure of the Library is due to the fact that it is not well known, thoroughly well known, understood for what it is. I am sure the situation is as I have just stated. And so I plan to try putting you at the one job of gaining for us publicity—local and general.[78]

He proposed the work to her as a cause. And he looked on his audience from a paternalistic perspective that assumed complete understanding of their needs.

Working within the library walls, Gates was to circulate an "even more friendly, personal and confidential" set of notes to improve staff morale. Dana defined her position as both clandestine and imperative. He specified that her

main task was to be caring and subordinate, even though he also implied that she was advancing in authority and power:

> Present yourself to all the staff, not as an official but as an aid, a helper, a friend and a welcome visitor to each one's desk. You must expect nothing, demand nothing, and yet everything. You will always have news, you will always be received with pleasure, you will conceal your powers and be an agreeable purveyor of news and have a sympathetic ear for woes, jokes, trials, joys,—and out of it all select for use in the *news*. This is a big job. I surmise you are tempted to think of the "rights" of the position you many occupy, and this temptation–born of Satan–you must eternally resist![79]

His words seem imbued with the tone of a crusader. Restructuring the job of the librarian, the assignment dressed managerial efficiency in evangelical zeal. The letter suggests that the corporate managerial revolution taking place across America, a process historian Alfred Chandler described in *The Visible Hand*, permeated the cultural institution, too.[80] Dana's language incorporated Taylorist rhetoric, praising efficiency in the business of culture.

In his entreaty to Gates to take up additional duties, Dana characteristically put the technology and the romance of print in creative tension. Marketing was both a scientific activity and an artistic one, and advertising could potentially be enslaving or liberating. Particular typefaces in magazines, posters, and shop windows were thought to influence emotions: the press could engender new social relations.[81] Printed images and texts were revoking the old social order and opening Americans to new ways of conceptualizing their society. Ink on paper, before the cinema, made the creation of the New Woman a concrete visual image for millions of Americans by representing her in posters as a self-propelled bicyclist or a cigarette smoker. It also implanted in readers an image of the business-minded male executive, whose concerns ranged from politics to children's books.

In the library, Gates achieved a level of autonomy and a distinguished rank but, like Beatrice Winser, also deferred to Dana as the "genius." The assistant librarians saw themselves as a "mere worker" within a highly organized industry, a bee whose only success was in relation to the life of the hive.[82] To judge from archival records, Dana's autocracy was very rarely challenged. Winser ran the institution as if it were a monastery, instilling an ascetic code and regulating minutiae such as sleeve length and lunchroom etiquette. Her attention

to the "efficiency" of the library's "public servants" freed Dana from mundane tasks.[83] "It seems hardly necessary for me to instruct people in the use of a toaster but I seem to have to," she sternly wrote in one note.[84] Her memos in the 1930s maintained that there would be "no painted lips and painted nails in this institution," and no sleeveless dresses were permitted.[85] Men were not to roll up their shirtsleeves or remove their jackets. In another memo, she authorized the temporary suspension of a strict dress code during a heat wave. Banana peels left in the wrong trash bin resulted in a staff-wide reprimand. Yet times were changing, as the photograph of Dana and the librarian by the press suggest. Her bobbed hair and sleek tubular dress, in the photograph, were outward signs of women's increased physical and vocational mobility in the twentieth century. In contrast, Dana's suit and moustache reflected masculine codes of behavior developed in the nineteenth century. He was an Edwardian, while she was almost *moderne*.

The development of autonomy in a few select librarians reveals their struggles amid limited opportunities. Although Gates printed and published quite a lot, she authored very little, but this too was a generational difference. The most significant public voice aside from Dana's was that of Louise Connolly, who first came to Newark as a supervisor in the public schools in 1902. With a master's degree as well as a college education, Connolly had more professional training than that of the rest of the staff, including Dana. She wrote to him as a peer. She ascended to the post of superintendent of the public schools of Summit, New Jersey, in 1906 but four years later was forced to resign her post when the head of the board decried the way the educational system was becoming "too feminized" under her leadership.[86] A public fracas that ensued that illuminates the problems that vexed professional women who were active in suffrage agitation.

Although she did not formally join the Newark Museum Association until 1912, at the age of fifty, as early as 1906 Connolly helped Dana prepare a proposal for a Museum of Local Industries that he submitted to the Board of Trade.[87] Employed at an hourly rate between 1912 and 1927 as the institution's Education Specialist, she went on a national tour of museums to assess the state of work, logging thousands of miles and tallying the programs of more than seventy institutions. The Newark Museum published her research, *The Educational Value of Museums*, in 1914. This statistical data was essential to give the semblance of science to Dana's argument in "The Gloom of the Museum" that art institutions systematically failed to provide interpretation or to be educationally relevant. His opinions first appeared as editorials

in the *New York Times* in 1913; when he published "The Gloom" as a booklet in 1917, Connolly's work was reprinted as a fifteen-page bibliographic appendix on "Literature of Museum Management."[88] Her confession that she saw self-abnegation as a part of the librarian's job suggests that most of the public servants consciously suppressed their individuality and embraced a code of selflessness, even as they pursued cultural activism with missionary zeal.

Photographs documenting the annual New Year's party at the public library provide insight into the library's ethos not visible in its typed social rules. A satirical spirit prevailed. In January 1918, a *Sunday Call* caption proclaimed "Library Staff Frolics in Holiday Spirit." Evening "playlets" written by Dana and Winser lampooned the work and their ideal of library economy, and archival photographs record the extent of the antics. Images of Gates frolicking that night are a counterbalance to the sanctimonious image Dana painted of her position as publicist. She both celebrated and parodied her industry as a librarian. Clothed in a white robe in one playlet, she wore a label printed on the library press, perhaps with her own hands, in thirty-point Cheltenham type, that identified her as the personification of Publicity (figure 26). In another, she dressed in torn newspapers and magazine covers, a garment symbolizing the frenzied production of print that yoked modern society together in what Frank Lloyd Wright called the "wide white band streaming endlessly" across the globe. In the *New York Journal*, *World's Work*, and the *Newark Evening News*, where headlines cried out serious news about labor unrest and impending strikes, the world war in motion, and President Woodrow Wilson's diplomatic maneuvers, there is a notice of the library party's gaiety, torn so that only the headline is legible. Set above the headshot of a woman was a caption that stood apart from the other headlines referring to war, strikes, and major international crises: "she shares his affections with another." The scrap of news, a banal human interest story, was distinctly a joke for an in-house crowd. On the stage safely framed, Gates subverted the idealization of publicity even as she praised it. The skit playfully teases, simultaneously encoding both obedient and disobedient gestures into the performance.

In another photograph taken that evening, librarians embodied the virtues of Handicrafts and Efficiency performed alongside Gates, now personifying Perfection (figure 27). The private pageantry by librarians is a window into a time when the ethos of handicraft and printing promised social solidarity and individual autonomy. The drama made the ideals of William Morris and Frederick Winslow Taylor into compatible creeds, partnered ideologies modernizing the cultural institution. Yet another playlet required two women librarians

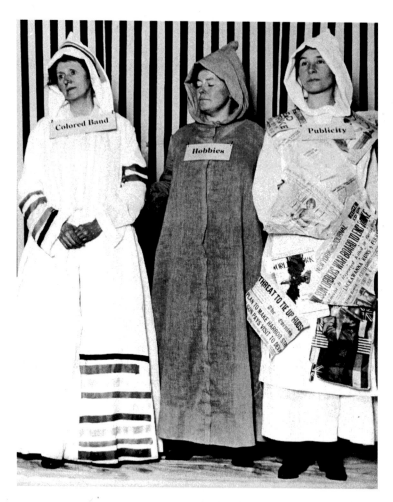

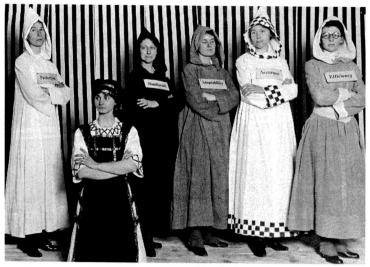

92

to masquerade in academic caps and gowns. One was labeled Mr. Dana and another Mr. Jenkinson, a trustee in attendance. In a photograph, the women scowl sternly to embody manly ideals of Knowledge and Understanding. A prop, the taxidermic owl at their feet, simultaneously signified authority and played into their effort to debunk such Enlightenment precepts. For a few hours one night, the carnivalesque plays inverted the relations of power and sense, and the dogma of the institution in word and image.[89]

As they acted in these skits and worked with Dana, the librarians carried out his methods of management and entrepreneurial applications of printing. By 1910, he offered Newark the library printer for hire at an hourly rate. All income was to go to city hall. In library training manuals, Dana suggested a publicity department as an essential way to establish a favorable relationship with newspapers, so that an institution's exhibitions are "always well written up in the local press." It is unclear to what degree Gates might have written advertising copy for local businesses, but it is likely that she did. Notices in the Newark newspapers trumpeted "Librarian and Staff as Advertisers."[90] The work transported the women far from their usual roles in uplift, pulling them into Newark's male sphere of entrepreneurship.

To further contextualize the implications of Gates's printing, she performed as a civic ideal while being unable to vote. There is bitter irony in the fact that Perfection, and all of the other virtues, were not full-fledged citizens. The female librarian embodied all of the era's contradictions. Winser and Connolly expressed their power by penning prosuffrage articles in the new political magazines of the era, convening meetings, and marching in parades: they even were the directors of the "Baseball Day Committee," an attempt

26. (opposite, top) Librarians' New Year's Playlet, 1918. Detail of a morality play, "Cooperation." Collection of the Charles F. Cummings New Jersey Information Center, Newark Public Library. Librarians Richmond posed as "Colored Band," Foster (Gould) as "Hobbies," and Gates as "Publicity." Such productions were considered virtuous activities, and made part of the librarian's duties by Dana.

27. (opposite, bottom) Librarians' New Year's Playlet, 1918. Detail of a morality play, "Cooperation." Collection of the Charles F. Cummings New Jersey Information Center, Newark Public Library. Shown is an "efficiency group," with librarians Gates as "Perfection," Buchanan as "Handicraft," Manley as "Adaptability," Winberg as "Accuracy," and Morley as "Efficiency." These personifications are turn-of-the-century ideals not specific to library science: they reference the Arts and Crafts movement's admiration for handicraft and the new paradigm of scientific management and efficiency studies epitomized by the work of Frederick W. Taylor.

to win men to the issue with free tickets to a game.[91] Gates was two decades younger than Winser and Connolly and much less prominent, and her sympathies on the issue are not recorded, but her expertise in publicity was the key ingredient to giving suffrage a new, acceptable face in the early twentieth century. Newspaper photographs of marching women dispelled the spinster stereotype. Half-tone reproductions of women posing with ballplayers or on the march down Broadway and Main Street gave their public pleas a human face.[92]

Suffrage was an unresolved and controversial issue in first decades of the twentieth century, and the most persistent horizon against which Gates, Winser, and Connolly viewed their social status. For them, unlike Dana, it had a bearing on professionalization and public personae. In November 1915, the state of New Jersey had rejected a referendum increasing women's rights, and in the winter of 1918 the movement still was battling vigorously. Within days of the 1918 New Year's play, New Jersey's Senator Frelinghuysen publicly pledged to vote for an amendment if it came to federal legislation. Meanwhile, the library continued to serve as a forum for debate and information. Women's clubs met there, and librarians were assigned to work with them on specific projects of municipal housekeeping. The library printer occupied a curious role amid these turbulent changes in society: she was empowered to publish and print, and was given responsibility for public relations and the day-to-day social work, yet she was beholden to Dana's central authority. She was a public servant in no uncertain terms. Gates's identity was emerging, but it was also expected to be sublimated to the mission of civic betterment and sovereignty. Aside from that one discordant, though playful, collage in a private soirée, she performed this role competently and industriously. Placed beside the library press, she conforms to Dana's design; within that structure, she pioneered a new identity. Aware of his eagerness to make the public library appear to be a virile venue, she accommodated his interest to represent the institution as a business intended to serve businessmen.

CIVIC CONSCIOUSNESS

The Newark Library acted in concert with the city and nation on Memorial Day 1911, when Gutzon Borglum's statue of Abraham Lincoln was unveiled outside the Essex County Courthouse (figure 28). The commemoration invented a local patriotic shrine in the city, and came two years after the United States Mint released the Lincoln penny on the centenary of the president's birth, events that exemplify the ways that the scale and methods of

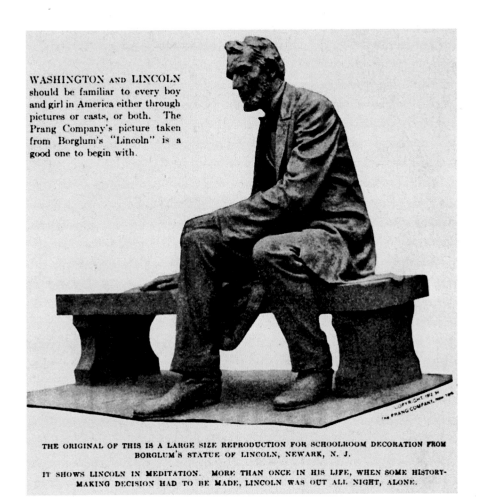

WASHINGTON and LINCOLN
should be familiar to every boy
and girl in America either through
pictures or casts, or both. The
Prang Company's picture taken
from Borglum's "Lincoln" is a
good one to begin with.

THE ORIGINAL OF THIS IS A LARGE SIZE REPRODUCTION FOR SCHOOLROOM DECORATION FROM
BORGLUM'S STATUE OF LINCOLN, NEWARK, N. J.

IT SHOWS LINCOLN IN MEDITATION. MORE THAN ONCE IN HIS LIFE, WHEN SOME HISTORY-
MAKING DECISION HAD TO BE MADE, LINCOLN WAS OUT ALL NIGHT, ALONE.

28. Gutzon Borglum, *Lincoln*, 1916, plaster reproduction by L. Prang Company advertised
in *School-Arts Magazine* 15, no. 6 (February 1916): 450. The library's journal, *The Newarker*,
applauded the affordable plaster and lithographic reproductions made by L. Prang for
schools. Borglum's monument outside the Essex County Courthouse strove to connect
Newark's local history to the tide of national commemorations. Like the Lincoln penny,
the plaster sustained a view of the "Great Emancipator" as a model of humility and
public service.

the business of culture were changing. It was the first United States coin to depict an American Caesar instead of the personification of Liberty, and all told more than twenty-seven million of the pennies were sent into circulation in the decade.[93] The library participated in this reinvention of national culture by celebrating Borglum's bronze as a symbol of civic ideals. Lincoln's journey from his childhood as a pioneer was the epitome of acculturation and self-determination, and had already been sensationalized in the 1890s in Ida Tarbell's profiles published by *McClure's Magazine*.[94]

Newark's public monument was funded by the estate of Amos Van Horn, local Civil War veteran and real estate mogul, and gave the city a way to participate in a national consecration of the president. By interjecting itself as an intermediary in Newark's celebration of Lincoln, the library harnessed a national outpouring of hagiographic praise to local purposes of adulation. In the library's publication to promote the sculpture, Dana urged that "The story of Lincoln can not be too often brought to the attention of our future citizens."[95] Interpreted as a martyr to embody self-sacrifice and selflessness, Lincoln was also was useful to whitewash Newark's Confederate sympathies. It transformed a fleeting glance that the president had cast toward the city into an intimate and momentous pause. Simultaneously, the library used the statue to revise history and chart future civic ideals.

Dana was a member of Newark's Committee on Civic Art and Architecture that oversaw the selection of artist and subject matter. He knew Borglum personally as well as through his writing—polemical manifestos published in Stickley's *Craftsman*. Borglum implored American art to reclaim "spontaneity" but also to serve "utilitarian" educational functions and "a common spirit."[96] The young and pugnacious artist was born in Idaho to Mormon Danish immigrants and had gained a reputation exhibiting in the St. Louis Exposition in 1904. His statue of Lincoln was one of his first public commissions, and would lead to five more in Newark. Borglum struck up a friendship with Dana based on their mutual sense of themselves as idiosyncratic free-thinkers who were rattling the status quo.

By portraying Lincoln seated on a bench, instead of a pedestal or as an equestrian hero, Borgium consciously sought to render his interpretation of republican ideals tangible. The statue became a physical encounter, scaled to life. By all accounts, the sculptor successfully galvanized public interaction, to the degree that the executor of the Van Horn estate, his comrades in Post 11 of the fraternal association of the Grand Army of the Republic, demanded that a railing be installed to prevent hands-on adulation. Lincoln was the second

round-shouldered hero in Newark: his stoop evoked the same modesty as the statue of inventor Seth Boyden that stood outside the library. Theodore Roosevelt's dedication speech drew an audience estimated at forty thousand. His interpretation of Lincoln's ideals was fiercely nationalist, demanding greater "co-operation" and the "suppression" of the anarchist and other anti-American creatures. Lincoln's and Boyden's statues were linked by this suggestion that self-sublimation was the ideal for a Newark citizen. Borglum praised the way Lincoln "was more deeply rooted in the home principles that are keeping us together than any man," another lesson that seems to have been pointed directly at Newark's immigrants.[97] The sculpture was intended to be a didactic force for the living.

The Newark Library's bookplates and posters articulated similar demands, asking for dedication to "useful service." One such call to civil service, "The Good Citizen," was an oath of patriotism that Dana printed first in Denver in the 1890s and then in Newark as both a poster and bookplate. It stated that society was "dependent upon each citizen doing his work in his place" and issued a plea to "do nothing to desecrate the soil of America, or pollute her air or degrade her children" (figure 29). Another was a "Creed for Americans." "The Good Citizen" was turned into a poster and placed in every school in Newark, where "hundreds of children . . . learned it by heart."[98] Oddly enough, Dana admitted to plagiarizing a British oath of citizenship and merely substituting "America." The pledge entered into wide circulation outside of Newark, where educators saw it as nurturing a "miniature democracy" in the school, in which "the young citizen will live a controlled and regulated life, learning to obey those in authority."[99]

In *The Newarker*, librarian Louise Connolly cited Borglum's statue and Roosevelt's speech as evidence of Newark's "acquisition of a civic personality and a civic consciousness."[100] Her argument was that community identity needed to be forged. The librarian especially applauded the Prang Company's decision to manufacture photographic reproductions and make "familiar to every boy and girl in America" Borglum's pious image of Lincoln.[101] The institution's advocacy of Borglum was manifold. A year before, the Newark Museum Association had exhibited his medal designs and his statuettes of John Ruskin, the recently deceased English art critic, and James Smithson, the benefactor of the eponymous Washington, D.C., institution. Almost five thousand visitors came to see Borglum's work in less than one month.[102] The library advertised Newark as a City Beautiful adorned by meaningful monuments. Shrewdly, the cultural institution intertwined the promotion of civic

THE GOOD CITIZEN SAYS

I am a citizen of America and an heir to all her greatness and renown. The health and happiness of my own body depend upon each muscle and nerve and drop of blood doing its work in its place.

So the health and happiness of my country depend upon each citizen doing his work in his place.

I will not fill any post or pursue any business where I can live upon my fellow-citizens without doing them useful service in return; for I plainly see that this must bring suffering and want to some of them. I will do nothing to desecrate the soil of America, or pollute her air or degrade her children, my brothers and sisters.

I will try to make her cities beautiful, and her citizens healthy and happy, so that she may be a desired home for myself now, and for her children in days to come.

The Free Public Library of Newark New Jersey 1913

29. Newark Public Library bookplate, "The Good Citizen Says," circa 1911. Collection of Special Collections Division, Newark Public Library. This oath emphasized Roosevelt's creed that citizenship was a duty and responsibility, not a right. The sayings, made into posters, too, became nationally disseminated and attest to Dana's knack for publicity.

ideals and municipal identity. Aesthetics was in the service of politics, and extended into commercial transactions. The street and the penny were mechanisms of spiritual and ideological transformation.

The Newark Library sanctioned the use of reproductions to reiterate that Lincoln was a model for contemporary reform in an effort to match the new scale of urban populations, commerce, and recreation.[103] The library's commandeering of diverse vehicles—the poster, magazine, newspaper, public plaza, and exhibition—were efforts to moralize civic spaces as a counterweight to commercial culture. The millions of pennies bearing Lincoln's portrait were intended to shore up a common culture and to compete with novelties like the cinema, for instance, where national annual attendance in 1910 exceeded twenty-five million.[104] Whereas Dana and Dewey viewed motion pictures as "primitive" because they encouraged passive spectatorship and "frittered away [hours] upon undisciplined dreaming and sensual fantasies," an artful lowly penny might endow a youth with a work ethic.[105] In 1910, Newark's forty-five cinemas were drawing tens of thousands of middle-class audiences weekly.[106] Dana saw his mission as fixing the modern reinvented image of Lincoln into Newark on the same scale. Thousands of plaster casts of Lincoln and an endless barrage of "Good Citizen" posters and bookplates were sent into schools as antidotes.

Starting the twentieth century as an empty new building, Newark's library expanded beyond the institution's conventional sphere, and strove to be more influential. Dana invented new roles for the librarian as a civic custodian and cultural mechanic. He declared the city's own character and personality to be self-determined and open to reinvention. Quantifying culture, he spoke of library and museum work and his audience in technocratic "scientific" terms as well as spiritual language. Advocating the city's ambitions, *The Newarker* suggested that culture could animate "civic consciousness" and "civic personality."[107] Dana mythologized the "city upon a hill" and covenant of his Puritan forbears in updated terms and modern material culture.[108] The library's periodical, classroom posters, and the new Lincoln statue and penny articulated a patriotic regulatory sentiment and united commerce and machinery. The call for self- and civic invention rang out loudly, with the expectation that Newark would rise above the condition of the industrial suburb through the collaboration of "the poet and the merchant."

Poster advertising the Newark Industrial Exposition (see figure 30).

The Virtues of Industry

"Industry" was a Progressive-era keyword that served specific local political ends. Often it was a term that signaled aspirations, and, like the industrial suburb, it was contingent. Having welcomed reformers of many stripes to use the Newark Public Library and Museum as a forum for civic improvement, the institution abetted the proliferation of distinct and different uses of the term. Women's clubs, for example, contested narrow interpretations of "industry" that did not value domestic work as well as factory manufacturing.[1] Some reformers held onto an old notion of industry as an individual virtue requiring diligence and skill.

An examination of reformers' participation in the municipal industrial expositions of 1912 and 1914 makes it clear that what was "industry" was contested and prone to manipulation. In a sea of manufacturers, women librarians, women's suffragists, and charities argued that their work had value as municipal production. While librarians and suffragettes handed out leaflets to make the case for their contributions to civic improvement, however, the Newark Museum Association was nowhere in evidence at these industrial expositions sponsored by the Board of Trade. Either it shied away or was obstructed from participation; its reputation as a beacon of industrial art therefore deserves some clarification.

For the 1914 municipal industrial exposition, titled "Newark Can, Newark Will," John Cotton Dana judged the poster contest along with a representative from the local Essex Press, a large printing firm, and Walter Moler, the director of publicity at Bamberger's, with the aim of identifying an image to advertise the event that would represent the city succinctly.[2] Dana spoke of poster design as a craft with the potential to increase urban education at the

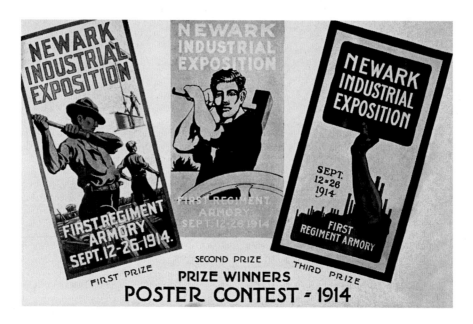

30. Posters advertising the Newark Industrial Exposition, in *Newark Can—Newark Will* (Newark, 1914), 6. Collection of the Charles F. Cummings New Jersey Information Center, Newark Public Library. Students in Newark's Fawcett School of Industrial Arts produced all three of the finalists in the design competition. Louis Caldwell's design was awarded first prize of one hundred dollars in gold; Cornelia E. Cusack's second, fifty dollars; and F. Bruninghaus's third, twenty-five dollars.

rate and on the scale of mass production. He urged harnessing this emergent art form to proselytize civic sovereignty. The three winners of the contest were all students in Newark's Fawcett School of Industrial Arts, where evening classes were available for working teenagers. The weak competition was the result of a small local field, but nevertheless a step toward Dana's plan to patronize living artisans. First prize went to a pastiche depicting a trio of iron-workers hammering, hoisting, and resting (figure 30). A design of a worker with hammer raised overhead, remarkable for its emphasis on youthful strength, was awarded second place. The design that was awarded third prize cropped a fragment of a muscular worker's body. The ambiguous and isolated arm seemed to be ready either to support or defy commerce, like a placard-waving member of the Industrial Workers of the World, a radical union that struck fear in the heart of businessmen. In retrospect, both the designers and the judges seemed to take their cue from the statue outside the library, the hammer-toting Seth Boyden. The image of the most submissive worker was the winning poster: progressive nostalgia superseded everyday fact.

The posters and brochures from Newark's municipal spectacles reveal the limited range of allegories that evoked the City Beautiful and City Practical. American posters in general depicted the industrial worker as a clean-shaven, muscle-bound, Anglo-Saxon ideal. Protective muscular male machinists and chaste, bountiful nymphs prevailed. The occasional Puritan, chivalrous knight, or Native American signified historical progress. These stock images were also used to express minority viewpoints. A feminized equestrian, resembling Joan of Arc, adorned the official program of the Woman Suffrage Parade in Washington, D.C., on 3 March 1913, the day before Woodrow Wilson's inauguration. In 1913, John Sloan marketed the Pageant of the Paterson Strike with the image of a rebellious proletarian, remarkable for its radical politics but perhaps even more for its adherence to the conventional images of workers. Newark's second- and third-place designs, combined, resemble Sloan's strapping young man. Dana and the judges from the department store and the printing firm seem to have concurred, agreeing to represent capitalist competition as a manly ideal. Dana's ambivalence toward Newark, vigorous in specific contexts, was squelched when the image of the industrial city was a virile "pleasing fable of our progress" that veered toward propaganda.[3] The librarian was thus complicit in the gendering of industry even as he and his institution aided associations that were seeking to expand and revolutionize the term.

INDUSTRIAL EDUCATION

The appointment of Addison B. Poland as Newark's superintendent of the Board of Education in 1901 fortuitously occurred the year before Dana's arrival, and they collaborated actively to institute "industrial education."[4] Dana was a member of the school board, and Poland, a library and museum trustee, ex officio. They justified industrial education in terms of municipal glory, vocational training, social advancement, and Americanization, all rationales circulating in the National Society for the Promotion of Industrial Education (NSPIE), which was established that same decade. They described education as a tool "to harmonize relations between the manufacturer and laborer," and both supported establishing compulsory education laws for all "employable children" between the ages of fourteen and sixteen.[5] At the same time, they often articulated a view of the school craft shop in metaphoric terms, not as an end in itself but as a vehicle for teaching civics.

Modern pedagogues admitted that they used handicraft as a metaphorical framework. Founding NSPIE member Charles Richards explained his curriculum at Teachers College as a context in which "handwork represents

emphatically a method rather than a subject matter of instruction."[6] Poland sought to increase "practicality" and relevance to daily life in the curriculum and diminish the prominence of book learning in Newark's public schools, subscribing to the reformers' notion of a modern education as increasingly mechanical and physical.[7] Poland argued that Newark's vocational education was enlightened because it was not specific to the trades but corporeal in a broader sense. Dana agreed that "manual training, while a preparation for a vocation, has little if any relation to a special trade. It is a course in tool using which is planned to produce definite, exact, and self-controlling mental activities through the trained response of body to mind and vice versa."[8] The handicrafts became in part what French philosopher Michel Foucault termed a disciplinary mechanism, institutional conditioning to manage and impose order on physical bodies.[9]

Poland equivocated on the exact purpose of industrial education, claiming it served the city's commercial-industrial complex and delivered egalitarian opportunity. Like Dana, he shrewdly appealed to multiple interests and constituencies. Perhaps the clearest declaration of Poland's policy of compromise came in his 1910 annual report, in which he explained his role as arbitrating between families and manufacturers as well as between capital and labor. He saw these groups as contentious and selfish proponents, and asserted that only he had an altruistic "humanitarian" concern for the students and could enact "practical efficiency" in saving pupils from "the greed of the parent, and . . . the greed of the manufacturer."[10] "Scientific management," he argued, would rescue pupils from the "malignant home" and "temper . . . the industrial enthusiast." He cast himself as a moral crusader and the Board of Education as a regulator. Industry was a virtue the system would implant to curb turpitude and modify ethnic character. Claiming that education was a way to compensate for these failing determinants, Poland aligned himself with what Richard Hofstadter later identified as a Progressive tendency to institutionalize social Darwinism.[11]

In 1910, Newark's children were being sucked into the factories at a high rate. There were 61,000 children of school age in a population of 347,000; 36,000 of these (between the age of six and twenty) were not enrolled in school.[12] Nationally, fewer than 50 percent of American children were completing all six grades of primary school and only 5 percent attended high school.[13] Newark High School, built in 1899 (and renamed Barringer High School in 1907), was the city's only educational venue for fourteen-year-olds until 1911. For twelve-year-olds, employment opportunities in factories

and stores were a more powerful attraction than educational institutions. As elsewhere in the United States, high school had an undefined purpose. The nineteen-teens brought swift changes, however, as the city built four more high schools and child labor laws gained momentum, if not yet teeth.

In 1905, Poland struggled to convince the city of the value of jewelry and woodshop in the curriculum, and reasoned that they had specific benefits "in democratizing, socializing, and, in general, Americanizing our foreign population."[14] The makeup of Newark's immigrant population was often compared to that of Chicago and Cincinnati, while the system's accommodation, most markedly to German Americans, was closer to that of St. Louis and Buffalo, where instruction was offered in German.[15] But this pluralist model of Americanization was one of the civilian casualties of World War I, like the German Hospital of Newark that changed its name to Newark Memorial, and the streets that were also cleansed of ethnic references. "Racial unity" was a goal widely espoused in the years before the war, considered a means to develop more acquiescent immigrant labor. In 1921, in the aftermath of the war, Newark's school system even more aggressively and overtly contended that industrial education was a cure for the "menace to America in a large unassimilated population."[16] The adoption of Francis Bellamy's Pledge of Allegiance is an example of the use of primary schools to indoctrinate patriotism, a conscious campaign to manufacture consensus. Pursuing handicrafts was more oblique and allegorical. Vocational education was considered a key part of Americanization, and was theorized in two connected arguments: it made immigrants into Americans and made the nation competitive in the global economy. Poland described manual activity as a way to build civic wealth, all the while trying to assuage fears that he was instilling a class-based system or demanding assimilation. His protest that he was not enforcing "uniformity" but fomenting "unity" corresponded to Charles Richards's description of industrial art as "social order."[17]

At the NSPIE 1908 conference, representatives of labor, capital, education, and social services stood on the same stage, advocating very different ideals of industrial education. Magnus M. Alexander, CEO of General Electric, argued that the federal government should fund a "rational apprentice system" in factories. Florence M. Marshall, director of the Boston Trade School for Girls, articulated a feminist view, that "All history proves that women have a right to industry." Leon C. Sutton, editor of *Labor World*, seeking to protect workers, warned that education should not be "used as a club to lessen the rate of wages."[18] The aging president of the organization, Carroll D. Wright,

who had pioneered the job of compiling governmental labor statistics for the state of Massachusetts, tried to dispel nostalgia for cottage craft in 1908, as he had earlier. His *Industrial Evolution of the United States* (1887) advocated a linear notion of progress and advised against thinking that "There is something poetic in the idea of the weaver of old England, before the spinning machinery was invented, working at his loom in his cottage, with his family about him." Wright eviscerated this image by contending that the "filthy little shop, occupied by a few foul-talking people" was retrograde.[19] He celebrated the rise of the new and ethical daylight factory in America that applied science to industry. In Newark, each of these perspectives was articulated.

Handicrafts lingered in the regimen of industrial education, especially since Jane Addams served as an NSPIE trustee. John Dewey was a member, too. In *The School and Society* (1899), Dewey characterized the industrial museum as requisite for schools to delineate a moral continuum. His diagrams

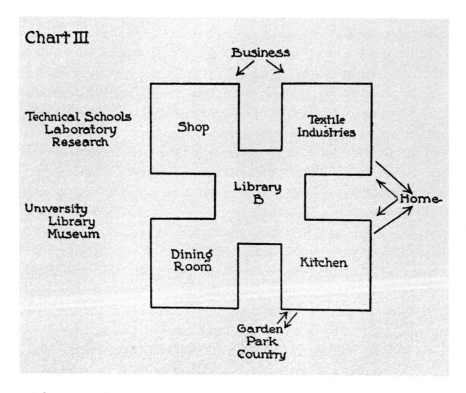

31. John Dewey, Chart III in *The School and Society* (1899), 95. "In the ideal school the art work might be considered to be that of the shops, passed through the alembic of library and museum into action again," wrote Dewey.

situated the library and museum between biological study and factory work, the kitchen and the shop (figure 31).[20] Home, business, and nature were oriented around a centralized and radically reinvented educational-cultural institution. In his Laboratory School in Chicago, work and play were fused. Children dedicated time to handicraft and gardening to acquire the notion of pleasurable work. Addams also salvaged the ancient idea of labor as redemptive of modern leisure, dedicating a space where women (predominantly) gathered to do handiwork, as if uncommodified spinning added more virtue than fatigue. Frank Hazenplug, who studied pottery in Hull-House, designed the original cover illustration for *The School and Society* (see figure 55). It depicts the educational and irenic effect of spinning. Whereas photographs of Addams's settlement house suggest that the aged handicraft demonstrators were taking refuge from factory life, in Hazenplug's depiction of youthful uplift one can discern Addison Poland's characterization of "manual training [laying] emphasis on training the powers of mind."[21]

In addition to its value as a metaphor, skill in handicraft was an integral part of the moral rationale for industrial education in Newark.[22] "Only skilled and experienced artisans" were to teach in the junior high and high school industrial education courses.[23] (Similarly, the Pennsylvania Museum and School of Industrial Art advocated "a good deal of practice in the craft itself, carried on as nearly as possible in the ways that obtain in actual industrial establishments."[24] Poland strenuously asserted that the curriculum taught transferable skills. In 1921, the *Elementary School Journal* praised Newark's system of industrial education for developing the autonomy of students and increasing national competency, and still spoke of it as an "artisan" tradition: "The purpose of the school is to prepare students to unite the skill of the trained artisan with the knowledge and taste of the artist so that utility and beauty may combine in manufactured products. Through schools of this type America may eventually lead the world in the industrial arts."[25] Such rhetoric moralistically paired national aspirations with handicraft, but with none of the nostalgia that became common later in the twentieth century.

Advocates for handicraft and the emerging science of psychology saw them as vehicles to promote social order and benign behavioral patterns. They rationalized shop classes as providing kinesthetic lessons in relation to William James's view of the body as an electrical motor. Jane Addams, for example—among the most politically radical in her generation because of her dalliance with socialism and pacifism, and her willingness to challenge to conventional gender roles—sought to reconcile corporate and individual

human needs.[26] Her 1909 publication *The Spirit of Youth and the City Streets* exemplifies the Progressives' pretension to interweave scientific and romantic notions of manufacturing:

> If a child goes into a sewing factory with a knowledge of the work she is doing in relation to the finished product; if she is informed concerning the material she is manipulating and the processes to which it is subjected; if she understands the design she is elaborating in its historic relation to art and decoration, her daily life is lifted from drudgery to one of self-conscious activity, and her pleasure and intelligence is registered in her product.[27]

Handicrafts were not conceived in opposition to modernity. Dewey criticized educators who saw his curriculum as infecting schools with commerce. Only "the academician within the walls of his own study, dreaming that he is a spiritual leader of the forces of which he is in fact a tamed parasite, may conceive modern business and education as two independent institutions," he wrote in 1906.[28] Industrial education was discussed as a partnership between capital and public institutions.

Industrial education was thought to heal psyches damaged by social fragmentation and dislocation. Learning ornament from ancient civilizations and integrating the lotus and acanthus into a modern block print became a metaphor for acculturation. Progressive educators such as Jane Addams, John Dewey, Charles Richards, and Arthur Wesley Dow discussed G. Stanley Hall's "culture epoch theory" of child development, in which a student "recapitulates the progress of the race," making it a part of the national discourse on education.[29] It was in the context of these ideals that Newark librarian Louise Connolly wrote the "Educational Value of Museums" and argued that handicrafts were vital to the continued development of Western civilization.[30] "Progress" was widely construed as cumulative technological stages. Dana looked upon immigrants as existing in a "pictorial stage" of mental development, and he and Connolly believed that their lessons on carding wool and tanning leather gave Newark's children rungs to climb one by one, so that Newark's modern textile and shoe factories and department stores could be gradually understood even as its goods increased in value. Newark citizens keenly appreciated library exhibitions of the Newark public students' "manual training and sewing," and between 1903 and 1908 audiences were estimated between thirty and forty thousand per exhibit.[31]

The campaign Poland waged for industrial education, which Newark's librarians supported with editorial fusillades, gained real traction in 1909, when the superintendent appointed Hugo B. Froehlich as Newark's director of the Department of Manual Arts. Froehlich instilled a curriculum of handicrafts and folk culture in the primary schools, and Newark's art and manual training teachers later eulogized his zeal in industrial education in the 1927 stained glass window installed in the Newark Museum. His work also connected students in the high schools directly to local factories, so that in his curriculum "industrial art" had an elastic definition. He had taught previously at Pratt Institute, the technical school established in 1887 by oil refinery magnate Charles Pratt to groom workers for the machine age, so his credentials suggested he would serve commerce in Newark too. Under Froehlich's guidance, Newark's industrial education became a multitiered operation for each age group, and integrally connected to civics. Froehlich followed the general national methods by developing shop curriculum along gendered lines, so that Boys' Industrial especially focused on printing and jewelry, and Girls' Industrial on textiles. Froehlich and Poland agreed with Addams and Dewey that industry was an activity that reintegrated the compartmentalized parts of modern life. Extending this sentiment into practice, the industrial curriculum included home economics, fashion, and bodily hygiene. In the primary school, too, Domestic Art had the "purpose of emphasizing various forms of needlework as necessary factors in a girl's education."[32]

Hugo Froehlich and Bonnie Snow, the director of manual art programs in Chicago, published their first *Industrial Art Text Books* in 1906 and warned readers on the title page that they were "not for the purpose of training children to make pictures." As in the curriculum at Teachers College, in Newark handicrafts were symbolic activities, preparatory rituals. "We must not look for originality from pupils who use this book," warned the authors in a condescending tone. They singled out self-expression as an especially inappropriate goal, setting their expectations instead upon teaching conformity through craft.[33] "The average man" was their target audience, for he "needs to know how to furnish his house, how to choose his clothing, how to arrange his business advertisements." The chapter on commercial graphics entreated students to value a dignified type design. The section on costume design encouraged teachers to dissuade students from fleeting fashion and to focus instead on "serviceable or business costume." The book advised teachers to encourage students to bring in clippings from newspaper advertisements and commercial department store circulars, and then to simplify the fashion

plates into "practical" garments. "Ruffles and puffs are not structural, and are to be avoided," was the advice, and the accompanying plate, a cut-paper costume of a Pilgrim father, reinforced the message of sobriety in severe visual terms. The ideological text established normative behavior and molded the taste of young citizens.

Whereas Froehlich and Snow focused on educating students in daily life and good habits, the Newark school curriculum, written with Dana's strong involvement, went one step further by suggesting that individual success was contingent upon active civic engagement. The course of study was begun in 1908. Dana encouraged Frank Urquhart, the editor of the *Sunday Call* and an amateur historian, to collaborate on the project. Although Urquhart was fairly objective in the three-volume study, admitting that industrialization brought with it unprecedented social problems, in May 1911 the Board of Education revised these observations into lesson plans, through which the liberal arts curriculum served propagandistic municipal boosterism.[34] Newark codified socialization in all its curricula; the teaching of industrial arts seems markedly un-Progressive, from a contemporary perspective. In retrospect, the instrumentalism of industrial education seems to foreshadow the more militant social engineering and insularity of the 1930s. "Billboard Nuisance, Pure Food Laws, Playgrounds, Shade Trees, and Hygiene" were sequences of study that supplanted the broad study of national and international history with parochial issues in 1911. Geography focused on local rail lines, canals, rivers, and ports as conduits for trade. "Civics and Civic Hygiene" dominated fourth and fifth grade studies as a theme, with separate briefs addressing the specific sanitation requirements of school and street cleaning.

The Newark curriculum illustrates the degree to which theories of behavioral determinism shaped pedagogy. Dewey had suggested making the school into a home as a way to cultivate informal learning. In Newark, industrial education was a vehicle for restructuring both the home and school into subordinates to city and factory. Sociologists such as Charles Horton Cooley were defining a new notion of constructing identity through "imaginative sociability," and these modes and methods of education aimed directly to engineer affiliations. Newark was manufacturing a civic identity; the *Sunday Call* extolled the wondrous results of library, school, and newspaper working together.[35]

The library printed leaflets like "How Boys and Girls Can Help Our City" and "How to Become a Good Citizen," which explicitly aimed to insure that each "child is interested in keeping a city beautiful, sanitary and pleasant to live in."[36] Like "The Good Citizen" oath printed and circulated by Dana's

librarians, the exact nature of the work involved remained less clear than the emphasis on knowing one's place, and the sense of duty to society (see figure 29). By the time students in the Fawcett School of Industrial Arts designed their poster for the 1914 Newark Industrial Exhibition, they had absorbed such oaths of municipal loyalty. As the children had walked past Seth Boyden on their way to and from the library, the image of the inventor, both his manly hammer and anvil and his humbly hung head, was in their line of sight. Newark's schools articulated a regulatory concept of civics, pointing to industry as a virtue of inestimable proportions.

IMPROVING INDUSTRIAL CONDITIONS: THE CONTEMPORARY OF NEWARK

In 1909, the same year that fifty of the city's wealthiest men chartered the Newark Museum Association, 120 women founded The Contemporary of Newark, a philanthropic charity that addressed social issues aggressively. Their naming of a Committee on Industrial Conditions indicates the degree to which they perceived civic improvement as their mandate.[37] The club-women asserted their right to assume a supervisory role over manufacturing and defined their own work as "municipal housekeeping." This Progressive-era phrase signified the expansion of women's work into the public sphere. Although the value of their contribution was recognized at the time, their power and authority were considered in essentialist terms.

Whereas older associations such as the Female Charitable Society and the Crazy Jane Society grew from tight-knit affiliations of coreligionists and "first families," The Contemporary of Newark decisively abandoned conventions of exclusivity. There were no restrictions on membership, and the group maintained no ties to religious or ethnic identity. Growing to fifteen hundred members in a few years, three times the size of the Museum Association, it constituted a more vibrant and city-wide project. The founders included many wives of the museum's trustees: Mrs. Richard C. Jenkinson, Mrs. Wallace Scudder, Mrs. William Disbrow, Mrs. Chester R. Hoag, and Mrs. H. S. Kinney. Indeed, the two organizations were mirror images, in terms of gender. The names of members embodied respectability and the accumulation of capital in Newark. Take the case of the Allings, a family that ran the city's oldest jewelry firm, whose superior artisanal skill and social standing dated back one century to the chair manufacturer of the 1830s. However, Mrs. Nathan Weinberg, a founding member of The Contemporary, also represented the immense changes taking place in Newark because she was Jewish. The membership reflected

Newark's ethnic diversity, and its roll call of Glasner, Krementz, Lebkuecher, Pflend, and Wiss signaled the ascendance of a new participatory democracy that was dramatically different than the old charitable associations established in nineteenth-century Newark. The Contemporary was a pluralist social association, more visibly active in Progressive politics than the library or museum. Pluralist in their membership, the clubwomen still favored slogans from the Christian Social Gospel movement to adorn their annual yearbook.[38]

Between 1909 and 1916, if a lecture on new sociological views of industry or urban policy occurred in Newark, it was probably the work of The Contemporary. The club's Committee on Industrial Conditions engaged in serious debate on the issue of "sweated industries," for instance.[39] Collaborating with Florence Kelley's National Consumers' League, The Contemporary made sure labels identified which clothing made in Newark was created in morally acceptable conditions: a particularly interesting feat, given that the members lived in a city where many employers—possibly even their own husbands—abhorred unions. Many of its speakers addressed local concerns, such as Newark's 1912 City Plan Commission devised by George Ford and E. P. Goodrich. Henry Turner Bailey lectured on "Art in a Democracy" a few years after giving a talk on jewelry design for the public library. The club was far less provincial than the museum, which exhibited its own trustees' paintings. Between 1911 and 1916, The Contemporary welcomed muckrakers to town and operated Newark's own Chautauqua. Lectures included Jacob Riis on "My Neighbor," Ida Tarbell on "Dress as a National Problem," Charlotte Perkins Gilman on "The Normal Woman and the Coming World" and again on "The Wicked Waste of House-Work," and Frederic C. Howe, then commissioner of immigration in New York City, on "The Alien, a Problem and a Program." These up-to-date political talks informed the city. The women fomented cultural change that went far beyond what their schedule of teas suggests.

Arguing for a radically redefinition of industry in the Newark community was central to the women's club. The other local women's benevolent associations, such as the Crazy Jane Society and Female Charitable Society, acted as philanthropic conduits for cottage work that ran parallel to the sweatshops.[40] These charitable organizations "put out" the labor of sewing —so that Newark women assembled precut garments and returned the finished product to the Crazy Jane Society, for instance. The Crazy Jane Society distributed clean sheets and clothing to its members in exchange for their in-kind payment of handiwork, so that it, like several of the rural craft revival organizations operating in the same era in Appalachia, directly encouraged

and sponsored home industry that repeated the worst of the urban manu-facturing offenses.[41] Dependency and short-term sustenance were deemed acceptable to them, unlike The Contemporary's quest to foster independent women. More traditional notions of the Social Gospel were evident in the Newark Female Charitable Society, which kept meticulous track of church attendance to determine its allotments of aid. Library trustee Franklin Murphy praised the Charitable Society for "reforming" Newark's poor and producing "good citizenship."[42] The Contemporary equated self-reliance in industry with good citizenship.

Only one of Newark's librarians was a member of The Contemporary: Kate Louise Roberts, for whom Dana created the position of chief of club activities. She was unusual among the staff by virtue of having been born in Newark. Unmarried, like many other librarians, she still lived at home. Her British-born father worked in steel manufacturing. Between 1904 and 1917, she assisted with various clubs' meetings and exhibitions in the library.[43] The Annual Reports proudly listed the names of hundreds of different civic associations, from the Board of Trade to the Keramic Arts Society, as well as The Contemporary, that used its meeting rooms. The library estimated these functions brought more than twenty thousand individuals into the build-ing each year. The Contemporary's lectures were among those held in the library, and its interests spilled over into the institution. Roberts organized "courses for clubwomen" and publicized them in the local newspapers. She placed a reference collection on the open shelves for clubwomen to use. These activities increased the library's circulation and elevated Newark's definition of civic welfare. For instance, when Roberts organized a discussion on Israel Zangwill's play *The Melting Pot*, she brought the topical issue of immigration and Americanization to a larger readership.[44]

Roberts was also a regular contributor to the editorial pages of the Newark papers, where she too extolled the value of manual training. She quoted Columbia University's Franklin Giddings, sociologist and econo-mist, when she called for reform in Newark's school curriculum, and reit-erated Dana's assertion that industrial education makes "good men." "For the purpose of making good men let us have manual training. For the pur-pose of making honest men, let us have commercial training," she wrote in 1909.[45] But her crusade avoided Dana's adulation of industrial education as immediately remunerative: "The work of a commercial high school prop-erly done should have as its product, not money, but morality." Six years his junior, she worked rotations in the lending library, picture collection, and

business branch over more than two decades. As club liaison, she extended the library's network and increased its social capital. When Roberts traveled to the Deutsches Museum in Munich in February 1912, only nine years after Oskar von Miller established it, she anticipated Dana's visit later that year. She praised the museum's textile exhibitions and simulated colliery as a "live place and not a cold storage collection."[46] She celebrated both modern manufacturing and the folk costumes as signs that the museum was "part of an educational system." The fact that Roberts traveled to Germany and alerted The Contemporary and general community to these German models of industrial art suggests that Newark had a broad base of intellectuals thinking about what form a progressive museum should take, looking for models in Europe as well as Philadelphia and Chicago. Dana had impressive and able co-conspirators, even if they were not entirely like-minded.

Women's industry was at the crux of the suffrage question. It became a rancorous issue in clubs and municipal improvement associations. A public debate in New York City in 1909 evaluated women's "household industry" in relation to civic welfare and women's rights. Charlotte Perkins Gilman, author of "The Yellow Wallpaper," and Anna Howard Shaw, president of the National American Woman Suffrage Association, argued over whether "domestic industry" should be defined as legitimate work.[47] Gilman wanted women to measure and value their labor in direct proportion to its remuneration, but her view was too extreme for the ears of the Manhattan audience, and unattractive to women who needed to believe that their volunteerism in organizations like The Contemporary was useful and meaningful.

Discussions about "ethical consumption" in the Progressive era originated in women's clubs, and the concept drove the legislation and regulation of industry, especially in relation to child labor laws.[48] In 1915, The Contemporary, describing its mission, quoted Frederic Howe: "when in addition to self-consciousness and family-consciousness, there arises a city-consciousness . . . then and not until then, does the city spring to life."[49] The Contemporary was an essential part of Newark's groundswell in civic idealism. In addition to certifying which Newark factory-made clothing was untainted by sweated labor, clubwomen established milk stations to regulate purity in food. They sponsored library exhibitions about child labor and health care, collaborating with settlement agencies, the National Child Labor Committee, and the National Consumers' League.[50] Its exhibition on tuberculosis prevention at the Newark Public Library in February 1906 attracted ten thousand visitors.[51]

The library and the clubs were mutually dependent and confirmed each other's importance. Kate Roberts wrote the *Club Woman's Handybook of Programs and Club Management* (1914) to build New Jersey's women's "confidence, organizational skills, and sense of power," and to encourage them to use the cultural institution as a platform and outlet for their interests.[52] By turning to The Contemporary, the library and museum gained social diversity, welcoming into their organization second-generation immigrants whose families had gained capital and were interested in "municipal housekeeping." When The Contemporary elected Beatrice Winser, assistant director of the Public Library, its first honorary member in 1915, the same year the suffrage issue was brought to referendum, the club declared itself a champion of women's right to public office. Winser was asked to serve as the first female member of the school board that year, and the suffragists perceived the appointment as a political victory. Her honorific club membership had significance: through her association with the library, that institution was a visible contender in furthering reform politics in Newark.

Dana was made an associate member of The Contemporary, and the bond proved advantageous to his institution. Roberts dedicated her book on club work to him, thanking him for a "liberal library policy." He had much to gain through his alliance with these more radicalized Progressives and through public identification as an adviser to the Women's Political Union (although he also ran the risk of alienating some of his trustees, especially more conservative ones such as Franklin Murphy). In 1915 and 1916, Dana's affiliation became especially useful to the museum when he invited the state's women's clubs to gather historically important artifacts for the exhibitions of New Jersey Industries. Culling goods through the women's associations, he concocted exhibitions on a shoestring budget. Moreover, he configured the museum as a place to spotlight ethical consumption and virtuous materialism, and created an intersection between marketplace activity and moral identity.

Acknowledging that the contentious issue of suffrage and temperance was dividing women's clubs, The Contemporary claimed to maintain "a non-sectarian and non-partisan consideration of public questions" and pledged neutrality, a condition the New Jersey State Federation of Women's Clubs required of all its affiliates.[53] To appear open minded, The Contemporary's 1912 "Discussion on Democracy and Woman" featured Talcott Williams, the first director of the Columbia University Pulitzer School of Journalism and a member of the Man Suffrage Association Opposed to Political Suffrage for Women,

in dialogue with Reverend Leslie Willis Sprague, who lectured frequently on the Chautauqua circuit and at Felix Adler's Society for Ethical Culture. Trustees Richard Jenkinson and Franklin Murphy declared their allegiances in the matter, with Murphy opposed to suffrage and Jenkinson a supporter. Meanwhile, Mrs. Jenkinson was a stalwart of The Contemporary and Mrs. Murphy was not. They found common ground in supporting the Young Women's Christian Association, just as their husbands did in funding the museum.

The Contemporary saw itself as performing municipal housekeeping: it operated in the public sphere, not as a private club. Members used the term "industrial" to try and leverage power in the broader public arena. Newark's library was linked to The Contemporary in multiple ways, from the editorials of Kate Roberts and lectures of Louise Connolly to its patrons in search of a good novel. Both the club and the cultural institution took great pains to advertise that their efforts were making "books of serious character popular." A January 1905 advertisement showed a woman beside a thermometer and pile of books pausing to consider G. Stanley Hall's *Adolescence* (1905), William James's *Talks to Teachers on Psychology* (1899), and Mrs. V. C. Cropton's *A Belle of the Fifties*. The courtier with a bouffant seemed to stroll into the library out of the latter, and to signify that reading one's way to self-improvement was like a spike of metaphorical heat (figure 32).

When Louise Connolly spoke to The Contemporary on "Does the Married Woman Earn Her Living?" she demanded that the definition of women's industry extend to engaged citizenship. Aesthetic uplift fit awkwardly under the rubric of industry, however, and was generally an object of scorn in Newark's newspapers. Unmarried and a member of the aggressively pro-suffrage Women's Political Union, Connolly posed her demand to a constituency entirely unlike herself. Most of the library's staff occupied the self-abnegating role of a public servant, so that the library arguably served more as a forum for discussion than an agent of change. Membership among these groups was not without discord, and the cultural institution occupied a precarious position. As often as Dana and his cultural institution were perceived to be a boon to the city, the women's associations were depicted as expenditures of unproductive industry. Cartoons ridiculed foreigners—"jungle folk"—swarming into the building as a horde of uneducated and frivolous exotic animals searching for entertainment, membership, and "class" (figure 33). The library's outreach and emphasis on accessibility were rendered as absurd attempts at domesticating feral species. The *Newark Evening News*, usually a supporter of Dana, satirized the clubs' social work by turning the

32. "Books of a Serious Character, Popular at Newark's Library," *Sunday Call*, 22 January 1905, NPL Scrapbook, 1903–1905. Collection of the Charles F. Cummings New Jersey Information Center, Newark Public Library. This publicity is aimed at a gendered audience by focusing on books about child development and women's letters, and stands in contrast to depictions of the library as a realm serving the mechanic, businessman, and child. Although it emphasizes idleness as a female trait, the difficult reading list includes William James and G. Stanley Hall. The lady of leisure with bouffant hair represents courtly emulation and serves as a historical precursor to the *moderne* female reader in figure 23.

women's projects of benevolent art education into comic relief.[54] The paper told of a clubwoman conducting a museum tour for "Mamie Reilly" and her son as an "Afternoon Uplift Event." The *News* lambasted the paternalism and pedigree of "Mrs. William Washington Preston Spikes" and her "committee for the welfare of working girls." The librarian, usually drawn as a demure Gibson girl, was absent from these jests.

Despite the retrograde views of the newspaper or of specific library and museum trustees, the clubwomen became significant voices in defining industry in the Newark Museum. As I will show in the next two chapters, they used it to exhibit the contents of their china cabinets, transforming their private possessions into public culture. In the library and museum halls, women's

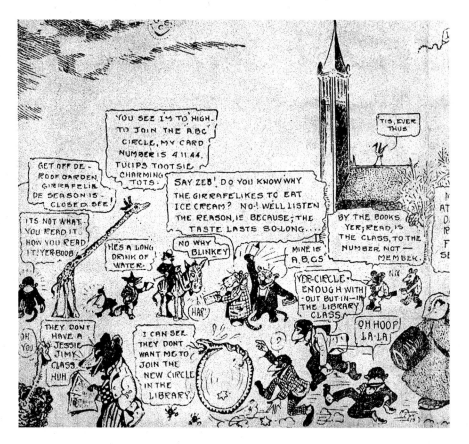

33. Detail of "Jungle Folk May Join Library's 'Kindred Spirit' Circle," *Sunday Call*,
2 March 1913, NPL Scrapbook, 1913–1918. Dorian, illustrator. Collection of the Charles F.
Cummings New Jersey Information Center, Newark Public Library. At the far left
side an ape exclaims "It's not what you read, it's how you read it! Yer boob," while a crane,
the lone speaker with an upper-crust idiom, perches upon a church, looks down upon
"the masses" disapprovingly, and says patronizingly, "Tis ever thus." In this caricature,
the paper ridicules both the library's ideal of uplift and Newark's general public.

consumption of fashionable commodities increasingly became charged with
civic significance. Pots and coverlets gained visibility as metonyms for his-
torical and contemporary production. The women transformed industrial art
into an expanded field of social relations and brokered patriotism in national
and municipal discourses. The Contemporary and the modern women's
clubs valued collaborating with the Newark Museum because it was open to
their expansive definition of industry, and the capital they wielded influenced
its program.

34. Installation photograph of German Applied Arts exhibit, metalwork section, in Newark, 1912. Collection of the Newark Museum. Peter Behrens's kettle is a Modernist icon in surveys of industrial design, but in this exhibition it was categorized by its material and alongside bronze statuary such as Franz Barwig's stag and Reinhold Felderhoff's *Diana*. It is the lone electrical appliance in the case, and its hammered patina was the result of casting in a factory. However, in the museum this condition of production was unclear when it was exhibited with hollowware that bore the marks of craft students' artisanal labor.

GERMAN INDUSTRIAL ART

In 1912, the Newark Museum Association brought to America a touring exhibition that it alternately described as "Modern German applied arts," "industrial arts," and "German Arts and Crafts." The profusion of titles underscores the transitional nature of these historical terms, and epitomizes the struggle to define the art gallery.[55] The trouble with classifying the art was integral to its heterogeneity. The exhibition included Austrian and German wine glasses, textiles, vases, and wallpapers, in addition to etchings, bronzes, and

jewelry (fig. 34). Dana had commissioned the exhibition from the Deutscher Werkbund, a German association of modern artists, craftsmen, designers, and industrialists formed in 1907, whose members theorized their production as *Kunstgewerbe*, a term that the museum's many titles strove to translate. Factions in the Werkbund debated whether to stress the pursuit of applied art or the peddling of it, and asked if production should ideally incline toward the conditions of the artisanal past or mechanized future. Arguing that household goods were indicators of morality, the Werkbund's ambitious mission was "to ennoble craft work by combining arts, industry, and crafts through education [and] propaganda."[56] This objective aligned with Dana's aspiration for the museum to broker Newark's production and civic spirit. Both the Werkbund and Dana envisioned advertisements and exhibitions as educational tools to unify society. Both employed polemic rhetoric, demanding that art and manufacturing reform and conform to the contemporary machine age. But the domestic goods on exhibit were predominantly handcrafted, only the advertisements were mass produced.

Newark's 1912 exhibition of German Applied Arts is often misleadingly referred to as the "first of modern design" in the United States. The characterization is problematic because so many artifacts were handcrafted and because so many earlier exhibitions might also be characterized as contemporary design.[57] Moreover, the show included diverse types and styles of work made by students enrolled in schools of arts and crafts and design, such as brass bowls from Vienna, advertising from Munich and Berlin, and woodworking from Stuttgart. Book bindings and ceramics were selected for exhibition from a school in Weimar that later became the Bauhaus. This production underscores the affinity between the Werkbund and Newark's commitment to vocational education. The industrial ethos was not narrowly defined in relation to the factory's conditions of production. Historical ornament still figured in these artifacts, which recuperated regional forms and patinas.

The 1912 exhibition was remarkable for three other reasons: Newark ambitiously arranged for the applied art to travel to other art museums (instead of its regular collaborators, schools and libraries), offered its patrons goods for sale, and, perhaps most important, targeted a niche immigrant constituency in the city, the German American community. Dana hoped "Germans whose interest and enthusiasm for the fatherland remains keen" would be patrons, and convinced other institutions in cities with similar populations to participate—the City Art Museum of St. Louis, the Art Institute of Chicago, the John Herron Art Institute of Indianapolis, the Cincinnati Museum Association,

and the Carnegie Institute of Pittsburgh.[58] The decision was a pragmatic way of diffusing the high cost of international freight and the production of a catalogue. It also illustrates that Newark was one of several American cities that saw industrial art as suited to forging their community's identity. From the initial planning stages, it was hoped that the exhibition's bilingual publication would capture the attention of the German American populations in these American manufacturing centers. Newark's library already was a platform for German design. A display of three hundred illustrations from the periodicals *Kunst* and *Jugend* "was much admired" by an estimated two thousand visitors in twelve days in 1905.[59] After the International Exposition in St. Louis in 1904, Germany's artistic competence in manufacturing had become widely discussed.

German Americans constituted the most highly educated and affluent of all Newark's immigrant groups.[60] They occupied a prominent role in public life and four distinct "Germantowns." Of Newark's 1911 population of 350,000, there were an estimated 40,000 German-born citizens and tens of thousands more second-generation German Americans: the value of their capital and real estate put together dwarfed that of the other large groups of more recent immigrants, including Italians, Jews, Irish, and Slavs.[61] In 1912, German-language fiction, art periodicals, and sheet music were "the most widely used of all the library's collections."[62] The "educated German mechanic" was the citizen who regularly visited the library, and the *Newark News* characterized the ethnic group as yearning for self-improvement. Dana too discussed the German artisan in relation to old New England ideals of a work ethic.[63]

Despite newspaper campaigns in the 1890s against the "Sabbath defiling Teuton" and his beer gardens, by 1912 the German community was described as exemplary for "tidiness and hygiene."[64] In 1906, the *Sunday Call* noted a dual assimilation process, stating, "If the German has been 'assimilated,' . . . the American has undergone somewhat the same process," and noted that Newark economically benefited from the absence of a vigorous temperance movement.[65] In fulsome praise, the newspaper continued, "For what the German citizen of Newark has done to this city, every Newarker has cause for eternal gratitude. More than to any other people is due the Germans the credit of liberalizing public sentiment in old Puritan Newark. . . . [To Germans] a lasting debt for culture is due."[66] The city's large German-owned breweries were economically and politically important. In 1907, Jacob Haussling, whose family liquor business relied on Newark's being a "wet" town, had

become the second German American mayor. Germans were responsible for many of Newark's cultural institutions, especially in music and theater, and had engineered musical festivals, Saengerfests, that were some of the largest public cultural events in the country.[67] German American philanthropy and community-building initiatives in Newark extended from the first hospitals to the library and museum; among the benefactors were trustees Christian Feigenspan, the brewer, and Louis Bamberger, Felix Fuld, and Moses Plaut, local department store owners.[68]

By 1912, Dana had spent ten years courting this ethnic population by printing library announcements in German, a significant public relations feat. He hired printing shops that used blackletter *fraktur* type, and kept a mailing list of prominent clerics, professionals, and businesses. The Werkbund's bilingual catalogue was a logical next step in appealing directly to the local ethnic audience. The *New Jersey Freie Zeitung* was published in Newark and after its founding in 1858 helped to sustain the ethnic identity of the city's population for nearly one hundred years. Nationally, German Americans produced half of all foreign-language newspapers. They also dominated the local and national printing trade.[69] Newark was home to a subsidiary of Jaenecke, the Hannover-based printing ink manufacturer that made the only product dense enough to please William Morris and give his "vast initials" and tapestry-like ornament bold contrast.[70] Exhibiting the applied art was a shrewd attempt to get the German-American population of Newark to see the cultural institution as their own.

Moreover, in the years before World War I, a generation of American reformers saw German education as a model for America, in universities and vocational education, and especially in industrialization.[71] Germany's sudden fast-paced factory modernization was the envy of other nations, and Dana, like many Americans, believed its success was built upon education and organization. American Progressives such as Addams and Dewey hailed German primary and technical schools. In 1905, the country's educational system was the major topic at the annual conferences of the National Education Association and National Association of Manufacturers. The call was for urgent action: "In the world's race for commercial supremacy we must copy and improve upon the German method of education."[72]

Design schools were seen as the reason Germany was in the "foremost place wherever artistic products are sold."[73] The Werkbund's exhibition was especially appealing because it included examples that provided a window into other methods of industrial education. At the 1906 conference of Eastern Art

Teachers Association and Eastern Manual Training Association, where Dana lectured on "Art in Relation to American Life," several other speakers urged that Germany's vocational training should be America's model. Most notably, James Haney, who taught in New York City public schools, admired the dedication of time to mechanical drawing.[74] In his 1909 articles on industrial education, Dana praised excellence in German vocational schools, and promised that the 1912 show would provide an inspiring lesson. Werkbund goods were visual testimony that "Germany has taken great strides in recent years in education, manufacturing, and commerce."[75] Superintendent of Education Poland also identified Germany as the yardstick when Dana and he argued for year-round vocational high schools.[76] Testifying for each other and collaborating, Dana and Poland lobbied for a handicraft curriculum and an industrial art museum that would be interrelated in ways to improve Newark's trade balance.[77]

At the 1904 Louisiana Purchase Exposition and at a 1908 annual publishing trade fair in Leipzig, Dana noted German excellence in the graphic arts, and he acquired examples of printing, endpaper designs, bookplates, and advertisements to display in the library. When the Newark Library publicized its subscription to periodicals, it drew attention to German ones in particular as excellent "artisans' periodicals" for teaching "good taste."[78] To Dana's eyes, German printing epitomized mercantile genius, civic organization, and superior industrial education.[79] In 1903, he explained the library's purchases of German posters on the grounds that "the most original conceits and some of the boldest and most effective pictorial designs in color are to be found among the products of the German presses."[80]

The origins of the 1912 exhibition lay in the library's subscriptions to German and British art journals, and Dana's visits to printing trade shows. His first letter of inquiry was speculative, and sent to an associate of the Werkbund in February 1911, only one year before the exhibition opened.[81] The letter was forwarded to Karl-Ernst Osthaus (1874–1921), a founding member of the Deutscher Werkbund, who welcomed the opportunity to serve as curator. Osthaus was young, ambitious, and affluent, and choreographed the loan of art from the Deutsches Museum für Kunst im Handel und Gewerbe in Hagen and the Österreichisches Museum für Kunst und Industrie in Vienna. He was building the Hagen museum with his own funds. Also engaged in missionary work on behalf of the Werkbund, he lectured sales staff at department stores on the moral qualities of goods, assessing display techniques for their commercial and aesthetic value.[82] Prizing consumer education, he

targeted salesmen as an important constituency. Werkbund conferences in 1909 and 1910 attracted approximately five thousand salesmen and saleswomen.[83] His museum exhibited commercial products and also acted as an intermediary between designers and industry.

The idea of using the museum to showcase commercial self-representation was being debated on both sides of the Atlantic. This approach was appealing to a small cadre of American museum professionals who were also constructing displays as vehicles to integrate contemporary commercial interests and manage civic consumption as a patriotic ritual: Stewart Culin at the Brooklyn Museum and Morris D'Camp Crawford at the American Museum of Natural History also urged "intimacy" with commerce.[84] To these curators, the slogan of Osthaus's museum, "Ohne Konsumenten keine Produzenten" (without consumers, no producers), articulated a bold and above all a modern mission for the contemporary cultural institution.[85] Dana requested that a Werkbund representative be present on the exhibition tour: salesmanship was an integral component of "good industry." The exhibition's range of artifacts was indicative of the Werkbund's ambition to influence the commonplace bourgeois commodity and foster a conceptual rapport between the house and the factory.

The Deutscher Werkbund championed the same type of reform of civic behavior and habits that Dana aspired to manage in Newark. The Werkbund claimed to teach a German "how to dress, how to furnish his room and his house, even how to walk down the street"—a scope that equaled the *Newarker*'s promise that the library could teach "every human interest, from Greek philosophy to paving; from state-craft to dress."[86] In August 1912, after the Newark exhibition had ended, Dana visited Munich. There, he applauded the orderliness of municipal cleaning, street signs, and transportation, and reported back to the Newark *Sunday Call*: "Munich proves all that the most zealous city planner ever claimed, that man can make his cities what he will."[87] When Frederic Howe applauded German city planning in 1910, he too had considered its sidewalks, benches, and department stores a perfect integration of civic idealism and entrepreneurial growth.[88] Dana followed Howe's itinerary through marvels of modern urban planning that informed "good business" and "good statesmanship." He surely appreciated Howe's deterministic view that "A people take on the color of their city as a chameleon takes on the color of its habitat."[89] The city was regarded as a laboratory where society's future would unfold.

The Newark Museum continued older paternalistic notions of teaching "good taste" but also suggested that commodity production and consumption were a means of molding social solidarity artificially.[90] The Werkbund's claim to "cooperation" made it an attractive alternative to the antagonistic ethnic and class divisions in the American economy. Dana was turning a blind eye to Germany's labor unrest, of course. However, the leading theorists of sociology in America informed his faith that cultural commodities and education could give consumers an identity and solve their social problems. In *The Conflict between Individualism and Collectivism in a Democracy* (1910), Charles W. Eliot, former president of Harvard, argued that capitalist abundance would decrease the threat of class warfare.[91] Eliot's "five-foot shelf" of classics within the reach of the middle-class consumer was one such sign of progress. Simon Patten, whose work Dana recommended in *The Newarker*, believed that American technology would "acclimate [immigrants'] primitive appetites and passions."[92] The quickening pace of American consumption would help immigrant "peasants" get over their "culture lag" and enable "a progressive society [to] integrate its parts."[93] Herbert Croly's *The Promise of American Life* (1909) and *Progressive Democracy* (1914), which Dana championed, also articulated this belief that progress in civilization was dependent upon corporate capitalism and acculturation. The decision to offer the artifacts in the Deutscher Werkbund exhibition for sale to the public was driven by a fusion of republican idealism and consumerist logic. Tastemaking, it was hoped, could mold social unity by manufacturing new emotional affiliations.

Advertising art was a focal point in Modern German Applied Arts because publicity was the portal of modern consumption. Dana asked the Werkbund to print their own catalogue for the 1912 exhibition to model the art of publicity. Osthaus personally supervised the printing of the catalogue, in part because he declared that advertising, especially via new lithographed posters, was "reforming the whole of our lives."[94] The catalogue, printed in Peter Behrens's "metallic type," celebrated the design as giving "expression to the age of steam and electricity" (figure 35). Germans interpreted Behrens's typography, corporate logos, and design as a "vigorous" new "impersonal" style, and Americans enthusiastically agreed.[95] On view in Newark were several examples of his advertising campaign for the Allgemeine Elektricitäts-Gesellschaft (AEG) that integrated iconography and typography on poster, company brochure, kettle, turbine factory, and storefront. Behrens's systematic application of a graphic design to integrate the company's process and products is considered a pioneering achievement of Modernism today. On the

GERMAN
APPLIED
ARTS

35. *German Applied Arts* catalogue, 1912, designed by Peter Behrens, printed in Munich by Fr. Wilh. Ruhfus, Dortmund, under the direction of Fritz Meyer-Schönbrunn, curator. The interior of the catalogue also used a Behrens typeface, Behrens-Antiqua. Collection of the Newark Public Library. The rhythmic horizontal bands, almost the "speedlines" of the next decade, are bright red-orange. Meyer-Schönbrunn was a curator at Karl-Ernst Osthaus's museum who wrote on Behrens's work critically as well as enlisting him to design this catalogue.

catalogue cover that he designed for Newark, Behrens used a swollen Roman typeface nearly identical to the one he had devised for AEG a few years earlier. For Newark, the serifs resembled soft ink bleeds more than chiseled stone.

The *Sachplakat* (object poster), exemplified by Lucian Bernhard's advertisements for Stiller shoes and Steinway pianos, also won admiration in Newark. This type of poster reduced the commodity into a thunderous visual synecdoche, with the only verbal persuasion being with the brand name, a vast amount of information conveyed in one fell swoop (figure 36).[96] However, *völkisch* allusions were not irreconcilable with this work. Julius Klinger's caricature for the *Lustige Blätter* (funny pages) of a man in a sleeping cap, "Mike with Pipe," depicting an antiquated meerschaum pipe, and the faux-hammered textures on Behrens's kettles exuded a similar cozy domesticity (figure 37). Modern cartoon illustration carried forward rustic and folk narratives. The Deutscher Werkbund hailed this "virile" advertising art that had superseded the nineteenth-century's "namby pamby" chromolithographs.[97] And *The Newarker* agreed, librarian Louise Connolly enthusing over "the one feature that must meet with unqualified approval, which unmistakably attains its end, ... the poster."[98] "The American poster is easily surpassed by these German examples," advised the *Pittsburgh Dispatch*.[99] The *Newark News* commended their civic value in particular, noting that "there is genuine

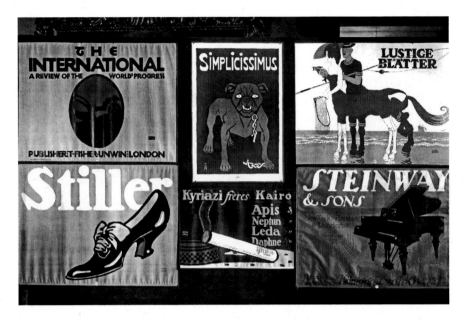

36. Installation photograph of German Applied Arts exhibit, Advertising Art section, in Newark, 1912. W. F. Cone, photographer. Collection of the Newark Museum. The posters included recent work such as Lucian Bernhard's designs for Stiller shoes and Steinway pianos as well as Thomas Heine's 1897 anti-authoritarian image of a red bulldog, a poster that announced the founding of the magazine *Simplicissimus* as a noted critical voice. Note the framed paintings behind the temporary wall on which the posters hung, suggestive of the ephemeral nature of the trade show then and now.

moral as well as artistic importance in showing . . . Americans . . . that advertising need not degenerate into a public nuisance."[100] A congratulatory note to Dana from Henry Lewis Bullen, the director of the American Type Founders Company's library in Jersey City, appreciated the German "reform" of commercial printing, and the modern quality of the typefaces suited for the industrial future.[101] Hybrid typefaces that balanced the strength of Roman letters with the informality of the Gothic were hailed on both sides of the Atlantic as suitably modern.

However, while the commercial posters and graphics were considered extremely "modern," "moral," and "virile," American reviews found the household furnishings were overwrought or oddly embellished with a peculiar level of attention to small, almost incidental craftsmanship. The *Newark News* praised the textile embroidery as an oddity because it was purposely imbued with rustic associations, "needlework handbags like those made by one's ancestors in country homes of long ago."[102] The ceramic artifacts in

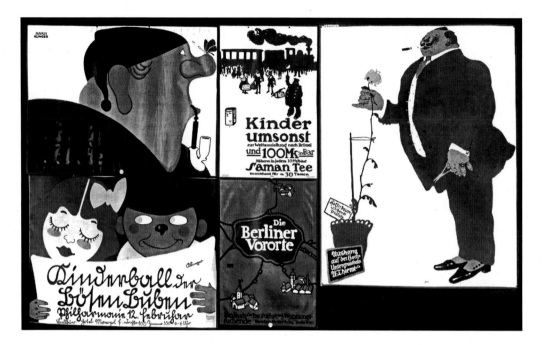

37. Installation photograph of German Applied Arts exhibit, Advertising Art section, in Newark, 1912. W. F. Cone, photographer. Collection of the Newark Museum. Posters such as Julius Klinger's work for the *Lustige Blätter* (funny pages), depicted levity and aimed to please a juvenile audience as well as teach manufacturers the advertising arts.

particular were interpreted as embodying an ethnic aesthetic, a "strong folk note" that demonstrated "the common bond of the race."[103] The *New York Sun* found the wrappers and chocolate boxes "as handsome as such things were in the old days of Japan."[104] *The Newarker* approved of these interpretations and confessed that "nothing like these things exists in America, excepting in rural byways and immigrant tenements as remnants from former days or distant countries."[105] Newark's museum purchased a dozen pieces of stoneware, such as tankards and punch sets that evoked Germany's "old traditions."[106] But the majority of the porcelain ceramics in the show were made by Meissen, the state-run manufactory where Europeans first mastered porcelain production. The Newark Museum acquired only three porcelain figurines but purchased several stoneware drinking vessels. Cincinnati's museum also bought primarily ceramic tankards, evidence that handicraft and ethnic identity were discerned, and valued, by the organizers.

Few scholars have asked why American museums bought these tankards that selectively fused *völkisch* and "virile" associations. The beer steins with

medieval pewter lids, priced at five to ten dollars, were mid-market commodities engineered to trigger sentiment.[107] Based on wheel-thrown forms, the Werkbund stoneware pieces were made in molds, a practice that permitted faster, standardized production. However, the designers and companies were deliberately recovering and reviving historical traditions. The orange-peel-like surfaces of the stoneware were the result of salt firing, and their alternately rich brown or gray-blue glazes had been associated for centuries with distinct regions. Young designers such as Richard Riemerschmid and Paul Wynand achieved a rich amalgam of nostalgia and modernity in their tankards. Their pieces were ethnic by function, sentimental to the touch, and modern in their expanses of flat form and color. Wynand's stoneware derived from historical precedents but was implausibly crude when made as a molded form. In details like the thumbed foot, the designer transformed into stylized ornament what had been a rough slap-dash mode of workmanship intended to stabilize a pot—an act of homage bordering on satirical pastiche (plate 6). While the vessels were sleek and refined, to most Americans' eyes the stoneware body and pewter hardware embodied a romance of archaic crafts.[108]

The punchbowl and tankards that Wynand designed for the Reinhold Merkelbach company prompted the catalogue to commend the folk traditions of sharing drink as a "virile" habit.[109] Spoken in Newark, these words implicitly sanctioned the local breweries of Ballantine, Krueger, and Feigenspan. Dana's interest in German steins exhibited a curious disregard for the debates over drinking alcohol. Temperance was hardening into Prohibition. The Werkbund included celebrations of distinctly modern beverages, too. In polar opposition to Wynand's tankard was the packaging for Kaffee Hag, the novelty beverage soon to be known as Sanka. Its bold iconic red hearts symbolized healthiness. Werkbund posters represented Kaffee Hag's therapeutic properties by depicting athletic tennis players decorously holding teacups and saucers. The exhibition sustained an interest in what William Graham Sumner had described as "folkways" in his eponymous 1906 book, through certain objects, but also celebrated modernization.

Dana, aware of Sumner's view that "the forms of industry" were unconscious "habits" and "strains," characterized the work of the Deutscher Werkbund as industrial arts in which "the remains of sound peasant art still live[d]."[110] His opinion illuminates his interest in handicraft as a way to enrich modern manufacturing and enliven the modern home. As a champion of design reform, he held onto his youthful attachments to the Arts and Crafts

movement as much as he grew to sanction larger factory production.[111] The Reinhold Merkelbach firm's stoneware, the AEG electric kettle and typefaces designed by Behrens—each, in its specific way, epitomized Jane Addams's description of experiencing transcendence through the "historic relation to art and decoration."[112] The pebbly ceramic tankard or the kettle's rattan handle artistically recreated historic associations in the technological, electrified present. Although the show's catalogue promised that the modern German applied art adhered to the Arts and Crafts tenet of "truth to materials," they did not, especially in their use of ornament. However, the spiritual ends were more important than the means, the Newark Museum suggested, as if to second Jane Addams's view that "A man who makes, year after year, but one small wheel in a modern watch factory, may, if his education has properly prepared him, have a fuller life than did the old watchmaker who made a watch from beginning to end."[113] The German exhibition did mark a departure from the idealism espoused by Ruskin, who saw alienation in divided labor. The drudgery of factory production, the show suggested, could be redemptive if it furthered civic patriotism.

Dana and Osthaus celebrated the machine as an ideal, but they also savored handicraft, and the latter was emphasized in the exhibition. But German Americans, whom the show targeted, seem not to have embraced the *gemütlich* production. The handicraft, and perhaps also ethnic sales pitch, made the 1912 exhibition an oddity. *Kunstgewerbe* was too catholic and tainted by commercialism for American enthusiasts of fine art. The director of the Metropolitan Museum of Art told Dana, "the Trustees have decided not to enter the field of what might be called Trade exhibitions."[114] This was not entirely an unfair appraisal; the Philadelphia Commercial Museum declined the exhibition on the grounds that it was too favorable to German trade interests.[115] By emphasizing the relationship between applied art and commerce, the Newark Museum crossed a boundary: only institutions in industrialized cities with large ethnic populations joined the experiment as a worthwhile undertaking. The sales that were hoped to energize the institution were not realized, and the attendance was equally disappointing: only 7,694 people came to see the German Applied Arts exhibit in Newark.

In May 1912, while Dana was away in Munich composing odes to its maps and street signage, the two-woman staff of the Newark Museum Association packed the exhibition and shipped the catalogues to the next venue, the St. Louis City Art Museum. They comprehended the fraught nature of the enterprise and defended Dana's selection in his absence. Librarian Marjary Gilson

wrote trustee Richard Jenkinson and thanked him profusely for defending the exhibition to the museum's executive council and for approving Dana's request to purchase a few hundred dollars worth of goods, including Wynand's stoneware tankard and punch bowl.[116] The stoneware tankard cost one dollar and fifty cents, and that same year trustees spent over one thousand dollars on a single oil painting. Gilson's gentle letter reveals the backstage work conducted by the librarians, and their commitment to the concept of "industrial art." Following Dana's wishes, Newark museum trustees bought the German tankards, *völkisch* emblems of indulgence instead of symbols of modern temperance or the new technological home. The women museum workers did not record any overt aversion to these artifacts tied to alcoholic drink when they defended the Werkbund goods. They accepted the electric kettle, coffee packaging, and beer tankard as a symbolic constellation that corresponded to Newark's own cooperative municipality.

CIVIC INDUSTRY

One month after the Werkbund show closed, two hundred thousand people visited Newark's municipal exposition and witnessed quite different interpretations of industry and industrial art. The cavernous city armory hosted a series of industrial exhibitions between 1912 and 1916 that, like Bamberger's, made the work of the Museum Association seem tiny in comparison. A visitor to world's fairs in Chicago in 1893, Buffalo in 1901, and St. Louis in 1904, Dana was accustomed to massive fairs, and his library's relegation to the margins and its inconstant participation in Newark's industrial fairs suggest that either he or his trustees vacillated over the institution's identity. The large municipal expositions call into question what he hoped his museum or library would communicate and to what end he sought to interpret "industry." Dana aspired to hybridize entrepreneurial success and social uplift, but in what proportions and in relation to which constituency?

In the municipal expositions held between 1912 and 1914, the business branch represented the Newark Free Public Library and was located among the printing trades. In contrast, the stalls of the local branch of the Consumers' League and the Women's Political Union were in the Social Services section (figure 38). A photograph of the Women's Political Union's stall, probably from the 1914 exposition when organizers dedicated an official "Suffrage Day," presented a bombardment of verbal arguments on posters, some demanding equity, others railing against taxation without representation. Some posters ridiculed Roosevelt and Wilson, and others were maps emphasizing the

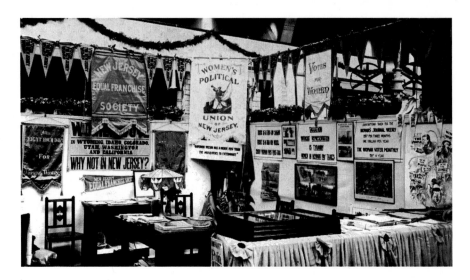

38. Suffrage booth at Industrial Exposition, Newark, labeled 1913. Photograph collection of the New Jersey Historical Society, Newark, New Jersey. The booth is filled with textual challenges to the status quo and also reproductions of some of the vicious cartoons the debate generated. In one, Theodore Roosevelt rants and a crowd of men marches, both calling themselves "the people," while lions carry banners to indicate "we're the animals." The suffrage activists used the antipodal nodes of barbarism and civilization in their graphic and verbal arguments.

progressive western states that already had accepted suffrage. Dozens of pennants labeled "Votes for New Jersey Women" were piled high for distribution behind a central table, on which sat a Tiffany lamp. At the time of the 1914 fair, prosuffrage forces were optimistic that the tides of the city's conscience were changing in their favor. But these agents of public welfare inhabited a primarily commercial environment. In 1914, "Suffrage Day," September 22, was sandwiched between "Railroad Men's Day" and "Grocer's Day." In 1912, John Dewey campaigned in Newark on behalf of suffrage just weeks before the exposition, and Harriot Stanton Blatch, daughter of Elizabeth Cady Stanton, did so shortly after it closed.[117] While the librarians handed out Made in Newark lists, the Women's Political Union distributed five thousand paper bags printed with the legend "votes for women."[118] Both contested reductive definitions of "industry" by perceiving it affectively in relation to their identity, but perhaps most forcefully through the production and distribution of printed matter.

Neither a charity nor a business, the Newark Museum Association was absent at both the 1912 and 1914 exhibitions. However, notions of art-industry

and *Kunstgewerbe* were in ample evidence in the municipal expositions, such as in printing booths and the atelier of Auguste L. Griffoul, whose bronze casts were deemed "splendidly" artistic.[119] The organizers of the municipal exhibition celebrated the arrival of the foundryman and his brothers from Auguste Rodin's studio as the birth of a new type of art-industry in Newark. His mantelpiece figurines, reproductions of designs by contemporary American sculptors such as James Earl Fraser, resembled the bronze stag by Franz Barwig or Reinhold Felderhoff's "Diana," which sat alongside Peter Behrens's electric kettle in the Deutscher Werkbund exhibition. The value of artistic trade was a current topic of concern across the city. For example, when Bamberger's opened its "great white" skyscraper in 1913, the department store's structure and interior were celebrated for their beauty.

Bamberger's series of annual Made in Newark exhibitions, staged annually from 1913 to 1915, surpassed all of the city's other expositions in their attendance. The *Sunday Call* declared "From the standpoint of manufacturing exhibits actually in motion the Bamberger show easily takes precedence over any industrial show ever held in Newark."[120] The store embodied civic sovereignty more than any other institution and articulated a coherent ideal of civic industry. Different manufacturers were ensconced across eight floors of goods. Centrally located on Market Street, in downtown Newark, the store exhibition was less overtly didactic than the municipal show, and was staged more theatrically than the armory permitted.

The library and museum emulated the department store's spectacle of local municipal industry and patriotism more than it influenced it. However, Bamberger's Made in Newark exhibition can be viewed as a material realization of the library's research. The store in essence made manifest the library's typed index cards of information. What had been civic information became a persuasive ritual of material pleasure. The real spectacle of the city, each day's attendance at Bamberger's Made in Newark exhibition exceeded the museum's entire annual number of visitors. Similarly, Newark's 1872 industrial exposition, which had attracted 130,000 visitors in fifty-two days, still dwarfed the Newark Museum's annual attendance between 1910 and 1920. The cultural institution and department store were defining industry along similar lines, but the department store outstripped the cultural institution in its popular influence and inventive experimentalism.

Bamberger's Made in Newark exhibition purported to be a "lesson" helping consumers because "every article made in this city was being shown in the process from raw material to finished product."[121] The rhetoric nimbly drew on

ideals of meaningful labor from the Arts and Crafts terminology and also on Dewey's conceit to foment social integration through manual arts activities. The store was suggesting that consumers would be morally superior if they understood the process of modern industrial production. Dana concurred, seeing civic awareness of production as an end in itself. These two different institutions, the library and the department store, fused civic republicanism with consumerist idealism, but the store left fewer visitors confused.

Bamberger's program of social welfare extended deep into the city. Employees attended classes after and before work and participated in morning rooftop calisthenics. Evening lessons in English, etiquette, and lettering climaxed in "salesmanship conferences," much along the lines of Osthaus's work with the Werkbund.[122] Social advancement was promised as a practical merit-based outcome of hard work. The department store's organization of mass activities and commercialized leisure penetrated the everyday spaces and pace of Newark. Bamberger's was not the fanciest store in town, but it had the largest network of distribution and public services. Its opticians gave free tests, and its experts taught rules in décor, advised on gift purchases, and sold paintings. Always visible, the storefront was brightly lit, and the store's ads smartly occupied the full back page of the *Newark Evening News*, which commuters routinely held up on trams and trains. The largesse of Bamberger's owners, Louis Bamberger and Felix Fuld, extended to the construction of Beth Israel Hospital, the beautification of Newark's parks, and the purchase of a page of the Gutenberg Bible for the library. Caroline Fuld, Louis's sister and Felix's wife, established a settlement house in 1904. The civic department store was a reality. Economic, political, and cultural capital in the turn-of-the-century city merged in Bamberger's. In 1913, President Woodrow Wilson himself switched on the lights for the grand opening of the "great white store" from the White House.

In the 1913 Made in Newark show, more than fifty local manufacturers were installed in Bamberger's to demonstrate modern workmanship in plain view. Johnson, Cowdin and Company's loom spun ribbon, Van Moppes and Sons cut diamonds, and five operators and four different machines from Weingarten Brothers stitched corsets, while Mossbacher and Company featured the fastest-known knitting machines to make athletic uniforms. Searls Manufacturing Company had a "full-fledged machine shop," W. H. Rich and Sons manufactured umbrellas, and the Crescent Cut Glass Company displayed "glass-cut-while-you-wait." J. Rummell and Company exhibited the stages of making their felt hats from rabbit fur. "Artists" were on display in

the picture department, such as E. J. Schwab "hand painting" watercolors, and Rudolph Ruzicka printing wood engravings. In the basement, Strait & Richards, a local firm, press-molded ceramic fire logs. Visitors learned how the Clark Thread Company processed raw materials into finished goods. As part of the emphasis on visible local production, Bamberger's installed a rotary press on the sixth floor, near the bookstore, and each day of the 1913 exhibition produced a new edition of the *Exposition Daily Recorder*, thereby echoing the library's demonstrations of industry.

The complimentary daily was an advertisement dressed up as a house organ, and is indicative of the store's success at eliding the difference between lessons in civics and consumerism, education and propaganda. Bamberger's advertisements protested a little too much when they declared "The big show is NOT a commercial enterprise in any sense of the word. It is a fair—an exposition—a civic function."[123] Like Dana's demonstrations of printing in the municipal fair or the library, Bamberger's considered the display to be a mechanical proof of civic idealism. Whitehead and Hoag, one of the country's largest and most innovative manufacturers of novelties, ran a booth on the first floor assembling and distributing their patented pin-back celluloid buttons.[124] They bore the words "Made in Newark," and, when pinned to the spectators' lapels and hats, the yellow-and-black emblem suggested that the store made citizens as well as commodities (figure 39).[125] The production of complimentary fliers and buttons blurred the distinctions between public welfare and corporate interest and realized Dana's vision that "a city which makes things must see to it that it also makes good men."[126] The department store issued the loudest cry for municipal patriotism in Newark.

A plate that Bamberger's commissioned to commemorate its 1913 refashioning into a civic monument suggests the degree to which the stores asked Newark citizens to identify it with their city's progress. The gauzy blue transferware, a middle-class affordable luxury, "made expressly for L. Bamberger & Co." in Staffordshire, England, depicted important Newark construction projects of the past twenty years such as the courthouse, city hall, library, post office, Barringer high school, the Prudential tower, and, of course, its own new skyscraper (figure 40).[127] The artifact, evidence of extreme urban pride and the commercialization of public space, continued a nineteenth-century tradition of commemorating contemporary modernization and framing industry as picturesque progress.

The plate built affiliation with the industrial city by commemorating recent commerce: the City Practical and City Beautiful were one. If the plate

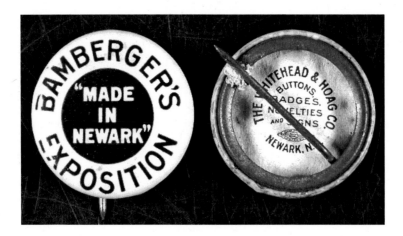

39. L. Bamberger and Company "Made in Newark" button, 1913,
manufactured by Whitehead and Hoag in the department store. Collection
of the author. These are some of the boldest buttons designed in the era,
legible at a distance. The Newark firm patented the sprung-wire pin decades
earlier, first produced these novelties for Lincoln's presidential campaign,
and thereafter for thousands of regional associations and lesser events across
the nation. The Newark firm played a decisive role in shaping the button
into a political and social device.

obscured the distinction between Bamberger's commercial mission and the
library's, it persuasively argued that all Newark's units glorified local indus-
try. Like other goods aimed at middle-market local consumers, it was pro-
duced in the thousands, a new scale in mass marketing. Distributed at the
Made in Newark shows, the plates suggested that consumerism was part of
civic industry and promised that buying was as transcendent as making. The
literary style of the self-promotion suggests an awareness that culture, not
simply retailing, was happening in Bamberger's. The cultural institution's
vocational lessons and internationalism might have been less potent than the
department store's, but its method of organizing an exhibition according to
material and locality was similar. The live demonstration illustrated spectac-
ularly what William James and John Dewey had termed the "cash value" of
an idea. Later Dana would write of the "cash-value of art in industry."[128] The
aspiration that Bamberger's and the library shared was not simply to catalog
Newark's production but to champion it and suggest emotional identifica-
tion. The civic ritual channeled participation in a value system. Bamberger's
commodities and demonstrations made industry tangibly patriotic. The ethi-
cally charged civic platter, like a suffrage, temperance, or union pin, expressed

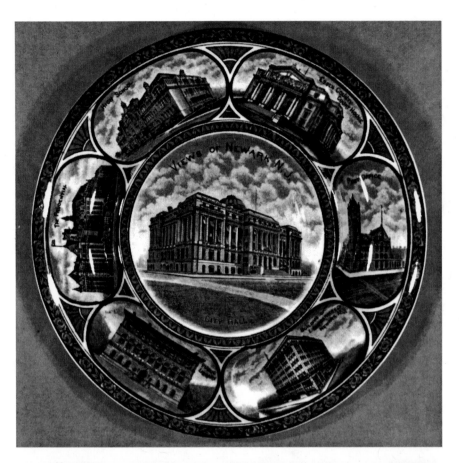

40. L. Bamberger and Company souvenir plate of Newark, 1913, manufactured for
Rowland & Marsellus Company in Staffordshire, United Kingdom. Collection of the
author. The novelty item was not used for dining but as an emblem to adorn the mantle
or wall, and made civic pride manifest in a small but potent way.

a Progressive political sentiment. Paradoxically, one bought these goods both to individualize one's house and to conform to a social fad.

The city's educators publicly admired Bamberger's dynamic and dramatic installations of selling goods, too. Superintendent Poland visited the store's exposition and praised it as "educational." The store connected ideals of technological and commercial cultural progress, consumer education, and entrepreneurial aspiration. When Dana visited the Made in Newark show he restated the need for "our young people" to learn about "the principal manufacturing interests of the city," and his recommendation was printed in the store's *Exposition Daily Recorder*.[129] In 1913, he praised commerce as more "honest" and democratic than traditional educational institutions, claiming "salesmen have done more than colleges to develop the peasantry of Europe into enterprising American citizens."[130] Publicly he placed faith in "the salesman as a missionary" and in capitalism as a positive system as vigorously as he wrote tirades against the conventions of the fine-art museum.

Industry had become a spectacle in which republican civics and commercial boosterism were inextricably linked. It functioned as an expansive metaphor that multiple constituencies used as they fashioned images of the modern school, the contemporary woman, the civic department store, and the good citizen. The Newark Public Library and Museum was borne aloft on a wave of new associations, pedagogies, and public identities that, when looked at carefully, reveal the variety of Progressivisms at work. The cultural institution was no more significant than The Contemporary, no more esthetic than the public vocational schools, and no more educationally dynamic than Bamberger's. Each of these forces contributed to the city and articulated distinct visions of order in relation to industrial conditions and commercial production. In 1912, Dana exercised independence in selecting the Werkbund for the museum. The show confused his public and trustees, but perhaps informed his method of organizing exhibitions in years to come. In 1915 and 1916, the Newark Museum attained its greatest moment when it became a participatory forum for women's clubs, entrepreneurs, immigrants, and educators. It was in these years that the tiny institution consolidated national notoriety as the primary agent that defined industry and industrial art in Newark, a reputation that it retains to this day, which perhaps unjustly overshadows the city and its genius.

PLATES

1. Hugo B. Froehlich Memorial Art Education Window, 1927, Newark Museum. Manufactured by J. and R. Lamb Studios, designed by Katharine Lamb Tait, New York, N.Y. Glass, lead; 64 × 35 in. Gift of the Manual Training Teachers of Newark, 1927. Collection of the Newark Museum (27.1451). Originally located in the stairwell of the 1926 building, the window was restored recently and now is currently installed in the 1989 extension. Not a portrait of Froehlich, it is a symbolic representation celebrating the common aims in vocational education upheld by the public school system and the museum. Roundels idealized students actively engaged in sewing, shop work, ceramics, textiles, modeling, painting, drawing, and manual training. The initial watercolor sketch emphasized personifications of the fine arts and kindergarten play, but in the completed work these were supplanted by sewing and shop work to make the subject matter correlate closer to Froehlich's subjects in technical school education. Ceramics and textiles were also not included in the original design and are included in name only in the window, barely legible below the figure's hands holding a wreath and lamp. Beginning in the late nineteenth century, the Manhattan-based firm of J. and R. Lamb outfitted thousands of private chapels, mausoleums, and churches with decorative furnishings and made windows for schools and businesses such as the Prudential and the United Cigar Stores Company. It is interesting to speculate if the firm considered its expansion out of sacred applications appropriate or not. The window was covered with plywood for several decades in the middle of the twentieth century when the museum and city grew less fervently bound to the ideal of manual training. Today, the window's message of praise for technical education is difficult to read in a purely secular light because the medium itself appears distinctly evangelical in tenor.

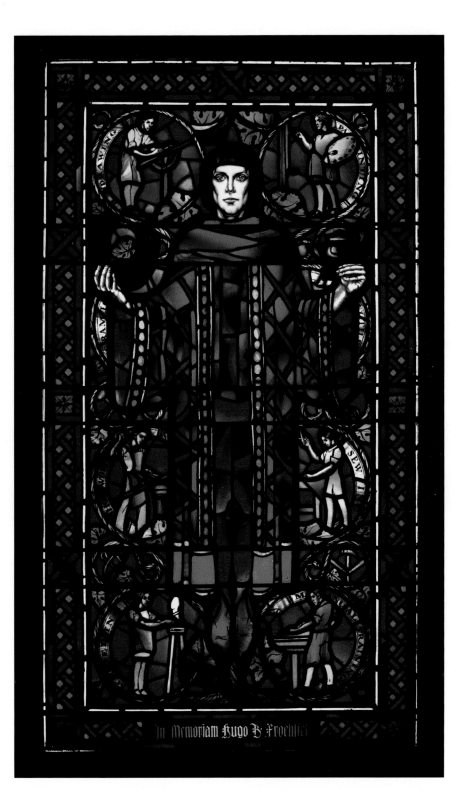

In Memoriam Hugo K. Froehlich

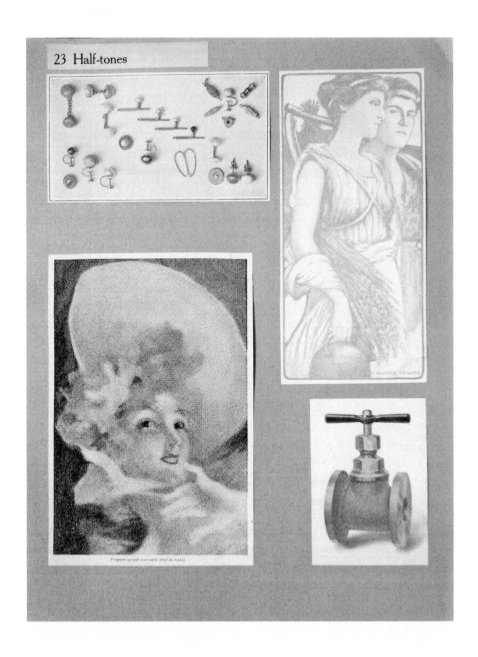

2. "#23 Half-Tones" in Newark Public Library's The Printed Book exhibition, 1909. Collection of the New York Public Library. The exhibition dramatically embodied Dana's notion that cheaper printing costs would bring about the democratization of art, and the terms were shocking to many connoisseurs who held onto notions that commercialism inherently degraded art.

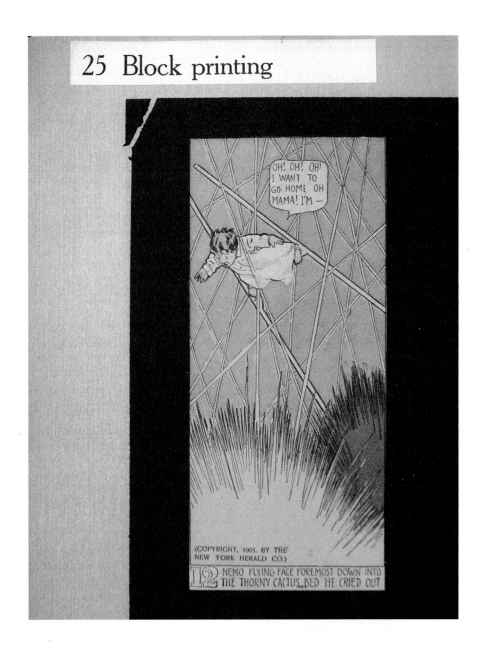

3. "Little Nemo," detail of "#25 Block Printing" in Newark Public Library's The Printed Book exhibition, 1909, originally published in the *New York Herald* and created by Winsor McCay. Collection of the New York Public Library. "Little Nemo" is an example of Newark's ecumenical vision of printing, and Dana's ability to juxtapose two-penny and two-hundred-dollar examples. It is also indicative of his pleasure in testing the boundaries of respectability.

4. John Cotton Dana, cover design of the first issue of *The Newarker* 1, no. 1 (November 1911). Collection of the author. In its name and scope, the public library's house organ ambitiously tried to represent the interests of the entire city. The magazine's weakness was also its strength: aggrandizing Newark. Note that Dana was too proud of his handiwork not to sign the map, and so eager to assert Newark's importance that he relegated Manhattan to the margin.

5. John Cotton Dana, design for print plate ("Ex incises japonicis J. C. Dana"), undated. Color blockprint, 5 × 3 in. Collection of Special Collections Division, Newark Public Library. Like his contemporary Frank Lloyd Wright, Dana used his connoisseurship of *ukiyo-e* to impress the world, and his gifts bearing this label, which translates "from the Japanese prints of J. C. Dana," were intended to make a memorable impression. Exhibitions of Japanese prints from Dana's own collection were educational but also smack of exhibitionism. He inscribed this one with a warning that the image was not a self-portrait.

6. Stein, 1910–1912. Manufactured by Reinhold Merkelbach, Grenzhausen, Germany, designed by Paul Wynand. Stoneware; pewter; 6 × 3½ × 5½ in. Purchase by 1913 Jenkinson Fund. Collection of the Newark Museum (13.205). The Newark Museum acquired this and other beer drinking vessels from its 1912 exhibition of German Applied Arts, sponsored by the Deutscher Werkbund. The revival of the German stoneware industry as an artistic heritage was a new phenomenon in the early twentieth century. The traditional form of the stein complicates reductive characterizations of the Werkbund as a "pioneer of Modernism."

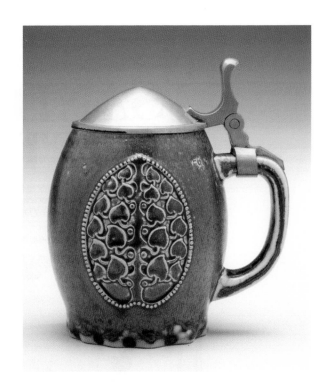

7. Toby jug cream pitcher, 1904–1910. Designed and manufactured by Clara Louise Poillon, Poillon Pottery, Woodbridge, New Jersey. Glazed earthenware; 4¼ × 4½ in. Purchase 1974 by the Members' Fund. Collection of the Newark Museum (74.76). Clara Poillon, a granddaughter of the owner of the Salamander Works in Woodbridge, New Jersey, made this vessel in the shop she inherited. Poillon exhibited in the Newark Museum Association's 1915 exhibition of Clay Industries and her recuperation of Anglo forms has received little attention in part because of their obvious historical references. The tendency to sentimental ornament in this American Toby mirrors that in the German tankard and illuminates the romantic dimensions and the complex social messages of artistic expressions categorized as Colonial Revival.

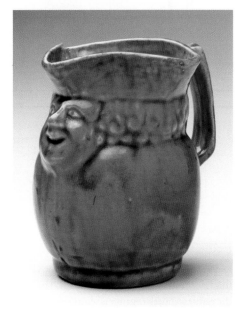

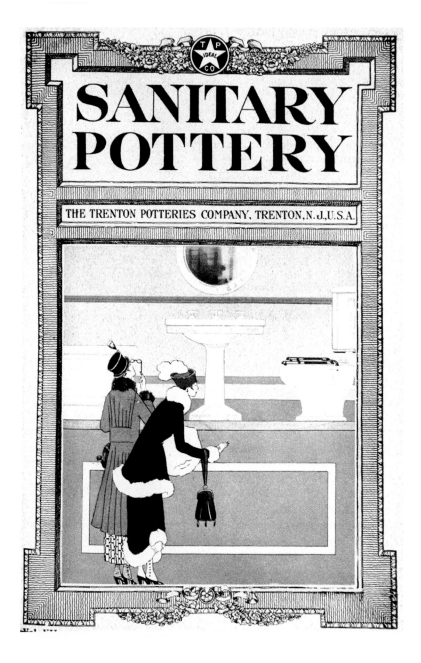

8. Cover illustration, *Sanitary Pottery* 7, no. 3 (July 1915). Collection of the Science, Industry, and Business Library, the New York Public Library. The Trenton Potteries Company produced this house organ, now a rare periodical. The aura around the display of porcelain toilets in the early twentieth century is worthy of reconsideration, as this illustration suggests. Were they alluring and sleek commodities? Was the bathroom really put on a pedestal, as this drawing suggests? Also enigmatic was the manufacturer's use of women and fashionable clothing— an overt attempt to connect the commodities to social status.

9. Announcement, New Jersey Textile Industries exhibition, October 1915. Collection of the Newark Museum. The museum sent this one-page folded flier to manufacturers and women's clubs to petition them to loan artifacts to the exhibition. The artistic print boldly advertised the show five months before it opened.

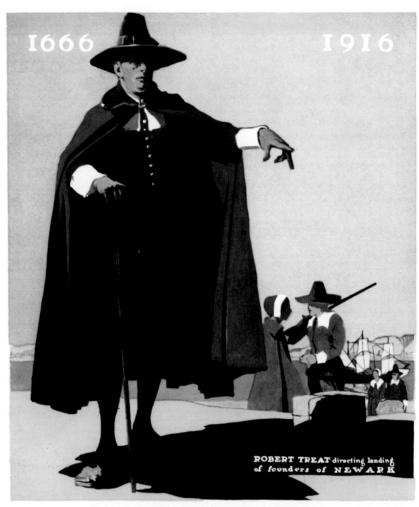

10. Pageant of Newark poster, 1916, manufactured by the Committee of One Hundred, design by Adolph Treidler, 1915. Collection of the Charles F. Cummings New Jersey Information Center, Newark Public Library. Civic patronage of posters was new: until that time the medium was primarily used for commercial applications. In this image, Newark's Puritan founder, Robert Treat, disembarked on the banks of the Passaic River in 1666.

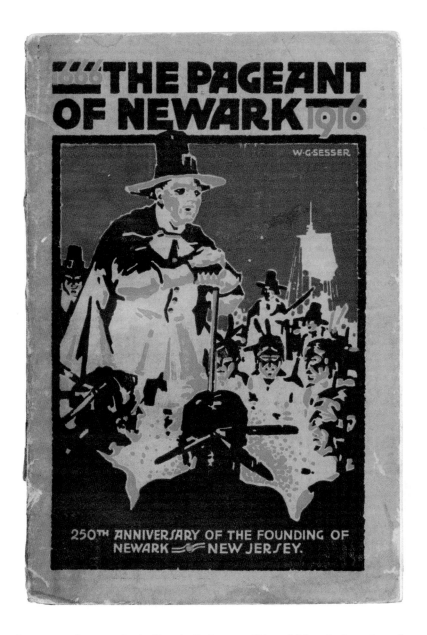

11. Thomas Wood Stevens, *Book of Words: The Pageant of Newark* (Newark: Committee of One Hundred, 1916). Cover design by Willy G. Sesser. Collection of the author. This publication was organized outside of the library but employed Willy George Sesser (1886–1927), a young designer who worked in Arthur Wiener's International Art Service (IAS); the absence of the IAS monogram, demarcating Wiener's firm, suggests that the design was an independent commission. Sesser's habit of reducing details, using saturated colors and a limited secondary palette, and integrating expressive hand lettering and imagery into a unified design related to the latest trends in graphic art in Europe. His use of orange corresponded to the pageant organizers' decision to unify the city with the same color in bunting.

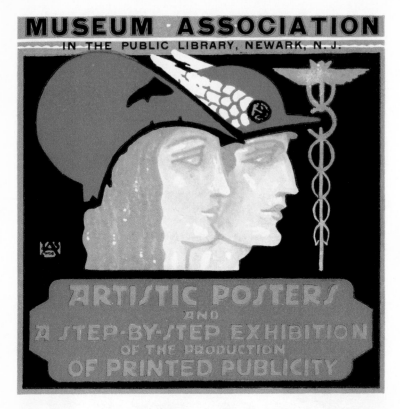

AN EXHIBITION

PAPER MAKING, LITHOGRAPHY AND COLOR
PLATE WORK, PRINTING INKS, POSTER DESIGN

For this Exhibition we are indebted to the following firms:

Trichromatic Engraving Co., Craske-Felt Co., Inc.
Philip Ruxton, Inc., Henry Lindenmeyr & Sons
Latham Litho & Printing Co., Ault & Wiborg Co.
all of New York City: Norman T. A. Munder & Co., Baltimore,
and especially to the International Art Service, New York

NEWARK MUSEUM ASSOCIATION
⌘ ⌘ ⌘ ⌘ APRIL 23 TO MAY 21, 1916 ⌘ ⌘ ⌘ ⌘

12. "Artistic Posters and a Step-by-Step Exhibition of the Production of Printed Publicity," broadside, 23 April–21 May 1916, Newark Museum Association, designed by International Art Service, New York City. Collection of the Newark Museum. The initials WGS inside the IAS monogram indicate Willy Sesser's hand. Dana's use of the museum as a showcase for "advertising art" was rooted in his efforts to encourage his peers to be interested in the value of high-quality publicity. Like the exhibition itself, the design was intended to suggest the power in combining artistic, educational, and commercial criteria. The design strikes a balance between classical imagery and modern modes of figurative representation, and foreshadows the conventionalized classical syntax and geometric ornament that came to be widespread in the 1920s. Dana's progressive antiquarianism spanned the Colonial Revival and neoclassical: all styles and technologies were apt if they taught dynamic entrepreneurship and fulfilled civic needs.

New Jersey Clay Products

Public Library, Feb. 1 to March 14, 1915
Open: 9 to 6:30, 7:30 to 9:30; Sundays, 2 to 6; 7:30 to 9

NEWARK MUSEUM

EXHIBITION CLAY PRODUCTS of New Jersey
February 1st
March 14th
1915

Any clubs, schools or any body of persons who are in
terested to visit this exhibition, will be conducted, on
weekdays between 9 a.m. and 9 p.m., by a competent
person who will explain all phases of the exhibit, if due
notice is sent to to the Museum.

The exhibition includes clay and clay-working, clay in-
education, historic pottery, terra cotta, tile, decorative
pottery, fire proofing, brick, sanitary ware, table ware,
electrical ware, refractories, hardware and pipes and
conduits. Catalog sent on request or can be obtained
at the Exhibition. J.C. Dana, Director.

The Newark Museum Association

41. "New Jersey Clay Products" poster, 1915, for Newark Museum Association's Clay
Industries of New Jersey exhibition, designed by International Art Service. Collection of
the Newark Museum. Here the full range of ceramic production is visible, from sewage
pipe and terra cotta ionic capitals to the table ware that the *putto* carries aloft on a board,
the traditional manner of conveying greenware in the factory. The cherub is not indolent
but industrious, and was a curious visual amalgam at a time when child labor was not
yet regulated and a topic of rancorous ethical debates.

Molding and Modeling Civic Consumption

CLAY INDUSTRIES OF NEW JERSEY, 1915

> Standing at the table is a clean old German kneading clay, his squat,
> bowed legs far apart, his body leaning forward, his long and powerful
> arms beating upon the clay like piston rods. Looking at him, I wonder.
> My heart aches. My flower-pots at home made by such as he gain a new
> significance. They are no longer mere receptacles for holding earth and
> guarding the roots of my plants. The rough, red surface of them is writ-
> ten all over with the records of human patience, human cooperation
> with nature, human hopes and fears.
>
> — Marion F. Washburne, "A Labor Museum," *The Craftsman* (1904)

In February and March 1915, the Newark Museum Association exhibited
recently made vases and tiles—the latest vogues in "art pottery"—alongside
bricks, terracotta, toilets, and old pitchers and teapots, and interpreted the
display as a triumphant saga. As in *The Craftsman*, the pots represented the
vitality of American manufacturing and were symbols of social transforma-
tion. The exhibition was designed to appeal to the connoisseur, maker, and
consumer, and suggested, as the German Applied Arts show of 1912 had done,
that home, store, and factory were parts of one system. Acting as a brokerage
firm or clearing house, the museum borrowed artifacts from manufacturers
and women's clubs, calling on citizens of different levels of wealth and status
and bringing them into rapport in its galleries. It declared its show to be "A
Commercial, Industrial, and Art Exhibition," reflecting the many perspec-
tives of its multiple participants.[1] Beyond sanctioning the useful as inherently
beautiful, the museum made commonplace furnishings into ciphers for good
citizenship. The exhibition included in its scope the process of modernizing
the home and the virtues of "art-in-industry," and framed these as civic aims.
Promises of spiritualization, entrepreneurial liberation, Americanization,
and sanitization coalesced in the display of such ceramics as sewage pipe and
patriotic pottery.

THE ROMANCE OF CLAY

Just as Hull-House's Labor Museum and *The Craftsman* located transcendence in a flowerpot, the Newark Museum saw pottery as a profound human process. Dana declared ceramics a story "of absorbing interest and even romance."[2] The breadth of his museum's examples was a deliberate strategy for upsetting hierarchies within the arts, breaking down precise definitions of art and industry, and, more overtly, an attempt to make the museum more accessible to the "working man" and "businessman" as well as the clubwoman and student who already exhibited there regularly.[3] Consumption became the coequal of manufacturing when the museum deemed both to be constructively patriotic and ethically nourishing. This followed Dewey's vision of an industrial museum as an interstitial dynamo that connected the home, factory, and school. The museum's published narrative, the "Story of Clay," described the recent development of American white ware, sanitary ware, art pottery, and terracotta production as an interwoven and interrelated "romance." It reconciled artifacts of distinct status and function under the banner of industry. Stories of heroic individuals and firms connected the one hundred and nine pieces of historical pottery on third floor of the library and the hundreds of examples of contemporary production on the fourth.

The museum described the self-reliant artisan in terms of moral regeneration and the acquisition of indigenously made commodities as a therapeutic deed, similar to *The Craftsman*'s ode to the modern potter.[4] Toilets demarcated scientific progress in hygiene and economic advancement in standards of living; historical pitchers depicted patriotic self-sacrifice; and contemporary art pottery implied the advent of new outlets for women's enterprise. The anxiety-filled early days of World War I prompted Americans to reconsider the relationship between production and nationhood, to discuss citizenship in relation to personal belongings and trade balances. In "The Gloom of the Museum" (1913), Dana had already boldly asked American museums to forgo their devotion to Eurocentric and antique art, and now he demonstrated ways to "buy American." His challenge was patriotic: to "set side by side in a case ancient and rare and modern and commercial pottery, and say 'Here are what some call the fine products of the potter's art when it was at its best in Italy long ago and here are products of the potters of America today.'"[5] To further local patronage, he commissioned a new Manhattan design agency known for its smart European taste, Arthur Wiener's International Art Service, to design the exhibition's poster. The museum thus attempted to cultivate "art-in-industry" itself in local professional production; it had encouraged

industrial education in 1914 when it had invited Wiener to be a judge for the municipal exposition poster contest. His firm of German and Austrian émigrés, the ranks of which included Paul Frankl in 1912–1914, brought bold *Jugendstil* ideas to both American chewing gum wrappers and large corporate identities.[6] The 1915 ceramics exhibition poster featured a *putto* working in a pottery, teetering en route to the kiln as he balanced a shelf of unfired vessels on his head (figure 41). The cherub was not like the muscular antique figure that Peter Behrens had proposed for the Werkbund's 1914 Cologne trade show but in a more languid vein of classicism, similar to Michael Powolny's ceramic figurines exhibited by the Newark Museum in 1912. Walter Moler, Bamberger's publicity director, wrote to Dana to praise it as one of the best posters the city had made. Dana was attuned to such innovation and was out to nurture it, largely because he had a small group of like-minded entrepreneurs who also savored risk, but also because he saw the modern immigrant in relation to Newark's historic role as an economic engine driven by German American artisans. Even the war did not diminish Dana's interest in German applied art.

The year 1915 was also a moment of domestic crisis when New Jersey held a referendum over women's suffrage. In pageants and balls held in Newark by the Women's Political Union of New Jersey, ceramics were a significant prop to demonstrate women's autonomy in the present. Holding "Colonial teas," the waitresses wore starched white linen caps to suggestively recuperate useful pasts. They also wore brilliant green, white, and violet dresses, the colors a rebus for "give women votes," and held out china as an emblem of their power to instill decorum and refine America (figure 42). Their attire was a symbolic constellation connecting multiple conventions that implied etiquette was a civilizing force. The tea service became a modern tool to signify municipal housekeeping, and was a bit of propaganda as modern as the map behind the women showing which states had already granted women the right to vote. The women visually demonstrated that suffrage was an antidote to barbarism and that tea drinking was a performance that engendered solidarity. The historicist aspects of their costumes alluded to revolutionary times when the ritual symbolized collective American values. In quite a different image staged in the same room on Halsey Street, Newark's ethnically diverse maidens dressed as sylphs in fantastical garments that evoked rustic and nocturnal fantasies (figure 43). Their reflective capes were modest versions of those used by Loïe Fuller in her internationally acclaimed Serpentine dance. Several films in circulation had made the swirling and physically liberated Fuller the

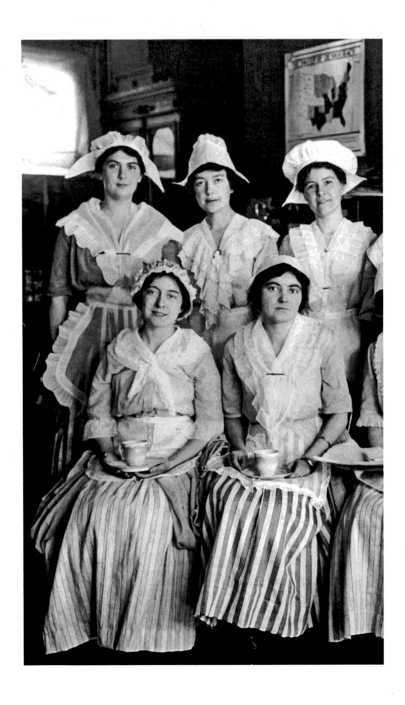

42. "Waitresses in Suffrage Ball, 19 February 1916, held in headquarters of the Women's Political Union of New Jersey, 79 Halsey Street." Photograph collection of the New Jersey Historical Society, Newark, New Jersey. This detail of twelve waitresses assembled for playful work (or industrious leisure) shows the women employing a variety of linen hats and eliding ethnic and historical distinctions in a display of unity.

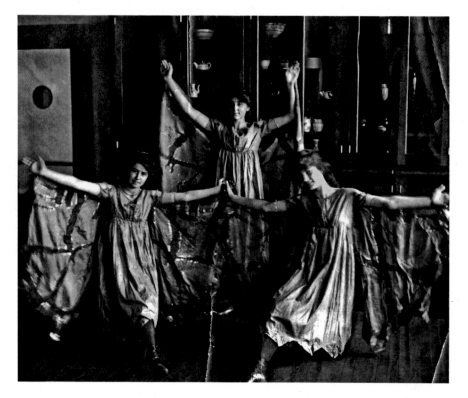

43. "Pageant of Sylphs at headquarters of the Women's Political Union of New Jersey" (in the same room in 79 Halsey Street), undated. Photograph collection of the New Jersey Historical Society, Newark, New Jersey. The role of a cupboard as a significant investment and conspicuous display in the women's suffrage movement is not usually emphasized. This ten-foot-long and tall cabinet is full of ornamental and useful ceramics, vases and teapots, and documents the role of these artifacts as symbols to rally solidarity.

embodiment of the New Woman. The art pottery installed at the Women's Political Union's headquarters and the use of teacups as important props for the Suffrage Ball suggest that ceramics could symbolize women's power. The suffragists' allegories were aesthetically heterogeneous but parallel expressions of self-determination and identity formation. The theatrical displays of pottery and bodies corresponded to the museum's interest in animating the abstract idea of collective industry. The plasticity of clay permitted it to embody diverse symbols and to be accessible. The decoration of the political headquarters also connected to the ideal of constructing a new just and moral aesthetic in the City Beautiful. The Newark Museum Association tapped these diverse sentiments, and invited women's associations to be collaborative partners.

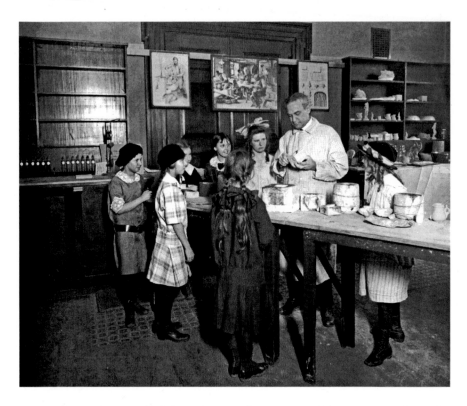

44. Installation photograph of Clay Industries of New Jersey exhibition, 1915, with Enoch Bourne demonstrating techniques. Thein, photographer. Collection of the Newark Museum. The demonstrations occurred as daily events, and were earmarked for children.

If static and mute ceramic artifacts could demarcate technological and societal change in quiet ways, the museum's docent tours and craft demonstrations staged more vivid examples of industrious heroics. "Be it known to you that the first person who tried pottery was woman!" the museum's tour guide exclaimed to schoolchildren, a message that gave pottery a chthonic gendered power.[7] In its time, this admonition penned by the museum's educational consultant, Louise Connolly, was a stridently feminist point of view, and aligned with her outgoing espousal of women's suffrage. The culture workers who spoke these words were emboldened by a significant ethnological text, *Woman's Share in Primitive Culture* (1894), the author of which, Otis T. Mason, argued that woman was "the organizer of industrialism."[8] Women's clubs in Newark and across America read Mason's evaluation of women's industry, surely brimming with intense enthusiasm because the text related to their own quest for recognition and rights. Quoting Mason, Charlotte

Perkins Gilman proposed that her gender was "the originator of primitive industry," especially pottery.[9] On 19 January 1915, Connolly presumably heard Gilman's lecture, "The Normal Woman and the Coming World," when The Contemporary hosted the crusading intellectual in Newark.[10]

Connolly's message differed in its emphasis from the museum's narrative the "Story of Clay." The installation of a male clay worker to demonstrate techniques each afternoon implied that the industry was virile. By engaging Enoch G. Bourne, an instructor at the Trenton School of Industrial Arts, the Newark Museum showed that industry was not an abstraction but a vital need, and reiterated the heroic stature of the laboring male body, a live Seth Boyden. Bourne's techniques of shaping and firing vases and tableware educated children in the transformative power of skilled labor (figure 44).[11] Throwing on the wheel and casting in plaster molds, he used ancient and modern methods. But more important, as a metaphor, Bourne personified the self-reliant individual who was cooperative for the good of the collective, an ethical citizen. "Every potter who does good work, and every artist who makes shapes and decorations of real beauty, not only furthers his own fame and fortune, but also improves the good name and the wealth of his state and his country," stated the museum's brochure.[12] Young visitors heard and witnessed the imperative to be industrious, and were told to look at the exhibition as an education readying them for work and life. The artifacts represented ways to improve all aspects of the built environment: distinctions in gendered industry were illustrated at many points in the exhibition. The artifacts were metonyms for reciprocal forces, and implied that the city's many parts were acting in concert.

MODELING CIVIC COOPERATION

Linking "art" and "commercial" as equal terms in the exhibition's title was brazen, and paralleled the social cooperation entailed in gathering the loans of art. Forty-six women and eight men lent historical artifacts. Sixty-four currently active manufacturing firms and seven recently established industrial art schools, in addition to several amateurs, lent contemporary goods. These divided along gender lines, the factories predominantly being male artisans and the students and individual artists mainly female. Instead of a curator selecting artifacts, the museum requested them from women's clubs and factories. The museum sent out unsolicited inquiries to conduct a local census. The participants that responded in the affirmative, such as a local firm that made ceramic fireplace hardware, Strait & Richards, were guaranteed inclusion merely on the basis of this paperwork (figure 45).[13] Herding

INQUIRY BLANK, TO BE RETURNED.

Name of your firm: STRAIT & RICHARDS inc.

Address Fabyan Pl.and Selvage sts. Newark N.J.

Please answer the following questions, so far as the custom of your firm permits, add criticisms and suggestions, and return in the stamped envelope enclosed as soon as convenient.

Are you favorably impressed by a Clay Products Exhibition and will you probably send an exhibit?
 Yes.

What clay products are your specialties?
Terra Cotta Gas Logs,Umbrella Stands.

What is your approximate output in such specialties?

from 10.000 to 12.000 Gas Logs per year. Just started making the Umbrella Stands.

Which of your products do you think would make a characteristic exhibit, one by which you especially wish to be known?

Gas Logs.

What can you show of such product or products?
Would suggest showing two Gas Log,on suitable Standards whihh we will supply. One in Oak finish and one in Silver Birch finish.

How much floor space would your exhibit probably occupy?

about six to eight square ft.but space must be 2-0" wide.
How much wall space?

How much table space?

Can you send photographs showing good examples of completed pieces or jobs? Yes. Interesting photographs of processes? No.

How much time will you require to prepare your exhibit?
Can send them down any time.

Kindly send us copy of your catalog or lists of your products.
Being mailed today.

together this tableau of participants, the museum realized cooperation and bridged communities.

"Cooperation" was a method of the exhibition and its content, and also an explanation of its success. "By cooperation we in America too can build up among our people an intelligence, ambition, and pride in the industries of the State,—essentials of any effective 'made in America' campaign," the museum told manufacturers of contemporary products and well-to-do connoisseurs of historical ceramics.[14] Teaching good taste to the middle class, a tradition born in the nineteenth-century museum, was an imprecise outcome but hailed nonetheless. The Newark Museum described its display of ceramics as "raising the common art standards . . . [in] cooperation with a living industry," thereby designating itself a disinterested intermediary to reconcile commercial enterprise and public welfare.[15] No previous show organized by the Newark Museum Association generated such crowds or relied on the cooperation of such a diverse coalition of lenders. Cooperation, a favorite Progressive keyword, bridged (and glossed over) diverse social inequities in Newark, especially hierarchies in class, status, and gender: it was in constant use. The attendance of twenty-eight thousand people, twice the annual visitation of 1914, marked the museum as the library's equal, not its minor appendage, qualified the exposition as one of the city's genuinely popular attractions, and suggested the public perceived the appearance of cooperation.[16]

Collectors, industrialists, and clubwomen all shaped the museum exhibition, but the cooperation was hard won. The museum promised manufacturers that they would gain "the feeling that they have a statewide interest behind them in their work," and also assured the New Jersey State Federation of Women's Clubs that they too would expand their sphere of influence through the collaboration.[17] Writing to the women's clubs at the height of their organizational power, for example, the museum asked for the loans of historical pottery for the exhibition.

The Progressive era saw a great outburst of secular social associations in America, and the newborn museum was dependent on them. Middle-class

45. Detail of Strait & Richards letterhead, above, and response of Strait & Richards to the Newark Museum Association's 1914 query, below. Collection of the Newark Museum. This inquiry form was the building block to gather goods from factories for the museum show, and illustrates the way the Newark Museum operated as a space more akin to the trade show. The candid question, "What is your approximate output?" prompted manufacturers to respond in square feet, dollars, or cautious evasion.

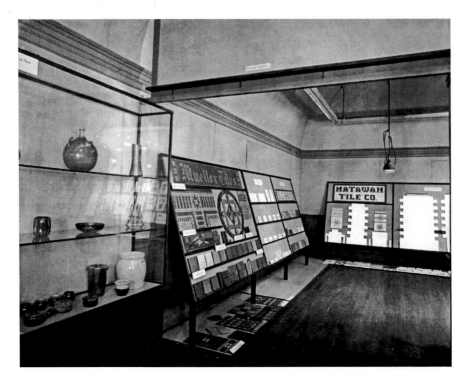

46. Tiles and vases in installation photograph of Clay Industries of New Jersey exhibition, 1915. Thein, photographer. Collection of the Newark Museum. In the southeast corner gallery, Fulper pottery owned by the Museum Association was in a glass vitrine, and the Mueller and Matawan tile companies had designed their own displays of their wares more akin to those of a trade show.

constituencies such as the YMCA and women's clubs were large coalitions of citizens organized around specific causes and regional interests. Ceramic manufacturers and dealers also were forming national associations and regional leagues. Several years later, John Cotton Dana recounted that the 1915 ceramics exhibition was a breakthrough because manufacturers finally agreed to participate, after years of refusing.[18] Businesses designed their own exhibition stalls and included their names and advertising plugs (figures 46 and 47). The trade exhibition that was intimated with some subtlety in the German show of 1912 fully flowered into an overt commercialism when tile companies such as Mueller and Matawan spelled out their names in their displays on makeshift walls and laid out their products much as they did in their own showrooms. Unpretentious trestle tables and temporary walls, with exposed scaffolding, acknowledged the short-term nature of the exposition. Although Fulper's vases beside Matawan's tiles were protected in a glass case, only

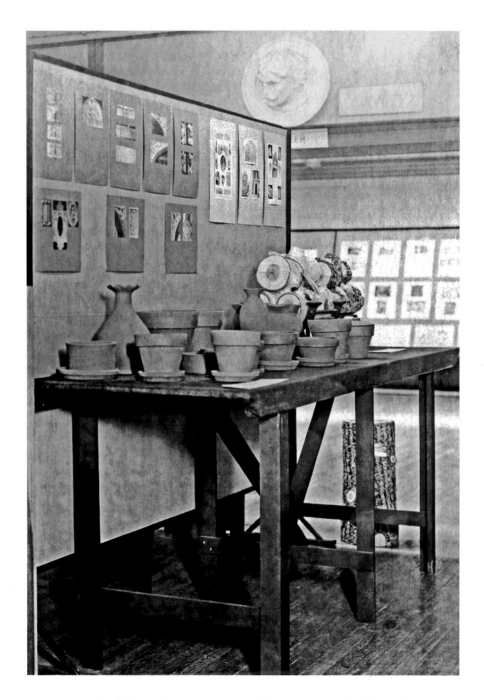

47. Strait & Richards logs and flower pots in installation photograph of Clay Industries
of New Jersey exhibition, 1915. Thein, photographer. Collection of the Newark Museum.
Fire brick, flowerpots, terra cotta, and gas logs were laid out on tables, floors, and
walls, with photographs showing the architectural applications of terra cotta pinned
to temporary walls: ornament and function were not distinct categories.

its most rare pink glaze vases, the *famille rose*, cost as much as one hundred dollars.[19] Most things sold for four or five dollars, and most of the show was laid out on tables and hung wherever there was space. A terracotta roundel, a bust of James Whistler made by the South Amboy Terra Cotta Company, was hung above mere flowerpots. The museum's decision to broker commercial production and civics further disconnected the exhibition from traditional humanist and fine art criteria.

In its guide, the museum narrated the story of the American ceramic industry and mapped specific local firms' histories. Romance was found in local continuity in art and industry. For instance, products such as Trenton's Ott and Brewer art pottery were sold at Tiffany and Company in the 1880s, and yet the firm had become more profitable as producers of porcelain insulators in the twentieth century. One hundred years after the Flemington Pottery opened to make functional stoneware for kitchens, it operated in 1915 as the Fulper Pottery Company and sustained itself from sales of artistic Vase-Kraft lamp bases, still made of stoneware but now coated with colorful viscous glazes. In 1861, the Millington, Astbury and Poulson factory had produced hundreds of earthenware pitchers using plaster molds. In 1915, its successor made toilets; both landed in the museum. In 1873, Millington, Astbury and Maddock became the first successful American producer of ceramic sanitary ware. Twentieth-century sanitary ware giants, such as John Maddock and Sons Company and Thomas Maddock's Sons Company of Trenton, traced their ancestry back to this firm. The companies were reinventing themselves each decade in the face of change, as employees unionized or were lured away by Ohio factories, and as coal-powered kilns lost ground to those using oil, gas, and electricity. The fourth floor of the Newark Museum featured Thomas Maddock's Sons' siphon jet water closet, an American marvel of modernity that had surpassed European inventive and productive capabilities, while on the third floor the earlier version of the firm, Millington, Astbury and Poulson, was represented by a molded earthenware pitcher that narrated the martyrdom of a Civil War hero. Past and present triumphs of New Jersey were linked as examples of virtuous local industry.[20]

CIVIC AND CONSUMER LITERACY

In pooling such different groups under the banner of "industry," the museum's aim of cultural literacy became difficult to distinguish from consumer education. A publicity photograph of Bourne demonstrating the plasticity of clay included his regular audience, Newark gamins in motley clothing. They

stare up in admiration, as if the demonstration was a way to circumvent language barriers, and "civilize" urban immigrant youth.[21] Dana went so far as to declare Newark's industrial production equivalent to an "intellectual life," and argued that human redemption occurred in "the making of good shoes by workers who are fairly paid and labor under wholesome conditions."[22] At the same time, Jacob Riis was claiming "one boy's club is worth 100 policemen," suggesting that extracurricular moral athletics could solve modern social problems.[23] Two thousand students attended the 1915 ceramic shows at the Newark Museum, a high number in that era. The announcements about the exhibition, mailed to each Newark teacher, applied Dana's notion of dignified advertising to a practical task.[24] Although no ceramic courses were taught to Newark schoolchildren aside from Maud Mason's at the Fawcett School, Newark's reformers believed in Addams's and Dewey's theories of socialization and the therapeutic value of handicraft.[25] Mason herself wrote to the museum that she was "endeavoring to instate right ideals and create a love for simple and beautiful ceramics."[26] The museum declared that the paths to patriotic glory lay in organizing a relationship between New Jersey's "fair and wholesome" factory work and Newark's domestic sphere, and this at a time when American consumers still sneered that domestically produced hotel china was "thick enough to breed indigestion," and producers were just beginning to refine porcelain.[27]

Showing that New Jersey was productive was Dana's way to teach citizens that there was a relationship between producing goods and producing good citizens. The "artist-potter," both male and female, and the "ceramic scientist" were new figures in America at the turn of the century, and Bourne demonstrated the value of both of these innovations, suggesting they were a natural extension of archaic industry.[28] Assessing the show himself, Bourne viewed his demonstrations in both an ethical and vocational context, as an "education and a guide to useful lifework for many students."[29] He was chosen because of his skills but also because Frank Fredericks, director of the Trenton School of Industrial Arts, considered him a "man of character."[30] "The museum of the future," Dana promised, "will . . . permit its visitors to see objects in the process of making," as if the metaphor of creation was itself fungible.[31] Just as manual art educators leapt between defining their mission in terms of teaching virtue and illustrating a vocation, so too did the museum. Dana applied Dewey's concept of doing-as-knowing to the museum, stating that "the doing of a thing is of greater interest and tends more to arouse thought and action than completed objects, however rare and costly and

however exquisitely displayed."[32] He has been interpreted as celebrating the commonplace, but there was also a moral injunction in his project, a mandate to make good citizens by proxy when one made commodities. Dana was not alone: art and trade journals alike expressed the hope that American industry was generating a new, modern national culture greater than its European origins. Clay molded and fired in New Jersey demonstrated social mobility, the power of education, and the ideal of the self-made American. The Newark Museum differed from the nineteenth-century utilitarian museum's mission (epitomized by the early years of the Victoria and Albert Museum) in its view of consumption as a way to be a virtuous citizen, as important as production.

Locating the craft demonstration in the museum connected cultural and consumer literacy. Educational lessons gained status as a propellant of civic growth. At Bamberger's Made in Newark expositions of 1913 and 1914, the department store advertised "every article made in this city was being shown in the process from raw material to finished product," a boast that rhetorically bundled together the idealism of the Arts and Crafts movement, arrogant American entrepreneurialism, and pragmatic education in much the same way as Dana's pronouncements.[33] By inviting manufacturers to participate in the exhibitions at their own cost in 1915, the museum emulated the mainstream spectacle of the department store. Cooperation became an intangible civic virtue and also a gritty mercantile interest.

Strait & Richards, the small ceramic firm that manufactured gas fireplace logs, was a major attraction in Bamberger's and a participant in the museum's show, too. It was the sole ceramic demonstrator in the Made in Newark exhibitions of 1913 and 1914, and Dana had probably seen the work and noted the showmanship of this Newark business that employed fewer than twenty men.[34] Their perforated logs, when lit with piped gas, animated the faux "welcome fireplace" in modern homes, most of which relied on central heating. Conjuring a sight of flames prevented "the sensation of chilliness."[35] The logs were an affordable luxury that provided comfort and symbolism. Sales of the logs in the thousands by Bamberger's and other retailers suggested that American urbanization was making consumers increasingly desire symbols of the rustic life. The presence of these high-quality ceramic goods in the museum exhibition suggested, as Dana had before, that middle-class domestic taste was a collective concern.

The Newark Museum's efforts to attract sales staff from local department stores to the exhibition were as vigorous as its attempt to corral schoolchildren.[36] Employees from Bamberger's toured the exhibition on three

consecutive days, learning the connoisseurship that would fuel sales. They witnessed the different ceramic processes behind the goods they handled.[37] Dana's creed of the "Salesman as a Missionary," published in *The Newarker* in 1913, was realized when Bamberger's sales staff, primarily immigrants, were actively enlisted in this celebration of Americanization, capitalism, and municipal industry.[38] Interestingly, in 1914, the Metropolitan Museum of Art employed Charles Richards, one of the founders of the National Society for Promotion of Industrial Education, to deliver "lectures for salespeople." The two museums were programmatically more alike than scholars have suggested.[39] The objective to improve consumer tastes and habits had been touted in world's fairs and museums since the mid-nineteenth century, but in the early twentieth century Newark's and Manhattan's art museum incorporated this aim too.[40] Like Karl-Ernst Osthaus, who lectured extensively for sales staff, and saw them as important educational links in activating the spiritual economy of Werkbund goods, Dana and Henry Kent, the secretary to the director at the Metropolitan Museum, valued consumer education as a part of their mission. These educational institutions actively collaborated with stores and designated specific types of consumption as generating cultural and civic virtue. The Dana store in Woodstock, Vermont, had beckoned rural consumers with "china ware" advertised in gilt capitals; the museum's agenda of exhibiting modern middle-class goods, functional and refined, updated and expanded the business of culture as young J. C. had known it.

Whereas few American firms had been competitive in grabbing a share of the domestic ceramic market in the 1870s, by 1915 Trenton was called the "Staffordshire of America," and firms there were using innovations such as continuous-firing tunnel kilns to keep up with the pace of national railroad distribution and expanding markets. Protectionist tariffs, the immigration of more highly skilled potters, the chemical analysis of native clays, and the growth of the national economy had improved the flow of American-made ceramics. Through a century of immigration and entrepreneurship, firms had gradually developed the specialized skills of ceramics. Ceramic technology had made strides because associations had shared intellectual property. In 1915, Buffalo China built the first fully electrified kilns in the world, taking advantage of hydroelectric power from Niagara Falls. Imports kept increasing, however, along with national prosperity. New Jersey's and Ohio's firms still were not looked upon with respect: middle- and upper-class appetites required the importation of approximately ten million dollars worth of European china, earthen, and stoneware in 1915 alone.[41] In 1915, the twenty-million-dollar

ceramic industry in New Jersey was primarily sanitary ware production.[42] The state remained competitive in sanitary ware, porcelain insulators for electric work, and tiles, while Ohio had the lion's share of white ware production by 1915.[43] Imports dominated the luxury goods market (with German and French goods outnumbering English products), leaving sanitary ware as a standout in the American industry. Tariffs imposed on foreign imports in the 1890s had slowed the flow of cheap German porcelain (which after 1875 had undersold English earthenware) and the Americans' share of their domestic market had grown from negligible amounts in 1870 to approximately 35–45 percent in 1915.[44] As the crisis of World War I deepened, shipping was interrupted more frequently, and worries swirled around American dependence on European imports and markets. Objects of daily life were invested with civic significance, and Newark's exhibition had national implications.[45] It was a moment when consumer education, especially the exhibition, was expected to have patriotic results.

If Newark's installation methods deliberately annulled hierarchies of context, use, and value, then its notion of applied art emphasized the leveling of those distinctions. The Jonathan Bartley Company's thick crucibles for smelting stood beside Walter Lenox's rococo-revival dinnerware for elegant dining. Crude stoneware crocks, early trials of sewage pipe, and earthenware pipkins for cooking beans were juxtaposed with refined artifacts like white biscuit porcelain statuettes of Ulysses Grant and Hiram Powers's *Greek Slave*.[46] While the gleaming white parian statuary, named after the marble of the Greek isle of Paros, was a respectable and mid-nineteenth century emblem of high culture intended for the parlor mantel, the pipkin had been stowed out of public view.[47] But in Dana's youth in the "New York Cash Store," these might have been jumbled together as merchandise. The work of the Woodstock-born Powers might have been exhibited as that of a native son whose work toured Europe and won acclaim at the 1851 Great Exhibition of the Works of Industry of All Nations, better known as the Crystal Palace. Newark's profusion of artifacts demonstrated that art and trade had been linked for a long time.

EMBLEMS OF CULTURAL STABILITY

In electing to focus on ceramics, the Newark Museum chose to honor cultural production that evoked biblical archaisms and was also notable for its recent successes on American soil. Ceramic manufacturing was highly skilled, unlike production in steel mills and tanneries. The workforce was Anglo-Saxon,

unlike that for silk production in Paterson, which attracted labor from continental Europe; it was still predominantly male.[48] The museum took pains to argue that ceramics was a handicraft business in factories as much as in studios. It expressed a commitment "to dignify and promote the industries and crafts," and explained that bathtubs were hand finished over weeks, and that each toilet was hand-dipped in glaze.[49] To convince its audience of the skill levels involved, the museum asked Thomas Maddock's Sons if they could produce lantern slides of production, and the firm agreed if Underwood and Underwood, the leading maker of stereoscopic images, would be used.

In the first two decades of the twentieth century, an age of strikes and unrest, the ceramics industry was an anomaly because of its stable labor relations, and this irenic atmosphere surely made it attractive as a "romance." In 1913, massive Paterson labor disputes roiled the textile industry, but pottery workers were too bound to paternalistic relationships and too divided to arrive at a consensus to strike.[50] The trades maintained hierarchies, even though technological inventions such as electric tunnel kilns and decalcomania (cheap methods of applying decorative ornament) deskilled production processes and splintered older modes of workmanship.[51] Unionism was slow to catch on in the potteries, most of which were staffed by insular families adhering to specific trades, and the creation of the National Brotherhood of Operative Potters in East Liverpool, Ohio, in 1890 was driven by a desire to secede from East Coast bosses and in opposition to the Knights of Labor.[52] While many newer industries depended less on workers with tradition and inherited knowledge, potters tolerated antiquated modes of wage compensation.[53]

In electing to focus on ceramics, the Newark Museum championed a peculiarly conservative industry, a romance that had skirted labor troubles. Dana's educational mantra continued to harp on the virtue of work, and in 1916 he published *The Romance of Labor: Scenes from Good Novels Depicting Joy in Work*, a collection of excerpts.[54] He and his co-editor, Frances Doane Twombly, a Summit resident active in local politics, gleaned an account of sheep shearing from Helen Hunt Jackson's *Ramona* (1884), of pottery making from Eden Phillpotts's *Brunel's Tower* (1915), and, as mentioned in chapter 2, of stockyard work from Upton Sinclair's *The Jungle*. But the extracted stories were little more than character sketches. The book studiously avoided the word "union" and any mention of labor strife. The publication was intended to uplift and inspire young minds, and the tongue-in-cheek epithets on the frontispiece, describing the authors as "a busy man" and "an idle woman,"

expose the template of morality at the root of the effort. Twombly, the spouse of a corporate lawyer who worked in Manhattan, was known as the "Mother of Recreation" in Summit, New Jersey, for her local efforts in the playground movement. She knew Dana through her good friend and boarder for a decade, Louise Connolly.[55] Their moral tenor was representative of Progressive reform, and of the way the library and museum espoused an industrial progressivism that espoused complicity with capital.

Four artifacts that were particularly emphasized in the clay exhibition illustrate distinct ways that the museum romanticized industry. Each balanced in its own way Dana's mandates for economic and aesthetic innovation, cultivation of reverence toward the past, and social cooperation. Together they show that the experimental museum was the site of several ideological contests. The museum tried to maintain itself as a forum in which opposites were reconciled instead of shown to be antagonistic.[56] The exhibition contained many contrasts between men's and women's industry. Like the dissimilarity between demonstrations by Bourne and the feminist educational guide, the installation reinforced normative behavior in some ways. But the mere inclusion of women artists was radical. The popularity of the exhibition is explicable in light of the ways that the artifacts sustained multiple interpretations, and pleased the ideological wants of its participants, especially manufacturers and women's clubs, but the range of interpretations indicates the fragility of the project. In hindsight, the great variety in symbolic meanings and artistic criteria presage the difficulty inherent in turning the museum into a forum of democratic participation.

THE ANTIQUE PITCHER

The Ellsworth pitcher depicted the Union Army's first mortal casualty in the American Civil War. Molded in a New Jersey manufactory in 1861 or soon thereafter, the squat rococo-revival pitcher depicts a stairwell brawl among five armed men in shallow relief decoration (figure 48). The pyramidal composition immortalized the first "martyr" of the Northern Army, Colonel Elmer Ephraim Ellsworth. His arms flail out in anguish, body language reminiscent of mourning on an Attic vase. The modeling of the semi-vitrified earthenware (called ironware or graniteware in the period) is not crisp, and to make out the story, apart from a legible banister and rifle-pointing men, is difficult. To aid its readers, Newark's newspapers included a line drawing of the pot to identify each character, and bring into focus details lost in the white slurry, such as the uniforms of the three Zouave troops. When it was made, the

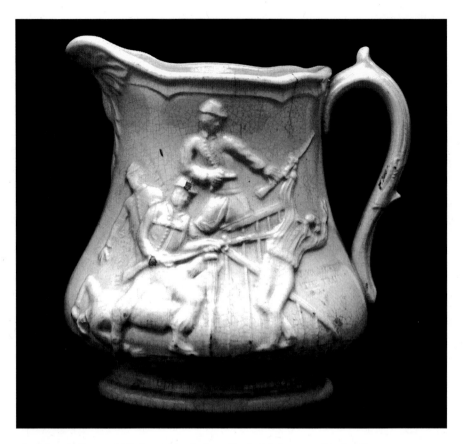

48. Colonel Ellsworth Pitcher, 1861, designed by Josiah Jones or Charles Coxon, manufactured by Millington, Astbury and Poulson, Trenton, New Jersey. Semi-vitrified earthenware (also called ironstone and graniteware); 9 in. Purchase 1914. Collection of the Newark Museum (14.1094). The exhibition of the Civil War–era pitcher came four years after Newark erected Borglum's *Lincoln* and Theodore Roosevelt had declared that "no other contest during the time of which we have record, certainly no other contest since civilization dawned on this earth, was as supremely important to all the nations of mankind" as the Civil War. The artifact resonated with local myth and was also a prism through which to see the war as a crusade for social justice.

vessel articulated patriotism and moral faith in the Union. On a dining table during and after the war, the jug would have been a testimonial for guests to retrace with their fingers the memory of a national moment of catharsis and their allegiance. Lincoln's speeches immortalized the debonair Ellsworth as a sacrificial victim, and new commodities brought the young martyr's face to the public, such as the thousands of mourning cards sold by Louis Prang, and equally numerous pocket-sized photographic *cartes de visite*. In 1915, the most discerning connoisseurs of American antiques collected older goods intended

for finer homes, not these middle-class commemoratives emblematic of industrialization. But the Beaux-Arts monument, such as Newark's *Lincoln*, Manhattan's Grand Army Plaza celebrating William Tecumseh Sherman, or Brooklyn's own Grand Army Plaza and Sailors and Soldiers Memorial Arch, idealized the Civil War as a noble cause and the defining aspect of American civic principles. In this broader context the Ellsworth pitcher was resonant.

The museum's Ellsworth pitcher was one of thousands made through the use of plaster molds by the Trenton firm of Millington, Astbury and Poulson, one of the first to excel at large-scale production. The vernacular design departed from the earlier practice of copying historical products in their entirety. Adding images with local relevance, the Trenton firm of mainly British-trained potters went beyond reviving the styles of classical antiquity, medieval Europe, or eighteenth-century France.[57] It sought to Americanize traditions inventively and to appeal to new consumer predilections.

America's leading historian of ceramics, Edwin AtLee Barber (1851–1916), director of the Pennsylvania Museum and School of Industrial Art, had already pronounced the Ellsworth pitcher a national treasure on the grounds of its depiction of moral virtue. The Newark Museum honored Barber's epic, *The Pottery and Porcelain of the United States* (1893), a pioneering and respectable work of scholarship, by receiving his permission to reprint parts of his book, including his paragraphs about the pitcher, in its catalog. Barber had organized the Invitational Exhibition of New American Ceramics in 1888, awarded a gold medal to Rookwood's art pottery, and was the first curator to catalog American ceramics in depth as a regionally diverse industry. His mission at the Pennsylvania Museum and School of Industrial Art was to display applied art as a resource for local manufacturers, and he claimed the young country to be rich in regional ceramic histories, primed for continual growth through cultural exchange. Barber, like Dana, believed patriotic consumption was the major ingredient lacking in America and condemned, for example, the White House's practice of importing "a service of china from abroad for use in State ceremonies" as an "un-American sentiment," a policy that was temporarily reversed in Wilson's term in 1918.[58]

Dana knew Barber and one of the major lenders of old stoneware, Albert Hastings Pitkin, through their association with the Walpole Society, a gentlemen's club of members interested in American antiques. In Dana's wry view, they were a "cult" with the goal "to demonstrate the but imperfectly and recently realized artistic tastes of our forefathers."[59] Good taste for most Walpole Society members involved Anglo heritage, associational history,

and patriotic sentiment, and the name of the society was specifically chosen to allude to quests for objects of virtù conducted by the eighteenth-century aesthete, Horace Walpole, the Earl of Orford. Touring historic Colonial New England on weekend trips, the Walpolians motored into nostalgia. Dana was probably the most self-deprecating of the twenty-one founding members. He described their long automobile trips, evenings of feasting, and moments of falling "on their knees before Olympian things . . . things which to pagans look like chests of drawers, beds and tables of the kinds our great grandfathers made."[60] These white, Anglo-Saxon, Protestant men were bound by their passion for American antiques, and they created the first museum collections of American furniture, silver, and other decorative arts. The collections of the Metropolitan Museum of Art and the Boston Museum of Fine Arts are rooted in this clique, and Newark's trustees surely considered their museum fortunate to be so well connected through Dana. He was not an affluent collector, but he deftly managed his social capital. Through his colleagues, the museum obtained six old stoneware vessels from Pitkin and Barber.

Although the Ellsworth pitcher was historical, it was a specimen of industrialized production, which Walpolians generally considered an artistic decline. They deemed older pottery spiritually more potent. Walpolian Richard Halsey gave his Federal-era plates, British made, with images of New York City, to the Metropolitan Museum because they embodied "the everyday life of our forefathers . . . [which] cannot fail to serve as object lessons and convey an historical illustration far more effective and impressive than could be secured by any text book."[61] The Ellsworth pitcher appealed to Dana's penchant for storytelling, too, and its deployment in the 1915 show is in part explained by its narrative drama as well as his tendency to scorn orthodoxies, even connoisseurship of antiques.

To borrow most of its historical artifacts, and make manifest local lore, the Newark Museum turned to the New Jersey State Federation of Women's Clubs. The Newark librarians shrewdly began correspondence with clubs over one year in advance of the exhibition, to "tabulate New Jersey's art assets."[62] Clubwomen numbered 400,000 nationally and had both money and influence. In 1915, especially because of the upcoming referendum on suffrage that fall, women were organized as a consumer bloc, arguably as they had never been before in American history, even though they lacked political unanimity.[63] The Newark Museum asked the clubs to gather historical New Jersey pottery, characterizing it as "peculiarly women's work to discover them" "since many of the pieces . . . are in homes."[64] The appeal to women as both

"torchbearers" of morality and "keepers" of the American home dated back to nineteenth-century domestic ideals and the rallies to raise morale and money with Sanitary Fairs in northern cities during the Civil War.[65]

Although the identification of domestic custodianship as a gendered role might seem insulting from a twenty-first-century perspective, in 1915 china collecting was celebrated in mainstream and politically oriented suffrage journals as a patriotic endeavor.[66] Invented as a genteel woman's pursuit in the 1870s, ceramic connoisseurship implied social pedigree and refinement but also serious cultural engagement. In *The China Hunters Club* (1878), upper-crust women's antiquing trips were portrayed as acts of virtuous and patriotic consumption.[67] The author of the popular book, Annie Trumbull Slosson, and her sister Mary Trumbull Prime, like the Walpole men helped establish pottery collections in academies and museums. Their male counterparts, such as Trumbull's husband, William Cowper Prime, who donated a ceramic collection in both of their names to Princeton University, were invested with more institutional gravitas.[68] Articles about china collecting appeared in the *Ladies' Home Journal* and *Young Woman's Journal*, indicating that the consumer appetite for ceramics was immense and the "romance" of china was popular.[69] Clubs went "relic hunting," and their pilgrimages focused on collecting antiques with associative history; the Walpolians especially searched for pieces with a Revolutionary-era provenance.[70]

In the early twentieth century, women's artistic ambitions, especially in china painting and collecting, were sometimes belittled, but the women's clubs saw their cultural work in public terms: "Conservation then in its best and highest sense is the raison d'être of the General Federation of Women's Clubs ... conservation of child life, of womanhood, of civic and national integrity ... preserver of all that is good in the civilization of the past."[71] Women's clubs were some of the earliest arenas where American artifacts were invested with public meanings, so it was both empowering and essentializing that Dana recognized clubwomen as the keepers of old pottery.[72] In the communiqués between the Newark Museum staff of women and the club members, there was an implicit assumption that women were the proper guardians of domestic culture, a characterization considered flattering by both parties.

When the museum highlighted a martial artifact such as the Ellsworth pitcher, it legitimized the gravity of the clubwomen's antiquing and "china mania" as a public work, not as a private obsession.[73] The cultural institution publicized the role of women as preservers of history, patriots who made the American home into a museum in its own right. It chose not to publicize the

fact that the Ellsworth pitcher had been purchased for four dollars from a Philadelphia antique store, at Barber's suggestion.[74] Associating the virility of Ellsworth with domestic preservation lent credibility to the historical recuperation performed by Walpolians and women's clubs alike. The relic made the "peculiarly women's work" a desirable and redoubtable endeavor.

The exhibition furthered the patriotic pitch of women's "municipal housekeeping" and the clamor to have noteworthy ancestors. As it grew in value, the provenance of the Ellsworth pitcher became an object of desire and debate, and the descendents of two potters, Charles Coxon and Josiah Jones, men previously recognized as cogs in the industrial revolution more than as artists, argued for the attribution of it to their respective forbears.[75] Dana deftly excused himself and appealed to Barber to adjudicate the question of the Ellsworth pitcher. Privately to Winser, his second-in-command, Dana questioned the competency of clubwomen to assemble quality historical specimens.[76] When he vowed that the catalogue would "grow more valuable as the years pass," his prediction was founded upon Barber's reputation and his own self-esteem, not the clubwomen's connoisseurship. Despite Dana's prejudice, the Kalmia Club of Lambertville brought to light eight different New Jersey potteries previously left out of Barber's research.[77]

In 1915, the Ellsworth pitcher embodied the ideal of civic sacrifice and *amor patriae*, messages central to urban Progressives' mission of Americanization. Other organizations—the YMCA, Boys Clubs, and playground movements, for example—were also in search of vehicles to build a common cultural patrimony. The pitcher had in its favor a "good war" and a dutiful American. The presence of a Newarker at Ellsworth's shooting, *New York Times* reporter Henry Winser, the father of the librarian Beatrice Winser, doubled the artifact's local anecdotal power. Moreover, the water pitcher already was an object charged with significance by the fierce battle for Temperance, trebling its capacity for exemplifying morality. Unlike the Werkbund beer tankard, the Ellsworth pitcher was an object of virtue lauded by the entire political spectrum, rising over the divisive issues of suffrage and prohibition. The homeowner who owned a copy of the Ellsworth pitcher was not merely consuming but preserving goods. Its conjectural female custodian cared for the emblem of heroic manhood, thereby integrating reciprocal civic acts. Good civics lay in apt consumption.

Made by one of a troupe of English-born and trained potters, the pitcher suggested that what was identifiably American became so through industry and empathy. Anglo-Saxon blood ran in the veins of American potters, and

British taste permeated the industry's culture. The ceramic artifact was also capable of Americanizing more recent immigrants. The Ellsworth pitcher told hyphenated Americans to express patriotism through the consumption of goods. In 1915, Dana showed this 1861 pitcher and said "Buy American," suggesting that nobility was transferred with ownership. As he boasted to fellow Progressive reformers in the periodical *The American City*, his industrial museum wielded economic, aesthetic, and spiritual influence:

> We believe that under modern advertising conditions it would not take much work of this kind to link the name of Trenton, for instance, with the idea of chinas and porcelains in the minds of both the wholesale and retail-buying and the reading public as thoroughly as Limoges has become linked with the same idea. And the same thing would be true of terracotta and the South Amboy region. Such exhibits should become valuable adjuncts to the "Buy in America" campaign.[78]

Clay was a metaphorical and literal building block of the community, and opened the aperture for civic activism in several guises. The Ellsworth pitcher reiterated the idea that American industry had modernized and matured. It was an antique, yet had contemporary relevance and showed the ways that individual agency could be channeled properly into a collective purpose. Although the scientific agenda of the museum is outside the focus of this study, in 1915 the museum contacted the state geologist for maps of clay beds so that its visitors could recognize the environmental conditions that predisposed their state to the ceramics industry and thereby heighten their emotional connection to the artifacts.[79] The maps suggested that the state's economic and artistic destiny flowed from the clay substratum. Formed of New Jersey's soil and part of its economic flowering, the Ellsworth pitcher was resplendent with the concept of homeland.

KERAMIC ART

If the Ellsworth commemorative embodied women's agency and role in maintaining political and ethical order, art pottery embodied a more direct way to express their new-found autonomy. By including the recent work of Newark's Fawcett School of Industrial Arts, the Newark Keramic Arts Society, and the State School of Industrial Arts in Trenton, the museum made amateurs the equal of professionals, both live and dead, and women on a par with men. Art pottery and female ceramic artists were contiguous post-1876

phenomena in the United States. Like equality between sexes, the artistic pot leveled the playing field between rustic provinces, industrial cities, and the modern metropolis. Cincinnati, New Orleans, and New Hampshire ceramics often competed successfully with those in Boston. Although women had been china painters for a few decades, several now became potters, challenging conventional gender roles. Taken for granted today, the decision by women to work with clay was a true liberation from circumscribed media like textiles which were imbued with explicitly domestic associations. Ceramic art laid claim to civic ideals, and the medium gained visibility when genuinely important public works adorned metropolitan subway stations and government buildings.

American women were especially passionate about both collecting and making ceramics after the Centennial Exposition in Philadelphia in 1876, when art pottery from Europe and Japan became identified as objects of desire. In direct response to her visit to the exposition, Maria Longworth Nichols established Rookwood Pottery in Cincinnati in 1880. Other women became china painters, swelling the National League of Mineral Painters' membership into the tens of thousands. At first, teachers from Boston to Los Angeles offered private classes in ornamenting pottery, and reserved throwing on the wheel for men. Moreover, ceramics and china painting were initially considered as pastimes, not professions. Pots sold for fifty cents or a few dollars (and because of their categorization as amateurs, the work of women potters is often absent in most art museum's collections). But as European collectors and museums purchased pottery from Rookwood and Grueby, American women accrued prestige. Meaningfulness in ceramics surpassed its economic proportions, corresponding to the ambitions of the New Woman. American women artists won medals at the 1900 Exposition Universelle in Paris, and thereafter pottery was a proper civic career, with an aesthetic focus on community enrichment. When the Woman's Club of Orange held a pottery exhibition in 1914, it merited an article in the *Sunday Call* and a visit by Dana, who gave a lecture on American production.[80] When they exhibited Rookwood's ceramics in 1913, the art was described as illustrating women's virtuous roles in American "industry."[81]

In Newark's 1915 exhibition, women's production spanned a wide aesthetic spectrum. Designs at times evinced tribal allusions to Anglo-American history, while Japonisme also remained a vigorous tendency. Much work in the 1915 exhibition emulated the dominant art nouveau expressions established by America's international gold medal winners, especially Rookwood's

misty glazes and Grueby's ridged vegetal ornament, but some contributors were using the new "peasant" styles of brightly colored brushwork innovated by the Wiener Werkstätte.[82] Maud Mason, who taught ceramics at the Fawcett School, and Jetta Ehlers, a china painter and the leader of the Newark Keramic Society, exhibited plates and plaques with conventionalized motifs from nature, and *Keramic Studio*, the leading clay-arts journal of the era, published the students' designs as well as reproducing photographs of amateurs' exhibitions.[83] Although most of the women in the 1915 exhibition categorized themselves as china painters, Clara Poillon and Mason described themselves as professional artists (and resided in Manhattan). The local school and association had regularly exhibited in the library since Dana's arrival in 1902, and the 1915 show continued this liaison and interest in connecting schools', amateurs', and professionals' production, as it had with Modern German Applied Art.

Founded by Adelaide Alsop Robineau (and her husband Samuel Robineau), *Keramic Studio* oriented itself to both tradesmen and handicraft circles and, like the Newark Museum, broke down the hierarchies of amateurs and professionals, men and women. Robineau had gained fame as the first modern woman ceramicist to throw on the wheel and make her work herself, a pioneering act. Journals, newspapers, and books about home decoration praised her achievements. Women flourished in schools such as the Newcomb Pottery, in New Orleans, in businesses like Rookwood, and as individuals, like Mary Louise McLaughlin of Cincinnati. Women could be in an artistic trade without risking the loss of their dignity.[84] While primers still depicted the amphora as an allegory for the passive female body, such as Walter Crane's *The Bases of Design* (1898), Robineau and her peers seized the wheel and vessel as a woman's territory for self-expression.

Publicizing women's right to artistic identity coincided with the battle for political autonomy heating up in New Jersey. A referendum concerning women's suffrage was to be held in October 1915. For two years before, Clara Poillon steadily advertised her New Jersey–made pottery in *The Women's Political World*, a suffrage newspaper, thereby locating her work in a battlefield.[85] In 1867, her grandfather had taken over the Salamander Works in Woodbridge that had been in operation since 1825.[86] She maintained it with her father but now made unique art pottery, not the old pickling crocks. Discontinuity and continuity was in evidence in the changing aspirations and novel definitions of Poillon Pottery Works. In 1915, Clara commuted to her New Jersey studio, tapping into distinct conventions to make her own versions of Toby jugs and

Japanese flower pots. She exhibited with the Municipal Art Society and at flower shows. Her "unusual novelties in tableware, electrolieres, lamp shades, garden sticks, [and] book ends" do not seem aesthetically radical but still signaled the New Woman.[87] Her inclusion in the Newark Museum's exhibition demonstrated that local women were working to modernize history, expanding entrepreneurially, and challenging conventions.

Poillon's Toby jugs, four-inch-tall objets d'art, were representative of the Colonial revival, but deserve to be read as conscious appropriations of patriotic emblems, not merely conservative forms (plate 7). Her monochrome green, turquoise, and yellow glazes, Americanizations of Qing dynasty imports, updated tender memorabilia. She advertised herself herself as a chemist as much as an artist, and supplied glazes to Manhattan art schools, such as one in the the Ethical Culture Society. Dana bought other versions of monochrome red, yellow, and green pots wherever he found them. He bought rural North Carolina pottery on sale in Woodstock, Vermont, and British-made Ruskin ware in Munich. Poillon too was recuperating the past and turned what had been a symbol of boozy indulgence, the Toby jug, into an elegant contemporary accessory, a creamer for the modern New Jersey clubwoman. (The British folktale was that Toby drank himself senseless, was buried, and then dug up by a potter.) Poillon's forms alluded to social rituals and also domestic beautification. She described her vases as reviving "Colonial" forms but as "designated especially for Japanese Flower Arrangement."[88] Destined for flower shows in Newport, Rhode Island, and on Lexington Avenue, they were radical for a woman to craft. The jug suggested that women art potters were reoccupying a rightful, almost chthonic role in industry and upending the conventions of gender roles.

Depending on her audience and context, Poillon's commodity suggested reverence for the past and promoted suffrage. If the female museum docent told visiting schoolchildren that the first potter was a woman (assuming the interpretive script that Connolly typed was followed), most likely she also noted that modern women could elect to be potters, too.[89] Poillon's creamer and Mason's and Ehler's works also might have been in the Women's Political Union's cupboards on Halsey Street, and a part of that socially functioning ornament. Even if women were most often discussed in 1915 as the consumers of goods in economic terms, the archives of the union suggest that women used ceramic commodities for the alchemy of self-invention. Industrial arts were vehicles of virtue, deeply pleasurable to have and hold, and demonstations of social capital.

SANITARY CHINA

The Newark Museum was invested in exhibiting historical pottery and had displayed old American firearms and other types of American antiques, but Dana confided to friends that his use of antiques like the Ellsworth pitcher was calculated, "partly to mask the industrial aspect and partly to arouse" the participation of clubwomen.[90] His inclusion of toilets in the 1915 exhibition was a strategy to rope manufacturers into collaborating and also to gain the blessing of civic reformers. The porcelain sink and toilet were linked to the Ellsworth pitcher, because Millington, Astbury and Poulson, makers of the pitcher, had evolved into Thomas Maddock's Sons, the oldest and one of the largest of Trenton's sanitary ware manufacturers. Thomas Maddock's was one of the three hundred local manufacturers to whom participation requests were mailed, and one of the sixty-four who agreed to provide a complimentary exhibit.

Urban reform and consumer literacy intersected in the display of brilliant white toilets and pedestal sinks. In its correspondence, the museum stated affirmatively: "We would very much like" to "exhibit a closet combination . . . not only because sanitary ware is so important in industry but because it is so important from an hygienic and sanitary view."[91] The proliferation of toilets, only beginning to become a standard middle-class expectation, was a measurement of modernization. Trade journals and street signs advertised the advent of "*modern* plumbing."[92] America's first all-porcelainous bathroom was a novel industrial achievement in 1904, when the Trenton Potteries Company's brilliant white toilet, sink, and bathtub won a gold medal at the Louisiana Purchase Exposition. A product superior to the metal tubs and urinals available in the Sears, Roebuck catalog, ceramic sanitary ware signified class, new hygienic ideals, and modern craftsmanship.[93] Although the bathroom is taken for granted in the twenty-first century, it is worth remembering that in the late 1920s, the President's Conference on Home Building and Home Ownership concluded that only 71 percent of urban American housing included fully plumbed sanitary facilities.[94]

When Dana eulogized "one of the chief contributions of America to health and comfort is her sanitary pottery," he wrote as an earnest missionary, not a satirist or a prankster.[95] Although porcelain sanitary ware is usually considered a factory product needful of less virtuosic handiwork than the production of a teacup, at the turn of the century a commissioner of labor noted "the production of [ceramic] sanitary ware remains a highly skilled operation."[96] In 1916, *Sanitary Pottery*, the periodical published by the Trenton Potteries Company,

the largest maker of sanitary pottery in America, described toilets as a high-end artistic luxury product: "The Trenton Potteries Company ware is made by hand, skilled workmen pressing the wet clay into plaster moulds. The number of pieces a man can make a day is limited, and skilled wage is high."[97]

Sanitary ware was an apt vehicle to express Newark reformers' desire to mold and refine citizens. Discerning the qualities and functions of ceramic tableware was a long-standing gauge of the civilizing process visualized in prescriptive literature and advertising, and the creation of the sanitary appliance market extended these narratives about social improvement.[98] Because the process of rendering muddy soil into fine commodities has an implicit suggestion of refinement, alchemical associations made ceramic artifacts symbolically charged. The metaphor was resonant in Newark, where the aim of education was to refine students into technically and socially competent citizens, or, as Dana put it, "to make good men."

In "New Jersey Clay," a pamphlet produced for the exhibition, the museum explained how citizens were molded like clay: "most of us hear, when we see the potter's vessels, so fragile, yet so indestructible, echoes of some half-remembered simile or metaphor. If we are Biblical, 'Shall not the clay say to him that fashioneth it, what makest thou?'"[99] A label next to modern porcelain industrial crucibles stated "gold is refined by fire in the crucible—man is tried in the crucible of life."[100] The artifacts and presentation methods articulated the metaphor of social engineering and improvement.[101] The displays of toilets and sewerage pipe in 1915 confirmed that the engineer and inventor redeemed American civilization.[102] The museum asked its audience to believe that the future of the modern city relied on increasing infrastructure in water hygiene and sewage, and that every individual homeowner needed to be vigilant against germs and disease. Although no photographic documentation of exhibited sanitary ware is extant, shipping receipts record that at least three toilets were displayed in the museum in 1915.[103] Exhibiting toilets was a sincere declaration of social reform and urban renewal, an intent now obscured by historical distance. Most immigrants to Newark came from countries with limited or no indoor plumbing, conditions that were prevalent in rural America, too, so that the exhibition extended the argument that the modern industrial city was fomenting progress.[104] Sanitary ware implied scientific and rational management of the human body, and, in the logic of the Progressive era, was therefore deeply moral.

Exhibiting sewerage pipe was yet another pragmatic nod to local economic achievement and also a distinct effort to blur the difference between

a cultural institution and a civics lesson. The *New York Times* applauded the "frankly commercial" intention of the exhibition, stating, "a more practical method of 'booming' an industry could not be devised."[105] However, then and now, issues of propriety and questions of art obscured the reformist intention of the display for some audiences. Some newspapers questioned whether the exhibition was appropriate or tasteful. "To see what is called 'sanitary ware' and drain pipes and the kind of tableware in use in 'quick lunch' restaurants and building bricks solemnly displayed in the guise of art," exclaimed the *New York Press*, "certainly would disturb our museum pundits. Yet over in Newark there is a director of a library and art museum who has had the courage to do just such a thing as this."[106] Art historians tend to see this chapter of history through the prism of Duchamp's *succès de scandale*, the urinal he titled *Fountain* that was submitted to the 1917 Society of Independent Artists and refused, but is now considered the twentieth century's most important work of fine art.[107] Duchamp's prank is usually credited as an act of individual artistic genius and theorized in relation to Roland Barthes's "death of the author." In stark contrast, Newark's exhibition of toilets, both large and miniature salesmen's models, reiterated the nineteenth-century gospel of design reform for collective progress and labeled artifacts to give firms credit. The museum exhibited toilets not for their shock- but their cash-value. The white urinal was a sign that America was joining the ranks of highly skilled international craftsmanship, and not emblematic of the death of handicraft but its modernity.

When Dana claimed "so far, the great contribution of American art is the bathroom," a statement Duchamp or Beatrice Wood recycled in publicity for the *Fountain* two years later, he transposed an existing European design reform discourse to local craft.[108] Hermann Muthesius, a critic and theorist of the Deutscher Werkbund, praised the functional brilliance of English bathrooms in a 1904 publication, *Das englische Haus*. Adolf Loos, an Austrian architect and critic, also extolled the mechanical strength and healthiness of American bathrooms in his 1890s essays when he came to America and was impressed by the grandeur of Louis Sullivan's skyscrapers. Dana knew these distinctive fin-de-siècle theorists who praised functional and standardized design as spiritual and nationally redemptive. His assistant librarian, Kate Louise Roberts, taught Sullivan's importance in terms of "functional" and "organic" design at clubwomen's meetings.[109] Working with a local audience comprising industrialists and clubwomen entranced by Beaux-Arts glory, school-age children, and its more conjectural audience of "working men" and "artisans," the Newark Museum preached the regenerative powers of

high-quality locally made commodities. Handicraft was still considered integral to the quality of this industrial art.

Many of the manufacturers envisioned their representation in the museum as a way to overcome American antipathy to native products. "One of the chief purposes of the exhibition of New Jersey's clay products," Dana wrote on behalf of the museum, "is to call attention to the merits of our own artisans and call forth an unprejudiced judgment on the attempts our manufacturers are making to add a certain beauty of forms, line, and color to the output of their kilns."[110] Even after the 1891 McKinley Act, a regulation specifically aimed at deceptive marketing, native potteries routinely mislabeled their goods as imports to increase their value.[111] The museum's stated goal was to elevate consumer desires, and commercial advertisements for sanitary ware noticeably aimed at women as the likely consumers of domestic goods. Prescriptive literature spoke to class aspiration. Manufacturers' publications claimed that ceramic sanitary ware had an elevated status due to its material properties. One informed potential consumers that appliances cost only 10 to 20 percent more in "porcelain" than in cast iron, and that "china" fixtures were essential in order to have "Bath Rooms of Character."[112] "Why, I thought they cost twice as much," exclaimed a dignified couple in a *Sanitary Pottery* illustration, happy to buy virtue at a cut rate. Affluent consumers who were building a house for five thousand dollars could "afford such taste," and those of lesser means were encouraged to work toward such a level of refinement.[113] Advertisements for "sanitary china" even depicted the allure of social aspiration in motion, representing sleek tubular women shopping in a Trenton salesroom, looking as if they had just left Paul Poiret's Parisian boutique (plate 8). With plumage on their toque and turban emphasizing their attenuation and verticality, the connoisseurs crane their heads upward to scrutinize the elevated holy trinity of a sink, toilet, and bathtub. One even uses a pince-nez to admire the sleek anthropomorphic horizontal shapes that complement her figure. The image depicts the "romance" of male production and female consumption. The women's high-heeled elegance articulated the aristocratic pretensions of porcelain manufacturers.

Similar to the drawing, but in sanctimonious verbal terms, the Newark Museum proposed that clubwomen's consumption might elevate the moral and civic welfare of fellow citizens. The cultural institution depended upon the social network and capital of clubwomen (as in countless other American cities), so when it tactfully praised women as tastemakers with a far-reaching and lasting educational impact, the museum applauded a system of cultural

patronage that was only ten years old. Women's clubs were civic networks of volunteerism with great monetary power and concerted organization, so the museum's appeal for collaboration was opportunistic. The museum's invitation promised that "an interest from the women's clubs, displayed toward the industry would react favorably upon both public and manufacturer."[114] This strategy recognized that clubwomen were already rallied around similar moralistic terms of consumer engagement.

THE HEARTH

The gas log by Strait & Richards, the one artifact carried over into the museum in 1915 directly from Bamberger's 1913 Made in Newark spectacle, reconceived the fireplace with gas plumbing, and was a means of recuperating the traditional hearth as an emotional resource. The product suited the new era of central heating and limited domestic servants. Gas flames left no ash and required no manual labor, and therefore were modern laborsaving devices and also scientifically hygienic. They also sustained the apparition of preserving Anglo-American domestic ideals and extended the Colonial revival begun in the late nineteenth century.

Skillfully hand-modeled by the company's craftsmen, and produced in the thousands from molds, the gas log and the ceramic toilet were both emblematic of engineering new degrees of comfort and scientific hygiene, but they mapped antipodean domestic spaces. Public display of the hearth and privacy were diametrically opposed but linked solutions. Despite our emotional and psychological distance from the Progressive era, the social function of the hearth to generate coziness remains accessible. The ceramic logs had several functions, as a domestic icon, artistic home furnishing, and sanitary appliance. They represent a transitional period between handicraft and deskilled labor, serial and mass production. In 1914, Strait & Richards employed a dozen workers and sold approximately 12,000 gas logs, a respectable figure that demonstrates that they were a mainstream and affordable luxury. Customers could order either birch logs or driftwood, a forerunner of the artificially distressed accessory. Perhaps most important, the logs sustained a romantic attachment to the rustic fireplace amid city life. Significantly, this furnishing gained popularity when America was reaching the tipping point toward becoming an urban nation. An old site of dirty sweaty labor was reconfigured for a new ideal in leisure.

The gas log is the lone fragment of the 1915 exhibition still on permanent exhibition in the Newark Museum, but its significance is obscure today. It sits

in an elaborate fireplace in the Newark Museum's Ballantine mansion, the well-appointed late-nineteenth-century Romanesque palazzo built with the beer brewer's fortune that now showcases the decorative arts in period rooms. Like a fountain lacking water, the logs' functional capacity is camouflaged by inactivity. So is its origin as a middle-class solution to stabilize domestic expectations and desires amid changing technologies and the dislocation of so many into apartments. Fireplaces were important cultural symbols in the popular *Ladies' Home Journal* and *Bungalow Magazine.* They were a necessity prescribed by Gustav Stickley's *Craftsman* and Edith Wharton and Ogden Codman Jr.'s *The Decoration of Houses* (1907). And for Frank Lloyd Wright, who had a penchant for mantels inscribed with moral admonitions, the hearth was a site that retained the symbolic meaning of domesticity in the twentieth century. It was a building block he never cast aside.

The ceramic forms resemble actual wood logs and do fool the eye—which is why Newark's curator Ulysses Dietz has placed them in their current location (they are also up to modern fire code, unlike real timber). Made to appear naturalistic, but not to fool the viewer, the ceramic logs defy all "design reform" and modernist ideology about the need for "honesty" in architectural construction, clothing, and human character. Disregarding John Ruskin's principle of "truth to materials," the Progressive era commodity illuminates the way the Arts and Crafts ideology was transformed into a middle-class ideology of buying the simple life.[115] The ceramic commodity documents an intermediary ritual in which consumers negotiated nostalgia and modernity simultaneously and reconciled the contradictory impulses yearning for industrialization and the pastoral. The open fire, depicted in popular lithographs as the centerpiece in Anglo and Dutch seventeenth-century homes, still articulated primeval power; finally, it had been made safe and spark free, only thirty years after Chicago burned to the ground. Centuries of fear were technologically eradicated.

For the middle-class Newark apartment dweller, the logs like the sanitary ware in the exhibition nourished aspirations of home ownership. For that reason, both also suggested that Americanization could happen via the domestic accessory. The social dimensions of the fireplace as fulcrum of familial sociability, mythologized in numerous Wallace Nutting photographs and *Ladies' Home Journal* investigative reports, were available to be accessed or bypassed at the consumers' discretion, and could be tailored to different ethnic identities and types of families. Moreover, the consumer and discerning museum visitor helped Newark achieve its own ascendence when they bought these

locally made goods: citizens became "Made in Newark." Like the ceramic toilet, the gas logs uplifted the household aesthetically and technologically. These were acts of municipal housekeeping. Located in the Newark Museum beneath the terracotta image of James Whistler that was used to adorn the façade of a Manhattan art gallery and a Brooklyn school of technical arts, the ceramic log was a domestic and diminutive version of municipal enrichment. It conveyed the sentiment that there was a distinct American artistic genius and character. The fireplace logs were a way for the consumer to rationalize participation in modern progress on private terms.

MIRRORING THE CITY

Despite the explicitly ethical and moral interpretations of the artifacts and processes of clay work, the exhibition was predominantly a forum to teach that modern consumption was a salutary necessity. Several vases in the exhibition were on loan from Newark's own department stores, including Bamberger's, which received a note of gratitude in the catalogue. Louis Bamberger, museum and library trustee, sold the local Lenox and Fulper products that Dana praised as good examples of art-in-industry. Visitors to Bamberger's encountered the museum's posters advertising the exhibition hanging there, and they saw some of the same goods at both venues.[116] When visitors recognized Bamberger's imprimatur on the exhibition, they learned that museum-quality applied art was within their economic grasp. From a consumer's perspective, while the blatant commercialism of the Newark Museum owed much to the model of the Deutscher Werkbund, it was more clearly derived from Bamberger's strategies of displaying goods. The flow of commodities and exhibition methods between the cultural institution and the department store illustrates the ways that the museum became dedicated to consumer education, and calls into question whether the institution intended to increase visitors' autonomy or institute conformity through its attempt to be a tastemaker.

By virtue of its specific focus on ceramics, the museum's method of organization, what it called the "one-industry exhibition," differed from that of the department store, which prided itself on being an encyclopedia of modern products. The museum's display of historical ceramics was not a major distinction, as the department store also used relics as proof of progress, displaying some of Edison's earliest 1880 lamps alongside twentieth-century ones. The museum also indexed consumable goods and displayed them as meaningful parts of civic life. There was an implied scientific aspect to the cultural

institution's selections: a visitor encountered maps of clay beds, antique jugs and their inscriptions, and was invited to ponder the value of brick to fireproof the modern skyscraper. In the department store, artifacts were atomized in relation to individual consumption and individualized application, and came together under the rubric of being Made in Newark. While the museum might seem at first like an objective and empirical appeal to rational appreciation, it too, like the department store, used artifacts to appeal on the basis of highly charged psychological, ideological, and emotional impulses and ideals.

In gathering the 1915 exhibition from multiple sources, the Newark Museum forged a pluralist and participatory model for the modern American museum in which entrepreneurship, technocracy, and social engineering were agreed upon by all involved as the common ideological framework. The museum became a stage on which multiple views, even politically contentious ones, were aired out. If commercial entities used the museum as a theater for their own purposes, so too did the suffrage-inclined librarian. In 1915 and 1916, the American museum-quality artifact included for the first time a locally produced household fixture. The museum provided visitors with the pleasure of finding on display artifacts that they recognized as already familiar. The new museum idea began with consumer participation and self-realization, modeling cooperation and autonomy as contiguous efforts. An American museum took on pragmatic experiment: it was formulated as a tentative and contingent assemblage of artifacts and people, and in relation to its specific environmental context, the regional industrial city.

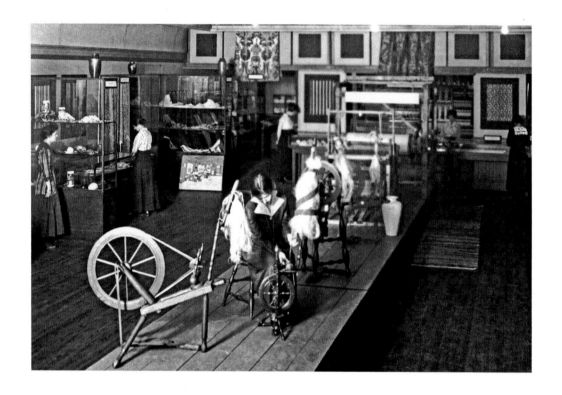

49. Craft demonstrations, installation photograph of Textile Industries of New Jersey exhibition, 1916. Commercial Photo Co., photographer. Collection of the Newark Museum. A long low plinth transformed the entire south gallery into showcase for craft demonstrations. Here, as on the cases, vases punctuated and added an aesthetic rhythm to the space and counteracted what Dana called "museum fatigue" and the "gazing collection."

Weaving the New into the Old

TEXTILE INDUSTRIES OF NEW JERSEY, 1916

> I believe that the ancient traditions of a people are its ballast.... You must
> knit the new into the old. You cannot put a new patch on an old garment
> without ruining it; it must not be a patch, but something woven into
> the old fabric, of practically the same pattern, of the same texture and
> intention. If I did not believe that to be progressive was to preserve the
> essentials of our institutions, I for one could not be a progressive.
>
> — Woodrow Wilson, *The New Freedom* (1913)

In February 1916, when the Newark Museum opened Textile Industries of New
Jersey exhibition, the display of silk tapestry and felt hats, hand-embroidered
shirts, and machine-knit socks realized John Dewey's claim that "you can
concentrate the history of all mankind into the evolution of the flax, cotton,
and wool fibers into clothing."[1] Among Progressive educators, textiles were
influential didactic devices suggestive of vocational and spiritual continu-
ity between the handcrafted past and industrialized present. The Newark
Museum, like President Wilson, seized upon textiles as an allegory for the
condition of the immigrant and his adoptive homeland, and the fluid social
relations between the individual and collective.[2] In the same period, William
James described education as akin to weaving: "The shuttle of interest will
shoot backward and forward, weaving the new and the old together in a lively
and entertaining way."[3] Although clothing was increasingly replaceable and
cheap, the 1916 exhibition held onto its potent symbolic implications. Cloth
could carry biblical references and signify economic and social distinctions.
Like Wilson's figurative patch and James's shuttle, the exhibition championed
simultaneous cultural preservation and social change. As in the clay show of
1915, the museum explained that material refinement was a metaphor for the
integration of society's constituent parts. The museum proposed that both
handicraft and machine production could be exemplary "object lessons,"
thereby sustaining the relativism in James's subtitle for *Pragmatism* (1907), "a
new name for some old ways of thinking." The attempt to synthesize ancient

and modern artifacts in Newark accommodated ethnic difference and boosted nostalgia for the American colonial era. Most significantly, for the first time the museum represented the symbolic body of Newark's laboring citizen as a woman.

The announcement for the Textile Industries exhibit, sent out to manufacturers in October 1915, promised it would be an educational and commercial survey of "cloth making, knitting, embroidery, rug weaving, felt hat making and allied industries"; on the cover of the brown pamphlet was an image of the representative face of the contemporary textile industry, a seated young woman in a red beret energetically reaching into her loom (plate 9). Finally, a woman had joined Seth Boyden in Newark's pantheon of mythical labor. The planar style of the two-color print disposes of details that would conclusively prove the worker to be a woman or at a hand loom, but the numerous red bobbins overhead, spools of thread, imply high-quality refined production as much as her body language suggests the necessity of manual dexterity. She tends the shed, the area where the upper and lower warp threads are open and the shuttle plies the weft. Her animated gesture suggests that she is a thinking worker, no mere attendant. She is quite unlike the women in Paterson's silk mills, each responsible for a dozen power looms, who were not valued for their artisanal skill and rushed about monitoring but not guiding the automatic machinery.

Articulating the museum's celebration of handicraft with a block print was apt, as Arthur Wesley Dow and Ernest Fenollosa were Americanizing *ukiyo-e* into widespread practice and encouraging a revival of the handicraft. The use of Cheltenham typeface inside the pamphlet indicates that the museum had printed the text in its own printing plant. Ever thrifty, the museum used the technology within its grasp, the same technique as to make Dana's print plate (see plate 4). The squat, compressed lettering and its architectonic integration into the composition, as well as the use of the brown paper for its middle tone, were sophisticated aesthetic choices, and would have been admired by connoisseurs who knew the modern German *Sachplakat* (object poster) popularized by Lucian Bernhard. If the lettering was fiercely avant-garde, the red beret endowed the worker with the romantic aura of a medieval or renaissance artisan. The pamphlet presaged that Newark's exhibition would idealize the labor of making textiles, and relate women to artisanal capital as never before.

The exhibition interpreted textiles as romances, a habit born of the museum's roots in the library and also the modern continuation of the Arts and Crafts spirit. Workers' self-improvement, refinement, and transmission

of heritage, as well as the ascendant machine, were all heroic tropes. As a material survey, the museum juxtaposed sentimental antiques, facts about the plunging cost of cotton, images of the ever-increasing scale of mechanized knitting, and microscopic photographs of wool fibers. The interpretive scheme articulated the distinctions between the processes of embroidery, felting, knitting, sewing, spinning, and weaving. Textile Industries became a forum to demonstrate each of these crafts. The performative emphasis of the exhibition illuminated the ways that methods of production were gendered. Textiles became politicized and spiritualized as artifacts and activities. Skill symbolized a host of meanings, from civic improvement to individual enrichment, from ethnic self-representation to its opposite, acculturation.

A SYNTHESIS OF INDUSTRIES

Patterning the exhibit after the survey of ceramics a year earlier, the museum included commercial, industrial, artistic, and historical textiles, but this time antique and contemporary artifacts were intermingled. The emphasis on performance increased, establishing the handicraft as a primary institutional method of education and interpretation. Instead of one lone demonstrator such as Enoch Bourne, who illuminated multiple techniques, there were many busy hands on view daily in the "Hand-work" section. In the central hall several types of spinning wheels and a clock reel were in operation, as well as six different looms, including examples of the Jacquard and heavy-timbered Colonial types. Distinguishing between modern recreations of Colonial rag carpets and ancien régime silk tapestry was part of the interpretive scheme. Devotees of handicrafts, amateurs—mostly women—and a few professional weavers demonstrated artisanal techniques, as Dewey had suggested to convey their universal value (figure 49). Newspaper reviews interpreted the demonstrations of industry in relation to Dewey's concept of educational synthesis and Wilson's aspiration to balance individual competition and collective cooperation. "One may find the weaver of tapestry using a small hand-loom taken from a quaint old shop someplace in the outskirts of New Jersey vying for attention with the manufacturer of silk from one of the largest Paterson silk mills," explained the *Sunday Call.*[4] From the 1916 exhibition, the Newark Museum purchased for its collection eleven pieces of "European peasant embroidery" and samples of mechanized artificial silk production, as well as highly figured ribbon made in Paterson, called "Silk City" or the "Lyons of America." These ribbons were woven on a Jacquard loom using a set of more than two hundred punch cards to guide the repeat.

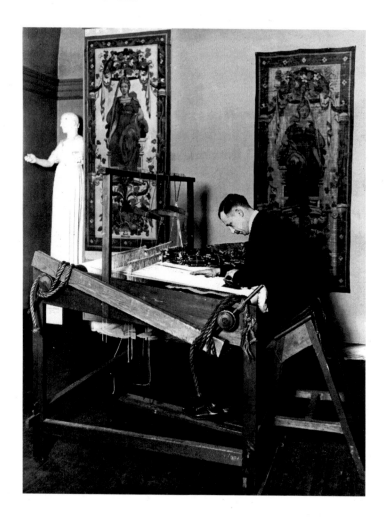

This range of "object lessons" from traditional and modern industries was considered desirable. Ancillary educational material included photographs of silk worms, displays of the sources of dyes, and specialized applications involving such innovations as fireproof asbestos cloth.

The diverse types of live demonstrations reflected the constituencies of the modern American metropolis. In one corner an "old Greek woman," Athene Vornazos, two years after her arrival in the United States, "occupied the post of honor on a platform while she spun thread with a bobbin." Nearby, a dapper French-born Alfred Gengoult, one of a dozen European-trained specialists who worked at Lorentz Kleiser's Edgewater Tapestries, wove elegant silk tapestry in a suit (figures 50 and 51).[5] One demonstrated a home industry, the other was a highly trained specialist in an emerging luxury trade. Simultaneously, the museum praised "peasants from Europe" and the highly

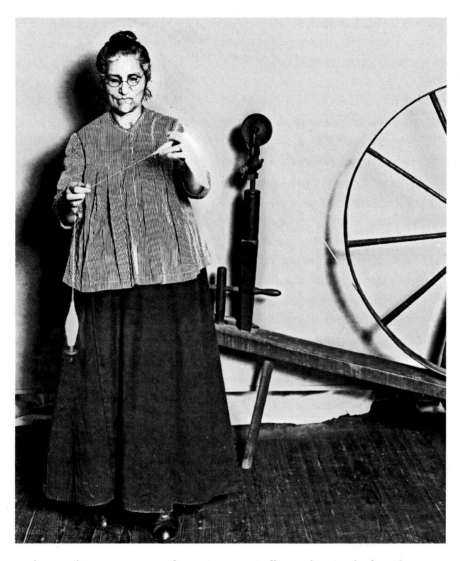

50. (opposite) Tapestry weaving demonstration, installation photograph of Textile Industries of New Jersey exhibition, 1916. Commercial Photo Co., photographer. Collection of the Newark Museum. Alfred Gengoult, representative of Lorentz Kleiser's Edgewater Tapestries, demonstrated the production of luxury goods that only the wealthiest Newark resident could afford.

51. (above) Spindle and distaff demonstration, installation photograph of Textile Industries of New Jersey exhibition, 1916. Commercial Photo Co., photographer. Collection of the Newark Museum. Athene Vornazos demonstrated the spindle and distaff, and was simply labeled an "old Greek woman" in several museum publications. The museum placed notices of her participation in Greek-language papers, in the hope that ethnic representation would lead to increased attendance and a sense of ownership of the public institution.

skilled and high-wage craftsman.[6] The former was carrying "the virtues of the past," while the latter was representative of the recent development of local firms patronized by the elite.

The commercial part of the exhibition aped Bamberger's 1913 Made in Newark exhibit remarkably closely. Collaboration bordered on collusion. Among the firms that were in both exhibitions were the Clark Thread Company, Newark Knitting Works, the Newark Rug Works and Oriental Rug Company, the Newark Embroidery Works, Newark's J. Rummell Company, and the Johnson, Cowdin and Company of Paterson. The Newark Museum's letter to Johnson, Cowdin asked them to contribute the same silk ribbon manufacturing machine and attendant that they had displayed at Bamberger's Made in Newark show. Although the request seems not to have been fulfilled, it attests to the museum's view of the store's show as an exemplary precedent.

Exhibiting artifacts from more than fifty manufacturers, the museum's classification scheme identified seven major types, clustering goods according to fibers and products, and New Jersey's economic strengths: cotton thread and knits, silk ribbon and tapestry, woolen garments, and hat making. Twenty manufacturers specializing in silk production represented Paterson, already past the peak of its expansion but still vital.[7] Hat making was one of Newark's assets, a five-million-dollar industry in which a dozen firms employed five thousand workers, 10 percent of the workforce. The Clark Thread Company was a nationally recognized name and had a massive factory in 1916, employing 2,700, almost 1 percent of the Newark's entire population and 5 percent of the workforce.

The largest and most ideologically significant change in orientation between the Clay Industries and Textile Industries exhibitions was the addition of a Homelands section, in which "Newark children of foreign parentage were asked to contribute, through the schools, textiles made in their home countries." Nineteen public schools answered the invitation to participate, and from these nineteen different ethnic traditions were selected as representative of Newark's population. Unlike the overall classification by manufacturing method, the artifacts were organized ethnographically. The subdivision of Homelands artifacts followed the conventional emphasis on national identity (and "schools") in art museums and on race in natural history museums and world's fairs. The term "Homelands" was applied to the city's "foreigners," lumping both European immigrants and African-Americans in this category (as did the city's charity maps). Each embroidered Russian blouse

or Norwegian hand towel functioned as a synecdoche for a class of Newark citizens and their culture. Looking at these textiles with a degree of wistful nostalgia, the museum explained "in some countries girls are still trained to spend the major portion of their time on the old-fashioned fetich, fine needlework."[8]

Textiles were explored as a universal necessity and pursuit, and the museum credited the organization of live demonstrations and the Homelands exhibit to The Contemporary, Newark's dynamic women's club. An examination of the museum archives makes it clear that the Textile Industries show cannot be attributed to a single curator, and that only parts of the selection can be attributed to the taste or control of Dana, the library director and secretary of the Newark Museum Association. Multiple agents populated the cultural institution's stage. On the one hand, it was an archive of current commodities, and on the other a forum for self-representation, albeit a tightly controlled and limited one. The contrasting methods used to select commercial and Homelands artifacts suggested that each reflected a distinct investment of social capital and was judged by different criteria. The museum became a web of relationships built upon trade, capital interests, and civic associations, and, to a lesser degree, a stage on which to enact the development of autonomy, particularly among enterprising women and ethnic minorities.

MODES OF AGENCY: PARTICIPATION, SELF-REPRESENTATION, AND INCORPORATION

Fifty thousand visitors attended the 1916 exhibition over six weeks, almost twice the number that had visited the ceramics survey the year before.[9] In retrospect, the show was the museum's high moment as a popular institution; annual attendance in the 1920s would struggle to reach one hundred thousand. To state that the Textile Industries exhibition was exceedingly popular begs the larger question of why. For decades, no other show so held the city's attention and involvement. The Newark Museum broadcast its message well beyond elite and middle-class audiences. In the nineteen-teens, fabric was an accessible metaphor for mainstream Americans, and the Textile Industries harped on its universality.

Locally, the industry was an important economic force. In 1916, 25 percent of all New Jersey factory workers were employed in textiles and several trustees owned firms. Trustee J. William Clark, president of the Clark Thread Company established in the mid-nineteenth century as an outpost of the Scottish empire based in Paisley, sent both cotton thread and employees to

the museum. Opening only three years after the deadly Paterson silk indus-
try strike, the exhibition's representation of collaboration between work-
ers and manufacturers was a symbolic achievement (and one that strategi-
cally ignored prior battles, such as that in 1893 at the Clark Thread works).
However, the exhibition's popularity cannot be ascribed solely to any one
constituency or dominant ideological vision. Three hundred different groups
from women's clubs, primary school children, art schools, and sales staff
from local department stores attended the museum. The 1916 textile exhibi-
tion had to precede the Newark Museum's 1928 stained glass window that
portrayed "Sewing." First the seamstress had to come into the galleries as a
performer. The varied interested sectors of Newark society mirrored the scope
of the museum's demonstrations and social networks, which were never
again so wide-ranging, even in later 1920s exhibitions about celluloid, leather,
and jewelry.

The excitement of the "live museum" demonstrations also explains the
large attendance. Contemporary observers attributed the success of the show
to the exciting sight of manufacturing rendered visible. Industry became a
lively spectacle. In light of the fact that film and radio would supersede these
types of visual displays in the next two decades, the 1916 museum exhibition
used a technological method that was at the apex of its allure. When asked why
his store did not continue with its publicity coup, the Made in Newark shows,
which had attracted hundreds of thousands of visitors, Louis Bamberger
merely stated "We outgrew it."[10] The store that had commenced eye-catching
window-dressing at the turn of the century with a coop of live chickens, later
built a radio station, WOR, to boost sales of receivers. Its advertising gambits
kept up with the changing pace and scale of consumer expectations. But in
1916, aping the department store, the museum latched onto a still accessible
cultural idiom. In the New Jersey Textile Industries exhibition, more than
ever before, the museum constructed a model of cultural literacy around a
preexisting method of consumer literacy. Newark's cultural institution and
its civic ambitions aligned with the immediate entrepreneurial horizon.

INTERPRETIVE SCHEMES
Historical Recuperation

The Newark Museum's interpretative schemes, seemingly contradictory,
reflected the range of its participants' investments. For instance, the "devel-
opment of the machine" was characterized as progress "from the primitive
loom of the savage to modern factory forms."[11] Simultaneously, antique and

obsolete methods were honored as spiritually enriching and worthy of recuperation. Visitors witnessed the workings of twentieth-century machinery, the Jacquard loom invented in 1801, and primordial utensils like the spindle and distaff, and were encouraged to value all of these as bearing reciprocal moral values. The "primitive" was needed in order to assert the "modern" and reinvigorate it, as the imperative to modernization remained undiminished. Nostalgia and pride in mechanical prowess cohabited in complex ways.

The exhibition called for reform but did not narrowly espouse utilitarian or evangelical interpretations of industry. In the mid-nineteenth century, John Ruskin had called for turning "honest thread into honest cloth," and Thomas Carlyle had validated manual labor in all-encompassing terms, stating "All work, even cotton spinning, is noble."[12] Their emphasis on the edifying and moral value of work lived on in the Newark exhibition. The *Sunday Call* interpreted the museum's display of antique coverlets as a "school for girls" and an example of the state of New Jersey "working out her salvation." These were heady words in February 1916, especially when New Jersey had voted down a suffrage referendum five months earlier. The tradition of seeing a work ethic as a vehicle for Christian deliverance dated back centuries, and in the debate over women's suffrage, domestic craft figured as a rhetorical trope with both progressive and retrograde aspects.

The section comprising old samplers, signed and dated, made visible the maturation of a young girl's virtues, her assumption of the right to use the alphabet, to count, to be a Christian, to assert fidelity to family and home. Although generic and formulaic in their invocations of biblical injunctions, each stitched piece suggested that individual acquiescence counted, and added up to collective goodness. Ten-year-old Ellen R. Mills's sampler from 1834 was deemed an exhibit of "pious industry," handicraft that implied civic ideals.[13] The Mills creation could also have been interpreted as fealty to a distinctly symmetrical domestic ideal. It was accented with classical Georgian ornaments. Today it can be read as a vernacular expression of an international neoclassical language of ornament. The sampler was a talisman of individual industriousness and educational uplift, as well as piety. Several museum publications and reviewers associated the antiques with "purity," charm imbued with spiritual significance. This view was based on their provenance, an era of purportedly greater cultural homogeneity and preindustrialized labor, two myths that remain part of twenty-first century sentimental hindsight. The museum suggested that the work of current immigrants evoked the skills of historical New Jersey pioneers, attributing moral value to all handicraft.

The New Jersey clubwomen, for their preservation of historical artifacts, won praise as custodians of virtuous domesticity.[14] Ownership and care were described as specifically gendered tasks in modern life: whereas the antique ceramics came from connoisseurs of both sexes in 1915, clubwomen alone supplied the historical textiles to New Jersey Textile Industries. For instance, a coverlet with the initials of its owner, Sarah Courter, was attributed to the hands of an itinerant weaver, "N. Young." Courter had worked a loom and spinning wheel, but the superior woven good required an expert like Young to complete because it was "above her own simple products." In the seventeenth century, the numbers of looms had been fewer than the spinning wheels supplying raw material. With industrialization, the household loom increasingly became a tool of moral edification and recreation. Moreover, the gendered quality of work often changed. Several antique textiles had patriotic mottoes or iconography, such as the eagle motif on the "Liberty and Union" coverlet made in 1834. The embroidery of the motif and its preservation were both overtly patriotic acts, imbuing it with a transcendent force. These historically evocative textiles were featured in museum publications and newspapers. New Jersey's valuable material culture poured into Newark, as if it really was a metropolitan hub and the keeper of the state's spiritual well-being.

Conserving Culture

Historical textiles and contemporary "home industry," like Athene Vornazos's homespun yarn, "primitive spindle and distaff," and hand-knit blankets, provided important educational lessons for the "salvation" of modern school children. In the eyes of advocates urging the conservation of "primitive" industry, such as Dewey, Addams, and Dana, "good" design—and especially historicist ornament—was the product of moral labor conditions, mechanized or not, and regulated commercialism. Lessons in "industrial democracy" that instilled the precise value of her "relation to the finished product" in a young worker, in Addams's view, elevated factory work above the affliction of divided labor and alienation.[15] The Homelands section of New Jersey Textile Industries was self-consciously patterned after Addams's Labor Museum, established in 1899, which aimed to preserve older methods of homemaking and domestic applied arts. The Newark Museum acknowledged the Labor Museum and its nascent cultural pluralism as a model.[16] While the antiques of affluent clubwomen taught one set of ideals in industry, the Homelands section, like the Labor Museum, celebrated the artisans of the city's ethnic and racial factions, and an entirely distinct value system.

The Newark Museum was proud of welcoming artifacts from so many "points of origin" and becoming a microcosm of the city's diverse industrious occupants.[17] Newark's superintendent of public education, Poland, authorized the museum to request school children to participate in the exhibition, and the museum's letter was multigraphed (by a portable copier with movable type) in over twenty languages.[18] Accessing a social network very different from the women's clubs, the museum used Newark's public school system and the pupils to penetrate immigrant enclaves. The new strategy was more direct than previous tactics of circulating printed texts through ethnic newspapers, churches, and welfare associations. More than 250 students lent artifacts, building into the show, in advance, a constituency of interested participants. The museum acquired these ethnic artifacts for nothing.

The emphasis on "everyday life" and the applied arts in the Homelands section permitted demonstrations of ethnic pride but also fomented civic solidarity. The museum's educational brochures explained that its exhibition would demonstrate that "the poorest immigrants from a distant land may have talents and ideals of art capable of transforming crude articles of daily use into things of beauty."[19] The exhibition contained Armenian, Chinese, Lithuanian, Polish, and Ruthenian artifacts, among others, representing twenty of Newark's minority immigrant groups.[20] In December 1915, students were asked to describe artifacts which represented their heritage, and they offered for exhibit a very broad array of domestic furnishings. For instance, elementary school student Sam Chetkin promised a Russian copper samovar, and Isidore Steinfeld a hundred-year-old Austrian brass hookah, a smoking pipe. From this query, the museum selected artifacts for the spring textile exhibition. Russian blouses embroidered with butterflies, Roumanian blouses with geometric cross-stitching, and Jewish prayer shawls (*tallit*) and bags for Passover bread (*matza tosh*) were a few of the goods granted recognition.

The "primitive" arts of foreigners comprised a benchmark to confirm the rest of Newark's progress, and establish a course for immigrants' future refinement. Placing "everyday life" in an evolutionary perspective, the museum appeared to interpret G. Stanley Hall's recapitulation theory to mean that students should relive the rise of "progress" from "primitive to industrialized society." The decision to classify all immigrant textiles by race and nation in this manner was an aspect of the Homelands exhibit that reveals its intellectual origins in nineteenth-century imperialism.[21] Moreover, artifacts from "foreigners" were not accorded interest in terms of the conditions of their production. While the sampler from 1834 was credited carefully to a ten-year-old,

Ellen Mills, broad cultural labels such as "Russian," "Jewish," "Roumanian," and "African" were used to classify Homelands artifacts. Insofar as it was evidence, a Russian tea service was closer in value to an ancient Anasazi pot in the 1904 world's fair than to Mills's handicraft.

The praise for "old-fashioned fetich, fine needlework," combined two contradictory frameworks, "innovative nostalgia," a transfer of moral aspirations onto aesthetic artifacts, and "imperialist nostalgia," sympathetic condescension toward the "other."[22] The Homelands initiative applauded the value of a pluralist city and yet also issued a dual-pronged paternalistic mandate, that immigrants welcome each other and see their "folk" origins as secondary to their new context. A message of civic unity prevailed. Each artifact and installation seemingly responded to the cultural institution's mandate that citizens subordinate themselves to Newark's identity.[23]

Progress through the Revival of Handicraft

"Modern" handicraft dominated the demonstrations, receiving far more attention than the knitting machine, awesome for its rapid speed and rate of production. The craft revivals included spinning, weaving, and tapestry, the latter a decorative tradition with regal European associations, a novel industry in the United States. These products were influenced by the American Arts and Crafts societies that had sprung into existence at the turn of the century, but also by Gilded Age patronage.

In the Newark Museum's gallery, Alfred Gengoult was installed at a loom with a six-foot-high cartoon and a finished length of silk tapestry above his head to convey a sense of both product and process. Unlike Jacquard looms programmed to create complex repeated patterns mechanically, he was essentially painting with silk fibers. At the low-warp loom, he looked down through the tapestry in progress at the cartoon below to guide his shuttle as he chose from dozens of colored threads. The large woven image of a female divinity behind him was destined for a Beaux-Arts courthouse, city hall, or mansion designed by the likes of McKim, Mead, and White. The Sibyl or muse ensconced in a canopy of classical architecture and floral garlands was one of a pair to be mounted symmetrically, a glimpse into undreamt of opulence for the average exhibition visitor.

The word "tapestry" represented the maturation of elite craft in 1916, and signaled a modern emulation of courtly ornamental art produced in Brussels and Antwerp centuries earlier. When the Newark exhibition opened, Lorentz Kleiser had established Edgewater Tapestry Looms in New Jersey only a few

years before. It styled itself the "American Gobelins." The modern silk tapestry was an exclusive luxury product with a limited audience. Although it was the fruit of decades of slowly developing patronage, it was hoped to be the commencement of a new and enduring American tradition. When Candace Wheeler had sold a product called American Tapestry in the 1880s, in the aftermath of the Centennial Exposition, she peddled the appearance of a novelty more than the genuine article: her production was embroidery enriched with metallic threads.[24] Wheeler flourished by collaborating with Stanford White and other well-connected designers and architects. Commissions for private castles at the end of the nineteenth century spurred entrepreneurs like Kleiser to believe there was cause to establish American production. Tapestry required a great deal of expertise and significant capital. Kleiser had gained experience working for the firm of Herter, interior decorators who for five decades adorned the residences of Vanderbilts and other extremely affluent clients with imports from Europe. Edgewater Tapestry Looms' employees numbered a few more than a dozen, and Gengoult was one of the workers Kleiser enticed to relocate from Lyons. The museum exhibition also featured two *bergère* chairs upholstered with the firm's fabric to suggest the grandeur now made in New Jersey. The production of a tapestry by a modern local firm was a manifest sign of progress in industry. A score of such tapestry companies were listed in the New York City directories of the twenties, although none survived the Depression. However, before Kleiser's firm disappeared, The Contemporary commissioned a large weaving of Newark to commemorate the founding of that city.[25] The tapestry was a vehicle valued for its ability to articulate public ideals.

In contrast to Kleiser's refined goods, Amy Mali Hicks demonstrated the revival of the rag carpet, a Colonial tradition, and Anna Nott Shook and Emily Smith showed off a patented portable "crafts loom for the home," a low-tension instrument a quarter of the size of Gengoult's (figure 52). Shook also displayed some of the brown and beige Mission-style runners that she had sold when her studio was in the Craftsman Building on Thirty-ninth Street in Manhattan, Gustav Stickley's "Mecca for home-builders and home-lovers." The American Arts and Crafts movement peaked as a high-brow fashion trend when this building opened in 1913, and began to atrophy when it folded in 1916. But Stickley's bankruptcy and Elbert Hubbard's death on the Lusitania did not put a brake on the movement's aesthetics. The three women weavers in Newark's exhibition maintained a vocabulary of conventionalized geometric ornament in a quiet earth-tone palette. Whereas Gengoult's silk

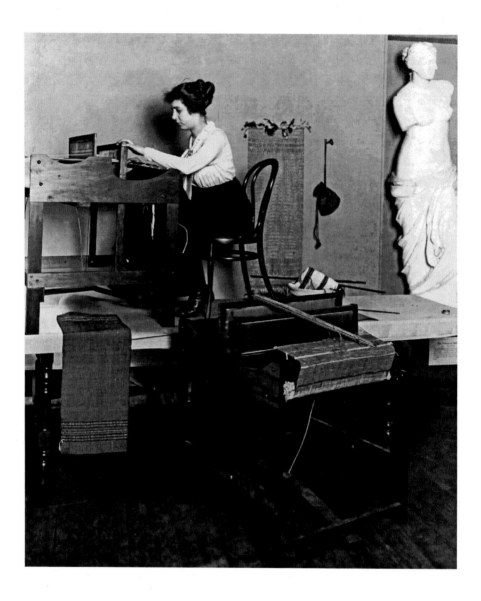

52. Homecraft loom demonstration, installation photograph of Textile Industries of New Jersey exhibition, 1916. Commercial Photo Co., photographer. Collection of the Newark Museum. Craft looms were another important example of contemporary production, and here weaver Emily Smith works, with A. Nott Shook's Homecraft Loom in the foreground. These were forerunners of the contemporary DIY (Do-It-Yourself) movement, and Shook advertised her loom design as a space-saving device compatibly proportioned to apartment-dwelling life. Note the plaster cast of Venus at the far right, a sign that the Newark Museum balanced its innovative exhibitions with conventional ones, and that the sense of temporary makeshift exhibitions was a constant in the years when it was camped out in the library.

tapestry was pictorial and sleek, and shimmered reflectively, Shook's weavings were intentionally wrought of rough fibers, and intended to ornament smaller spaces as accessories, not hold the wall as icons.

Amy Hicks later published *The Craft of Hand-Made Rugs* (1936) and Anna Shook produced *The Book of Weaving* (1928), both texts that praised the Arts and Crafts ideals of William Morris and yet admired even more the aesthetics of American Colonial production, in which ornament was more restrained. They urged fellow women to embark upon the crafts as a worthwhile investment. While Edgewater Tapestry Looms was based upon the notion that America's budding empire needed splendor, Hicks and Shook produced and valued hooked and other rugs that emulated Navajo and Anglo Colonial-era patterns. Indigenous textiles ceased to be emblems of threatening cultures and became synecdoches for a chthonic American ethos, to the degree that when Theodore Roosevelt decried Cubism as a degenerate "lunatic fringe" in his review of the 1913 Armory show, his example of healthy art "from the standpoint of decorative value, of sincerity, and of artistic merit" was "a really good Navajo rug."[26] Selectively adapting Morris's notion of vernacular craft to American archetypes, Hicks and Shook saw their work as suitable for the contemporary American home and woman. Moreover, they were aware that the modern hand weaver would most likely be an apartment dweller, and promoted the small size and portability of their looms to win over hobbyists, as newspaper reviews noted with appreciation.

The female art-weavers affected rusticity, whereas Edgewater Looms aspired to urbane elegance, but these were not incompatible. Shook sold her space-saving handlooms from her midtown Manhattan atelier, reinventing the cottage industry in the skyscraper. Her product adapted and recuperated historical traditions, and was seen as distinct from recapitulation theory because the work was not an attempt to modernize the "primitive" mind. Tapestry weaving had historically been a male occupation, but Hicks claimed to weave as "our grandmothers and great-grandmothers" had. Perhaps what is most dissimilar to the contemporary art exhibition is that none of the weavers claimed to devise original designs. Artistic virtues lay elsewhere. The tapestry was judged in relation to its historical accuracy. Newark's museum and its newspapers regarded each of these individual craftsworkers and their methods as signs of progress in art.

Industry as Emancipation

Hicks called for women's self-employment as the means to realize autonomy. Her words echoed those of Charlotte Perkins Gilman, and, more specifically in her praise of handicraft, Harriot Stanton Blatch, daughter of suffrage pioneer Elizabeth Cady Stanton, whose 1905 article titled "Weaving in a Westchester Farm" had described her idyllic life to readers of *International Studio*. Blatch advised that "the crafts shop with its greater possibilities of freedom for the worker may possibly be the solution of the problem of independence for the mother of the race."[27] In 1898, at the convention of the National American Women's Suffrage Association in Washington, D.C., she celebrated "the spinning and weaving done by our great-grandmothers in their own homes."[28] Reiterating Ruskin's idea of "joyful labor," she infused it with an essentialist view of a society in which "women . . . are responsible for the human relations within each industrial social or domestic unit." She offered no guidelines to women who worked as wage earners. Emphasizing "spiritual wealth," much as Addams had theorized industrial education, Blatch argued, "All the leading economists have come to admit that the product of the housewife's energy, though not sold or paid for, is wealth." She saw handicraft as a solution for "nervous disorders," "degeneracy of the race," and, again in harmony with Addams, as a way of redeeming industry from "drudgery." Although Blatch described weaving as a means of establishing autonomy, she herself was already liberated by her affluence.

Although she was considered a militant when she was the New York City director of the Women's Political Union, Blatch's opinions diverged little from the mainstream mass-produced magazine *Ladies' Home Journal*. Edward Bok, the editor, invited Jane Addams to argue on behalf of women's suffrage in its pages, but his editorials consistently disputed the value of granting women the vote, contending that their job was the integration of new "revolutionizing business methods" and "greater efficiency" into domestic industry. Bok told his female readership that it was their duty to transform work so that "housekeeping is no longer drudgery."[29] Similarly, weavers Hicks and Shook emphasized their joy in being industrious, and embraced the domestic sphere as the appropriate context in which to express themselves.

The modern women art-weavers advertised their wares and skills as individual entrepreneurs. In the 1916 Textile Industries show, however, elite members of The Contemporary with no skill volunteered to reenact the spinning of wool on stage in the museum (figure 53). A memorandum notes the decision: "to teach the club ladies spinning" was an assignment that The

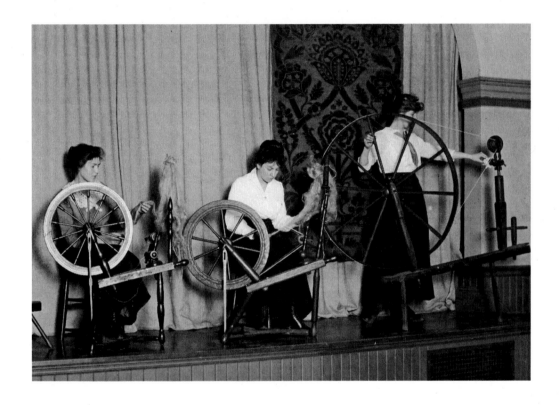

53. The Contemporary clubwomen spinning demonstration, installation photograph
of Textile Industries of New Jersey exhibition, 1916. Commercial Photo Co., photographer.
Collection of the Newark Museum. The Contemporary clubwomen spinning on a
raised stage document the role of volunteers and especially women in interacting with
the public and making the museum exhibition educational. The women here had no
prior manual skill at spinning, and practiced to serve in this capacity. The auditorium,
planned for the library to hold lectures, became a physical theater of craft, a site for active
experiential education.

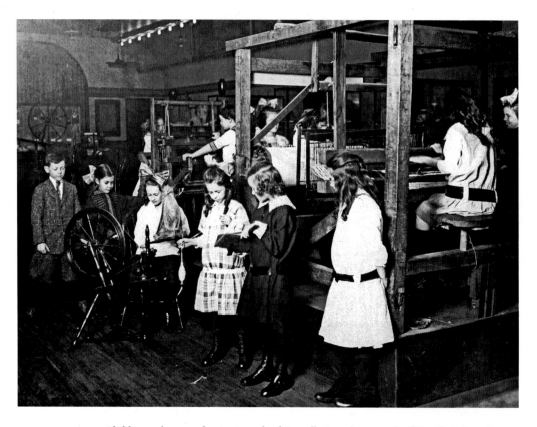

54. Children at loom and spinning wheel, installation photograph of Textile Industries of New Jersey exhibition, 1916. Commercial Photo Co., photographer. Collection of the Newark Museum. Did children visiting the exhibition handle the loom and spinning wheel, or merely pose with these tools? The Newark Museum consciously designed these images as an argument for what museums could be.

Contemporary undertook in late 1915.[30] Performing with a reel and great wheel borrowed from New Jersey Historical Society and three additional treadle wheels from local residents, four women, all attired in long black skirts and white long-sleeve blouses, demonstrated historic techniques. What sort of work ethic was being generated if no finished goods were being produced? At first, these volunteers seem to stand in contrast to Blatch's explanation of the correlation between economic, social, and artisanal capital. However, their performance reaffirmed the therapeutic value of manual labor. The tenacity with which the clubwomen pursued their volunteerism suggests that spinning was a means to affirm their value as good citizens.

The labor of the clubwomen volunteers was a spiritual antidote to materialism, modern alienation, and immoral leisure, and a didactic lesson that had

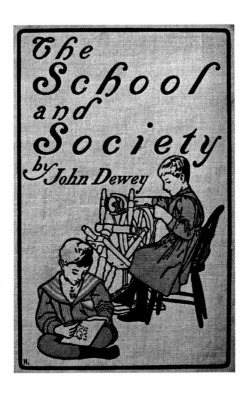

55. John Dewey, *The School and Society* (Chicago: University of Chicago Press, 1899), cover illustration by Frank Hazenplug (1873–1931). Hazenplug's image suggested that manual dexterity was a tool to teach diligent citizenship, and the image informed the Newark Museum's choreography of the children's bodies in figure 54. The museum's educational consultant Louise Connolly knew Dewey's work, required reading among progressive teachers, and might have choreographed the photograph herself, for she used it in her publication "Children at the Exhibition."

Newark's schoolchildren for its prime target (figure 54). The Contemporary's *Year Book* stated its mission "to awaken a more general appreciation of the imaginative forms of recreation," and the textile demonstrations realized this objective that corresponded so closely to Addams's and Dewey's pedagogical goal.[31] The museum demonstrators differentiated modern "drudgery" from "honest labor." Industrial education sanctioned child labor as noble. Photographs of children visiting the museum's spinning wheels pictorially communicated this distinction, and bear close resemblance to the image of innocent work that Frank Hazenplug composed for the cover of Dewey's *The School and Society* (1899) (figure 55).[32] There too, handiwork was expressly modern. Also in the exhibition were the Jacquard weavings of Clara Stroud, a teacher at Fawcett School, and her students, as well as a loom loaned by the Paterson Textile School. Demonstrations and completed artifacts were visible proof of uplift.

Similarly, the basketry and weavings made in the New Jersey Essex County Hospital (in Cedar Grove) and the New Jersey State Reformatory for Women (in Clinton) were imbued with moral weight. These products of rehabilitation were signs of redemption. To a degree, this correctional labor

stood parallel to the educational work of The Contemporary club. The baskets had value not because they were aesthetically remarkable or commercially viable but as manifestations of the new educational system. Like Maud Mason, Stroud taught virtue to Newark's students of industrial education, not merely vocational skills. If the handiwork of The Contemporary club and state prisoners were bound to the same moral logic, they were still distinguished by class-bound notions of labor. The aesthetic similarities located them as products of amateurism, and granted the milieu respect. They were made outside of the mainstream economy and yet accessed its visual language, either as style or ideal. Amid this aesthetic homogeneity and these confusingly hieratic economies, industry remained a cynosure, a morally upright response to the problems of modern life.

The museum staff of two librarians facilitated the work of The Contemporary's volunteers and the art-weavers, and occupied yet a third type of compromise between wage earning and uplift: autonomous expression and self-sacrifice. Working off-stage, the librarians have been overlooked because of their voluntary sublimation and subsidiary status in the cultural institution. They inventively seized on advertising as moral instrument in support of suffrage, perhaps with even more of a popular touch than Dana used for his causes. Newspapers photographed Winser and Connolly on a forty-one-town hike, a campaign to raise political awareness. Working together as the chairs of the Suffrage Baseball Day Committee, they used the national pastime as a vehicle of propaganda. The Women's Political Union distributed free tickets to a game on 25 June 25 1915, and had the players hold up banners. They also gave away pins and leaflets, such as reprints of Jane Addams's essay in the *Ladies' Home Journal*.[33] They did this with the blessing of their supervisor, Dana, who, along with Superintendent Poland, was on the advisory committee of the Women's Political Union. Connolly, who taught a ten-lesson course in "Suffrage Argument" for two dollars, and offered herself as a free lecturer on "The Social Conscience," was motivated by personal experience. She and Winser were publicly aligned with the movement, marching in Newark's suffrage parades in 1912 and 1914. The librarian who was chair of club activities, Kate Roberts, was a hostess of one of many suffrage open house events.[34] Meanwhile, Dana wrote curmudgeonly editorials claiming improvements in education were necessary if suffrage was going to bring about positive change, finessing a political position that was distinctly at odds with that of several trustees. Nevertheless, Winser had Dana's public support when Mayor Thomas Raymond appointed her to Newark's Board of Education in January

1915. She was the first woman member. In 1917, Dana publicly chastised the city's Board of Education in 1917 when they censured Connolly, who had supposedly questioned the necessity or value of reciting the Pledge of Allegiance.[35] Newark was gradually but uneasily dealing with its progressive feminists.

In the winter of 1915–1916, many New Jersey clubwomen and Newark's librarians were smarting from the failure of the suffrage referendum and the confines of municipal housekeeping. Arguments both for and against suffrage revolved around key terms such as "industrial efficiency," "industrial conditions," and "industrial welfare." The New Jersey State Federation of Women's Clubs had endorsed suffrage between 1906 and 1909 and then backed away from the issue when it began to divide the membership.[36] Women's suffrage was still not inevitable. Politicians obscured the issue: President Woodrow Wilson claimed that he would vote yes on the matter as a "private citizen," and deferred to state's rights, designating it a regional issue instead of a universal moral one.[37] In contrast to Wilson the Democrat, the Republican candidate for president in 1916, Charles Evans Hughes, had declared himself in favor of suffrage. In October 1915, just as planning for the Textile Industries exhibition was going into high gear, thirty thousand women had paraded in New York City for the right to vote. On 19 October 1915, only 15 of 189 districts in Newark voted to advance women's suffrage. The city was anti-suffrage.[38]

As the author of the interpretative lessons for the Textile Industries exhibition, Connolly drew on the ideals articulated by suffrage leaders such as Blatch, who described "the crafts shop" in terms of "freedom for the worker" and "independence for the mother of the race." Yet she occupied a very different social station and advocated her political opinions outside of the library or in the form of vague emotional entreaties to visiting elementary school students. The librarians and members of The Contemporary appear to have agreed with Blatch's and other suffragists' arguments, but viewed their own labor in the cultural institution within the framework of maternal duties. In this way, the ethic of "municipal housekeeping" found diverse variants of expression but maintained a collectivist aim. Amid her suffrage campaigns, Winser also became the first honorary member of The Contemporary, suggesting that the mission of civic uplift was a common denominator between the clubwoman and librarian.

Connolly was a rarity in that her insubordinate thoughts slipped into the museum archives. Amid the correspondence concerning the Homelands exhibit, and battling against the malaise after the defeat of suffrage, she wrote "Truly when the suffragists' chorus rises, 'You can't represent us, for you

don't understand us,' the observant man is constrained to admit there may be something in it."[39] Reenacting a work ethic with a spinning wheel might seem like an oblique strategy to campaign for women's autonomy and even suffrage, but the use of the museum as a stage to achieve self-representation brought these distinct perspectives and groups into coalition. The display of labor, like Boyden's statue outside, was intended as a metaphor.

RECONCILING MUSEUM AGENT, ARTIFACT, AND AUDIENCE

Newark's cultural institution was a small-town affair, and nowhere is this more apparent than in the archival evidence of the involvement of the J. Rummell and Company and the extended members of this family business in the textile exhibition. The Rummells supplied the exhibition with artifacts and also shaped the institution's interpretive message. Seeking examples of hats, the museum corresponded with Alfred T. Rummell, the secretary and treasurer of the felt hat company that his parents, Jacob and Lena, had founded after they emigrated from Hesse. The fifth largest of Newark's six big hat-making firms (in terms of employees), Rummell's display occupied the most space in the exhibition. Their work was laid out as a visual narrative, a fifteen-foot storyboard of three-dimensional objects showing the stages of felting and more than twenty-five different types of hats in production (figure 56).

Katherine Rummell, Alfred's cousin or sister, lived in the same house as his father, Jacob Rummell, and was a pivotal participant and organizer of the exhibition. She was thirty-four, a decade younger than Alfred, unmarried, as she would remain, and a member of The Contemporary of Newark. A woman of means interested in the mission of uplift, she was an Associate Member of the Newark Museum Association between 1915 and 1920. She is remarkable because she chaired the clubwomen's efforts to gather the Homelands artifacts, historic textiles from the regional women's clubs, and coordinated the spinning and weaving demonstrations in addition to leading educational tours. Retracing what Addams would have called Katherine's "lines of activity," one can see a modern woman engaging in cultural volunteerism as a social and intellectual activity and perhaps as an outlet for political expression and a vehicle to raise her status. Although the precise ideological meanings of Rummell's work can probably never be ascertained, she dedicated an immense investment of time and energy in weekly and sometimes daily meetings. She remained an active member of The Contemporary into the 1920s, and, unusual for the unmarried female of the era, bought a house at a

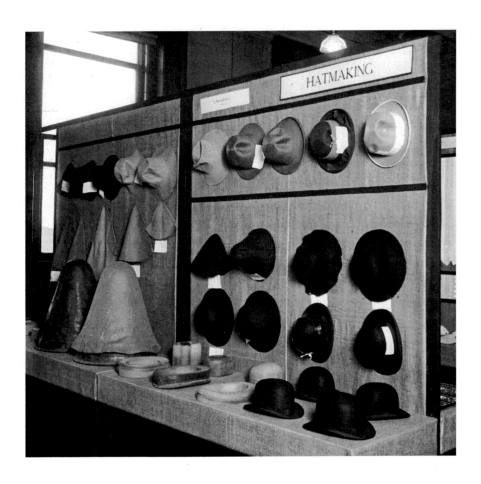

56. Hat manufacturing display, installation photograph of Textile Industries of New Jersey exhibition, 1916. Commercial Photo Co., photographer. Collection of the Newark Museum. The Rummell Hat Company's display was the largest space dedicated to a single factory, probably because it demonstrated processes more than finished products. The process of turning rabbit fur into hats emphasized refinement. The German American family had one member active in the museum as volunteer, in addition, a sign of Newark's intimate scale and the reliance of the institution on individual investment.

fashionable address on Lincoln Park where she housed ten boarders. She had an unusual relationship to industry, "municipal housekeeping," and ethnic identity, and, while not unique to Newark, she embodies so many of its distinctive features.

As representatives of Newark's newly minted social capital turning outward to civic engagement, the Rummells are compelling. They were not one of Newark's first families; their wealth did not elevate them into mansions or make their name household brands. But the Textile Industries exhibition would not have happened in the same way without their assistance at each step of its unfolding. The Rummells, like numerous other Newark German Americans, had undergone a process of Americanization and gentrification between 1850 and 1915. Like Bok, the editor of *Ladies' Home Journal*, whose autobiography, *The Americanization of Edward Bok* (1921), celebrated the rise of a "Dutch Boy," the Rummells would have seen the term "Americanize" in a positive light.

The story of Rummell industry in Newark begins with Jacob's establishment of the family firm in the second half of the nineteenth century. Alfred maintained the firm under the family name until the mid-1930s, when he died and it passed out of the family's hands. Several members of the family worked in the hat trade in the late nineteenth century, and by 1900, the Rummell firm employed more than two hundred workers. The German-American community that settled in Newark the mid-nineteenth century had accumulated substantial capital by 1916, and were differentiated from the immigrants who came from southern and eastern Europe and brought fewer skills, ones that were less compatible with Newark's urban economy. In 1910, Jacob employed two African American servants and Alfred one. Perhaps the clearest sign that the family status rose was the enrollment of Alfred's son Leslie in Cornell, from which he graduated in 1916. In a few generations, the family gained entrance into American institutions and developed entirely new expectations. While Jacob's wife Lena was the Rummell company's bookkeeper, his daughter-in-law Katherine was freed from work, and belonged to a circle of benevolent clubwomen intent on charity work and social uplift.

Both Alfred and Katherine were born in America and were beneficiaries of Jacob's journey and rise to wealth. Both saw the museum as a worthwhile cause, and both helped it and used it in their own distinct way to legitimize themselves in their communities. Alfred was not skilled in handicraft the way his father had been. He was a manager of craftsmen who maintained the firm's Manhattan office. His wife was not German, and he seems to have been the

first in the family to marry outside of their ethnic group. Katherine collected American antiques, and through her volunteer museum work in Montclair and Lambertville came into contact with clubwomen who had a genealogical investment in coverlets and samplers. Several of them wrote about their heirlooms and ancestors, none about their family factories. On the other hand, Katherine also worked with the participants of the Homelands exhibition and collaborated with Newark's less affluent and recent immigrants. Furthermore, she actively demonstrated handicraft as a museum educator but seems to have never worked in the family firm. The romance of handicraft and autonomy were linked in a disorderly relationship.

The Rummell factory was representative of the museum's definition of industry in Newark in 1916. It was of a respectable scale, employed a few hundred workers, and produced artifacts of everyday life that signified social affiliation and a degree of elegance. Extensive didactic descriptions documented the degree of hand finishing involved in the felt hatmaking enterprise. The museum staff considered the Rummells' display one of the highlights of the exhibition: "class after class stood spellbound before this group of simple objects, whose advantage over the motion picture lay in the mental activity provoked in the observers." Dewey's idea of active, not passive learning was being enacted. Yet the museum's educational brochures explained in detail the complex process of transmuting raw rabbit fur into an object of luxury:

> The unfelted hairs were shown; the perforated revolving cone to whose surface they were drawn by suction . . . ; the resultant thin cone of crisscrossed hairs, ready to be shrunk by wetting and heating; the various stages of smaller and thicker material, down to the compact, unformed felt hat; the dyeing, and pressing, and stiffening, and binding, and lining, until the hat of commerce emerged, final form of a handful of rabbit's hair.

This narrative of refinement was rife with implications of recapitulation theory and the promise of social advancement.

The Rummells' product signified social respectability. Newark's production of felt hats dated to the arrival of German artisans in the 1840s and 1850s. Moreover, in turn-of-the-century Newark, the felt hat was regarded as a particularly German accessory, so much so that in July 1906, the *New York Times* admired a *Sängerfest* audience of two thousand in relation to the commodity. The crowd in Newark was described as "faithful to the gray soft felt

hat familiar at German gatherings," as if this accessory differentiated them from other Americans.[40] Cheaper wool felt hats were also being made and exhibited, but the J. Rummell Company's handicraft stood in distinction to mass production.

Since Rummell was neither the largest nor most elite of Newark's hatters, its prominence in the exhibition warrants speculation. The firm became familiar to the museum through its participation at Bamberger's Made in Newark show of 1913 (corroborating the argument that the museum directly emulated the department store). The letters between the museum and firm betray no familiarity, and retain a formal mode of address. As a manufactory of artisans, the firm embodied both "honest labor" and civic enrichment. Like ceramics, felt hat making was a field of production that did not evoke the specter of strikes and disagreements between capital and labor. Publications about the exhibition kept afloat abstract ideals such as the "dignity of labor" and "industrial democracy," autonomy and social unity, carefully avoiding conflict with what William James called their "sticky edges."[41] The mainstream media met this idea with increasing skepticism. "All spouting about the beauty and dignity of factory work is mere moonshine," the Saturday Evening Post had stated in 1912, but among reformers evangelical fervor remained undiminished.[42] The museum focused on materials more than workers' conditions to navigate this dilemma. The Newark Museum's aim to gloss labor with Morris's ethical rhetoric and combine it with Taylor's "scientific management" emulated the pragmatic solutions articulated by reformers such as Louis Brandeis and Jane Addams. These reformers accommodated to the proposals that "day-light" factories improved labor conditions and that a rational "government by fact" increased upward mobility. The museum exhibition held out the Rummell factory as exemplar. Newark's sweatshops went unmentioned. The felt hats also reconciled artistic quality and commercial production. Whereas Arts and Crafts apologists like Amy Hicks repeated stories of the "degeneration" of the "critical senses" in the mid-nineteenth century, the Rummell firm's production manifestly contradicted this characterization as well as the social implications born along in the word "degradation."

A beneficiary of both immigrant skills and Americanization, Katherine Rummell was a link between "folk handicrafts" and modern entrepreneurial manufacture. In her duty as chair of the Homelands initiative, when she gathered representative textiles from "immigrants," she acted as an intermediary who plied the liminal space of the hyphenated citizenship peculiar to urban America. Several reviewers saw the Homelands exhibition in relation

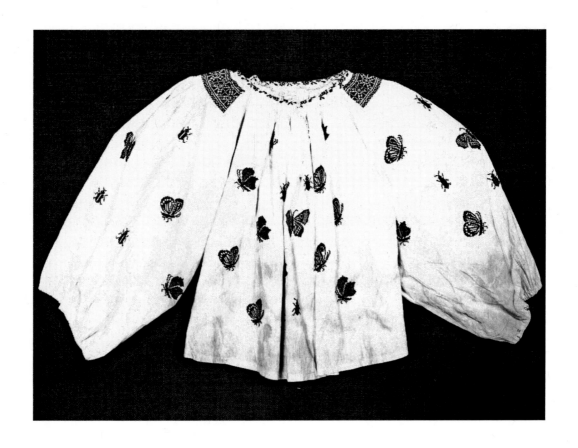

57. Russian blouse, in Textile Industries of New Jersey exhibition, 1916. Commercial
Photo Co., photographer. Collection of the Newark Museum. The embroidered cotton
blouse was in the Homelands section of the exhibition, therefore on loan from one
of Newark's Russian families, and valued for its rustic associations and exemplary
preservation of the "peasant" arts.

to Americanization, a process that at the time was ambiguous. In judging the crafts, the *Sunday Call* quoted the opinion of Mary Antin, whose own immigrant journey was the basis for her autobiographical novel, *Promised Land*, and who said the Homelands exhibit "perhaps best of all, will help direct the process of Americanization, so that the best of the native qualities is retained."[43]

Alfred and Katherine Rummell bring into focus the debate over whether America would be a "melting pot," the title of Israel Zangwill's 1909 play, or Horace Kallen's "symphony of dissonances."[44] It is impossible to gauge their own view of Americanization, but in light of Katherine's membership in The Contemporary, and Alfred's correspondence with the museum, it seems they thought that they were raising their status in Newark and moving beyond the limitations of their immigrant parents. Scholars have perpetuated Horace Kallen's chauvinistic view of Antin's acceptance of acculturation, but her autobiography, *Promised Land*, which celebrates explicitly America, describes the dangers of assimilation, as well. She wrote unequivocally, "Disintegration of home life is part of the process of Americanization."[45] In hindsight, in an era of limited self-expression, the theater of craft gave women a vehicle to recuperate cultural identity under the aegis of municipal enrichment. The discrepancy between the two explanations of Americanization illuminates the indeterminacy in Woodrow Wilson's allegory: his words could be read as a demand to assimilate or to recognize the value of ancient traditions. Simultaneously, Katherine staged a Colonial past that was entirely fabricated and foreign to her own family identity when she voluntarily learned to spin wool on a wheel. The museum's ideal of "learning by doing" entailed a complex negotiation for the clubwomen, and so did its praise for the crude stitching of butterflies on Russian cotton blouses collected from a fifth grader (figure 57). Women, in particular, acted as intermediaries to link diverse concepts of industry and distinct constituencies.

The idea of a Homelands exhibit was born in settlement houses, and even there its political intentions or ramifications were not clear, as the process of ethnic identification was at odds with a message of assimilation.[46] The Herron Institute in Indianapolis, originally geared toward fine art, began to display such artifacts of everyday life in 1915, and the trend grew. By 1919, the Albright Art Gallery in Buffalo, the Memorial Art Gallery in Rochester, the Worcester Art Museum, and the Cleveland Museum of Art used the Homelands title and format as a way to welcome "foreign-born residents."[47] While earnest goodwill was intended in these overtures, in hindsight the spectacles served the institutions in search of a constituency as much as it helped the local

immigrant populations. Grafting the concept onto a cultural institution did not clarify its enigmatic politics of acculturation and ethnic identification. Local adaptations of the term and vehicle utilized performance and redramatization to very different purposes, and presented very distinct notions of cultural activism.[48] As I show in the next chapter, the Homelands exhibit was repeated in Newark later in 1916 in a very different context.

COOPERATION AND CONSUMPTION

The museum exhibition was an educational experience that made sense because it relied on the organization, sympathy, and performances of club-women. A similar pluralist organization also existed in another context, the marketplace. Bamberger's already pioneered the celebration of ethnic traditions as modern refinement, wherein "Hungarian peasant pottery" and numerous varieties of English bone china and Lenox porcelain were considered equally appropriate for modern New Jersey. In this respect, William James's "pragmatic method" of teaching was the Progressive ideal informing both displays. The exhibitions were not organized by narrow disciplinary boundaries but illuminated by varieties of experience, bringing out of each artifact "its practical cash-value, set ... at work within the stream of ... experience."[49]

The museum's annual report argued that its exhibition had genuine and immediate commercial value to Bamberger's and other department stores. This was one justification for the Textile Industries exhibition. Approximately one thousand sales staff from Newark department stores was estimated to have attended the Textile Industries on tours conducted by The Contemporary. Jane Fales, the director of the Department of Textiles and Clothing at Teachers College, brought her students and asked to borrow exhibits as well as reproduce them in a publication. Harry B. Taplin, superintendent of training at R. H. Macy's, wrote to the museum to secure some displays to teach his employees, and the *Museum Bulletin* records the museum's willingness to share its lessons in the differences between cotton, flax, and silk. The museum experience was considered a success as consumer education.

By making consumption a central method of educational participation and the gallery itself a forum of selections, the Newark Museum abandoned the role of authoritative tastemaker. Its museum education became a participatory exercise, what Dewey called "conjoint communicated experience," and an adjunct to the marketplace. The individual remained important and the active craftsman within civic, industrial, social, and entrepreneurial

"cooperation." The autonomy of the consumer had blossomed since the Civil War, and the museum confirmed that consumer advocacy played a role in civic and federal policies. Most important, Dana's call to "Buy American" and Bamberger's slogan "Made in Newark" were attempts to channel local patriotism into purchasing power. A work ethic was to be the common denominator in lieu of a shared religion, language, or a unifying social heritage. Moralistic consumption was nothing new, but consumer activism gave it a new form of expression. The father of Candace Wheeler, the inventor of the "American Tapestry," had seen cotton as antithetical to his abolitionist beliefs and had refused to wear it.[50] A comparable impulse increased dramatically when the United States entered World War I in April 1917.

Katherine Rummell gave tours of the museum galleries and educational demonstrations on Monday, Wednesday, and Friday afternoons, accommodating very different definitions of industry and applied art from those of her family's firm. She left no recorded judgment on the exhibition's aesthetic discrepancies, such as the comparative value of Edgewater Tapestry Looms and those of Anna Shook. The museum paid a man, "Mr. Searvant," fifty cents a day to demonstrate the Colonial loom, a massive timber structure, and the tapestry weaver was limited to a few afternoons per week because his employer could not afford to donate more of his skilled and valuable time, but clubwomen stood outside this economic hierarchy of skilled male labor, and accepted their situation. Their role was to stage a work ethic that could be grasped by the school children and articulate civic cooperation as an ideal. Katherine Rummell's work indicates that women made the museum function by sustaining contradictions and maintaining a selfless dedication to it as a social space. They embodied cultural pluralism more vividly and clearly than any museum label or specimen.

The array of eclectic ethical symbols and systems were reconcilable, even melodious, in the museum because of the coalition formed among clubwomen, art-weavers, librarians, and museum staff. Industry, inclusive of both handicrafts and large-scale manufacturing and entrepreneurship, was imbued with dignity. The museum expanded the message of redemption articulated by the Arts and Crafts movement, suggesting that transcendence could be gained through engagement in factory handicraft or consuming such respectable goods. Women defined their own variant of progressive industrialism, emphatically collaborating in the cultural institution.

In 1916, the women spinning wool, such as Athene Vornazos and Katherine Rummell, or weaving it, such as Anna Shook, conveyed moral, artistic, and

political aspirations, some rooted in gender and others in class and ethnic identities. The museum positioned them to step into the language and metaphors of James, Addams, Dewey, and Wilson and embody abstractions. The textile exhibition related to each of the pressing debates of the day: the construction of a worker's individuality, a nation's economy, an immigrant's culture, and a woman's morality. Socially charged artifacts and activities sustained the pivotal metaphors of the industrial city and fueled its ambitions. The museum had long championed cooperation as a civic virtue and was seemingly absorbing the "co-operative" aspects of a factory, transferring business practices comparable to shareholding and profit sharing into the exhibition's creation. The term gestured vaguely toward a collective mode of agency that would sustain both individuality and group solidarity. The museum financed the Textile Industries exhibition through preexisting social networks, and its large attendance is explicable because so many constituencies were engaged at an early stage in the planning process, and saw themselves as prime creators of the exhibition. The appearance of collective authorship was neatly achieved, a new cultural paradigm emerging for the first time in the American museum.

Women personifying industry in Newark Pageant (see figure 61).

A Parade of Civic Virtue

The wise City . . . makes its Celebration instruct its citizens in the Civic Virtues and the fine art of Happiness, and thus leads them to promise to Make for Themselves a City more Useful, more Beautiful and more Delightful.

— John Cotton Dana, *The Newarker* (1914)

To commemorate the two hundred and fiftieth anniversary of Newark's founding in 1916, there was an eight-month outpouring of mass spectacles, including a three-day music festival, an industrial exposition, a pageant, the dedication of three new civic monuments, and numerous celebratory rallies, dinners, athletic events, and parades. Drumming up excitement in *The Newarker* in 1915, Dana encouraged participation as a way "you get more out of life, are more of a real person and less of a nobody."[1] His capitalized homilies invoked his Puritan ancestral namesake, minister Cotton Mather, and his message of corporate self-improvement presaged Dale Carnegie's *How to Stop Worrying and Start Living* (1948). The library and museum hosted exhibitions, performances, and a poster design contest that determined the official icon. Robert Treat, the founder of Newark in the seventeenth century, was the celebration's emblem of industry and civic order. For twelve months, downtown Newark was immersed in orange-and-black celebratory bunting and saturated with romantic images of founders in flowing capes and wide-brimmed conical black hats. The guise of the Puritan appeared to reconcile individual entrepreneurial ambition and corporate authority, and was an effort to make the industrial colossus feel like a "community."[2] Newarkers who participated in reenacting foundational myths dressed in his costume as a means of identification and self-realization. The library-cum-museum sanctioned monuments and pageants celebrating the manly Puritan and also served as a stage to represent womanly industry as significant civic virtue. These reinventions of Newark's pasts vied for attention. Each of the components of the 1916 celebration—the poster, pageant, and municipal exposition—expressed the ethos of the industrial city in divergent ways. The rhetoric of public welfare was

vague while the commercial strategies clear, so much so that Louise Connolly summarized the quandary to The Contemporary: "The men have contributed according to their interest and power. . . . They have regarded this outlay as good business; they expect, collectively and individually, returns in the kind of prosperity they pursue." She asked if in response "we women" would build "the Human Newark."[3] In retrospect, the celebration of 1916 reveals the improbable idealism of the library and museum staff and illuminates the inchoate nature of the cultural institution's attempts to foster cultural pluralism and social uplift.

CHOREOGRAPHING COMMUNITY DRAMA

Municipal celebrations flourished in the early twentieth century and then disappeared. From the perspective of settlement workers, the rites enacted social uplift, and from the perspective of the Board of Trade the attendant publicity boosted the city's reputation and economic fortunes. The Century magazine identified in municipal celebrations the promise of social engineering, stating that "Nothing is more likely to cement the sympathies of our people and to accentuate our homogeneity than a cultivation of [municipal] pageants."[4] At its founding in 1913, the American Pageant Association took root in settlement houses, at the intersection of municipal art and social work, and its founder, Percy Mackaye, believed the new open-air art form was especially useful in "redeeming country and industrial districts."[5] Newark's efforts in 1916 took the form of a modern morality play, a narrative that balanced self-improvement and paternalistic uplift.

Newark was not a pioneer but a latecomer to the municipal celebration: several recent nearby efforts inspired the 1916 celebration. Jersey City and Elizabeth had already held festivals to mark their historical birthdates, and New York's 1909 Hudson-Fulton spectacle demonstrated that a cultural institution had much to gain if it participated in organizing mass leisure. Crowds of more than five million had attended the Hudson-Fulton celebration, a weeklong gala that connected two histories: the tricentennial of Henry Hudson's exploratory voyage to North America and the centennial of Robert Fulton's introduction of the age of the steamboat. Dana had noted the ways artifacts, performance, and publicity had made the cultural institution a pivotal site in the celebration.

In 1909, the Metropolitan Museum of Art and the American Museum of Natural History, among other cultural institutions, collaborated with a state commission and a coalition of local and regional governmental and

philanthropic agencies, such as the Charity Organization Society of the City of New York and the Russell Sage Foundation, to devise representations of history and progress: the civic virtues of the past were defined for modern emulation.[6] In the Hudson-Fulton exhibition in the Metropolitan Museum of Art, historical American applied art finally entered the galleries alongside J. P. Morgan's old master Dutch paintings. Visitors particularly admired furnishings arranged in domestic room arrangements, an innovation in American museum display, and gained a highly selective view of these as their proper American heritage.[7] Spectators who flocked to see the reenactment of Hudson's *Half Moon* and Fulton's *Clermont* navigating the river also had visited the museum, making the show into the blockbuster of its era. The massive regional spectacle and an unprecedented publicity campaign of subway and magazine advertisements were credited with creating the influx of three hundred thousand visitors to the museum in nine weeks, equaling more than half the annual attendance of the museum in 1908.[8] Thousands of museums, schools, and institutions coordinated exhibitions and performances, blending musical and athletic events with pageantry and masquerades. Patronage of art and social relief were interfused in the case of the Hudson Fulton celebration. Robert Weeks de Forest, a member of the Board of Trustees of the Metropolitan Museum and the Sage Foundation, and his wife, Emily Johnston de Forest, a collector of American antiques, supported expenditures to increase civic prestige and also ones tailored to social improvement.

Newark's 1916 celebrants emulated the events of 1909. The Hudson-Fulton celebration had been the turning point at which the Metropolitan first began to advertise itself aggressively as a public destination, not just a private club. Dana applauded the ways publicity made the cultural institution less elitist without suffering a loss of dignity or moral vigor. In a 1909 letter to the *New-York Evening Post*, he praised the affordable, artistic, and educational catalogue of the exhibition as pivotal in making the museum accessible.[9] In Newark, advertising art, museum exhibitions, and civic commerce would consciously manipulate local history and foundational myths. Dana and his institution would be complicit in these efforts, and struggled to shape the depictions of history and representations of the contemporary city.

DEPICTING NEWARK'S IDENTITY

In 1915, newspapers publicized a national contest to devise a poster for Newark's celebration. The Committee of One Hundred, a group almost

identical to Newark's Board of Trade, had formed to mastermind all aspects of the gala and to sponsor the competition. The One Hundred invited prominent citizens, such as Dana, to join its ranks, as well as educators, clergy, and philanthropic clubs such as The Contemporary. Dana had encouraged patronage of the artistic poster and the annual remembrance of the 1666 Puritan landing since his own arrival in Newark, so his involvement was considered essential. When he selected the image of the Puritan leader as the emblem of the yearlong celebration, his library and museum set up to broker mass culture in unprecedented ways. In the modern city awash in advertisements, the specter of a Puritan pointing the way forward was reproduced on posters, pamphlets, stamps, and commemorative knick-knacks, each of which historicized and sought to dignify various entrepreneurial gambits (plate 10).

The poster fulfilled the committee's desire to market and brand Newark, and the *New York Times* considered the endeavor suited for a commercial city and praised the competition, noting it "highly characteristic of Newark to take a bold step forward in the line of commercial art."[10] For a municipality to take agency of its own propaganda was considered innovative. This type of morale-raising poster became common once the United States entered the European war in 1917, and provided useful propaganda to sell bonds. But in 1916, Newark was precocious in conceiving of the medium as an edifying agent of civic change, and Dana surely deserves credit. Once he reconfigured it to serve municipal patriotism, the poster was immune from criticism that it was a public nuisance. He saw art competitions as invigorating, as if Herbert Spencer's theories of survival of the fittest might apply to culture. He had judged the poster competition for Newark's 1912 Industrial Exposition and again for the 1914 Industrial Exposition, so his expertise was well established.[11]

The Newark Library already identified the poster as a useful hybrid of commerce, entertainment, and education. As early as 1902, Dana had celebrated European posters made by designers Jules Chéret, Eugène Grasset, Alphonse Mucha, and Henri de Toulouse-Lautrec, alongside Americans Elijah B. Bird, Will Bradley, William W. Denslow, Arthur Wesley Dow, Maxfield Parrish, Edward Penfield, and Ethel Reed. In 1905, the exhibition of images from the pages of *Jugend* and *Kunst* was well attended and considered by Dana a lesson in the art. Graphic design, still called "advertising art," had been central in the Deutscher Werkbund exhibition in 1912, and in 1914 Dana had dedicated another exhibition wholly to German posters. Dana's assessment of quality in the German work published in the catalogue of the 1914 show foreshadowed the outcome of the 1916 contest:

The German poster is clear, concise, sharp. . . . The drawing is most often bold, and usually conventionalized as opposed to naturalistic. Large uninterrupted spaces of pure elementary colors are the rule, and the colors are nothing if not virile. . . . And how have the Germans built up this art of making posters? By frequent competitions; by frequent exhibitions in all parts of Germany, . . . and, above all, by the tendency to look upon advertising as an art, and not as an industry which shall be plied at the least cost with the greatest amount of profit.[12]

The call for submissions asked that images be "typical of an era of haste and quick perceptions." The design needed to be suitable for reproduction as both a postage stamp and a billboard. In addition to Dana, the five judges included a respected designer and connoisseur from outside of Newark as well as two prominent local businessman. Arthur Wiener, co-founder of the design agency International Art Service, represented the emergent graphic design professional, while Charles Matlack Price, whose study of posters was the foremost American book on the medium, served as the expert aesthete.[13] Dana had hired International Art Service to design the poster for the 1915 ceramics exhibition, and in 1917 it would compose a design to brand the library's new branch in Roseville. Like Dana's own handiwork, the firm's production was boldly colorful and planar, and used crisp classical historicist designs in addition to ones influenced by Japonisme. Price had a national reputation but was known for more conservative taste. The promise of cash prizes to the winners, and the decision to pay ten well-known designers in advance for submissions—they included Edward Penfield and Louis Fancher—assured Newark's contest a degree of publicity. As part of the interest in increasing connoisseurship of advertising, the public voted on the best poster. While this "election" was expected to improve the public's powers of artistic discrimination, the selection was to be controlled by the judges.

Of the 230 posters received, the judges chose to hang 146. After this initial winnowing, they decided which sixty-four would be good examples for the public to admire. These sixty-four were then exhibited at Anderson Galleries in Manhattan and then in other cities, to draw attention to Newark, and the judges also reproduced them in an explanatory booklet. The library produced this "how-to" pamphlet and used it to explain that other cities might use such a competition as a tool to increase civic patriotism.

The competition's criteria did not specify iconography or style. The theme of commemoration had left the design open to interpretation, with

the only requirement being the inclusion of the dates of Newark's found-
ing and celebration, so it is noteworthy that the romanticized image of the
seventeenth-century English pioneer emerged as a dominant icon. Among
the sixty-four finalists, eleven depicted images of a black-garbed Puritan-
Pilgrim amalgam, a romanticized and nationalistic figurative cipher that had
emerged in the course of the nineteenth century. Leather, shoes, electricity,
jewelry, beer, or celluloid billiard balls could have represented the more recent
story of Newark, but factory chimneys, gears, and the blacksmith were the
archaic emblems used to distinguish its industrial genius.

The winning poster by an amateur American of German descent, Adolph
Treidler (1886–1982), depicted an authoritarian Robert Treat, his face almost
obliterated by cast shadow of his wide-brimmed hat, the black wool capotain
(see plate 10). His stern gesture, an outstretched arm and looming index fin-
ger, and the decision to obscure his eyes endowed him with authority but little
humanity. Alfred Leete's 1914 recruitment poster featuring a confrontational
Lord Kitchener might have influenced Treidler; the British design was visible
enough in America in 1917 that James Montgomery Flagg appropriated it to
depict Uncle Sam. Treidler's design was eighth in the popular vote, winning
only ninety-nine of the three thousand ballots cast. Popular support went
to a more amiable figurative depiction of bounty, a beautiful angelic woman
designed by Alonzo E. Foringer. In the educational brochure, the judges
explained that the composition of simplified planar masses on a field of bright
orange stood out in the competition. Dana thought its brazen colors resem-
bled German work, and similarly Charles Price described the way Triedler's
poster rendered the others effeminate, mere "advertisements for soap."[14]

The Puritan was upright and moral, a design that adhered to what Dana
described as the "virile" German style. The judges deemed "dignity" a neces-
sity attribute to accord to the city through the poster, and their criteria become
clearer when one glances through the reasons they gave for eliminating other
submissions. Price considered one design of a Puritan sowing wheat and a
machinist to represent "drudgery" instead of "uplift." Judges dismissed as too
light-hearted and playful Louis Fancher's Puritan, who held a birthday cake
and whose face had a hedonistic smirk. The Puritan writing in a book with a
quill pen was too theocratic and against Dana's modern educational ideals.[15]

The image of the angelic woman, the runaway favorite in the popular
vote, resembled popular magazine covers. Foringer drew her wearing a toga
and riding astride a winged wheel of progress, her hair aswirl. Her dreamy eyes
contradicted her unmanageable armload of goods, which included Mercury's

wand (a traditional emblem of commerce), a book, an alembic, and a smoldering torch. Behind her a massive gearwheel articulated an industrial halo, while on the horizon line a locomotive and ocean liner signaled Newark's modern transportation network. Her pallor and full body illustrate the decade's shift to represent the idealized American woman as both a more fleshy and saintly innocent. Although Foringer would achieve lasting fame for his image of a Red Cross nurse in World War I as the "Mother of the World," the buxom figure and pink cheeks he gave to Newark were closer to the women of his contemporaries Howard Chandler Christie and Joseph Christian Leyendecker, who made tennis players and bicyclists simultaneously chaste and prurient. The judges complimented "the people" on their selection, but explained that the drawing's beauty would be lost when enlarged or reduced from the two-foot original. Moreover, she lacked the vigor that Dana thought necessary to articulate entrepreneurial ambition and civic order.

Treidler's Puritan was chosen because it was modern in style but conservative in imagery: it conscripted Newark to the cause of Civic Virtue. Dana helped to recuperate the New England Puritan, a trend begun in his youth that he had witnessed firsthand. In 1884, John Q. A. Ward's bronze Pilgrim statue was installed in Manhattan's Central Park, and in 1886, Augustus Saint-Gaudens's bronze of Deacon Samuel Chapin strutted into Springfield, Massachusetts, right beside the library where Dana was the director in the late 1890s. While Ward's statue elicited quiet praise, Saint-Gaudens's Puritan carried a Bible of massive proportions and was considered a grand "grim athlete" who would terrify children into moral rectitude.[16] The New England forbear was beginning to embody the national creed just as Thanksgiving became a widely practiced tradition. Newark's 1916 Puritan was imperious in the manner of Saint-Gaudens's design but lacked overt theological references. There were no large-scale public representations of Puritans in Newark, and they acted out no major role in Howard Pyle's and Kenyon Cox's murals in the 1907 Essex County Courthouse, but Dana extended New England symbolism to the mid-Atlantic city.

Newark's trustees used the Puritan to personify the city's commercial ethos, and even brewers embraced him because Treidler's figure resembled the modern managerial businessman. His severe black outfit resembled a modern business suit, especially when viewed beside a half-nude mechanic or lady bountiful. In some inventive depictions, especially to advertise the municipal exposition, the Puritan seemed engaged in modern labor relations, as a historical taskmaster directing a machinist toward the factory. Standing beside

the shirtless machinist, the Puritan symbolized the apotheosis of the white-collar managerial revolution taking place in the early twentieth century (figure 58). Treidler's image of Treat sold Christian Feigenspan's beer, Prudential life insurance, and Bamberger's napkins—all manufactured by trustees of the museum and library. Newark's Puritan was updated to wear baseball regalia and to emblazon a multitude of baby trinkets. Advertisements punned on the name Treat as an injunction to consumers to gratify themselves. The city's first grand hotel—a necessary amenity to transform an industrial suburb into a metropolis—was christened after the Puritan as part of the 1916 celebration.

The Puritan icon was officially licensed, and in some cases the One Hundred pursued action against noncomplying merchandisers and manufacturers.[17] Businesses literally needed to buy into the spirit of cooperation—even cutlery makers in Meriden, Connecticut, who wanted to make commemorative silver spoons. Pirated copies of the image were on pennants and handkerchiefs. But trustees Whitehead and Hoag paid to use Treidler's image on commemorative buttons, pennants, and medals awarded at sporting events and to students participating in poetry contests. Consumers who wanted to participate in the event could connect a coin to their watch fob or keychain. The One Hundred authorized a high-quality limited edition lithographed version of Treidler's poster for sale to one tier of consumers as well as the production of fifteen million stamps with the design. The latter were peddled to Newark businesses to keep the event visible and express allegiance. The Prudential affixed the patriotic emblems to its thousands of pieces of mail, presaging the way that gummed miniature posters would later explode as a demonstration of moral support, a phenomenon that continues today.[18]

The poster, Dana's pet project, depicted commerce as a masculine arena, and three new monuments in the cityscape reiterated this representation of the seventeenth-century founding as a manly task. Newark's Committee on Civic Art and Architecture, on which Dana served, also emphasized a virile past when it commissioned three works from Gutzon Borglum. One was erected outside the library: a lamppost and "isle of safety" to direct traffic on Washington Street (figure 59). The lamp standard, titled "The Indian and the Puritan," was the only of the three that Borglum electrified. At its base, the bronze shaft is flanked by two carved marble figures, a Puritan looking downtown and a Native American looking north, to represent the historic role the site played in trade, and at its top is a bouquet of illuminated blossoms. The integration of figurative sculpture and electric light corresponded to the lamps Louis Comfort Tiffany had been making for the past decade, in

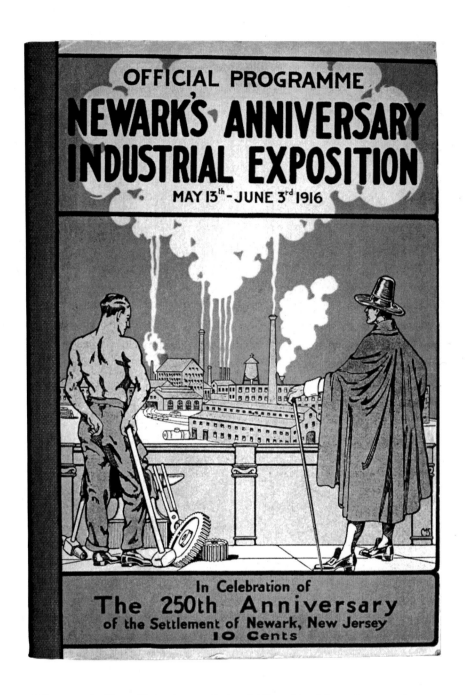

58. Program for *Newark's Anniversary Industrial Exposition, May 13–June 3, 1916.*
Collection of the Charles F. Cummings New Jersey Information Center, Newark Public
Library. Admiration for the industrial city literally becomes the bridge that joins the
mechanic and Puritan, which symbolize both past and present in addition to the
reconciliation of labor and capital. However, the image defines industry in purely virile
terms, unlike the handicraft espoused by the Newark Public Library and Museum.

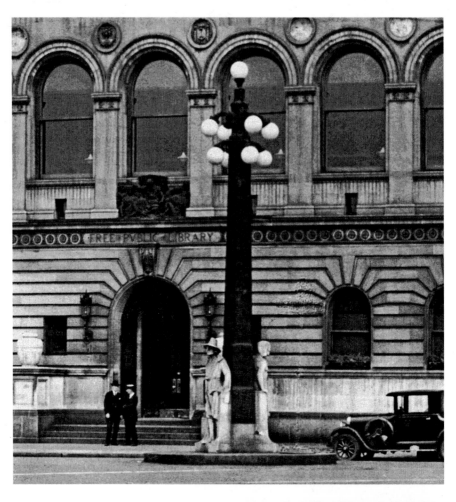

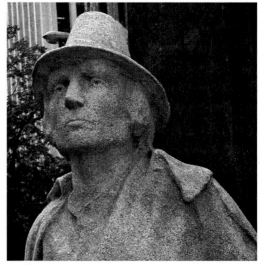

which he integrated organic form and new technology. Borglum electrified the Pilgrim, negotiating modernity and mythology. He also depicted the Puritan constructing the city's first well and landing on the Passaic. These two works drew attention to the importance of civic infrastructure—drinking water and the new harbor. In contrast to these monuments that were designed safely within accepted neoclassical types, his lamp was overtly technological. Borglum welcomed the reinvention of the ancient Native American pathway into a road for automobiles. His inscription described the Puritan as an entrepreneur whose ambitions "awoke the industries."

Borglum had published several repudiations of "pseudo-classical taste" and "European-derived art" and lamentation of the "monuments we have built [that] are not our own," and these criticisms were identical to those which Dana leveled. They implored fellow artists create art that was "American, drawn from American sources."[19] To that end, in Newark Borglum explained that his bronze lamppost blossoming with pink droplets took its form from a flower native to the banks of the Passaic River, the marsh mallow. The pink glass globes atop the "Indian and the Puritan," now long missing, were indebted to Tiffany, too, and show Borglum drawing on art nouveau as a native expression. Like his 1911 Abraham Lincoln outside the Essex County Courthouse, the "Indian and the Puritan" was an accessible part of the city's everyday life. Electrification was functional, like Lincoln's bronze bench, which served as a resting spot for the living. The sculptor helped the contemporary citizen reconnect with and touch the past, not as distant mythology but a contemporary folkway. His retelling of foundational

59. (opposite) Gutzon Borglum, *The Indian and the Puritan*, 1916. Marble figures; bronze map standard. Collection of the Charles F. Cummings New Jersey Information Center, Newark Public Library. The memorial, located on Washington Street, has been relocated several times due to alterations in traffic patterns. When new, its pink bulbs illuminated Newark and the library with alluring colors. The shaft bears the inscription: "The bridging of the rivers eastward and the rude road built across the marsh was an enterprise of patriotic citizens: an epoch-making event. It awoke the industries and made the present city possible." As visible in the detail, photographed in 2009, the marble has deteriorated from pollution as much as vandalism.

myths made Newark simultaneously both ancient and modern. Now relocated into Washington Park, and closer to Karl Gerhardt's 1890 memorial to Seth Boyden, Borglum's "Indian and the Puritan" was once in the middle of Washington Street.

Dana, who was a friend of the artist and an advocate of Treidler's design, probably saw the modern Puritan as imbuing his library with virility and power. In 1916, *The Newarker* looked back and applauded Borglum's earlier triumph, reproducing photographic evidence of the ways children interacted with Lincoln affectionately "at almost any hour of the day . . . at play."[20] The library sanctioned this type of firsthand learning experience that recuperated the past and made history accessible and a part of daily life. The paternal quality of Borglum's statues was noted as useful to help raise the eyes of Newark's youth. The monuments were conceived as and interpreted to be father figures. Dana appears to have selected Treidler's and Borglum's designs because they rendered his paternalistic notion of uplift in literal terms. Citizens would encounter a figure of authority and power on an everyday basis.

The orange-and-black Puritans entered the curriculum in elementary schools, as well. Newark's industrial arts curriculum used the imagery to teach civic virtues. Hugo Froehlich, the educator who came to Newark because Dana had lobbied for specialist in industrial education and who, after his death, was memorialized in a stained glass window in the museum, designed lessons that taught students how to make Puritan dolls and suggested they sew historical costumes for school pageantry. Replicating historical daily life was a pervasive feature in American education during the Progressive era, when teaching the patriotic significance of holidays became codified along with the recitation of the Pledge of Allegiance. Part of the 1916 celebration included an essay contest sponsored by Newark's school system in which pupils were asked "to promote a feeling of loyalty toward the city, and to create a love for it and an interest in its traditions."[21] The compositions were exhibited in Bamberger's and judged by the public library. Winners received Tiffany medals forged in Newark, and these too bore Treidler's image of the Puritan. The *School Arts Book*, the most influential source of elementary school art projects over the first three decades of the twentieth century, endorsed lessons about Colonial American "everyday life." Its editor, Henry Turner Bailey (a longtime friend of Dana), was a regular speaker in Newark's public library and lectured The Contemporary on "Art in a Democracy."[22] He encouraged handicraft lessons to reenact "The First American Thanksgiving," with the rationale that "the arts make common ground on which the children of the native born and of

the foreign born meet in happy, intelligent and ceaseless activity."[23] Schools, no differently than commercial advertisements, used the terms "Pilgrim" and "Puritan" interchangeably, turning aside theological and historical distinctions. Plans for building "Pilgrim" furniture and Colonial dollhouses were disseminated in the *School Arts Book*, and in classrooms, the historical capotain functioned as a gendered accessory to connote manly industry.

Dana, Newark's educators, and the Committee of One Hundred enacted an educational program to imprint the city with emblems of authority, examples of Anglo-Saxon cultural preeminence, and specimens of entrepreneurial citizenship, and their scientific management of the city transformed its everyday appearance. Orange and black were the official colors of bunting, publications, and costumes for the entire year of 1916. The public library used orange and black oilcloth in window dressing. The colors associated the event with Princeton University, leapfrogging past more logical selections such as the colors of the state's or city's emblems. By appropriating the academic colors, the city of Newark asserted its role as a regional hub. Princeton's football pennants were widely recognized and sold across the country. The team had won national championships in 1906 and 1911. Newspapers dedicated columns to college athletics in those years before professional leagues took on greater economic and emotional significance. Weekly attendance at Princeton games was in excess of thirty thousand in the autumn of 1915, they were mass spectacles. College sports were considered moral recreation, rituals that built social bonds and loyalty. While the image in the *Newark Evening News* of a Puritan striding onto the baseball diamond with a bat might seem ridiculous, they were attempts to graft athleticism and modernity onto the historical figure. They differ little from the plastic tomahawks waved at the baseball games of the Atlanta Braves today.

Athletic competitions in Newark throughout 1916 embodied the ideal of civic incorporation. In April, *The Newarker* looked forward to May 1 as if it were opening day with "its rejuvenescent air, its promise of festivity out-of-doors" when "that get-together habit amongst our citizens . . . shall create a solidarity of purpose."[24] Mixing sermon with sensationalist news, the magazine issued pithy directives to encourage unanimity. Athletics promised individual glory and team solidarity. Jane Addams compared a "team" of factory tailors to a baseball squad, claiming they experienced greater efficiency and joy in labor.[25] Looking down on rural life, she saw a lone worker as akin to a pitiful farm boy tossing a ball against a barn by himself. Reformers, especially in the playground movement, saw sports as a useful way to conduct

socialization. Newark's choreographed physical culture inducted the city into both competition and solidarity: if football was Americanized in the Progressive era by incorporating Taylorist ideals of managerial efficiency and corporeal discipline, so too were Newark's amateur athletes.[26] Amateur athletics imbued Newark with nobility and also demonstrated allegiance to Roosevelt's creed of "the strenuous life." Sport was also titillating. A reporter at a Princeton game connected the physical movements of football to one of the founders of modern dance, Isadora Duncan's peer, asserting that it was "not without a suggestion of Ruth St. Denis that the Princeton men, crouched and rose, half-sinuously."[27] *The Newarker* devoted several pages of each issue to photographs of athletes as exempla of the city's youthful vigor and bright competitive future.

Newark's cultivation of collegiate athletic colors was also a form of municipal social climbing. The One Hundred could have chosen the colors of Rutgers, Princeton's competitor in the first football game ever played in 1869, and geographically closer. But crimson carried problematic allusions to strikes and labor battles. With Franklin Murphy a Princeton alumnus, and Wilson in the White House, the orange and black articulated networks of wealth and power. The *Newark Evening News*'s mailboxes and delivery trucks became orange and carried the municipal spirit of 1916 through the twentieth century until the paper folded in 1972, by which time the origins of the color as an emblem of municipal identity were mostly meaningless, if still eye-catching.

However, as Treidler's design was replicated, appropriated, and transformed into a spectacle, it was susceptible to reinvention. The Puritan dominated the city's celebration, but when domesticated as a knick-knack he sometimes lost the grim severity of Treidler's depiction, as if his authority was deliberately neutralized. When Bamberger's transformed Treidler's design into a plate, the Puritan gained facial features that softened his countenance (figure 60). The department store Hahne's advised, "Let Every Housewife Get Her Home in Preparedness to Receive Visitors to Newark's 250th Anniversary," and offered its stock of official Robert Treat pennants and flags to aid in the race for domestic "preparedness."[28] High-, middle-, and lowbrow department stores alike—Hahne's, Bamberger's, Goerke's, and Plaut's—established temporary souvenir booths in their stores to market hatpins, cuff links, lapel buttons, brooches, flag buttons, tie clasps, ash trays, silver loving cups, napkin rings, paper weights, jewel cases, match boxes, baby's mugs, leather coin purses, cigarette holders, book covers, and watch charms

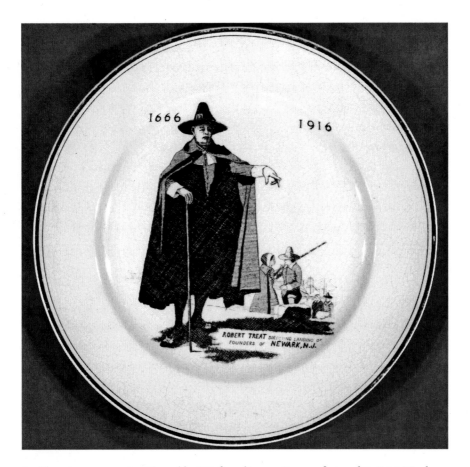

60. Plate commemorating Newark's 1666 founding, 1916, manufactured D. E. McNicol,
East Liverpool, Ohio, "made expressly for L. Bamberger & Co." Collection of the
author. The earthenware plate with transfer print used the licensed official design.
Each department store designated a boutique in the store specifically for these types of
commemorative goods, which included pennants, "Robert Treat hats," shaving mugs,
spoons, and postcards.

(to list a few of the commodities that are obsolete today). The objects con-
stituted a visual stream that was as encompassing as advertisements are in
twenty-first-century media. L. S. Plaut & Company made the Puritan reen-
actment a unisex affair by selling "Robert Treat hats" in five different colors
marketed specifically to women. Advertising it as an "overnight success," the
store claimed the hat embodied the "pilgrim spirit."[29]

Officially sanctioned consumption helped fashion the appearance of
municipal consensus but, as Joseph Roach suggests in his study of Mardi
Gras, performance and historical reenactments are often as inventive as they

are mimetic. Commodities like the capotain were intended for the city's mas-culine personification but had the capacity to undermine it. Masquerade was beyond anyone's control, and in the course of the mass marketing of the hats and other Puritan paraphernalia history took a back seat to living theater. Citing James Clifford, Roach argues that groups "negotiating their identity in contexts of domination and exchange . . . patch themselves together," and Newark's official and informal theatrics involved many distinct constituen-cies being forcibly woven together.[30] Historical reenactments of Puritan life were familiar sights in 1916, a "usable past" in the development of patriotism. But when citizens of all ages and ethnicities assumed hold of the Puritan guise they could turn Dana's parade of Civic Virtue into a theatrical event that was outside of authorized use.[31] In photographs of costumed Newarkers romping with glee, reenactment and charade commingle.

THE PURITAN IN THE PAGEANT

In the Pageant of Newark, four thousand civilian actors drew audiences of eighty thousand to two evening performances. Tens of thousands attended the daytime rehearsals, and thousands more busied their hands crafting his-torical costumes and sets. Photographs of the spectacle in *The Newarker* show squads of Puritans and Indians exuberant and delighted by their temporary engagement in imaginary play. Athleticism was part of the pageant's attrac-tion; women, playing the part of Native Americans, wore exotic costumes, their arms bare and hair unfastened, and their male counterparts performed bare-chested. Their appearance jostled Puritan codes of decorum, and some citizens considered the spectacle prurient. Dance, music, and the manipula-tion of geysers of steam and colored electric illumination added to the drama of the evening event. The nocturnal performance and its mass scale denied the recognition of all but a few individuals. Transformed from reenactment into fantasy, the masquerade became a medium of self-invention and civic myth making.

Pageantry in the first decades of the twentieth century was a hybrid of activism and art. Often aided by improvement associations such as the National League of Women Workers and the National Child Labor Committee, most pageants strove to manufacture a sense of community by recuperating specific histories and myths, usually local rather than global.[32] In the divine saga of America's settling, industrialization was depicted in a positive light. In "The Pageant of Darien," for example, written in 1913, Puritan voyagers (who had never actually resided in the Connecticut suburb) were conjured

up as precedents for the "Modern Commuter."[33] Mary Porter Beegle's dance *The Romance of Work* (performed in Manhattan in 1914) began with spinning wool and culminated in "The Dance of Steam."[34] Newark's pageant organizers hired Beegle to be their choreographer, and she articulated foundational myths through a barrage of allegories.

Newark's pageant began with Robert Treat buying land from Native Americans, a transaction that dramatist Thomas Stevens reinvented to position citizenship in modern pragmatic terms. The moral of the story was that the Indian had failed to learn the progressive-minded business instincts of the Puritan. Distinctions between the Indians' sinful "desire" and the Puritans' noble "commerce" were essential in the story to assert the superiority of the latter. During the performance, the Puritan issued a call to keep commerce subservient to the polity's needs, and therefore preserve its nobility: "Let thy looms weave not vanities, thy forges / Spend not their heat on unregenerate steel." Stevens, who had taught drawing and lettering before entering pageantry, explained that he designed the pageant to be "symbolic in character" and more vivid and "real" than actual history.[35] *The Newarker* explained that if the "Indian" had wisely invested the monetary equivalents of this merchandise, with a rate of 4 percent annual interest, he would have become a millionaire by 1916.[36] Theodore Roosevelt's "Square Deal" promised that modern Puritans would succeed.

The figure of the Puritan oversaw the first half of the pageant, a historical performance, and then the second half of the program, entitled a "masque" after the seventeenth-century form of courtly entertainment. He was actor and then chthonic spirit providing the moralistic voice-over. In the course of the drama, he became more sympathetic and less theocratic, yet also less physically present. Refusing women the ballot, he was introduced as particularly intolerant. Washington's, Lafayette's, and Lincoln's visits to Newark, trivial events in reality, became important punctuation marks equal to Seth Boyden's discovery of malleable iron in the 1830s. Newark's Confederate sympathies in the Civil War were censored. The less appealing chapters of Newark's recent history were purged. The narrative glossed over the city's unchecked industrialization, which had resulted in a high mortality rate. Recent conflicts between capital and labor were censored. The city experienced three strikes during the pageant, and the battle to unionize garment workers was a daily topic in newspapers. However, Newark's industrious Puritan never strayed from celebrating capitalist enterprise as a citizen's primary responsibility.

Stevens's masque showed respect for what were called immigrant gifts by suggesting a healthy city was only possible when it welcomed foreign "industries."[37] He personally coached each "nation" to tell its own story, and essential to many of them was the personification and symbolization of industry. Modern immigrant groups gained entrance on the grounds of remunerative contributions: Greeks conveyed to Newark Classical Greek sculpture; the French contributed Bernard Palissy (the sixteenth-century Huguenot potter) and Jacquard (inventor of the eponymous loom); and the Italians, Cimabue (the thirteenth-century Florentine painter). Stevens thought these "great allegorical figures" helped the "nobody" immigrant gain self-respect, or, in Dana's words, feel like "somebody."[38] The asymmetrical logic of the pageant asked an audience to contemplate their birthplaces overseas in terms of abstract symbols and to see Newark, their adoptive industrial suburb, as a metropolis. The audience, however, might have slept in Kearny or been working in the city only long enough to earn money to move elsewhere, like so many American factory workers, immigrants or not. Almost invisible was the African American community. They comprised a silent backdrop for Lincoln when he appeared but were not duly celebrated for their contribution to industry. "Alien life and dissonant faith" was admitted on condition of productivity.[39] Ultimately a supplicant female Liberty was needed to convince the male Puritan Spirit to let immigrants enter: they met at the city's new 1916 port, as if the Board of Trade had provided the text. The drama brought to life William James's definition of pragmatism as a woman who "unstiffens our theories."[40] Social welfare was rational so long as it was good for business.

The great contradiction of the Pageant of Newark was that it was described as the cultural contribution of women and yet reinforced their marginalization, depicting them as gauzy abstractions to comfort hardworking Puritan businessmen. Women in the audience watched their rights being rejected, as if the historical tableau presaged the failure of the 1915 referendum on suffrage. Moreover, the pageant was a component that would not have been part of the 1916 celebration had clubwomen not lobbied for it. Late in the planning, the One Hundred authorized their request and delegated it to their labor, but did not wholly cede control of it to them.[41] By inviting three members of The Contemporary to join their inner circle, the One Hundred had sought to insure their participation. As the year of planning unfolded, clubwomen had expressed dissatisfaction. The Contemporary used its resentment over limited representation to leverage the creation of a separate and less-than-equal Committee of Fifty.

The production of the pageant also essentialized women's labor. Their manufacture of the seven hundred pageant costumes became a spectacle in its own right. Volunteerism was praised as industry. The *Newark Evening News* exclaimed, "Hum of Industry Reigning Here, Where Women Sew, Sew, Sew on Costumes for Pageant."[42] *The Newarker* described the headquarters as a "Hive of Busy Women," qualifying the women's labor as virtuous because they gave "their time without the slightest remuneration."[43] A handful of librarians collaborated with these clubwomen in this pan-female event. Louise Connolly supervised costumes on the Design Research Committee and Marguerite Gates assisted with publicity; Beatrice Winser, whom Dana had already depicted as a bee on her bookplate, also advised "the hive." Several women's allegorical costumes blended primitivism and exoticism, as if to celebrate the remunerative effects of immigration. For instance in a tableau, "Clay Industries" was colorfully attired, bearing an *olla* on her head like a Hopi (figure 61). Actresses in these tableaux vivants, Helen Duncan, Joe La Duca, and Mollie Kaufman, underwent transubstantiation as they were idealized in terms of commodities. While men symbolized nations and specific industrial geniuses, women were abstract personifications or representations of an archaic or primordial cultural state. This imbalance was seemingly assuaged by the fact that women were given credit for the pageant's coming to fruition.

The pageant's Puritan was a virile figure like Treidler's, and clearly a surrogate for the modern American white-collar businessman.[44] Newark's founder was brought to life in the pageant by one of Treat's actual descendants, unlike the young immigrant women who personified Clay and Leather. Maintaining the pioneer as both entrepreneurial and ecumenically moral, the masque reiterated foundational myths and contemporary identities. Public images of the Puritan delineated commerce and leadership as a masculine privilege. Dana, the Newark transplant with Puritan roots, orchestrated an image that seemed to mirror and confirm his position.

A skeptic might have noted that the cover of the Pageant's published script depicted the Puritan founder as the savior of the other races, towering over feather-crested Native Americans around a campfire (plate 11). The designer, Willy Sesser, was a Viennese-born and Munich-trained member of the International Art Service, the same firm Dana had employed to create the central image of the Clay Industries exhibition poster of 1915. Sesser's use of the brown paper wrapper as a mute field on which to print dazzling orange highlights corresponded precisely to the palette and reductive forms of Lucian

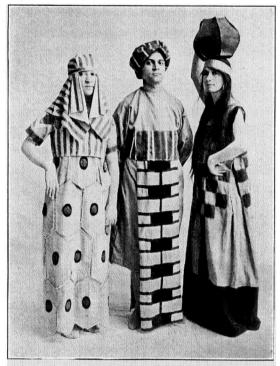

COSTUMES : CLAY, HIDES AND LEATHERS. MOLLIE KAUFMAN
HELEN DUNCAN, JOE LA DUCA

61. Women personifying industry in Newark Pageant. *The Newarker* n.s. 1, no. 7 (May 1916): 193. Collection of the author. At right, Helen Duncan symbolized "Clay Industries," an *olla* on her head. Mollie Kaufman and Joe La Duca, labeled "Hides and Leathers," bear greater resemblance to courses of bricks and the tight-knit structure of hexagonal clay particulates. Women's costumes symbolic of industry consciously alluded to ancient civilizations.

Bernhard's *Sachplakat* (object poster) which Dana had exhibited in 1912 and 1914.[45] The publication stands out in the 1916 celebration as a self-conscious attempt to marshal vanguard aesthetics, and suggests that Dana or Gates had built a following for this bold imagery among the pageant's directors. The Colonial Revival jacket cover conceived an elastic and mercurial Puritan that functioned both as a specific historical allusion and as a more fantastical general metaphor. Treat's stature was similar to the cultural authority invested in Dana's expertise. However, the cultural institution and its leader were largely symbolic figureheads in the industrial city, wielding limited influence in shaping the 1916 celebration. Dana resigned in December 1915 from the One Hundred. Archives record that he was irate when the executive officer,

button-maker Augustus V. Hamburg, would not include "home industrial life" in the Municipal Industrial Exposition as a way to engage "the foreign element."[46] However, by the time he resigned he had already lent the organization credibility by coordinating Newark's national poster contest, by ceding *The Newarker* to the One Hundred's control (to use for fundraising), and by selecting the Puritan figurehead. Dana and Treat made the industrial city appear noble.

GENDERED AND ETHNIC INDUSTRY

Having resigned from the One Hundred, Dana addressed The Contemporary club to warn the women of the imminent failure to incorporate Newark's ethnic subcultures into the celebrations. He charged them with the task of spreading "sympathy and intelligence" in the coming year, when "Newark's new-found citizens [will] be asked to take an active part in the 1916 celebration."[47] His call for reform quoted the statistics of social science and the grim despair of Jacob Riis's photographic documentation, as well as recent novels, especially Mary Antin's *The Promised Land*, which he read and promoted (as already noted in chapter 4). The novel's central moment of becoming "somebody" pivoted on catharsis in the lobby of the Boston Public Library, an image that reinforced Dana's idealization of the library as "the only real people's college."[48] Enlightening immigrants with civic virtues was the mission he fancied, but he delegated it to clubwomen or his assistants.

At the opening of the Industrial Exposition in the city armory on 13 May 1916, Woodrow Wilson's secretary of war declared "we are a race of mechanics and industrial workers," engaging masculine terms of economic and national boosterism.[49] For five weeks, 140 industries—including Murphy Varnish and Whitehead and Hoag novelties, mainstream commercial businesses—were on display in the armory that had been occupied by the 1912 and 1914 exhibitions. On June 2, Colonel Theodore Roosevelt campaigned in Newark to recapture the White House, and focused on the imperative to "Americanize" industry through increasingly Taylorized production. Encouraging xenophobia, he identified the European war and "the hyphenates" of immigrant associations as dual threats to American manufacturers, and demanded that "we must in every way encourage industry," which should be "developed with the highest efficiency and in nationalized fashion."[50] "Industrial justice" was his way of explaining that high pay to manufacturers was fair. Roosevelt invoked Progressive jargon such as "co-operation," "social reform," and "collective national spirit" to articulate his vision of mandatory national military service.

The platforms of Bull Moose, Old Guard Republican, or Democratic politicians tended to fail to see that industry could be interpreted as a more expansive and collective form of engaged citizenship. The vision that the museum had endorsed in the clay and textile shows was never widespread.

The library had minimal representation at the fair in the social service exhibit, alongside charity organizations; it did not vigorously promote its business branch, as it had in 1912 and 1914. In 1916, in *The Newarker*, there was no explanation of why the library and museum failed to participate in the municipal exposition. Newark's real estate interests displayed a maquette of new and future downtown skyscrapers, and the Prudential dangled the exciting prospect of building a new forty-five story headquarters that would compete with Woolworth's Cathedral of Commerce rising in Manhattan. Praise for Lewis Cigar Company's "John Ruskin Cigars," and their "expert workmanship," rolled in Newark, was one of the few allusions to industry as handicraft. In *The Newarker*, Rabbi Solomon Foster, a young ally of Dana's, questioned whether "the product [was] more valuable than the producer," and bizarrely speculated about what would happen if "ignorant, vicious, sinful men create treasures that will bless mankind with peace and happiness."[51] Dana's public statement was that the exposition was a brilliant success. He had delegated his vision of pluralist industry to The Contemporary, and asked his staff and the clubwomen to realize the enigmatic concept.

In April 1916, The Contemporary and the women's Committee of Fifty agreed to collaborate and to form the Homelands Association of Newark.[52] Katherine Rummell, the pivotal museum member who had volunteered for the Textile Industries show, was made the director of the association. She drafted a letter asking the museum's trustees for their official approval of an exhibition of the Arts and Crafts of Our Foreign Born. The letter, although in the museum archive, is marked "never sent." Embattled with his trustees, Dana never worked to obtain the Newark Museum as a venue. Instead he suggested a public school be used. He remained absent from planning meetings. In his stead, Louise Connolly acted as the museum's liaison. The project received one thousand dollars from the One Hundred upon request, but was not featured in the official programs and only noted in *The Newarker* after the fact.

The Homelands Association membership had varied and distinct concepts of Americanization. A representative of the National Americanization Committee articulated the project in terms of assimilation. Connolly argued that Newark's foreign citizens needed sympathy and that women "among whose ancestors 'Americanization' has already been created or achieved"

should be able to empathize with them.[53] She also expressed a concern to prevent the ranks of the Industrial Workers of the World (the "Wobblies") from growing, a national worry in the face of the widening European conflict. A young museum staff member, Alice Kendall, who installed the exhibition, met weekly with Katherine Rummell, who embodied the Americanized immigrant that Connolly deemed necessary, and the two discussed dividing chores, such as contacting ethnic leaders. Ten years apart in age, they came to uplift from entirely different backgrounds. Kendall was a 1910 graduate of Simmons College, descended from generations of New Englanders. Rummell's younger relation Leslie, who graduated from Cornell, was touted as the first college graduate in the family, so presumably she had no college education.

At the third meeting of the Homelands Association, the solidarity of members cracked as several complained to Louise Connolly about Dana's absence. They openly sparred over whether to advance their own cause or that of immigrants. One clubwoman, Kate Belcher, wrote to Connolly, "I am a democrat and I am interested in doing something for the strangers within our gates, but my special interest in this thing is to encourage the women of the Committee of Fifty to get into real touch with the things that count."[54] Frederica Howell, another member of The Contemporary and the spouse of a museum trustee, sent a grievance directly to Dana, warning him: "principles may be carried too far."[55] His resignation from the Committee of One Hundred, she believed, was a separate affair that should not deter his participation with the Homelands project. The Contemporary may have organized lectures by Jacob Riis and Frederic Howe, but it still had members who were less interested in social problems than in the aesthetic uplift of pageantry and exhibitions. In the course of the spring, Connolly's involvement in the Homelands project diminished and so too did that of some members of The Contemporary. To judge from the archives, Kendall, thirty years younger than Connolly, became the museum's prime missionary, and felt "heartily sorry" for Katherine Rummell's lack of colleagues. As the weekly meetings turned into eight-hour days, Kendall lamented that the clubwoman "can't seem to find anyone to depend on."[56]

On 10 July, in the Burnet Street public school five blocks northwest of the Newark Public Library, the exhibition of Arts and Crafts of Our Foreign Born opened. Seventeen committees, each representing one of Newark's ethnic minorities, were allotted rooms. African, Armenian, Chinese, Belgian, Bohemian, French, German, Greek, Hungarian, Jewish, Italian, Lithuanian, Polish, Russian, Ruthenian, Slovak, and Swiss participants represented

their "nations." The organization by national association corresponded to the racial logic common in nineteenth-century natural history collections, as well as world's fairs, which Franz Boas and others were slowly questioning and altering. The exhibition of beds, chests, bed covers, and lace emphasized common "folk" traditions, and defined industry in terms of homespun. Frederick Keer, a museum trustee, lent some Meissen porcelain to the German display, distinguishing his ethnic group (also Rummell's) as particularly refined in the crafts. Rudolf Ruzicka, the young engraver born in Bohemia who had studied wood engraving at age eleven in Hull-House in Chicago and gone on to demonstrate the craft in Bamberger's, loaned fine crystal made in his homeland. The Newark Museum would later exhibit and publish his prints. This small circle of sophisticates wanted to celebrate their own cultural identities: cultural pluralism developed slowly and unevenly in Newark although it was one of the most diverse cities in the United States.

Newark's newspapers considered the exhibition to be successful, and unanimously judged the program of African American folk songs and dancing as the emotional climax of the event. The *Newark Evening News* described the exhibition as a show of "Americanization" despite Kendall's characterization of it as a display of ethnic pride. Jane Addams's settlement work was the lens through which the journalist perceived the event: "The folk songs of the negroes won instant and prolonged applause, hearty and sincere. The audience did not sort itself out into groups, but all nationalities were scattered throughout the room and presented a sight that would have gladdened Jane Addams had she been there."[57] The "program of motion pictures, dances and songs of the homelands or tableaux vivants" included displays not of acculturation but rather of the preservation of ethnic identification: Irish performed "The Leadin' Road to Donegal"; Italians "The Twilight Saint"; and Jews "The Feast of Purim."[58] A heat wave kept temperatures in the nineties throughout the exhibition, and a frightening polio epidemic was raising the city's level of anxiety. Two mysterious deaths in Newark in July had escalated to two hundred by mid-August. So severe was the panic that the library closed its fourth floor for the summer, and newspapers reported large numbers of children and families relocating.

Kendall's evangelical fervor for social uplift was untroubled by the heat or epidemic: at the end of her exhausting work the young librarian conveyed her zeal to Dana in a five-page report. The Homelands show was, she explained, "a true 'expression of the people,' which is what we are after, I believe? But it will make you groan, I'm afraid."[59] In the rest of the letter, Kendall was both

breathless and intoxicated with a sense of a successful accomplishment. The Homelands Exhibition coincided with Dana's vacation in Vermont; he sent "congratulations and hearty thanks" to her.[60]

Kendall maintained in her correspondence with Dana the reverential tone that characterizes most library correspondence. In late August, a few weeks after the exhibition closed, Kendall wrote to Rummell, who was vacationing on Cape Cod, and was more reserved—she offered a formal statement of gratitude. The inversion of status groups and class was part of modern Newark: Kendall, the college graduate, boarded with a family and was not going to be vacationing that summer, while Rummell, a clubwoman whose father had been a common tradesman, was at the New England seaside. There was a decade's difference in their ages and enormous distinction in their industry: one was a wage earner and the other a volunteer.

A subsequent letter from Kendall to Rummell in November 1916 thanked her for her contribution of Colonial kitchen furnishings that would abet the "Americanization of the foreigner."[61] "Mr. Dana feels much encouraged at the prospect," Kendall wrote, leaving her own opinion outside of the communiqué. Kendall could have been expressing pleasure in their mutual interest in history or patronizingly alluding to their own ethnic differences. Historian Michael Kammen, among others, cites the Homelands Exhibition as a pioneering effort in community relations and cultural pluralism, but viewed through archival evidence, the effort was clearly hostage to hierarchical distinctions in gender, status, and class. The divisive project inflamed some clubwomen's antipathy to immigrants. Among others it generated increased empathy, but apparently only among those clubwomen who were close to the immigrants in status and cultural identity. Cordoned off as uplift and domestic industry to be conducted by women, the Homelands show was compartmentalized and marginalized by Newark's ruling class.

THE COLONIAL KITCHEN
In contrast, the Colonial kitchen erected in 1916 was one of the most popular and longest-running installations in the Newark Museum (figures 62 and 63). It, too, displayed Newark's newest citizens, but in the "old customs" of their adoptive land. The museum printed a formal notice in its annual report heralding the opening of the kitchen in December 1916, and over seventeen thousand school children were estimated to have visited this exhibition by March 1917. The installation recreated the "restrained, austere" domestic industry of the "Puritan spirit," and, to insure that visitors could identify

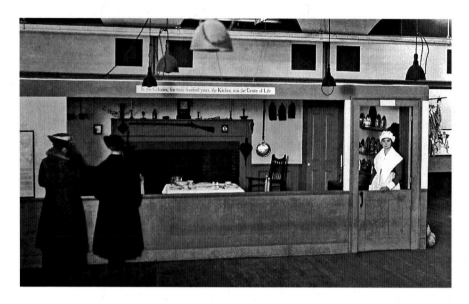

62. Installation photograph of Colonial Kitchen exhibition, undated, Newark Museum
Association on third floor of Newark Public Library. Commercial Photo Co., photographer.
Collection of the Newark Museum. This photograph documents the space between
museum performer and voyeur, and the Newark Museum's decision to blur the
distinction between authentic historical artifacts and theatrical interpretation.

with the "everyday life" of the past, the Colonial kitchen was inhabited every
afternoon from four to six by two young women in Colonial costume.[62] This
sentimental representation presented a "useful past": Puritans conducted a
domestic science curriculum. A far cry from the Homelands Exhibition in its
mode of repose, the level of theatricality was similar.

The kitchen performed a sleight of hand by bringing students inside to
become museum artifacts. What at first glance might look like acculturation,
getting young immigrants to pretend to be Priscilla, Longfellow's Puritan,
was complex. In 1916, the most ardent suffragette saw domestic industry
as a metaphor to symbolize women's autonomy. Moreover, the act of per-
formance held allure: in the kitchen Newark's second-class citizens became
objects of desire. The museum transformed participants into exemplary
Colonial-era women of virtue. The theatrical tableau was so successful that
the museum installed variations of it in 1918, 1920, and 1926.[63] No other exhi-
bitions were considered vital enough to maintain for over a decade. In 1920,
Dana and librarian Della Prescott transformed the exhibition into a textbook
for schools to build their own Colonial kitchen, and public demand neces-
sitated several editions.

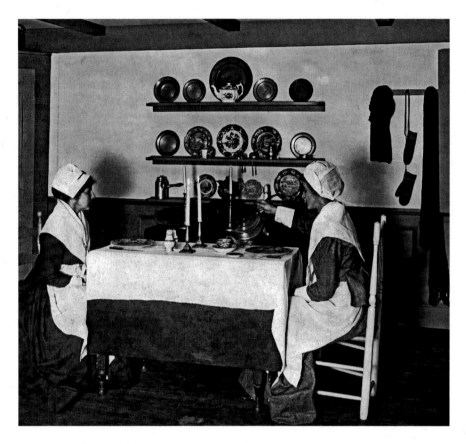

63. Dining in a Colonial Kitchen, installation photograph, undated, Newark Museum
Association on third floor of Newark Public Library. Commercial Photo Co., photographer.
Collection of the Newark Museum. While figure 62 can be interpreted as evidence that
the museum was prescribing normative behavior, this tableau resembles the Colonial teas
held by the Women's Political Union (see chapter 4), and opens the possibility that the
museum performance was entertaining and empowering. Although Newark students
often occupied the space of the Colonial Kitchen, in this image librarian Alice Kendall
and a Mrs. Travis demonstrate the proper tea etiquette. Here the unmarried New Woman
modeled exemplary domestic ideals.

In photographs of the museum's Colonial kitchen, pots and pans, home-
made lace, pottery, a spinning wheel, and a rifle are arranged around the focal
point of the hearth, an ersatz brick fireplace. The ensemble was Colonial in
terms of roughly approximating modest eighteenth-century New England
architecture, clothing, and taste. The tools hanging on the walls were a mix-
ture of old objects and replicas. The fireplace and mantel, where the rifle hung,
embodied Emerson's call for self-reliance, and the educational text belabored
this message.[64] Above the doorframe to the room, printed in large type, was

the educational message: "In the Colonies, for two hundred years, the Kitchen was the Center of Life." The museum presented an entirely Anglocentric perspective on American history. Didactic text explained that in the Colonial era, "each home was in large measure a complete community in itself."[65] Was the message a rebuke to the New Woman wanting to take a larger role in municipal stage, and venture out beyond traditional housekeeping, or an affirmation of the historical contribution of women? There is more evidence to suggest the latter: the museum hoped to foster a sense of collective unanimity.

The volunteer participants—available to "answer questions and give explanations of objects"—were students from the Webster Street School, a school to train teachers.[66] Newark's student body was 67 percent "alien" by birth or cultural identification, so that the actors wearing starched white linen collars and bonnets were largely immigrants, first-, or second-generation Americans. They were learning Colonial lore and making their own "age of homespun" fifty years after Horace Bushnell declared the activity especially edifying.[67] Just as the 1916 Textile Industries exhibition had demonstrated the symbolic value of the spinning wheel to all Americans, so too did the Colonial kitchen become an allegory for weaving anew the fabric of the community and the individual. Homespun was literally about the organization of domestic economy and an act of refining raw materials. Dana described the kitchen as a metaphor for home life that schools could communicate and disseminate. He hoped it would enact "the substitution of order for chaos."[68] Modestly dressed, the performers emphasized domestic rituals in pouring tea into china and spinning wool. Visitors witnessed historic "everyday life" as an aspiration of upward mobility.

The Colonial Kitchen exhibition freed the Newark Museum to reject the fine-art museum's criteria, the slavish worship of "price, rarity, and age" that Dana had lambasted in his 1913 publication "The Gloom of the Museum." In that polemical tract, he had promised that the museum of the future would "make manners seem more important, to promote skill, to exalt handwork and to increase the zest of life."[69] Because the performance of "manners" and "handicraft" was the focal point, the museum sanctioned the use of modern Colonial Revival hardware, especially if affordable props might increase the likelihood that schools would reproduce the installation. In creating its Colonial kitchen, Newark used modern reproductions of turned Windsor chairs, pewter tankards, and even "hand-forged" iron implements. Gustav Stickley's Chippendale, Sheraton, and "Olde Englishe" novelties, and Bamberger's pewter suited the museum's needs.[70] These commodities

imported historical allusions of handicraft into the modern American home and the museum, too. The Colonial Revival style was elastic and permeable; it could be oak or mahogany, geometric or serpentine, silver or pewter, china or earthenware. The museum's fake hearth presumed that a fireplace aided the visualization of family virtue and individual self-improvement.[71] The fireplace was "allied to the past and to the present," a mythic symbol for a modern house with central heating, and a device to transport one morally and ethically to the past.[72] The 1916 installation continued and expanded upon themes that the museum had articulated by displaying Strait & Richards's ceramic gas logs in Clay Industries.

In the Bronx and Westchester, historic kitchens had been recreated as scenes for patriotic reenactment for the Hudson-Fulton celebration in 1909. Sanitary Fairs in the Civil War era also used the symbol. Its popularization had grown after 1876, when a New England Colonial kitchen was exhibited in a log cabin at the Centennial Exhibition in Philadelphia. In 1910, Dana had visited George Francis Dow's representations of New England history at the Essex Institute in Salem, Massachusetts, where a people "dressed in homespun costumes" performed beside a lit fireplace.[73] Theatrical Colonial role-playing was an especially vibrant trend and was only increasing in 1916.[74]

The transformative capacity of the Colonial Revival style was articulated by many so-called Progressive cultural voices. In 1910, in Alfred Stieglitz's *Camera Work*, a critic wrote that "the Colonial room is one of the heritages of the past left for our artists to glorify. It is one of the ideal riches of our race."[75] The magazine featured images of historical interiors in which costumed women were part of the antique furnishings, presaging the photographs Wallace Nutting would mass produce a decade later.[76] The hearth was a sentimental portal into national identity. "Colonial" reproductions might have been marketed to nourish conservative attitudes, but they permeated American culture too broadly to represent any single political ideology. They were neither codified nor yet fatigued. Proof of the vitality of Colonial costume was its use in the suffrage cause. As noted in chapter 4, at a New Jersey Women's Political Union's Suffrage Ball, on 29 February 1916, the waitresses riffed on the Colonial era by wearing starched white caps and combining these with colorful skirts of green, white, and violet stripes, the cipher for Give Women the Vote. The Young Women's Christian Association also sponsored a Colonial Tea, but avoided the use of associative ornament that was ideologically prosuffrage. New England was the provider of this "usable past," a resource for debates about ethics and ideologies.

Calling "cheery fireplaces" essential to make the settlement house an idealized home, Jane Addams also used the hearth as a performance, not an inert artifact.[77] The Colonial kitchen similarly located authenticity in performance. Newark's ensemble shared in the intellectual aims of historian Carl Becker in "liberalizing the mind" and "deepening the sympathies" of the young American.[78] When Dana suggested that all schools create their own simulations of the historic home by assembling replicas, he encouraged the purchase of "compo-board" and lighting a fireplace with "an electric lamp, hidden in sticks and covered with red tissue."[79] Going beyond a penchant for the storytelling, Dana took license with inauthentic furnishings in order to make the presentation dramatic and theatrically powerful. This exercise was considered educationally progressive because it bypassed book learning to present "real life." The benefits were considered especially valuable in making American ideals accessible to young non-English-speaking Newark citizens.[80] As theater, the Colonial Kitchen Exhibition corresponded to the Homelands Exhibition. In both instances, the museum was invested in active performance more than authenticity. Its objective was emotional and moral empathy, not the teaching of facts or a precise history lesson.

In the *Atlantic Monthly* in 1910, scholar Carl Becker argued for pragmatic education, and worried that the citizen "detached" from history was a "dead mind." He proposed imaginative interaction as a therapy to cure modern alienation, a psychological solution to a social problem.[81] Similarly, Addams and Dewey saw an obsolete butter churn or spinning wheel as invested with restorative powers, which they selectively adapted in relation to recapitulation theory. The Newark Museum also invited its audience to recuperate history "from the bottom up," a phrase Addams used more than once to locate the banal as a primary vehicle toward enlightenment. The widely influential Becker encouraged the general reader to "turn on the past and exploit it in the interests of advancement."[82] Theodore Roosevelt articulated a similar view in *History as Literature* (1913), lending credence to the idea that the usable past was the only history worth writing.[83]

Exhibitions in the Newark Museum were constellations of objects with multiple meanings, and it is difficult to state definitively whether its performances prescribed normative behavior or offered participants spaces to reinscribe their own identities, the type of empowering rite that Joseph Roach sees occurring in Mardi Gras. Dana condescendingly thought the kitchen especially had "strong appeal to foreign-born adults and to their children" because "many of its features were still near to their experience."[84] One can

either accept Dana at his word, that his intention was not "to Americanize, or re-Americanize anybody," or interpret it as disingenuous, as his Colonial kitchen was a lesson aimed especially at immigrants: "The peculiarity of our situation is that so many of our children are step-children, half-children, adopted children. It is a mercy that there is an inheritance not only of blood, but of memories, of ideas, and of hopes. If this story stimulates emulation of the real virtues of our forefathers . . . and hence leads to real patriotism, it will have achieved the desire in the hearts of the authors and publishers."[85]

From today's perspective, the Colonial Kitchen Exhibition was a performative engagement with moral fiction that implied an aim of social engineering. However, Dana actively distanced himself from the term "assimilation," a sign of his Progressive sympathies and intentions. His protest against acculturation corresponds to Dewey's agonizing over the issue: "The children are too rapidly, I will not say Americanized, but too rapidly denationalized. They lose the positive and conservative values of their own native traditions, their own native music, art, and literature."[86] Both urban educators were trying to conserve the traditional cultural identities of immigrants, and favored teaching "industrial habits" to prevent cultural loss and what they perceived to be its attendant moral degeneration. These turn-of-the-century thinkers repudiated their nineteenth-century Vermont childhoods as parochial and spiritually limiting. They embraced automobiles and travel, but simultaneously fetishized the pastoral lifestyle and invented strategies to recuperate obsolete industries. Moreover, finding meaning in the modern city, they struggled to accommodate to its novel forms of leisure, especially cinema, popular music, and dance halls.

Rationalizing immigrant labor as an ethical, industrial, and commercial contribution, Dana and *The Newarker* stated that "each new race brings something that we need," but also repeatedly emphasized that individuals must subordinate their differences to a collective identity.[87] This was evident in the masque of Newark's pageant and Dana's Colonial kitchen. Most important, Dana's message bore similarities to the official mandate of assimilation and materialism delivered in a sermon at the South Park Presbyterian Church by the new editor of *The Newarker*, Henry W. Wack, who described the pageant as a "psychological point where the indifferent citizen is remade into a new civic asset."[88]

To refrain from focusing on the enigma of Dana's ideological position and mistaking the institution for the man, one can turn to his librarians to understand how tenuous his commitment to social work really was.

Louise Connolly, in a rare moment of insubordination to Dana preserved on record, wrote to a clubwoman that he was "simply spilling ideas as usual" when he asked The Contemporary to conduct the Homelands Exhibition.[89] She explained the obvious: that Dana deferred to and relied upon Newark's women to turn industry into a metaphor of uplift. While he vacillated over whether his institution promoted conservative messages of normative behavior or more pluralist ideals, Connolly openly argued that clubwomen's sympathies should extend to "foreigners." Frances Hays, the director of The Contemporary, regarded uplift from a more abstract and evangelical perspective when she hoped the pageant would christen a city that had "much material prosperity but no soul yet."[90] Women, like the pageant's personification of Liberty, were given the job of softening the collective civic heart, and they shouldered the task in different ways.

The Survey, the leading magazine of "constructive philanthropy," described the result of the yearlong celebration: "Newark actually became a conscious community swayed by large but definite motives transcending the previous experience of the individuals dwelling within it."[91] The periodical estimated the pageant's audience at one hundred and sixty thousand, a number greater than half of the city's population at the time, and gushed, "no community aesthetic, except the pageant of St. Louis, has ever so thrilled and fused a whole city."[92] From one perspective, the celebration did engineer "a Newark consciousness," turning the city industrial into a homeland.[93] But *The Survey* also lambasted Newark for spending four million dollars on pageantry and failing to provide funding to social services in a headline that read, "Is Newark Penny-Wise and Pound-Foolish?"[94] Newark's peculiar brand of progressive industrialism was ultimately focused on civic boosterism. Its library-cum-museum alternated between being a sycophant to the Board of Trade and, less frequently, a gadfly demanding civic improvement for the underclasses. Dana's democratic boast that he was building a "museum of everyday life" is often taken at face value, but it is enigmatic in the context of the actual daily operations of his institution. The civic virtue of industrial arts splintered along individual antipathies and compartmentalized self-interests, from the Board of Trade and clubwomen to the museum and library staff. The expansive definition of industry that the library and museum was beginning to realize in the Clay and Textile exhibitions faltered. The inclusion of twentieth-century commodities and mass spectacles in its exhibitions invited new communities to participate the library and museum but ultimately made the cultural institution into a platform for the city's entrepreneurial elite.

The Industrious Citizen

Statues of the inventor Seth Boyden and of the entrepreneurial Puritan sculpted by Gutzon Borglum idealized industrious forebears, suggesting Newark was a mystical workshop. In the 1920s, the city continued to erect celebratory representations but also of collective enterprise, such as Borglum's monument in Military Park, *Wars of America*, and the museum's window commemorating Froehlich and manual education. These illustrations of anonymous and selfless heroics told the librarian pedaling to her job or the stockboy hustling to Bamberger's that such civic endeavors could sweep aside the limitations imposed at birth—of one's ethnic associations, sex, or class. Coming to Chicago at the turn of the century made John Dewey "appreciate at every turn the absolute opportunity which chaos affords."[1] Newark too was an American dynamo convulsively pioneering its future. The city was a place to remake oneself and invent new goods, to lift oneself up by one's bootstraps like Boyden or Bamberger. Its librarians dispensed advice on business publicity and domestic beautification, transcending conventional roles and expectations.

The nettlesome contradiction in Progressive uplift, the mismatch between aesthetic pursuits and utilitarian vocations, bedeviled many libraries and museums. The industrial and mercantile dynamism of the city of Newark was regarded with optimism: with its momentum these two gears might interlock. With a missionary's zeal, Dana struggled to reconcile these objectives. To his credit, he conceived pragmatic strategies to fuse these aims instead of polarizing them into a segregated consciousness. His library and museum became complicit with Newark's commercial system and a material and visual reflection of its modernity. The transformation of the library and museum into an institution unburdened by absolutes in aesthetics and humanistic education

occurred because he, his trustees, and their city placed a premium on speed, efficiency, invention, and the "cash-value" of culture. Dana's attempt to persuade Newark that the vitality of its library and museum was dependent on its reality as "experience"—rather than its suggestion of an autonomous "logic"—was a shift aligned to the new philosophy of American Pragmatism. Louis Menand has rightly characterized this change in institutional practice—one that took hold in jurisprudence and in university education—as an expansion of consciousness motivated by engagement with the fluidity of social relations in the modern urban enivronment.[2] The discordances and social and economic disparities in America's swelling cities were new evidence, and dilated the eyes of Oliver Wendell Holmes, Jr., and William James, and Dewey, making them begin to sense the degree to which culturally constructed assumptions had governed their disciplines and institutions for several decades. Like these thinkers, Dana was a curious mixture of New England paternalism and cultural pluralism, who transferred into Newark's library his own restlessness and ambivalence toward location—a sense of alienation that was representative of his learning, generation, and career path. He embraced Newark because it was less inhibited and less provincial than the previous cities in which he had worked—Springfield, Massachusetts, and Denver, Colorado. In New Jersey, his credentials as an aesthete and freethinker were treated with respect and his willingness to work with business was regarded as a credible method of uplift.

In Dana's presswork, his own discomfort with his role as a patrician prompted him to present himself as a crafty Vermont farmer or a daring connoisseur of Japanese and European decorative arts. As a nervy and highly creative designer, he brought bold aesthetic concepts and playfulness to the cultural institution. He took obvious delight in the posters, magazines, exhibitions, and ephemera he concocted, especially his own woodblock print that he affixed to *ukiyo-e* when he gave them away. On these exotic pictures, his label was a roughhewn and virile yet learned emblem. The ornamental image balanced homage to Japan with a declaration of purpose in Latin, a pretentious if light-hearted collage (see plate 5). This testament to self-invention now sits quietly in archives, but it is the record of a performer who was desperate to be heard by and to impress his audience. His playful sense of craft extended into the institution. His designs preserved his deep-seated ambivalence toward cultural hierarchies, and his own proclivity for self-fashioning. In the diversity of his production is yet more evidence that runs counter to the tendency to characterize museums as monolithic extensions of a hegemonic system.

Newark conjured and demanded these multiple guises and persona that Dana authored. His uncertainty toward his adoptive hometown's industrial character was long-standing, and his envy of Henry Watson Kent's cultural riches was forthright in their private correspondence. His pride in exercising his hands helped him reconcile his lack of ease with his Vermont origins, his urbane sophistication, and his status in Newark. In his last decade, outside of the scope of this study, he pointed more and more frequently to his birthplace of Woodstock, Vermont, and his father's general store as touchstones of virtue, as if he had not run away from that strict Congregationalist hamlet.[3] The audacity of his print plate supports my interpretation that Dana's contrapuntal attitudes toward culture, his pride in serving it up, and his eagerness to debunk notions of expertise limited his ability to build consensus. He verbalized his passion for artistry with difficulty, relying on Veblen's "instinct for workmanship" and Dewey's and Addams's terms for the aesthetic construction of self and community.[4]

Dana's attacks on the art museum, fueled by Veblen's acerbic witticisms, are his most enduring legacy. But they also contain complex layers of contradiction, and deserve to be seen as responsive to his location in Newark. While he declared the art museum a luxury, largely because he saw large expenditures of money as wasteful, he still penned odes to the beauty of *ukiyo-e* and required that art pottery and fresh wildflowers ornament the library shelves as if these aesthetic dispositions had obvious and indisputable value. To his eyes, the cost of expensive fine-art museums outweighed their educational benefits, whereas industrial arts were, above all else, efficient. His constructive suggestion, the creation of local museums in each community in order to address local work, hobbies, and pleasure, is usually considered mundane but is in theory an autoethnographic experiment worth realizing. While social historians often cite his antagonism to art museums as a radical critique, his pessimism was rooted in his hauteur and usually is reiterated outside the context of his own self-fashioning. He cast himself as an iconoclast and Yankee radical, writing to Gutzon Borglum, "I was kicked down and out by the rich crowd that dominate the town." The Dartmouth graduate and member of the Century Club was a tangle of contradictions in an era of massive upheaval. The paternalistic autocrat articulated republican impulses, and the institution builder penned anti-institutional tracts. Although Dana's condemnation of the museum's tendency to perpetuate elitism in American life is still accurate, his insights should not preclude his admirers from seeing some of these accusations as theatrical gestures. After all, gilt-framed oil paintings and

plaster casts are always visible beyond or beside the shows of Werkbund post-
ers or demonstrations of weaving. His emphasis in reform was on establish-
ing or maintaining order. He encouraged self-improvement in relation to self-
regulation, a conservative view that rejected legislation as meddlesome and
hailed individual businessmen and engineers as exemplary and up-to-date.

Despite his praise for them as agents of civilization in the abstract, Dana
rarely agreed with local businessmen on matters of aesthetics. When his
library cunningly emulated the urban pulse of advertisements and engaged
in the craft of making its own posters, most of Newark's trustees bristled at
Dana's idea that publicity was necessary to conduct the business of culture.
They were predisposed to see advertising as a rational and scientific necessity,
but when he used these methods to promote the cultural institution he pro-
voked skepticism and anxiety. Moreover, his integration of social work into
the library's business went farther than many of his trustees cared. Brewer
Robert Ballantine thought that his loan of Edouard Detaille's *Cavalry Charge*,
an oil on canvas depicting Napoleon, would endow Newark with more glory
than the show of tables and sewing made by students in local schools that
Dana organized. Napoleon was a virile topic, and his picture told an enter-
taining story. Dana's appreciation for patent commercialism attracted deri-
sion. The trustees had reasons to grouse, because Dana's criteria for public
and private culture did not dovetail neatly. How *ukiyo-e* or Little Nemo would
improve Newark's printers and be of greater value than French Barbizon
school oil paintings was not self-evident. Ballantine and Murphy might have
had questionable taste, but their suspicions were well founded: Dana's aspi-
rations were contradictory. His interests leapt from job training to domestic
beautification, and he failed to outline the precise causal relationship between
the two.[5]

An exhibition about the art of advertising that Dana organized in the
spring of 1916, when Newark's pageantry was in full gear, is evidence that he
could rarely integrate his commitments to community welfare and to entre-
preneurial schemes. He was most clear in his objectives when he was dictat-
ing step-by-step lessons on how to design publicity for a business, especially
if the business was an abstract entity like the modern city and he could set
type freely on his own (plate 12). His 1916 exhibition of posters deviated from
his focus on the anniversary of the city's founding, and competed with the
official poster that he had initially guided to fruition. Above all, it suggests
Dana, when left to his own devices, dreamed about advertising as an art and
science he could mold.

The exhibition announcement also shows that the Newark Library and Museum surpassed its peers in its attention to quality. This was Dana's real talent as a craftsman and educator, where his focus of purpose was untrammeled by committees or conventions, and where the banal details of cooperation and uplift could be bypassed, sustained ethereally in artistic imagery. Willy Sesser of the International Art Service, whose cover for the script of the Newark Pageant was also published the same month, designed the announcement for Dana's exhibition municipal posters. The image combined the profiles of the Greek goddess of wisdom, Athena, and of the god of commerce, Mercury. It drew on historical ornament to speak to the present age, an alternative future-past to the Colonial Revival aesthetic that was predominant in Newark's pageant. If the flier maintained the gendered dichotomy of culture and commerce, it also was a rarity in which the library or museum depicted male and female heroic figures standing together in concert. The two ideals fit together on equal footing, in a way that Alfred Gengoult, the tapestry weaver, and Athene Vornazos, the old woman demonstrating spindle and distaff, did not. This 1916 poster exhibition also suggests that Dana's work would have taken a different form if he had left the industrial city or if he had not had a lively staff that brought it to his attention. The sociability engendered by his resilient coworkers made the Newark Library and Museum infinitely more complex by bringing it into closer rapport with human issues.

The city enabled women to become experts and professionals in uplift. The tension between aestheticism and utilitarianism was also without resolution for these women. The librarians, members of staff, and volunteers, who articulated allegories of industry and represented municipal unanimity, assisted other people's self-realization energetically. Ultimately it is they who personified the metaphor of the industrious citizen on a daily basis. Of the actors in this study, this female staff has received little credit in prior histories, largely because of their selflessness and deference to Dana. Their minimal presence in previous histories suggests that Beatrice Winser and Louise Connolly, as well as Kate Louise Roberts, Marguerite L. Gates, Marjary L. Gilson, and Alice Kendall, dramatically expanded Newark's notion of what type of citizen a woman could become. Connolly publicly stated that selfless sublimation was a logistical and spiritual prerequisite to make the cultural institution successful. From a twenty-first-century vantage point, it is easy to assume that the librarians worked as they did at a personal cost, and it is more difficult to see their gains. They were sustained by an evangelical faith in progress at a time when the notion of public tradition was unstable and the

status of women in public office barely tenable. They shouldered an immense load of work and responsibilities to the public, and they served culture as a calling more than as a day-job.

Moreover, their commitment to Newark's "romance of industry" lifted their own task of librarianship from the sphere of drudgery, and imbued their vocation with a moral purpose. In private correspondence, such as the drawing of "Home Sweet Home," made by a coworker on the occasion of Dana's journey to a 1905 American Library Association conference in Portland, Oregon, his assistants expressed the ambivalence toward Newark that they shared with him. The cartoon suggests that mocking the sooty smokestacks was a liberating rhetorical ploy. Sanctifying the factory was both an official injunction and an office gag (see figure 8). Dana and his librarians toyed with Newark as a metonym of their consignment to mediocrity. But the industrial city was also a novel context that goaded them to embrace a degree of risk and experimentation not witnessed in staid Boston or stately New York City. Women's cultivation of the industrial city has received scant attention because of their acceptance of the convention that they forego individual recognition, an anachronism in today's workplace, as well as in contemporary understandings of the arts, but the bookplates and occasional poetry of "B.W." and her co-workers are evidence that, like Dana, they too found Newark a place in which they could invent themselves anew.

In the photographs of holiday parties, the librarian's "playlets" performed in 1918, actors in the New Year's celebration dramas personified aesthetic and vocational uplift coupled under the aegis of library science. The librarians symbolizing Handicraft and Efficiency were linked arm in arm, fusing two pivotal ideals in the institution, Taylor's scientific management and the manual creed of the Arts and Craft movement. Handicraft was an easily grasped moral philosophy in library and museum administration. These women gave vitality to the institution, and experienced a shift of power that was peculiar to their moment: they gained a sense of professionalism and autonomy in direct proportion to the degree that they surrendered their identities to the institution and its civic project. The union of Handicraft and Efficiency was a recuperative performance, a triumph that asserted their fitness of purpose. If, in granting these women such agency, I run the risk of "exhuming the desires of the dead," to quote Benedict Anderson, at least I do not condescend to them.[6]

In the same image, the librarian dressed as the Colored Band illustrates a local definition of industrial education, a method devised by Dana himself to mark pamphlets and other products of the commercial world—publications

with thin spines (too narrow to label with letters and numbers). Live demonstration was not only a trope for the public but also a vehicle for playful intramural reflection. The dramas within the library reveal a view of culture that was not about freedom or authenticity. Like pageant performers, librarians experienced self-realization through their immersion in the institution—and their critique was safely respectful. Costumes in the library and municipal pageant are remarkably similar: the performances were surrogates, public demonstrations of the value of women's industry, each poised "within a particular equilibrium of social relations," to quote E. P. Thompson.[7] The librarians orchestrated an abstract and temporary emancipation: they lived through a moment when their public and private identities were interlocked in the struggle for suffrage. When Katherine Rummell spun wool, or Alice Kendall poured tea in the Colonial kitchen, performance intersected with ideological belief, and the distinctions between private and public terms of cultural engagement that Dana avoided addressing directly were inescapable.

In her stewardship of the library and museum after Dana's death, Beatrice Winser continued to navigate Newark's two distinct ideals in business and culture and still held onto his mythic view of artisans. "One of Miss Winser's ambitions," a newspaper noted, "is to see a nation-wide organization that will bring American workmen and their associate artists into more general appreciation as creators of beauty. If few American boys and girls turn to craftsmanship and artistry, the reason is, as she sees it, that there is little public honour for those who excel in fine work of mind or in work hand-performed with tools."[8] Her selflessness extended to her desire to maintain Dana's idealistic philosophy. The city also still struggled to reinvent its reputation as an "industrial suburb." In the 1920s, Bamberger's regionally magnetic brand name contrasted with its more pretentious slogan, "One of America's great stores." Maintaining fidelity to local production, Bamberger's sold Fulper pottery made in Flemington, New Jersey, and installed John Kunsman, their designer-craftsman, to demonstrate throwing clay pots on a kick wheel amid its merchandise. In 1939, the guide to the state of New Jersey compiled by the Works Progress Administration noted that the three largest employers, Bamberger's, the Prudential, and the local utilities corporation, made Newark a "company city."[9] Expressing what Martin Minner calls Newark's "metropolitan aspirations," the 1939 handbook argued that a "genuinely cosmopolitan tone" had developed. However, these two characterizations are mutually exclusive notions of the dynamic urban organism, and their contrast reveals the deeper problems of defining civic identity in relation to cultural

achievement. Dana's enigmatic legacy is the contemporary small museum that advertises itself as both regional and international, and is caught between these ambitions, and without a clearly defined audience.

Newark's citizens, who Dana ungracefully labeled "the citizens-to-be of you and me," also spoke of the library civilizing and liberating them. Newark-born novelist Philip Roth has used the library, often irreverently, as a milieu to invoke and update Mary Antin's idealization of the library as a beacon of enlightenment that sparked the imaginations of less affluent citizens. In his novella *Goodbye, Columbus*, Roth describes a boy looking for Gauguin's images of Tahiti who asks a librarian where the "heart" collection is shelved.[10] Although there is much to deplore about the ideal of "civilizing" immigrants and promoting a dominant culture, Dana's institutional legacy remains profoundly tied to the ideal of civic self-realization. Newark's dynamic history is especially worth recuperating to show that the reinvention of the cultural institution was the work of many participants. Surging and energetic civic associations, especially women's clubs, and the local merchants' laissez faire attitude toward Dana were two types of collaboration. Most of all, the dynamic modern American urban context sustained social networks and civic ideals in surprising ways, its commercial and cultural edifices engaging and entertaining each other as civic arenas.

The institutionalization of Dana's personal appreciation of comics most clearly indicates both the heroic intentions and the limitations of his embrace of modernity and his passion to lure juvenile citizens into the museum. An undated broadside for the children's museum extended cultural advertising to the youngest Newarkers, and devoted the institution's hand press and Cheltenham type to their needs. The poster invited "boys and girls" to bring in "anything interesting" and install it in a case, and depicted ragamuffin boys comparing their collections of marbles, birds' eggs, "arah-heads," and stamps (figure 64). The poster boldly suggested that all of these banal curiosities were worthy of a place in Newark's museum. The poster was visually anchored by an electrotype of a drawing by Clare A. Briggs, one of the highest paid newspaper cartoon-strip artists in the country in the first quarter of the twentieth century (figure 65). It was radical advertising because the comic strip characters speak idiomatically, and the collection of refuse like the Lorillard tobacco company's tins bear suggestive brand names such as "Mechanic's Delight" and "Climax." The representation of museification was quaintly rustic and humorously irreverent. "Aw Jiminy," quips one adolescent, "I got a whole lot of climaxes." Dana took pleasure in the novelties of the comic, especially for the

64. Newark Museum Association broadside, "Boys and Girls: These cases are kept for specimens brought by you," circa 1920, with illustration by Clare A. Briggs (1875–1930), first printed in the *New York Herald-Tribune*, 1914. Collection of the Newark Museum. Filling the museum's cabinets through public subscription was a method maintained in the children's museum, but considered impractical in the regular galleries after 1916. Dana reserved increasingly the discernment of beauty and good design to the jurisdiction of the expert, usually a museum professional. The definitions of the participatory museum and interactive work of art continue to shift today.

65. Detail of "Boys and Girls."

male reader. He bought racy ones in France and Germany when he traveled, and preserved them in his papers. The poster reveals that many of the modernizations he hoped to institute were born of wistful longing for and a repudiation of his own small-town birthplace and a sense of his own boyhood play. Briggs's work was perceived at the time as a satire of the provinciality of rural America, the world Dana had eagerly left behind.

The innovative museum enabled both Newark's children and its ceramic and textile manufacturers to represent themselves. A museum was to be filled through local conscription rather than through expert curatorial selection. Like manufacturers, children were offered space to represent themselves,

supposedly not dictated to or controlled. Exhibitions inventoried local material culture through managerial devices and strategies. While the results might appear to resemble democracy in action, the methods of counting cultural production were Taylorized, achieved through census-like data gathering. In the end, of course, the museum was mediating its audience as well as welcoming it through these shrewd and innovative technologies. Newark's cultural institutions retain an unsteady and unpredictable allure because Dana left traces of his ambivalence toward his audience, his Enlightenment project, and the city itself, in records such as this poster. Visually, it is an uneasy marriage of stiff and constrained text, struggling to be as vernacular and fluid as the drawing in its center. The comic and poster sustain the schizophrenic dialectic of Dana's cultural gravitations.

If Newark's negotiation of the dialectic between art and industry sounds like an antiquated Victorian discourse, its struggle to demonstrate its relevance and immediate value to its communities should sound familiar to contemporary museum goers. And what is still shocking is the manner in which Newark's mail-order mechanistic invitations to participate connected the cultural institution to the civic constitution: the museum's use of junk mail and generation of democratic participation were born in the same turn. The bold claim to be a transformative agent was realized when its invitation for contribution was genuinely an open call. The project to transform "everyday life" also carried with it a disciplinary message (like the legislation of Prohibition), but the scripted lessons and performances in uplift and civics were neither orderly nor disciplined. The museum agenda became a composite of voluntary subscription and self-representation, with equal parts community authorship and social engineering.[11]

In recent years, Newark's model of local participation has grown relevant again. The mid-century Modernist resistance to both religion and locality has eroded, and "critical regionalism" has grown in magnetism.[12] An open embrace of commerce is still infrequent, but it is usually a celebration of consumption more than of production. Vernacular artifacts and material culture are spiritualized and turned into emblems of pathos, particularly relics from manmade disasters. These enable us to realize that in order to matter a cultural institution must, in some ways, engage contemporary events and their immediately relevant social contexts. In 1911, when the Newark Museum Association collaborated with Temple B'nai Jeshurun, then on Washington Street near the business center of town, to install Navajo blankets inside the Moorish synagogue, it negotiated a modern concept of aesthetic, material,

and spiritual enrichment that would be described only much later as multi-cultural policy.[13] While that sort of visual turn has become an expectation in twenty-first-century museums, few attempt to latch onto a story as tangible as that of Seth Boyden. Newark's monument of the inventor was of far greater currency to the institution, a way of explaining the abstractions of both culture and industry. And the commemoration of Froehlich's window suggests that the artisan's body remained a metaphor, one legible to the entire population, and still legible today. The individual craftsman is still useful to communicate civic ideals, to inspire autonomy and responsibility, to celebrate common purpose, and, more problematically, to identify a sense of direct agency in a complicated world.

The nature of work has only become increasingly abstract and alien in the course of the last hundred years. Innovative nostalgia continues to thrive, flourishing in the heritage industry and also the average art school. While being manually industrious is still considered a heroic feat, it is usually not tethered to a collectivist impulse or framework. Praise for an individual's virtuosity was not part of the message in Newark's exhibitions, but such a final objective is widely acceptable in the museum today. We value cultural labor only in terms of individuals. Seth Boyden stands obliquely within his city, in it but no longer of it, and the library and museum, splintered, have little to do with older collectivist definitions of industry. Job training and lessons in civics, such as how to complete a 1040-EZ form for the IRS, might occur in the library, and decorative arts are exhibited in the museum, but *The Newarker* and the public education system no longer connect these disparate efforts. The word "industry" soldiers on, improbably enriched by new associations with Hollywood and Daniel Bell's poetic notion of a postindustrial society, but also reduced, cut apart from craft and its aspect of joyful work. We still do not know how our cities will survive without productive labor. Bell's term increasingly reads like a withdrawal of responsibility, a false image of autonomy. In this light, Newark's aspiration to create a civic culture has both an appealing and haunting spectral quality. Like the isolated individuals in the roundels of the window dedicated to Froehlich, the virtue of cultivating the industrial city seems impossibly archaic and yet immediately tactile, surely worthy of preservation.

NOTES

Abbreviations
NJHS New Jersey Historical Society
NMEF Newark Museum Exhibition Files
NPL Newark Public Library

Introduction: Cultivating the Industrial City

1. "Work of the Libraries," *Newark Evening News*, 9 April 1906, Newark Public Library Scrapbook (hereafter NPL Scrapbook), 1906–1908. "Mr. Dana Tells of Exhibitions," *Newark Evening News*, 11 July 1908, NPL Scrapbook, 1906–1908. Also see John Cotton Dana, "The New Relations of Museums and Industries: The Story of the First Ten Years of a Group of Experimental Museums" (1919), as reprinted in *The New Museum: Selected Writings by John Cotton Dana*, ed. William A. Peniston (Newark: Newark Museum in association with the American Association of Museums, 1999), 112.

2. Ruth Schwartz Cowan's insights into the sociology of technology and Jeffrey Meikle's commitment to exploring the materiality of technology provide a methodological and historiographical basis for this thesis. Ruth Schwartz Cowan, "The Consumption Junction: A Proposal for Research Strategies in the Sociology of Technology," in *The Social Construction of Technological Systems*, ed. Wiebe E. Bijker, Thomas P. Hughes, and Trevor Pinch (Cambridge, Mass.: MIT Press, 1987), 261; Jeffrey Meikle, "Leo Marx's *Machine in the Garden*," *Technology and Culture* 44 (January 2003): 147–159. Also see John F. Kasson, *Civilizing the Machine* (New York: Grossman, 1976); Leo Marx, *Machine in the Garden* (1964; New York: Oxford University Press, 1970); and Howard P. Segal, *Future Imperfect: The Mixed Blessings of Technology in America* (Amherst: University of Massachusetts Press, 1994), 13–26.

3. I take this notion of a paradigm shift of pragmatism from Louis Menand, *The Metaphysical Club* (New York: Farrar, Straus and Giroux, 2001), viii–xii. My understanding of library reform is informed by Dee Garrison, *Apostles of Culture: The Public Library and American Society, 1876–1920* (New York: Free Press, 1979).

4. On the turn-of-the-century dialectic between art and industry, see Eileen Boris, *Art and Labor: Ruskin, Morris, and the Craftsman Ideal in America* (Philadelphia: Temple University Press, 1986); Daniel T. Rodgers, *The Work Ethic in Industrial America, 1850–1920* (Chicago: University of Chicago Press, 1978); James B. Gilbert, *Work without Salvation* (Baltimore: Johns Hopkins University Press, 1977); Judy Arlene Hilkey, *Character Is Capital: Success Manuals and Manhood in Gilded Age America* (Chapel Hill: University of North Carolina Press, 1997); Jeffrey P. Sklansky, *The Soul's Economy: Market Society and Selfhood in American Thought, 1820–1920* (Chapel Hill: University of North Carolina Press, 2002); Robert H. Wiebe, *The Search for Order, 1877–1920* (New York: Hill and Wang, 1967); and David Nye, *The American Technological Sublime* (Cambridge, Mass.: MIT Press, 1994).

5. *The Successful Business Men of Newark* (Syracuse, N.Y.: Van Arsdale, 1873), 5; David Lawrence Pierson, *Narratives of Newark* (Newark: Pierson, 1917), 345.

6. "Artisans' Periodicals Found in the Library," *Newark Evening News*, 12 June 1903, NPL Scrapbook, 1903–1905; John Cotton Dana, "Modern German Applied Arts" (Hagen: Deutsches Museum, 1912), 11. Also see "Mechanics Now Using the Free Public Library," *Sunday Call*, 7 November 1909, NPL Scrapbook, 1906–1913. My emphasis on the intersection of handicraft and consumerism takes as its point of departure Simon Bronner's thesis that turn-of-the-century America was "a society in transition from a spiritual to a material age and from a producer to a consumer society," although his work also delineates specific histories that contradict this generalization. Simon J. Bronner, "Object Lessons," in *Consuming Visions: Accumulation and Display of Goods in America, 1880–1920*, ed. Simon Bronner (New York: W. W. Norton, 1989), 219.

7. My understanding of Progressivism is influenced by Steven J. Diner, *A Very Different Time: Americans of the Progressive Era* (New York: Hill and Wang, 1998); Daniel T. Rodgers, *Atlantic Crossings: Social Politics in a Progressive Age* (Cambridge: Belknap Press, 1998); and the seminal work of Richard Hofstadter, Arthur Schlesinger Jr., Daniel Boorstin, Robert H. Wiebe, and David W.

Noble (so-called "consensus history" for the focus on the upper echelons of political and economic urban polities). Also see Steven J. Diner, "Linking Politics and People: The Historiography of the Progressive Era," *Organization of American Historians' Magazine of History*, "The Progressive Era," 13, no. 3 (Spring 1999), http://www.oah.org/pubs/magazine/progressive/diner.html (accessed August 29, 2009); Daniel T. Rodgers, "In Search of Progressivism," *Reviews in American History* 10 (1982): 113–132; Richard L. McCormick, "Public Life in Industrial America, 1877–1917," in *The New American History*, ed. Eric Foner, rev. ed. (Philadelphia: Temple University Press, 1997), 107–132; and Peter Filene, "An Obituary for 'The Progressive Movement,'" *American Quarterly* 22, no. 1 (Spring 1970): 20–34.

8. Mark I. Gelfand, *A Nation of Cities* (New York: Oxford University Press, 1975), 15–19.

9. "Work of the Libraries," *Newark Evening News*, 9 April 1906, NPL Scrapbook, 1906–1908.

10. Lawrence W. Levine, *Highbrow/Lowbrow: The Emergence of Cultural Hierarchy in America* (Cambridge: Harvard University Press, 1988).

11. John Cotton Dana, letter to the editor, *New York Times*, 11 February 1913.

12. "Jersey a Beehive of Industry," *New York Times*, 18 October 1907, 18. The beehive was an ancient motif with an important regional history too: Alexander Hamilton's Society for the Establishment of Useful Manufactures, an effort to harness Paterson Falls in the 1790s, featured an apiary as its emblem. See James P. Johnson, *New Jersey: History of Ingenuity and Industry* (Northridge, Cal.: Windsor Publications, 1987).

13. Don C. Skemer, "David Alling's Chair Manufactory: Craft Industrialization in Newark, New Jersey, 1801–1854," *Winterthur Portfolio* 22, no. 1 (Spring 1987): 1–21.

14. See Frank Urquhart, *A Short History of Newark* (Newark: Baker, 1916), 140. Also see Samuel Harry Popper, "Newark, New Jersey, 1870–1910: Chapters in the Evolution of an American Metropolis" (Ph.D. dissertation, New York University, 1952), 17, 410–411; John T. Cunningham, *Newark* (Newark: New Jersey Historical Society, 1966); and Martin V. Minner, "Metropolitan Aspirations: Politics and Memory in Progressive Era Newark" (Ph.D. dissertation, Indiana University, 2005).

15. See Stuart Galishoff, *Newark: The Nation's Unhealthiest City, 1832–1895* (New Brunswick: Rutgers University Press, 1988), 1–35, 79–104.

16. Municipal industrial exhibitions were held in 1912, 1914, 1916, and 1922, mostly organized by the Board of Trade.

17. Board of Trade, *Newark, A Manufacturing City* (Newark: Board of Trade of the City of Newark, 1902), 33.

18. See Susan E. Hirsch, *Roots of the American Working Class: The Industrialization of Crafts in Newark, 1800–1860* (Philadelphia: University of Pennsylvania Press, 1978), 74–81.

19. Board of Trade, *Year Book, 1911* (Newark: Board of Trade of the City of Newark, 1911), 25.

20. Board of Trade, *Newark, A Manufacturing City*, 64.

21. For other interpretations of the depiction of labor in America, see also Melissa Dabakis, *Visualizing Labor in American Sculpture: Monuments, Manliness, and the Work Ethic, 1880–1935* (Cambridge: Cambridge University Press, 1999) 1–34; and Edward Slavishak, "Civic Physiques: Public Images of Workers in Pittsburgh, 1880–1910," *Pennsylvania Magazine of History and Biography*, 127, no. 3 (July 2003): 309–338. See also Meredith Arms Bzdak, *Public Sculpture in New Jersey: Monuments to Collective Identity* (New Brunswick: Rutgers University Press, 1999); Michele Bogart, *Public Sculpture and the Civic Ideal in New York City, 1890–1930* (Chicago: University of Chicago Press, 1989); Richard Oestreicher, "From Artisan to Consumer: Images of Workers, 1840–1920," *Journal of American Culture* 4, no. 1 (Spring 1981): 53; Harry R. Rubinstein, "With Hammer in Hand: Working-Class Occupational Portraits" in *American Artisans: Crafting Social Identity, 1750–1850*, ed. Howard B. Rock, Paul A. Gilje, and Robert Asher (Baltimore: Johns Hopkins University Press, 1995), 176–197; and Tim Barringer, *Men at Work* (New Haven: Yale University Press, 2005).

22. On Progressive philanthropy, see Robert H. Wiebe, *Businessmen and Reform: A Study of the Progressive Movement* (Cambridge, Mass.: Harvard University Press, 1962); and Daniel Fox, *Engines of Culture: Philanthropy and Art Museums* (1963; New Brunswick, N.J.: Transaction, 1993).

23. "Public Library Open," NPL Scrapbook, 1889–1900, n.p. See Bruce Ford, "The Newark Library," in *A History of New Jersey Libraries, 1750–1996*, ed. Edwin Beckermann (Lanham, Md.: Scarecrow Press, 1997), 73–85.

24. "A Useful Library," *New York Sun*, 12 January 1913, as quoted in Frank Kingdon, *John Cotton Dana: A Life* (Newark: Newark Public Library and Museum, 1940), 95.

25. Frank Crunden, "The Public Library as a Factor in Industrial Progress," *The Industrial Exponent* (November 1905), NPL Scrapbook, 1903–1905; Frederic C. Howe, *The City: The Hope of Democracy* (New York: C. Scribner, 1905), 280–314.

26. "Mr. Hill and the Brooklyn Public Library," *New York Times*, 23 March 1901.

27. Frank J. Urquhart, *A History of the City of Newark, New Jersey*, 3 vols. (New York: Lewis Historical Publishing, 1913) 3: 245–246.

28. L. Bamberger and Company, *Exposition Daily Recorder* no. 4 (6 February 1913): 4.

29. *Newark Evening News*, 24 September 1921, 14.

30. Newark, New Jersey, City Plan Commission, *City Planning for Newark* (Newark: Hardham Printing, 1913), xxvi.

31. "Newark a City of Optimism and Progress," *New York Times*, 19 October 1913.

32. Each generation has interpreted Dana and the Newark Museum selectively, as champion of the underclass, of the living artist, and community activist. On Dana as a democratizer, see Edward Alexander, *Museum Masters: Their Museums and Their Influence* (Nashville, Tenn.: American Association for State and Local History, 1983), 395, and Nicholas Maffei, "John Cotton Dana and the Politics of Exhibiting Industrial Art in the U.S., 1909–1929," *Journal of Design History* 13, no. 4 (2000): 301–317. On Dana as a champion of living artists, see Jesús-Pedro Lorente, *Cathedrals of Modernity: The First Museums of Contemporary Art, 1800–1930* (Aldershot: Ashgate, 1998), 224. Stephen E. Weil's introduction to *The New Museum*, ed. Peniston, emphasizes Dana the educator and pioneer of "outreach." My interpretation of the connections between the Newark Museum and Bamberger's builds on the scholarship of Carol Duncan, the late Charles F. Cummings, John E. O'Connor, Neil Harris, William Leach, and Dianne Pilgrim, as well as the generosity of several other curators, librarians, and directors, especially Ulysses G. Dietz. In addition, I am grateful to Duncan and Dietz for their comments on my dissertation. A selective bibliography of essential scholarship on the Newark Museum includes Carol Duncan, "Museums and Department Stores: Close Encounters," in *High-Pop: Making Culture into Popular Entertainment*, ed. Jim Collins (Malden, Mass.: Blackwell, 2002), 129–154; John E. O'Connor and Charles F. Cumming, "Bamberger's Department Store, *Charm* Magazine, and the Culture of Consumption in New Jersey, 1924–32," *New Jersey History* 102, no. 3–4 (Fall-Winter 1984): 1–33; Neil Harris, "Museums, Merchandising, and Popular Taste: The Struggle for Influence," in *Material Culture and the Study of American Life*, ed. Ian M. B. Quimby (New York: W. W. Norton for the Winterthur Museum, 1978), 140–217; William Leach, *Land of Desire* (New York: Pantheon, 1993), 164–169; Miles Orvell, *The Real Thing: Imitation and Authenticity in American Culture, 1880–1940* (Chapel Hill: University of North Carolina Press, 1989), 180–181; Dianne DeGlow Hauserman [Pilgrim], "John Cotton Dana: The Militant Minority of One" (Master's thesis, New York University Institute of Fine Arts, 1965); Barbara Lipton, "John Cotton Dana and the Newark Museum," *Newark Museum Quarterly* 30, no. 2–3 (1979): 1–58. My manuscript was written before the publication of Dr. Duncan's study, initially marketed under the title *How to Have a Museum with Brains*, and without the benefit of reading it. While the museum has received such ample attention, the major assessment of the Newark Library remains Garrison's *Apostles of Culture*.

33. Franklin Murphy to Richard Jenkinson, 28 December 1915, Jenkinson Scrapbooks, vol. 1, New Jersey Historical Society (NJHS); *Women's Political Union of New Jersey Campaign Year Book, 1914*, Amelia Moorfield Papers, box 1, NJHS.

34. Twenty-one librarians from the predominantly female staff attended a celebration of the transcontinental telephone in Newark's YWCA in 1916. Beatrice Winser to Richard Jenkinson, 24 March 1916, Jenkinson Scrapbooks, vol. 1, NJHS.

35. *Newark Star*, 10 January 1912, NPL Scrapbook, 1906–1913.

36. Ford's Detroit plant underwent such attrition in 1913 that its turnover was 370 percent; Rodgers, *Work Ethic in Industrial America*, 163. Of the total workforce in the United States, 20 to 30 percent was unemployed.

37. Whitehead and Hoag's employees shifted in number from four hundred to eight hundred several times in the course of two decades, Murphy Varnish had between seventy-two and two hundred employees. William Stainsby, Bureau of Statistics of New Jersey, *Industrial Directory of New Jersey* (Trenton: Bureau of Statistics, 1901); Winton C. Garrison, Bureau of Statistics of New Jersey, *Industrial Directory of New Jersey* (Camden: Bureau of Statistics , 1906, 1912); George C. Low, Bureau of Industrial Statistics of New Jersey, *Industrial Directory of New Jersey* (Camden: Bureau of Industrial Statistics, 1915); Lewis T. Bryant, *Industrial Directory of New Jersey* (Paterson: Bureau of Industrial Statistics, Department of Labor, 1918).

38. The 1911 annual report of Newark's Board of Education lamented how "in some of the Newark schools fifteen different languages are spoken by children." See Linda Jacewich, "The Impact of Immigration on Newark, New Jersey's Public and Parochial Primary and Grammar School Programs during the Migration: 1880–1930" (Ph.D. dissertation,

Seton Hall University, 1993), 20; and Marilyn R. Kussick, "School Reform as a Tool of Urban Reform: The Emergence of the Twentieth-Century Public School in Newark, New Jersey, 1890–1920" (Ph.D. dissertation, Rutgers University, 1974). The African American population was approximately 2 percent in 1912, but would soon grow as the apparition of limitless growth in manufacturing attracted a northern migration.

39. John Cotton Dana, "Solving Social Questions," *Newarker* 2, no. 2 (December 1912): 221.

40. John Cotton Dana, *Notes on Bookbinding for Libraries* (Chicago: Library Bureau, 1906), 53.

41. John Cotton Dana, *Installation of a Speaker and Accompanying Exhibits*, New Museum Series 3 (Woodstock, Vt.: Elm Tree Press, 1918).

42. *Newark Evening News*, 12 November 1912, NPL Scrapbook, 1906–1912.

43. *Fourteenth Annual Report of the Board of Trustees of the Free Public Library*, made to the Honorable Board of Aldermen of the City of Newark, N.J. 1902 (Newark: Free Public Library, 1903), 27.

44. Much scholarship has situated Dana as an obscure or unheralded Modernist: Dianne H. Pilgrim, Dickran Tashjian, and Richard Guy Wilson, *The Machine Age in America, 1918–1941* (New York: Brooklyn Museum in association with Harry N. Abrams, 1986), 66, 276; Jay E. Cantor "Art and Industry: Reflections on the Role of the Museum in Encouraging Innovation in the Decorative Arts" in *Technological Innovation and the Decorative Arts*, ed. Ian M. G. Quimby and Polly Anne Earl (Wilmington, Del.: Hagley Museum, 1973), 344–345; Jeffrey Meikle, *Twentieth Century Limited: Industrial Design in America, 1925–1939* (Philadelphia: Temple University Press, 1979), 20, 30–31; Maffei, "John Cotton Dana and the Politics of Exhibiting Industrial Art," 301–317.

45. See Michael Conforti, "The Idealist Enterprise and the Applied Arts," in *A Grand Design: The Art of the Victoria & Albert Museum*, ed. Malcolm Baker and Brenda Richardson, (Baltimore: Harry N. Abrams and Baltimore Museum of Art, 1997), 25–47; Brandon Taylor, *Art for the Nation: Exhibitions and the London Public, 1747–2001* (Manchester: Manchester University Press, 1999), 67–98.

46. Chalmers Hadley, *John Cotton Dana, A Sketch* (Chicago: American Library Association, 1943), 56–57.

47. Dana's peers compared him to William Morris. See "Art in the Home," *Outlook*, 7 February 1914, 28.

48. John Cotton Dana, "The Relation of Art to American Life," in *Proceedings of the Joint Convention of the Eastern Art Teachers Association and the Eastern Manual Training Association* (New York, 1906), 46; also published in Newark's *Sunday Call*, 24 June 1906, and in *School Arts Book* 6, no. 1 (September 1906): 35–42. Michael E. McGerr, *A Fierce Discontent: The Rise and Fall of the Progressive Movement in America, 1870–1920* (New York: Free Press, 2003).

49. John Dewey, *The School and Society, Being Three Lectures*, 2nd ed. (Chicago: University of Chicago Press, 1900), 31–21, 105. Robert Crunden, *Ministers of Reform: The Progressives' Achievement in American Civilization, 1889–1920* (New York: Basic Books, 1982), xii, 55–63. Also see John Dewey, "Observation and Information in the Training of Mind," in *How We Think* (Boston: D. C. Heath, 1910), 146–151.

50. See Edward S. Cooke, Jr. "The Long Shadow of William Morris: Paradigmatic Problems of Twentieth Century American Furniture," *American Furniture* 2003, 213–237; William Morris, *The Decorative Arts: Their Relation to Modern Life and Progress* (London: Ellis and White, 1878), 4, 25.

51. See Andrea Tone, *The Business of Benevolence: Industrial Paternalism in Progressive America* (Ithaca: Cornell University Press, 1997). Also see Rodgers, *Work Ethic in Industrial America*, 88; Jane Addams, *Democracy and Social Ethics* (New York: Macmillan, 1913), 165.

52. See Shannon Jackson, *Lines of Activity: Performance, Historiography, Hull-House Domesticity* (Ann Arbor: University of Michigan Press, 2000).

53. Jackson, *Lines of Activity*, 13.

54. Jane Addams, "First Outline for the Labor Museum," Jane Addams Memorial Collection, microfilm edition, reel 3, 18, as quoted in Jackson, *Lines of Activity*, 263.

55. Jane Addams, *Twenty Years at Hull House* (New York: Macmillan, 1911), 173.

56. See Michael Kammen, *Mystic Chords of Memory* (New York: Knopf, 1991), 270–348; Sklansky, *Soul's Economy*, 173–221.

57. See Sklansky, *Soul's Economy*, 122–170.

58. See Bill Brown, *A Sense of Things: The Object Matter of American Literature* (Chicago: University of Chicago Press, 2003). For a nuanced interpretation of the hegemony and agency in Progressive era consumption, see Richard Ohmann, *Selling Culture* (London: Verso, 1996). In comparison, the scholarship of Richard Sennett, Jackson Lears, and William Leach, upon which my perspective is also based, tends to conclude that consumerism is deleterious or even toxic to civic republicanism. See Richard

Sennett, *The Fall of Public Man* (New York: W. W. Norton, 1992); Jackson Lears, *Fables of Abundance* (New York: Basic Books, 1994); and Leach, *Land of Desire*. My interpretation of Newark material culture draws on the work of Jules David Prown, "Mind in Matter: An Introduction to Material Culture Theory and Method," *Winterthur Portfolio* 17, no. 1 (Spring 1982): 1–19; Thomas J. Schlereth, *Cultural History and Material Culture: Everyday Life, Landscapes, Museums* (Charlottesville: University Press of Virginia, 1990); Arjun Appadurai, "Introduction: Commodities and the Politics of Value," in *The Social Life of Things: Commodities in Cultural Perspective*, ed. Appadurai (Cambridge: Cambridge University Press, 1986), 3–63; and Roger Stein, "Artifact as Ideology," in *"In Pursuit of Beauty": Americans and the Aesthetic Movement*, ed. Doreen Bolger Burke (New York: Metropolitan Museum of Art and Rizzoli, 1986), 23–51.

59. Marion F. Washburne, "A Labor Museum," *Craftsman* 6, no. 6 (September 1904): 574; Mertice Maccrea Buck, "Hull-House Labor Museum, Where Immigrant Women Are Taught Spinning and Weaving and Also the History of These Industries," *Craftsman* 13, no. 2 (November 1907): 229–230.

60. On the Commercial Museum, see Steven Conn, *Museums and American Intellectual Life, 1876–1926* (Chicago: University of Chicago Press, 1998), 115–150.

61. Jenkinson Scrapbooks, vol. 2, NJHS.

62. William P. Wilson, Director of the Philadelphia Commercial Museum, to John C. Dana, 2 February 1912, Newark Museum Exhibition Files (NMEF); Newark Museum to William P. Wilson, Commercial Museum, 30 August 1915, NMEF.

63. Jane Addams, *The Spirit of Youth and the City Streets* (New York: Macmillan, 1909), 126.

64. See Garrison, *Apostles of Culture*.

65. Louise Connolly, "How to Use a Library and How Not to Use It," *Sunday Call*, 9 April 1906, NPL Scrapbook, 1906–1908.

66. Raymond E. Callahan, *Education and the Cult of Efficiency* (Chicago: University of Chicago Press, 1962); Martha Banta, *Taylored Lives: Narrative Productions in the Age of Taylor, Veblen, and Ford* (Chicago: University of Chicago Press, 1993).

67. "Library and Museum Directed by Woman Widen their Service in Decade of Stress," *New York Times*, 24 December 1939, Winser papers, scrapbook 5, NJHS.

68. For an analysis of these sentimental products as tactile and emotional accessories, see Kenneth L. Ames, *Death in the Dining Room* (Philadelphia: Temple University Press, 1992), 97–146.

69. The performative aspect of craft demonstrations relates to the work of Judith Mastai and Amelia Jones. See Amelia Jones, *Body Art: Performing the Subject* (Minneapolis: University of Minnesota Press, 1998), and Griselda Pollock, "Un-Framing the Modern," in *Museums after Modernism*, ed. Pollock and Joyce Zemans (Malden, Mass.: Blackwell, 2007), 1–34. This view diverges from Tony Bennett's notion of the "exhibitionary complex" by seeing the library as a material and social space with diverse physical and tactile phenomena and message, not a primarily visual theatre or stable set of power relations between institution and audience. See Tony Bennett, *The Birth of the Museum* (London: Routledge, 1995), 63.

70. Benedict Anderson, *Imagined Communities* (London: Verso, 1991).

71. See David Adams, "J. & R. Lamb Studios: The First 75 Years," *Stained Glass Quarterly* 102, no. 2 (Summer 2007): 120–133; Katharine Lamb Tait, "On the Lamb Studios," as told to Donald F. Samick, 22 March 1975, manuscript, Rakow Research Library of the Corning Museum of Glass.

72. See Neil Harris, "The Gilded Age Revisited: Boston and the Museum Movement," *American Quarterly* 14, no. 4 (1962): 545–566; Paul DiMaggio, "Cultural Entrepreneurship in Nineteenth-century Boston, Part I: The Creation of an Organizational Base for High Culture in America," and "Cultural Entrepreneurship in Nineteenth-century Boston, Part II: The Classification and Framing of American Art," in *Rethinking Popular Culture: Contemporary Perspectives in Cultural Studies*, ed. Chandra Mukerji and Michael Schudson (Berkeley: University of California Press, 1991) 374–397; 398–423. Also see Carol Duncan, *Civilizing Rituals: Inside Public Art Museums* (New York: Routledge, 1995).

73. As histories of cultural institutions grow, we are still only beginning to recapture the ways Newark paralleled and differed from other industrial municipalities, be it Manchester, Cleveland, or Budapest. See Amy Woodson-Boulton, "Temples of Art in Cities of Industry: Municipal Art Museums in Birmingham, Liverpool, Manchester, c. 1870–1914" (Ph.D. dissertation, University of California, Los Angeles, 2003); Amy Woodson-Boulton, "'Industry without Art Is Brutality': Aesthetic Ideology and Social Practice in Victorian Art Museums," *Journal of British Studies* 46, no. 1 (2007): 47–71.

74. "Als Ik Kan," *Craftsman* 11, no. 2 (November 1906): 253; "Book Review," *Craftsman* 11, no. 5 (February 1907): 595; Richard Hofstadter, "William Graham Sumner, Social

Darwinist," *New England Quarterly* 14, no. 3 (September 1941): 457–477; Joan Campbell, *The German Werkbund: The Politics of Reform in the Applied Arts* (Princeton: Princeton University Press, 1978), 3–18; Gillian Naylor, *The Arts and Crafts Movement: A Study of Its Sources, Ideals and Influence on Design Theory* (Cambridge, Mass.: MIT Press, 1971), 184–189.

75. Theodore Roosevelt, "Race Decadence," *Outlook* 97 (8 April 1911) reprinted in *The Works of Theodore Roosevelt*, ed. Hermann Hagedorn, 20 vols. (New York: C. Scribner's Sons, 1926) 14: 151–166; "Jersey Old Guard Greet Roosevelt," *New York Times,* 2 June 1916.

76. See Arthur S. Link, *Wilson: The Road to the White House* (Princeton: Princeton University Press, 1947), 490–498.

77. *A Half-Century of Art, 1855–1905* (Newark: Frederick J. Keer's Sons, 1905), n.p.

78. *Exposition Daily Recorder* no. 1 (3 February 1913): 2.

79. *Exposition Daily Recorder* no. 6 (8 February 1913): 4.

80. Similarly, Hahne's, another local department store, used in its advertisements the story of Michael Faraday, the "humble apprentice" who became the founder of the electric industry. The stores suggested their bookstores were a means of upward mobility. *Newark Evening News*, 17 February 1916 and 24 September 1921, NPL Scrapbook, 1918–1921.

81. Susan Porter Benson, *Counter Cultures: Saleswomen, Managers, and Customers in American Department Stores* (Urbana: University of Illinois Press, 1986), 124–167.

One: The Engine of Culture

1. On Wright's emphasis on communication as "universal automatic fabric" see Paul Goldberger, "Frank Lloyd Wright at Hull House," speech at Hull House Museum, Chicago, 1 March 2001, http://www.paulgoldberger.com/speeches.php?speech=flw, accessed 29 September 2009.

2. John Cotton Dana, "Democracy of Art," *Printing Art* 8, no. 6 (February 1907): 377–383.

3. John Cotton Dana, "Advertising, the Essence of Public Service," *Advertising News*, 23 December 1916, 37.

4. Ibid.

5. "The Library and the Printing Press," handbill, 23 January 1904, NPL.

6. [John Cotton Dana], "Why the Newarker?" *Newarker* 1, no. 3 (January 1912): 42–43.

7. "The Library and the Printing Press."

8. The version of The Printed Book that the Newark Library sold to the Library of Congress was bound and is in the rare book collection. The one sold to the New York Public Library was first in the art collection but is now in the general collection.

9. S. H. Horgan, "A Library Exhibition of Book Building," *Inland Printer* 43 (July 1909): 543–544; "Book Material on Exhibition," *Newark Evening News*, 26 July 1909, NPL Scrapbook 1909–1913.

10. John Cotton Dana, "The Gloom of the Museum," *Newarker* 2, no. 12 (October 1913): 389.

11. See Henry Watson Kent, *What I Am Pleased to Call My Education*, ed. Lois Leighton Comings (New York: Grolier Club, 1949), 142–144; Regina Maria Kellerman, *The Publications and Reproductions Program of the Metropolitan Museum of Art: A Brief History* (New York: Metropolitan Museum of Art, 1981); and William M. Ivins, *Addresses Given at the Opening of the Exhibition of the Metropolitan Museum Printing Held in the Pierpont Morgan Library on 24 October 1938* (New Haven: Yale University Press and AIGA, 1939), 20.

12. Steven Conn, *Museums and American Intellectual Life, 1876–1926* (Chicago: University of Chicago Press, 1998), 112–118.

13. Dana, "Democracy of Art," 383; John Cotton Dana, "A Museum of Everyday Life," *Woman's Home Companion* 52, no. 1 (January 1925): 29.

14. Chalmers Hadley, *John Cotton Dana, A Sketch* (Chicago: American Library Association, 1943), 19.

15. John Cotton Dana, "Printing Presses in Museums and Libraries," *Museum* 1, no. 1 (May 1917): 40.

16. William J. Dane, "The History of Fine Printing: A Special Collection in the Newark Public Library," *Special Collections* 4, no. 1 (1988): 45–59.

17. "Library Buys Old Printing Press, and Thereby Hangs an Interesting Tale," *Sunday Call*, 18 March 1907, NPL Scrapbook, 1906–1913.

18. See Robert Morse Crunden, *Ministers of Reform* (New York: Basic Books, 1982), x.

19. John Cotton Dana, "How Museum and Schools May Aid Good Workmanship," *Newark Evening News*, 23 August 1913, reprinted in *The New Museum: Selected Writings by John Cotton Dana*, ed. William A. Peniston (Newark: Newark Museum in association with the American Association of Museums, 1999), 187; Timothy Dwight, *Greenfield Hill: A Poem in Seven Parts* (New York: Childs and Swain, 1794), 1: 152–155. My interpretation is informed by Richard L. Bushman, *From Puritan to Yankee: Character and Social Order in Connecticut, 1690–1765* (Cambridge, Mass.: Harvard University Press,

1967), 18; and John Griffith, "The Columbiad and Greenfield Hill: History, Poetry, and Ideology in the Late Eighteenth Century," *Early American Literature* 10, no. 3 (Winter 1975–1976): 235–250.

20. Percy H. Boynton, "Timothy Dwight and His Connecticut," *Modern Philology* 38, no. 2 (November 1940): 199. Dwight insisted that "the love of property . . . seems indispensable to the existence of sound morals."

21. "There is always a little barrier between the brain-worker and the hand-worker. It should be slight. It should not lead to misunderstandings." A speech by Dana at the Trenton Free Public Library, "The Work of the Free Public Library" reprinted in *Trenton Free American,* 10 June 1902, NPL Scrapbook, 1899–1902. Also see "Books at Library upon Industrial Education," *Sunday Call,* 28 November 1909, NPL Scrapbook, 1906–1913.

22. Barbara Lipton, "John Cotton Dana and the Newark Museum," *Newark Museum Quarterly* 30, no. 2–3 (1979): 9; John Cotton Dana, "On the Boy Who Whittles," *Newarker* 1, no. 8 (June 1912): 137.

23. "Wants Progress in Museums," *New York Times,* 19 May 1926, 24.

24. Dana, "Printing Presses in Museums and Libraries," 40.

25. *The Acorn* 1, no. 2 (June 1872). On the moral dimensions of the hobby, see Steven M. Gelber, *Hobbies: Leisure and the Culture of Work in America* (New York: Columbia University Press, 1999).

26. For a sense of the heyday of artistic typefaces in the 1870s, see Doug Clouse, *MacKellar, Smiths & Jordan* (New Castle, Del.: Oak Knoll Press, 2008).

27. A regional capital of artisanal craft that peaked in Dana's youth, Woodstock had the state's largest number of jewelers, clockmakers, and makers of musical instruments per capita of any Vermont town. In 1870, when Dana was fourteen, Woodstock's population of fewer than three thousand was home to fifty-eight carpenters, fifteen masons, twenty-one blacksmiths, six joiners, four furniture makers and sellers, five tinsmiths, four wheelwrights, six harness makers, nine shoemakers, sixteen tailors and seamstresses, four watchmakers, six jewelers and silversmiths, four bookbinders, one gunsmith, and thirty-three "mechanics."

28. See Richard L. Bushman, *Refinement of America: Persons, Houses, Cities* (New York: Knopf, 1992), xix. On the country store, see Thomas Schlereth, "Country Stores, County Fairs, and Mail Order Catalogs: Consumerism in Rural America," in *The Consumer Culture and the American Home, 1890–1930: Proceedings from the Second Annual McFaddin-Ward House Museum Conference,*

ed. Glenda Dyer and Martha Reed (Beaumont, Tex: McFaddin-Ward House, 1989), 38–57.

29. Dana, "The Gloom of the Museum," 391.

30. Dana, quoted in Lipton, "John Cotton Dana and the Newark Museum," 8–9.

31. Dwight, *Greenfield Hill,* 6: 457. In his childhood house, now the town historical museum, a paper silhouette that Dana cut of his mother is redolent with filial piety.

32. John Ruskin, *Works of John Ruskin,* ed. E. T. Cook and Alexander Wedderburn, 39 vols. (London: Longmans, Green, 1903–1912), 7: 464.

33. See William N. Hosley, "Regional Furniture/ Regional Life," in *American Furniture* (1995): 3–38; Edward S. Cooke Jr., *Making Furniture in Preindustrial America: The Social Economy of Newtown and Woodbury, Connecticut* (Baltimore: Johns Hopkins University Press, 1996). See also Philip D. Zimmerman, "Regionalism in American Furniture Studies," *Perspectives on American Furniture,* ed. Gerald W. R. Ward (New York: W. W. Norton, 1988), 11–38.

34. *Trenton Free American,* 10 June 1902, NPL Scrapbook, 1901–1903.

35. See Ray Nash, *Printing as an Art: A History of the Society of Printers, Boston* (Cambridge, Mass.: Harvard University Press, 1955), 55. Also see "Boston Printers at the Local Library," *Newark Evening News,* 18 November 1909, NPL Scrapbook 1906–1913.

36. See Wayne A. Wiegand, *History of a Hoax* (Pittsburgh: Beta Phi Mu, 1979).

37. For his advertisement of Horace, see *New York Times,* 30 May 1908, 20; *New York Times,* 11 December 1909, BR795.

38. Reference to the seventeenth-century tutor Henry Peacham, trained at Trinity College, who fused Royalist sympathies with Puritan idealism in his tracts, suggests Dana was self-conscious of these social paradoxes.

39. John Cotton Dana, "The Place of the Public Library in a City's Life," *Libraries* (1916; Freeport, N.Y.: Books for Libraries, 1966), 70.

40. Richard Sennett, *The Craftsman* (New Haven: Yale University Press, 2008), 286–296.

41. Max Weber, "The Protestant Work Ethic and the Spirit of Capitalism" (1904–1905) in *Classical Sociological Theory,* ed. Craig Calhoun, Joseph Gerteis, James Moody, Steven Pfaff, and Indermohan Virk, 2nd ed. (Malden, Mass.: Blackwell, 2007), 231–240.

42. Garrison, *Apostles of Culture,* xii.

43. See Alan Trachtenberg and Eric Foner, eds., *The Incorporation of America: Culture and Society in the Gilded Age* (New York: Hill and Wang, 1982).

44. John Cotton Dana, "The Harvard University Course in Printing," *Graphic Arts* 1, no. 3 (March 1911): 219.

45. Michele H. Bogart, *Artists, Advertising, and*

the Borders of Art (Chicago: University of Chicago Press, 1995), 18–20.

46. Hadley, *John Cotton Dana*, 60.

47. The controversial use of art as advertising caused debate. This was especially illuminated by the fracas over the use of Sir John Millais's *Bubbles* (1886) by Pear's soap. See Margaret Timmers, *Power of the Poster* (London: Victoria and Albert Museum Publications, 1998), 178; and Richard Ohmann, *Selling Culture* (London: Verso, 1996).

48. Melvil Dewey, "Advice to a Librarian," *Public Libraries* 2 (1897): 267, as quoted in Garrison, *Apostles of Culture*, 96.

49. John Cotton Dana, *Denver Public Library Hand-book* (Denver: Denver Public Library, 1895), 14.

50. "Social Questions," 13. See Marion Casey, "Efficiency, Taylorism, and Libraries in Progressive America," *Journal of Library History* 16 (Spring 1981): 265–279.

51. John Cotton Dana, "The Public and Its Public Library," *Appletons' Popular Science Monthly* 51, no. 2 (June 1897): 245.

52. *American Library Association 16th Convention* (1896), 5, as quoted in Theodore Lewis Low, *The Museum as a Social Instrument* (New York: American Association for Museums in association with the Metropolitan Museum of Art, 1942), 10; Kingdon, *John Cotton Dana*, 57.

53. Arthur E. Bostwick, *The American Public Library* (New York: Appleton, 1910), 3.

54. "Shows Library as Educational Force," *Newark Evening News*, 27 March 1917, NPL Scrapbook, 1913–18.

55. John Cotton Dana, "Newspaper Readers," *Newarker* 1, no. 11 (September 1912): 186.

56. "Leprous New Journalism," n.p., NPL Scrapbook, 1889–1900.

57. *15th Annual Report of the Board of Trustees of the Free Public Library* (1903), 33.

58. Dennis Maloney, "The Newark Evening News: A New Jersey Institution, 1883–1972" (Master's thesis, Drew University, 1956), 23; Benedict Anderson, *Imagined Communities* (London: Verso, 1991), 25–62. On the *News*, also see Jerome Aumente, *From Ink on Paper to the Internet: Past Challenges and Future Transformations for New Jersey's Newspapers* (Morristown: New Jersey Heritage Press, 2007), 75–90, and Douglas Eldridge, "The Rise and Fall of the Newark News: A Personal Retrospection," *New Jersey History* 104, no. 1–2 (Spring-Summer 1986): 40–69.

59. In 1914, Newark had four dailies, eighteen weeklies, and dozens of monthly newspapers.

60. George Herbert Putnam, "The Relation of Free Public Libraries to the Community," *North American Review* 499 (June 1898): 672.

61. "Thirty per cent. of [the population] has come to us from an alien life and alien institutions. One-third of the people in our six leading cities are of foreign birth; seventy-one per cent were either born abroad or born of foreign parentage. In the assimilation of this foreign element no single agency is perhaps so potent as our foreign libraries." Putnam, "Relation of Free Public Libraries to the Community," 666.

62. Bostwick, *American Public Library*, 2.

63. Jane Addams, *Twenty Years at Hull-House* (1910; New York: New American Library, 1960), 90.

64. "Public Library Doings," *Sunday Call*, 27 April 1902, NPL Scrapbook, 1901–1903; Bostwick, "The Future of Library Work," *American Library Association Bulletin* 12 (1918): 51, 53. The Newark Public Library already had a Fine Arts Commission, chaired by local bibliophile Monsignor George Doane. Doane purchased William Morris's Kelmscott editions on his summer trips to London. The Fine Arts Commission had organized previous exhibitions, and Dana invigorated the mission in both his emphasis on variety and commercial relevance.

65. "Free Public Library Thrown Wide Open for Public Inspection," *Newark Evening News*, 19 April 1902, NPL Scrapbook, 1901–1903.

66. *Sunday Call*, 9 November 1902, NPL Scrapbook, 1901–1903.

67. John Cotton Dana, "A Museum of, for, and by Newark," *Survey Graphic* 55, no. 11 (March 1 1926), as reprinted in Peniston, *The New Museum*, 177. The function of fiction in libraries was the subject of an ongoing acrimonious debate. See Charles Cutter, "Pernicious Reading in Our Public Libraries," *Nation* 33 (10 November 1881): 371; "Women in Library Work," *Independent* 71, no. 3270 (3 August 1911): 244–50. Garrison's *Apostles of Culture* analyzes the role of fiction as a politically divisive issue. On gender, see Abigail A. Van Slyck, "The Lady and the Library Loafer: Gender and Public Space in Victorian America," *Winterthur Portfolio* 31, no. 4 (Winter 1996): 221–242.

68. *Trenton Free American*, 10 June 1902, NPL Scrapbook, 1901–1903.

69. "The Reading Public as I Know It: In a Large City," *The Outlook*, 24 May 1902, 250.

70. John Cotton Dana, "The Age of Pictures," *Sunday Call*, 10 August 1902, NPL Scrapbook 1901–1903. The idea of advertising as hieroglyphic is articulated in Edith Wharton, *The Age of Innocence* (1921; New York: Modern Library, 1930), 42, as quoted by Miles Orvell, *The Real Thing* (Chapel Hill: University of North Carolina Press, 1989), 40. Also see Daniel Pope, *The Making of Modern Advertising* (New York: Basic Books, 1983), 107–108.

71. Leonard Dreyfuss, *An Idea that Saved a Business* (Newark: United Advertising Corporation, 1918), 13–14.

72. Pope, *Making of Modern Advertising*, 258.

73. Garrison, *Apostles of Culture*, 196–295; and also see John Higham, *Strangers in the Land: Patterns of American Nativism, 1860–1925* (1963; New York: Atheneum, 1970), 234–263.

74. "The Library Devotee: On Maps," *Newarker* 1, no. 3 (January 1912): 47.

75. Dana, "The Age of Pictures."

76. John Cotton Dana, *Modern American Library Economy as Illustrated by the Newark N.J. Free Public Library* (Woodstock, Vt.: Elm Tree Press, 1912), 57.

77. Dana, "The Age of Pictures."

78. Herbert Croly, *The Promise of American Life* (New York: Macmillan, 1909), 139; Dwight, *Greenfield Hill*, 6: 457.

79. John Cotton Dana, *The Stories of the Prints* (Newark: Newark Museum Association, 1918), 3; "Art at Home and Abroad," *New York Times*, 23 April 1911, SM15. For more on *ukiyo-e* (or "pictures of the floating world") see Sandy Kita, "From Shadow to Substance: Redefining Ukiyo-e," in *The Floating World of Ukiyo-e* (New York: Harry N. Abrams, 2001), 27–79; Richard Lane, *Masters of the Japanese Print* (London: Thames and Hudson, 1962); and James Michener, *The Floating World* (New York: Random House, 1954).

80. "An Exhibition of Japanese Prints at the Library," *Sunday Call*, 5 March 1905, NPL Scrapbook, 1903–1905.

81. Edwardian Britain lauded Admiral Togo (1848–1934) as the "Nelson of the East" after his victory over the Russian navy in 1904. The golf course christened Togo Hill was built by John Cotton Dana and his brothers on a hill just outside of Woodstock between 1890 and 1910, purportedly using local jailbird labor at ten cents a day. Charles Dana wrote *The Complete Guide to Togo Hill* (Woodstock, Vermont: Elm Tree Press, 1921) to celebrate the golf course and Greek amphitheater, Persian Gardens, and Japanese gate built on what had been a dairy farm.

82. John Cotton Dana, "Solving Social Questions," *Newarker* 2, no. 2 (December 1912): 231. Nationally, newspapers from New York to Miami carried the quotation and story.

83. "Decoration of Schoolrooms," *Newark Evening News*, January 1903, NPL Scrapbook, 1901–1903.

84. Eileen Boris, *Art and Labor: Ruskin, Morris, and the Craftsman Ideal in America* (Philadelphia: Temple University Press, 1986), 82–98.

85. "A Progressive Library," *New York Tribune*, 8 November 1908, NPL Scrapbook, 1906–1913.

86. "The Library's Collection of 360,000 Pictures," *Newarker* 1, no. 10 (August 1912): 171.

87. John Cotton Dana, *Pedagese* 1, no. 2 (April 1914): 1–2, Dana Collection, NPL.

88. John Cotton Dana, "Romance in Newark Industries," *Newarker* 2, no. 5 (March 1913): 276.

89. Hadley, *John Cotton Dana, A Sketch*, 56.

90. "Library a Leveler," *Newarker* 1, no. 11 (September 1912): 184.

91. John Cotton Dana, "The Public and Its Public Library," *Appletons' Popular Science Monthly* 51, no. 2 (June 1897): 245; and Hadley, *John Cotton Dana*, 22.

92. "A Poster Exhibition for Newark," *Sunday Call*, 30 November 1902, NPL Scrapbook, 1901–1903. The art poster was part of a complex self-referential commodification of culture. Ohmann's *Selling Culture* illuminates the interrelation between advertising revenues, increasing disposable incomes, advances in printing and image-reproducing technology, and branding. On the use of posters to sell books, see Stephen W. Nissenbaum and Michael Winship, eds., *A History of the Book in America*, vol. 3, *The Industrial Book, 1840–1880* (Cambridge: Cambridge University Press, 2000), 155–161.

93. Dana, "Democracy of Art," 377–383.

94. Frederick Winslow Taylor, *The Principles of Scientific Management* (1911; New York: Harper, 1923), 64–72.

95. John Cotton Dana, "Scientific Management of Libraries," *Epworth Herald*, 6 December 1913, NPL Scrapbook, 1913–18.

96. John Cotton Dana, *The Printed Book, Its Materials and Features* (Newark: Newark Public Library, 1909), n.p., collection of New York Public Library.

97. Dana, "Advertising, the Essence of Public Service," 37–40.

98. Garrison, *Apostles of Culture*, xiv.

99. Dana, "Advertising, the Essence of Public Service," 37.

100. Ibid.

101. John Cotton Dana, "Dana before Special Libraries Meeting at Washington," manuscript, 2, Dana Collection, NPL. Also see John Cotton Dana, "A National Bureau of Municipal Information," *Special Libraries* (September 1914), Dana Collection, NPL

102. Dana, "Dana before Special Libraries Meeting."

103. "How to Get the Best Work Out of Yourself and Others," *Newarker* 1, no. 3 (January 1912): 45. The business branch of the Newark Public Library contained several books by Walter Dill Scott, such as *The Psychology of Public Speaking* (Philadelphia: Pearson, 1907), *The Psychology of Advertising in Theory and Practice* (Boston: Small, Maynard, 1908), and

Increasing Human Efficiency in Business (New York: Macmillan, 1911). Also see Merle Curti, "The Changing Concept of 'Human Nature' in the Literature of American Advertising," *Business History Review* 41, no. 4 (1967): 335–357.

104. "Printing Promise," *Newark Evening News*, 4 February 1911, NPL Scrapbook, 1909–1911; Dana, "The Harvard University Course in Printing," 219.

105. Dana, "Democracy of Art," 377–383.

106. *New York Times*, 30 May 1908, 20; *New York Times*, 11 December 1909.

107. Charles Loomis Dana and John Cotton Dana, *Horace for Modern Readers* (Woodstock, Vt.: Elm Tree Press, 1908), xvi.

108. John Cotton Dana, "Sunday Supplements and Their Comics for Children," *Newarker* 1, no. 6 (April 1912): 98. Attribution to Dana is based upon the similarity of complete sentences with those in his "Relation of Art to American Life."

109. Dana, "Relation of Art to American Life," 54–55.

110. "Comic Nuisance," *Outlook*, 6 March 1909, 527; H. Scheffaur, "Comic Supplement," *Lippincott's*, March 1909: 381–383; also see Ian Gordon, *Comic Strips and Consumer Culture* (Washington, D.C.: Smithsonian Institution Press, 1998), 164–166.

111. Lillian Wald, "Make Comics Educational," *Survey*, 5 April 1911, 103 as quoted in Gordon, *Comic Strips and Consumer Culture*, 177.

112. Gordon, *Comic Strips and Consumer Culture*, 177.

113. Ibid., 179.

114. Dana, "Relation of Art to American Life," 46, also reprinted in *The New Museum*, ed. Peniston, 201.

115. For his more overt reference to Veblen, see Dana, "The Gloom of the Museum," 8.

116. "The Japanese Print as a Reformer: Its Power to Influence Home Decoration," *Craftsman* 30, no. 2 (May 1916): 130–139. See also Minnie L. Wakeman Curtis, "How Beauty and Labor are Interwoven in the Daily Life of Japan," *Craftsman* 17, no. 5 (February 1910): 517–527; Arnold Gesell, "A California Bungalow Treated in a Japanese Style," *Craftsman* 18, no. 6 (September 1910): 694–698; "The Simple Beauty of Japan in an American Apartment," *Craftsman* 28, no. 4 (July 1915): 358; and Gustav Stickley, "Als Ik Kan: The Japanese Ideal Applied to Art in Our Public Schools," *Craftsman* 21, no. 2 (November 1911): 339.

117. Cheryl Robertson, "House and Home in the Arts and Crafts Era: Reform for Simpler Living," in *"The Art that is Life": The Arts and Crafts Movement in America, 1875–1920*, ed. Wendy Kaplan (Boston: Little, Brown and the Boston Museum of Fine Arts, 1987), 336.

118. Dewey, *The School and Society*, 32. See Naima Prevots, *American Pageantry: A Movement for Art & Democracy* (Ann Arbor, Mich.: UMI Research Press, 1990), 35–36.

119. Maurice Annenberg, *Type Foundries in America and Their Catalogs* (Baltimore: Maran Printing Services, 1975). Immediately after being laboriously created for specific projects at the Kelmscott Press, types were issued in photo-facsimile. In 1893, when Morris refused to authorize the commercial casting of his Golden type, Joseph Phinney of American Type Founders created "Jenson Old Style" using a pantographic punch-cutter to copy his letters. See Henry Lewis Johnson, *Printing Type Specimens* (Boston: Graphic Arts Company, 1924).

120. Susan Otis Thompson, *American Book Design and William Morris*, 2nd ed. (New Castle, Del.: Oak Knoll Press and the British Library, 1996), xxi, 78. Also see Simon Loxley, *Type: The Secret History of Letters* (London: Tauris, 2006), 73.

121. Dana, "Advertising, the Essence of Public Service," 40.

122. Ibid. For Bruce Rogers's perspective on Cheltenham as a degraded specimen, see Bruce Rogers, *A Report on the Cambridge University Press* (Cambridge: Cambridge University Printer, 1950), 15.

123. Dewey, "The Scholastic and the Speculator" (1891) as quoted in Bill Brown, *A Sense of Things* (Chicago: University of Chicago Press, 2003), 45.

124. Untitled broadside, Library Print Shop poster, n.d., Special Collections Division, NPL.

125. "Placards on the Library," *Newark Evening News*, 5 July 1912, NPL Scrapbook, 1906–1913.

126. Ibid. The Calkins and Holden Agency described the Murphy advertisements as "the best we have in type display."

127. See Bogart, *Artists, Advertising, and the Borders of Art*, 89–124.

128. Stephen R. Fox, *The Mirror Makers: A History of American Advertising and Its Creators* (New York: Morrow, 1984), 27.

129. Earnest Elmo Calkins and Ralph Holden, *Modern Advertising* (New York: Appleton, 1905), 309.

130. *Scribner's Magazine* 17, no. 5 (May 1895): advertising supplement 79; *Scribner's Magazine* 17, no. 6 (June 1895): advertising supplement 83.

131. Dana, "A Museum of Everyday Life," 97.

132. Hubbard defended the telephone monopoly as "heaven" and idealized early American entrepreneurs such as John J. Astor and A. T. Stewart. See his "Little Journeys to the Homes of Great Business Men" series printed at the Roycroft Shop in 1909. For examples

of Roosevelt's pithy quotes, see Jacob A. Riis, *Theodore Roosevelt, the Citizen* (New York: Outlook, 1904).

133. Dana's advertisements were idiosyncratic and in methods approximated the campaign for truth in advertising described by T. J. Jackson Lears. See Lears, *Fables of Abundance*, 194–208.

134. Newark Public Library, "You Have the Will—We Have the Way," 1919, Dana Collection, NPL.

135. "Newark's Library and Industries," *Newark Evening News*, 12 December 1919, NPL Scrapbook, 1918–20.

136. See Gelber, *Hobbies*; and Roy Rosenzweig, *Eight Hours for What We Will: Workers and Leisure in an Industrial City, 1870–1920* (New York: Cambridge University Press, 1983).

137. Dana, "Democracy of Art," 378.

138. See Alan Trachtenberg, "The Incorporation of America Today," *American Literary History* 15, no. 4 (Winter 2003): 759–764.

Two: The Business of Culture

1. Frederick Winslow Taylor, *The Principles of Scientific Management* (New York: Harper and Brothers, 1911), 8.

2. Dana, "The Work of the Free Public Library," reprinted in *Trenton Free American*, 10 June 1902, NPL Scrapbook, 1899–1902; Dana, "Why the Newarker?" *Newarker* 1, no. 3 (January 1912): 42–43.

3. *Newarker* 1, no. 1 (November 1911): 3.

4. Chalmers Hadley, *John Cotton Dana, A Sketch* (Chicago: American Library Association, 1943), 74.

5. Ibid., 16.

6. On advertising as a new national distribution system, see Jackson Lears, *Fables of Abundance* (New York: Basic Books, 1994), 225.

7. "Library Books in the Stores," *Sunday Call*, 12 August 1906, NPL Scrapbook 1905–1906.

8. See Jane Addams, *Democracy and Social Ethics* (New York: Macmillan, 1913), 165. See also Daniel T. Rodgers, *The Work Ethic in Industrial America, 1850–1920* (Chicago: University of Chicago Press, 1978), 87–89.

9. *19th Annual Report of the Board of Trustees of the Free Public Library* (Newark: Newark Free Public Library, 1907), 13.

10. *17th Annual Report of the Board of Trustees of the Free Public Library* (1905), 29.

11. See the graph in *Newarker* 1, no. 3 (January 1912): 41–42.

12. A Newark librarian hired in the late 1920s, Marian C. Manley, wrote a book about the business branch, and she maintained Dana's earlier institutional message. Marian C. Manley, ed., *Business and the Public Library: Steps in Successful Cooperation* (New York:

Special Libraries Association, 1940).

13. The vice president of Filene's, Louis Kirstein, was its main advocate. In 1949, the top public business libraries in the country were in Newark and Cleveland. Edwin T. Coman, *Sources of Business Information* (New York: Prentice-Hall, 1949).

14. Kevin Mattson, "The Librarian as Secular Minister to Democracy: The Life and Ideas of John Cotton Dana," *Libraries and Culture* 35, no. 4 (September 2000): 515–534.

15. *Newarker* n.s. 1, no. 8 (June 1916): 221.

16. Dana, "Munich," August 1912, typescript, Dana Collection NPL.

17. John Cotton Dana, "A Museum of Service," *Survey Graphic* 49, no. 9 (1 February 1923): 581.

18. *Newarker* 1, no. 10 (August 1912): 160.

19. See Albert Shaw, "London Polytechnics and People's Palaces," *Century* 40 (1890): 164, as quoted in Daniel T. Rodgers, *Atlantic Crossings: Social Politics in a Progressive Age* (Cambridge, Mass.: Belknap Press, 1998), 132–133.

20. Rodgers, *Atlantic Crossings*, 132–133.

21. H. B., "The Study of a City in the Schools of that City," *Newarker* 1, no. 8 (June 1912): 133.

22. *Newarker* 1, no. 8 (June 1912): 132.

23. John Cotton Dana and Frances Doane Twombly, eds., *The Romance of Labor: Scenes from Good Novels Depicting Joy in Work* (New York: Macmillan, 1916).

24. See "The Boycott on 'The Jungle,'" *New York Times*, 18 May 1906, 8. Also see Giedrius Subačius, *Upton Sinclair: The Lithuanian Jungle* (Amsterdam and New York: Editions Rodopi, 2006) on how Sinclair revised the manuscript in order to appeal to Lithuanian readers.

25. "How To Get the Best Work out of Yourself and Others," *Newarker* 1, no. 3 (January 1912): 45.

26. Charles Horton Cooley, "Abstract of 'The Social Significance of Street Railways'" (27 December 1890), paper delivered at Fourth Annual Conference of the American Economic Association in *Publications of the American Economic Association* 6 (1891): 71–73.

27. Cooley, *Human Nature and the Social Order*, 183–187, as quoted in Sklansky, *The Soul's Economy: Market Society and Selfhood in American Thought, 1820–1920* (Chapel Hill: University of North Carolina Press, 2002), 221.

28. *John Cotton Dana* (Boston: Merrymount Press, 1930), 23.

29. Lindsay Swift, "Paternalism in Public Libraries," *Library Journal* 24 (1899): 609–615, as quoted in Dee Garrison, *Apostles of Culture* (New York: Free Press, 1979), 97. See also Lindsay Swift and Worthington C. Ford, *The Public Library in Its Relation to the State and to Literature* (New York: privately

published, 1900); and Herbert Small, ed., *Handbook of the New Public Library in Boston* (Boston: Curtis, 1895).

30. Carl Purington Rollins, *Addresses Given at the Opening of the Exhibition of the Metropolitan Museum Printing Held in the Pierpont Morgan Library on 24 October 1938* (New Haven: Yale University Press and AIGA, 1939), 47.

31. In 1925, Harold Ross conceived *The New Yorker* magazine as a business plan through which the most elite commercial establishments would run their advertisements at low prices within a periodical with a pedigreed identity. See Thomas Kunkel, *Genius in Disguise: Harold Ross of the New Yorker* (New York: Random House, 1995).

32. John Cotton Dana, "Of Business," cover of *The Newarker* 1, no. 8 (June 1912).

33. James B. Gilbert, *Work without Salvation* (Baltimore: Johns Hopkins University Press, 1977), xv.

34. John Dewey, "The Need of Industrial Education in an Industrial Democracy," *Manual Training and Vocational Education* 17, no. 6 (February 1916): 412, as quoted in Rodgers, *Work Ethic in Industrial America*, 91.

35. William C. Redfield, "The Moral Value of Scientific Management," *Atlantic Monthly* 110 (September 1912): 411–417. See also Rodgers, *Work Ethic in Industrial America*, 56–58.

36. Lindy Biggs, *The Rational Factory: Architecture, Technology, and Work in America's Age of Mass Production* (Baltimore: Johns Hopkins University Press, 1996).

37. Richard Jenkinson, alongside Louis Bamberger, was the most enlightened of trustees, and in 1907 he resigned from the American Manufacturers' Association when it pledged to fight unions. Nevertheless, his idea of municipal uplift was founded on entrepreneurial progress. "R. C. Jenkinson Will Not Fight Unions," *New York Herald*, 30 June 1907, Jenkinson scrapbook, NJHS.

38. Mary Alden Hopkins, "1910 Newark Factory Fire," *McClure's Magazine* 36, no. 6 (April 1911): 663–672.

39. *Ladies' Garment Worker*, 3 January 1912, 1; *Newarker* 1, no. 7 (May 1912): 120.

40. "How the Library May Be Bettered," *Newark Evening News*, 20 March 1902, NPL Scrapbook, 1901–1903.

41. "Library Bookbinder," *Newark Advertiser*, 4 February 1905, NPL Scrapbook, 1903–1905.

42. *17th Annual Report of the Board of Trustees of the Free Public Library* (Newark: Free Public Library, 1905), 17.

43. "Library Bookbinder."

44. "Interesting and Instructive Exhibition of Industrial Art to be Seen at Public Library," n.d., NPL Scrapbook, 1906–1913.

45. "Jewelers Attend Lecture," *Morning Star*, 18 February 1907, and "Jewelers and Educators Striving to Raise Standards of Workmanship," *Sunday Call*, 17 February 1907, NPL Scrapbook, 1906–1913.

46. *First Annual Report of the Newark Museum Association, 1909–1910* (Newark, 1910), 17. See also *A Survey: Fifty Years of the Newark Museum* (Newark: Newark Museum, 1959), 7.

47. John Cotton Dana, "The Clay Industries Exhibition of New Jersey," *Newarker* 4, no. 2 (December 1914): 24.

48. *Eighth Annual Report of the Newark Museum Association, 1916–1917* (Newark, 1917), 24.

49. This statement dates from 1913. See John Cotton Dana, *A Small American Museum, Its Efforts Toward Public Utility* (Newark: Newark Museum Association, 1921), 7. Dana wrote "A Small Museum" to be read in his absence at a convention of museum directors and associates held October 1921, and published it in the *New York Times*, *Newark Evening News*, *Boston Transcript*, and *American City*. In this text he quoted his earlier arguments, without citation.

50. For an extensive analysis of Purdon's design curriculum in India, see Arindam Dutta, *The Bureaucracy of Beauty: Design in the Age of Its Global Reproducibility* (New York: Routledge, 2007), 7, 85–88.

51. "The peasants who made the objects in this exhibition do not call themselves artists; they are good workers with a sense of design and color. . . . [The] work of the peasant is the inspiration of a large part of the new movement in handicrafts throughout Hungary and in Germany and Austria as well." John Cotton Dana, "Hungarian Peasant Art," *Newarker* 3, no. 6 (April 1914): 502–503.

52. "The Newark Industrial Exposition, from the Library's Point of View," *Newarker* 1, no. 7 (May 1912): 123–125. See also, "Newark's Library at Exposition," *Sunday Call*, 26 May 1912, NPL Scrapbook, 1906–1913; "Newark's Library at Industrial Exposition, Which Had Many Visitors," *Sunday Call*, 9 June 1912, NPL Scrapbook, 1906–1913.

53. Christopher Dresser, *The Art of Decorative Design* (London: Day and Son, 1862).

54. Richard C. Jenkinson, "Greater Newark—The Eighth City of the United States," *Newarker* 1, no. 1 (November 1911): 14.

55. *17th Annual Report of the Board of Trustees of the Free Public Library* (1905), 25.

56. Samuel Popper, "Newark, New Jersey, 1870–1910" (Ph.D. dissertation, New York University, 1952), 52–53.

57. *Exposition News* 12 (25 May 1912): 1.

58. *Ibid.*, 3.

59. *Newarker* 1, no. 8 (June 1912): 1.

60. See Eileen Boris, "Reconstructing the

'Family': Women, Progressive Reform, and the Problem of Social Control," in *Gender, Class, Race and Reform in the Progressive Era*, ed. Noralee Frankel and Nancy S. Dye (Lexington: University of Kentucky Press, 1991), 73–86; Sarah Deutsch, *Women and the City: Gender, Space and Power in Boston, 1870–1940* (New York: Oxford University Press, 2000); Kathryn Kish Sklar, "Explaining the Power of Women's Political Culture in the Creation of the American Welfare State, 1890–1930," in *Mothers of a New World: Maternalist Policies and the Origins of Welfare States*, ed. Seth Koven and Sonya Michel (New York: Routledge, 1993), 43–93.

61. See Elizabeth F. Baker, *Technology and Women's Work* (New York: Columbia University Press, 1964), 37–49; and Ellen Mazur Thomson, "Alms for Oblivion: The History of Women in Early American Graphic Design," *Design Issues* 10, no. 2 (Summer 1994): 27–48. In 1870 the United Typographical Union was the first national trade union to admit women workers as members. Women compositors were a source of cheap labor that modernization demanded. They were dispensed with in two generations; their entrance into the turn-of-the-century field of Linotype or Monotype composition was actively discouraged and even ridiculed in trade journals. In reality, stenographic skills probably would have made more women than men prepared for the innovation. Mechanized type setting and automated composition technology increased efficiency, and these higher-wage and higher-status positions were increasingly awarded to men in the twentieth century.

62. This was traditionally the case: sewing was depicted as a woman's task in Diderot's eighteenth-century *Encyclopédie*. See Marianne Tidcombe, *Women Bookbinders, 1880–1920* (London and New Castle, Del.: British Library and Oak Knoll Press, 1996)

63. Although my perspective has been influenced by Joanne Ellen Passet, *Cultural Crusaders: Women Librarians in the American West, 1900–1917* (Albuquerque: University of New Mexico Press, 1994), and Martha H. Patterson, *Beyond the Gibson Girl: Reimagining the American New Woman, 1895–1915* (Urbana: University of Illinois Press, 2005), research into the status of the educated New England librarian in the industrial city is minimal.

64. On the lack of research into women librarians, see Suzanne M. Stauffer, "'She Speaks as One Having Authority': Mary E. Downey's Use of Libraries as a Means to Public Power," *Libraries & Culture* 40, no. 1 (2005): 38–62.

65. *The Llamarada* 9 (1905), 105.

66. Mary Emma Woolley, *Education* (Boston:

Hall and Locke, 1911), 125–126.

67. Ann Douglas, *The "Feminization" of American Culture* (New York: Knopf, 1977).

68. "Femininity was newly defined on a vocational basis," notes historian Garrison, and became defined by stereotypes. Such labels as the "unsexed spinster" compartmentalized the enigma of investing these women with authority. Garrison, *Apostles of Culture*, 184.

69. Marjorie Schwarzer, *Riches, Rivals & Radicals: 100 Years of Museums in America* (Washington, D.C.: American Association of Museums, 2006), 177.

70. *23rd Annual Report of the Board of Trustees of the Free Public Library* (1912), 8.

71. Frank I. Liverwright, "One of America's Great Stores," n.d. typescript, 8, New Jersey Reference Division, NPL.

72. "Sarah Ball to Leave Business Branch," *Newark Evening News*, 12 January 1917, NPL Scrapbook, 1913–17.

73. Richard Jenkinson to Beatrice Winser, 10 January 1927, Jenkinson scrapbook 2, NJHS.

74. *The Museum* 1, no. 1 (May 1917): 40.

75. John Cotton Dana, "Publicity Plan, 1918," n.d., typescript, Dana Collection, NPL, 2.

76. Ibid., 6.

77. Ibid., 8.

78. Ibid., 9.

79. Ibid., 10.

80. Alfred D. Chandler Jr., *The Visible Hand* (Cambridge, Mass.: Belknap Press, 1977).

81. Walter Gilliss, "Black Letter and Its Appropriate Use," *Printing Art* 3, no. 3 (May 1904): 65; editorial, "The Psychology of Typography," *Printing Art* 8, no. 6 (February 1907): 406.

82. "Library and Museum Directed by Woman Widen Their Service in Decade of Stress," *New York Times*, 24 December 1939, Winser family papers, scrapbook 5, NJHS.

83. John Cotton Dana, *Denver Public Library Hand-book* (Denver, 1895), 66.

84. NPL Memorandum, 6 March 1923. To regard her workers' technological ineptitude with empathy, readers should remember that electric appliances were still not widespread.

85. NPL Memorandum, 31 December 1937.

86. "Summit Is Rent by a School Dispute," *New York Times*, 19 February 1910, 20.

87. Holger Cahill, "Miss Connolly Continued Her Teaching in the Library and Museum," in *Louise Connolly* (Newark: Library and Museum, 1928), 19.

88. No other staff member was as important to the shape the institution's agenda as Connolly. (Although Marjary Gilson's work in the Art Collection for the public library, and duties in the museum after 1909, did result in Dana including her views on "Picture

Collections" in an anthology that he edited on library management.) Connolly is the only staff member on record to offer him advice or openly disagree on a matter of importance. In comparing Gates and Connolly, it is interesting that they represent the two halves of the modern museum as stated in "The Gloom of the Museum." In Dana's analysis, to advertise and educate are the defining features of what made a museum "alive." These correspond to his intellectual coupling of social and entrepreneurial uplift but also their development into specialized positions. See John Cotton Dana, *The Gloom of the Museum* (Woodstock, Vt.: Elm Tree Press, 1917), 24.

89. On the politics of theater in the Progressive era, see David Glassberg, *American Historical Pageantry: The Uses of Tradition in the Early Twentieth Century* (Chapel Hill: University of North Carolina Press, 1990); David Glassberg, "History and the Public: Legacies of the Progressive Era," *Journal of American History* 73, no. 4 (March 1987): 957–980; Martin Green, *New York 1913: The Armory Show and the Patterson Strike Pageant* (New York: Scribner's, 1988); Cathy James, "'Not Merely for the Sake of an Evening's Entertainment': The Educational Uses of Theater in Toronto's Settlement Houses, 1910–1930," *History of Education Quarterly* 38, no. 3 (Autumn 1998): 287–311; Timothy Lloyd, "Whole Work, Whole Play, Whole People: Folklore and Social Therapeutics in 1920s and 1930s America," *Journal of American Folklore* 110, no. 437 (Summer 1997): 239–259; and Naomi Prevots, "American Pageantry: A Movement for Art and Democracy" (Ph.D. dissertation, University of Michigan, Ann Arbor, 1990).

90. For a description of the library's "paid research," see John Cotton Dana, *Modern American Library Economy as Illustrated by the Newark N.J. Free Public Library* (Woodstock, Vt.: Elm Tree Press, 1910), 264–265. For one of many comments on the active role of the business branch see "Newark's Library and Industries," *Newark Evening News*, 12 December 1919, NPL Scrapbook 1918–1920.

91. Neale McGoldrick and Margaret Smith Crocco, *Reclaiming Lost Ground: The Struggle for Woman Suffrage in New Jersey*, 2nd ed. (Trenton: New Jersey Historical Commission, 1993), 43–49; Margaret Smith Crocco, "Women of New Jersey: Charting a Path to Full Citizenship, 1870–1920," *New Jersey History: Proceedings of the New Jersey Historical Society* 115, nos. 3–4 (1997): 37–59.

92. See Lisa Tickner, *The Spectacle of Women: Imagery of the Suffrage Campaign, 1907–1914* (Chicago: University of Chicago Press, 1988), 58–66; and Ellen Carol DuBois, "Working

Women, Class Relations, and Suffrage Militance: Harriot Stanton Blatch and the New York Woman Suffrage Movement, 1894–1909," *Journal of American History* 74, no. 1 (June 1987): 34–58.

93. David W. Lange, *The Complete Guide to Lincoln Cents* (Irvine, Cal.: Bowers and Merena Galleries and Zyrus Press, 2005), 2–33.

94. Kathleen Brady, *Ida Tarbell: Portrait of a Muckraker* (Pittsburgh: University of Pittsburgh Press, 1989), 94–102.

95. John Cotton Dana, preface to *The Newark Lincoln: A Memorial* (Newark: Free Public Library, 1912), ix. On the transfiguration of Lincoln's representation, see Barry Schwartz, *Abraham Lincoln and the Forge of Memory* (Chicago: University of Chicago Press, 2000).

96. Gutzon Borglum, "Individuality, Sincerity, and Reverence in American Art," *Craftsman* 15, no. 1 (October 1908): 3–6; and Gutzon Borglum, "The Betrayal of the People by a False Democracy," *Craftsman* 22, no. 1 (April 1912): 3–9.

97. Gutzon Borglum, "The Beauty of Lincoln," in *The Newark Lincoln: A Memorial*, 58.

98. John Cotton Dana, "The Library and Vocational Education." *Public Libraries* 23, no. 10 (December 1918): 492.

99. Calvin N. Kendall and George A. Mirick, *How to Teach the Fundamental Subjects* (New York and Boston: Houghton Mifflin, 1915), 266–267. The oath was reprinted in Stephen Graham, *With Poor Immigrants to America* (New York: Macmillan, 1914), 210–211, and also in *Publishers' Weekly*, 17 August 1918, 508.

100. Louise Connolly, "The Newark Lincoln," *Newarker* 1, no. 12 (October 1912): 192. Connolly's choice of words confirms Warren Susman's argument that an idealization of personality was displacing the premium Victorian culture had placed on character. See Warren I. Susman, "'Personality' and the Making of Twentieth-Century Culture," in *Culture as History: The Transformation of American Society in the Twentieth Century* (New York: Pantheon, 1984), 271–286.

101. Editorial, *School-Arts Magazine* 15, no. 6 (February 1916): 450.

102. *Third Annual Report of the Newark Museum Association, 1911–1912*, 24. The exhibition of paintings and bronzes by American artists was open February 24 to March 15, 1910. The attendance was estimated at 4,631.

103. John Cotton Dana, "Motion Pictures Feed Man's Prehistoric Appetite," *New York Sun*, 17 February 1917, Dana Collection, NPL; Jane Addams, "A New Conscience and an Ancient Evil," *McClure's Magazine* 38 (January 1912): 340. Also see Maureen A. Flanagan, *Seeing with Their Hearts: Chicago Women and the*

Vision of the Good City, 1871–1933 (Princeton: Princeton University Press, 2002). On the struggle to obtain leisure and the fight against its regulation, see Kathy Lee Peiss, *Cheap Amusements: Working Women and Leisure in Turn-of-the-Century New York* (Philadelphia: Temple University Press, 1986); David Nasaw, *Going Out: The Rise and Fall of Public Amusements* (Cambridge, Mass.: Harvard University Press, 1999); Roy Rosenzweig, *Eight Hours for What We Will* (Cambridge: Cambridge University Press, 1983).

104. On movie going and class, see Melvyn Stokes, "Introduction: Reconstructing American Cinema's Audiences," in *American Movie Audiences*, ed. Melvyn Stokes and Richard Maltby (London: British Film Institute, 1999), 3–7. See also, Leslie Midkiff DeBauches, "Reminiscences of the Past, Conditions of the Present: At the Movies in Milwaukee in 1918," in *American Movie Audiences*, 129–139, for analysis of a comparable city.

105. Dewey, "Industrial Education in an Industrial Democracy," 412.

106. Popper, "Newark, New Jersey, 1870–1910," 210.

107. Connolly, "The Newark Lincoln," 192.

108. John Winthrop's sermon to passengers on the *Arbella* in 1630 drew upon Matthew 5: 14–16. See Francis J. Bremer, *John Winthrop* (New York: Oxford University Press, 2005), 175–183.

Three: The Virtues of Industry

1. Noah Webster, *An American Dictionary of the English Language* (Springfield, Mass.: G. & C. Merriam, 1849).

2. *Newark Can, Newark Will*, 12–26 September 1914 (Newark: Newark Industrial Exposition Association, 1914), 5–6.

3. Ibid., 27.

4. The tenure of Poland was marked by a change in terminology. Charles B. Gilbert, the Superintendent of Newark's Board of Education at the turn of the century, had urged the study of "manual arts," and Poland updated the program to "industrial arts." See Samuel Popper, "Newark, New Jersey, 1870–1910" (Ph.D. dissertation, New York University, 1952), 403–404.

5. "Big Campaign for Industrial Education," *New York Times*, 3 May 1914, X10; Ernest Batchelder, "The World's Advance in Industrial Education: Exhibits at the Third International Art Congress in London Full of Suggestions to Americans," *Craftsman* 15, no. 1 (October 1908): 34–42.

6. Charles R. Richards, "Handwork in the Elementary School" (1901), a lecture to National Education Association, reprinted in Charles A. Bennett, *History of Manual and Industrial Education, 1870–1917* (Peoria, Ill.: Manual Arts Press, 1937), 453. Richards went on to direct the Cooper Union and the American Association of Museums, and to write a history of the industrial museum. See Ronald D. Cohen and Raymond A. Mohl, *The Paradox of Progressive Education: The Gary Plan and Urban Schooling* (Port Washington, N.Y.: Kennikat, 1979).

7. Although this ideological view is usually associated with Dewey, at the time it would have been discussed in relation to Herbert Spencer. For a period perspective see Robert Hebert Quick, *Essays on Educational Reformers*, vol. 17, International Education Series (New York: Appleton, 1895), 454–469.

8. "Books at Library upon Industrial Education," *Sunday Call*, 28 November 1909, NPL Scrapbook, 1906–1913.

9. Foucault conceived the term in *Surveiller et punir: Naissance de la prison* [Discipline and Punish] (Paris: Gallimard, 1975) to liken penal to education systems; on the use of the phrase in museum studies, see Tony Bennett, *The Birth of the Museum: History, Theory, Politics* (London: Routledge, 1995), 63–70.

10. The hope that schools could replace the domestic structure was pervasive, and Dewey's texts effectively legitimized such a perspective, even if his own view was more complex and nuanced.

11. Richard Hofstadter, *Social Darwinism in American Thought*, rev. ed. (New York: G. Braziller, 1969), 51–104.

12. See A. W. MacDougall, *Resources for Social Service, Charitable, Civic, Educational, Religious, of Newark, New Jersey* (Newark: Bureau of Charities, 1912), 5, 86–95.

13. David I. Macleod, *The Age of the Child: Children in America, 1890–1920* (New York: Twayne, 1998). Also see appendix in Marilyn R. Kussick, "School Reform as a Tool of Urban Reform: The Emergence of the Twentieth-Century Public School in Newark, New Jersey, 1890–1920" (Ph.D. dissertation, Rutgers University, 1974), 267.

14. Newark Board of Education, *Annual Report* (1905), 57–58, as cited in Popper, "Newark, N.J., 1870–1910," 409.

15. Steven J. Diner, *A Very Different Time: Americans of the Progressive Era* (New York: Hill and Wang, 1998), 93–96.

16. David B. Corson, "Ideals and Accomplishments of the Newark School System," *Elementary School Journal*, 21, no. 9 (May 1921): 677.

17. Richards, "Handwork in the Elementary School," 452–453.

18. Lillian S. Cushman, "A Report of the Second Annual Meeting of the National Society for

the Promotion of Industrial Education," *Elementary School Teacher* 9, no. 5 (January 1909): 233–249.

19. Carroll D. Wright, "The Factory System as an Element in Civilization," *Journal of Social Science* 16 (1882): 110, 122, as quoted in Daniel T. Rodgers, *The Work Ethic in Industrial America, 1850–1920* (Chicago: University of Chicago Press, 1978), 72.

20. John Dewey, *The School and Society, Being Three Lectures*, 2nd ed. (Chicago: University of Chicago Press, 1900), 93–94, 105. "In the ideal school there would be something of this sort: first, a complete industrial museum, giving samples of materials in various stages of manufacture, and the implements, from the simplest to the most complex, used in dealing with them; then a collection of photographs and pictures illustrating the landscapes, and the scenes from which the materials come, their native homes, and their place of manufacture. Such a collection would be a vivid and continual lesson in the synthesis of art, science, and industry" (105).

21. Newark Board of Education, *Annual Report* (1910), 93–94, as quoted in Kussick, "School Reform as a Tool of Urban Reform," 248, 254.

22. See vigorous disagreement over the value of craft in education, for instance, in the sparring between Denman Ross and Mary Ware Dennett in *Handicraft* magazine. See Mary Ware Dennett, "The Arts and Crafts: An Outlook," *Handicraft* 2 (April 1903): 5–8; and Denman Ross, "The Arts and Crafts: A Diagnosis," *Handicraft* 1 (January 1903): 229–243. For a general discussion on Arts and Crafts pedagogy, see Robert W. Winter, "The Arts and Crafts as a Social Movement," *Record of the Art Museum, Princeton University* 34, no. 2 (1975): 36–40.

23. Newark Board of Education, *Annual Report* (1910), 93–94; Kussick, "School Reform as a Tool of Urban Reform," 257.

24. Leslie W. Miller, "The Work of the Pennsylvania Museum and School of Industrial Art," *Annals of the American Academy of Political and Social Science* 33, no. 1 (January 1909): 107.

25. Corson, "Ideals and Accomplishments of the Newark School System," 667.

26. Heated debate over Addams's politics and legacy lingers, such as the opposite interpretations in Rivka S. Lissak, *Pluralism and Progressives* (Chicago: University of Chicago Press, 1989) and Mina Carson, *Settlement Folk* (Chicago: University of Chicago Press, 1990). These authors' disagreements are primarily rooted in exegesis. My perspective is that Addams was able to theorize and espouse pluralism, but that there is a visible gap between her

yearnings and ability to realize them. The Labor Museum was undeniably a paternalistic construction.

27. Jane Addams, *The Spirit of Youth and the City Streets* (New York: Macmillan, 1909), 122–123. My interpretation is indebted to Daniel T. Rodgers and Michael E. McGerr. Here, Addams was repeating the opinion of John Ruskin: "My efforts are not to making the carpenter an artist, but to making him happier as a carpenter." Ruskin, "Picture-Galleries—Their Functions and Formation," in *Works of John Ruskin*, ed. E. T. Cook and A. Wedderburn (London: Longmans, Green, 1905), 13: 553; first printed in *Report of the National Gallery Site Commission* (1857). On Ruskin, see Brandon Taylor, *Art for the Nation* (Manchester: Manchester University Press, 1999), 76–81.

28. John Dewey, "Culture and Industry in Education," 21. Addams, however, called vocational school undemocratic, and once vocational educational took the form of a state-funded separate track, Dewey changed his opinion, arguing that shop work should develop individuality, not train students for "the existing industrial regime; I am not sufficiently in love with the regime for that." See John Dewey, "Education vs. Trade Training," *New Republic*, 2, no. 27 (8 May 1915): 42. Also see Berenice M. Fisher, *Industrial Education: American Ideals and Institutions* (Madison: University of Wisconsin Press, 1967), 100–105.

29. John Dewey, "The Place of Manual Training in the Elementary Course of Study," *Manual Training Magazine* 2, no. 4 (July 1901): 197, as quoted in James B. Gilbert, *Work without Salvation* (Baltimore: Johns Hopkins University Press, 1977), 108.

30. Louise Connolly, *Educational Value of Museums* (Newark: Newark Museum Association, 1914), 60–65.

31. Chalmers Hadley, *John Cotton Dana, A Sketch* (Chicago: American Library Association, 1943), 57. "Work of the Libraries," *Sunday Call* (25 March 1907); "Good Dress and Shirtwaist Making in Evening Industrial High School," *Sunday Call* (31 March 1907); "Mr. Dana Tells of Exhibitions," *Newark Evening News*, 11 July 1908, NPL Scrapbook, 1906–1913.

32. Hugo B. Froehlich and Bonnie E. Snow, *Industrial Art Text Books*, 8 vols. (New York and Boston: Prang, 1922), 5: 39.

33. Froehlich and Snow, *Industrial Art Text Books*, 3: 27.

34. "The Study of a City in the Schools of that City," *Newarker* 1, no. 7 (May 1912): 133. See also H. W. Powers, "The Offering in Trade, Vocational and Technical Schools,"

School Review 43, no. 5 (May 1935): 337–349. Urquhart was willing to critically view the city's past in the official publications by the Committee of One Hundred, such as the program for *Newark's Anniversary Industrial Exposition.*

35. Charles Horton Cooley, *Human Nature and the Social Order,* 2nd rev. ed. (New York: Scribner's, 1922), 352–353; *Dial* 53 (1 November 1912): 250. Also see Erving Goffman, *The Presentation of the Self in Everyday Life* (Garden City, N.Y.: Doubleday, 1959), 15, 22–50.

36. "A Progressive Library," *New York Tribune,* 8 November 1908, NPL Scrapbook, 1906–1913.

37. *Year Book of the Contemporary of Newark, New Jersey, 1912–13* (Newark, 1913), 22.

38. Ibid., 17. Typical was a quotation from Lyman Abbott that "Democracy is not only a political opinion, it is also a religious faith."

39. Ibid., 22.

40. Eileen Boris, "Crafts Shop or Sweatshop? The Uses and Abuses of Craftsmanship in the Twentieth Century," *Journal of Design History* 2, no. 2/3 (1989): 172–195.

41. Ibid.

42. *A Century of Benevolence, 1803–1903: The History of the Newark Female Charitable Society from the Date of Organization, January 31 1803, to January 31 1903* (Newark, 1903), 175.

43. *16th Annual Report of the Board of Trustees of the Free Public Library* (1904), 29.

44. *Year Book of the Contemporary of Newark, New Jersey, 1912–13,* 7.

45. Kate Louise Roberts, letter to editor, *Newark Evening News,* 7 June 1909, NPL Scrapbook, 1906–1913.

46. Kate Louise Roberts, "Kate Louise Roberts Tells about Munich's Rare Museum," *Newark Evening News,* 24 February 1912; "Munich Shows How Museum Can Be Part of Education System," *Newark Evening News,* 2 March 1912, NPL Scrapbook, 1906–1913. Also see Wolf Peter Fehlhammer and Wilhelm Fuessl, "The Deutsches Museum: Idea, Realization, and Objectives," *Technology and Culture* 41 (July 2000): 517–521.

47. "Thinks Husbands Aren't Mainstays," *New York Times,* 7 January 1909, 9; and "'Votes for Women' Wins Applause," *New York Times,* 10 January 1909, 14. See also Nancy F. Cott, *The Grounding of Modern Feminism* (New Haven: Yale University Press, 1987), 188–190.

48. Landon R. Y. Storrs, *Civilizing Capitalism: The National Consumers' League, Women's Activism, and Labor Standards in the New Deal Era* (Chapel Hill: University of North Carolina Press, 2000).

49. *Year Book of the Contemporary of Newark, New Jersey, 1915–16,* 2.

50. See Florence Kelley, *Modern Industry: In Relation to the Family, Health, Education, Morality* (New York: Longmans, Green 1914). On Kelley's origins, see Kathryn Kish Sklar, *Florence Kelley and the Nation's Work: The Rise of Women's Political Culture, 1830–1900* (New Haven: Yale University Press, 1995).

51. *19th Annual Report of the Board of Trustees of the Free Public Library* (1907), 18.

52. Kate Louise Roberts, *The Club Woman's Handybook of Programs and Club Management* (New York: Funk & Wagnalls, 1914), iii. Roberts's *Handybook* described a range of "social betterment" activities, such as reading books by English Arts and Crafts leaders such as C. R. Ashbee's *Craftsmanship in Competitive Industry* and William Morris's *Hopes and Fears for Art,* as well as American works such as Candace Wheeler's *Principles of Home Decoration* and Edith Wharton's *The Decoration of Houses.* She was also an outspoken advocate for suffrage. Her letter to the editor of *The Woman Citizen* in 1918 stated that "moral unity" was the aim of suffrage agitators. She urged New Jersey's aged male senator to reconsider his opposition, stating "Life is a constant adjustment. The keynote of the new philosophy is elasticity. . . . Stoppage spells stagnation." See Kate Louise Roberts, Letter to the Editor, *The Woman Citizen,* 12 October 1918, in the Gerritsen Collection of Women's History, http://gerritsen. chadwyck.com.

53. Circular, "The Contemporary of Newark, New Jersey, A Civic, Educational, Social and Moral Force in the Community" (circa 1914–15), n.p., NPL.

54. "An Afternoon Uplift Event," *Sunday Call,* 10 May 1914, NPL Scrapbook, 1913–18.

55. To date, the 1912 show has been characterized as a lost opportunity, when Americans failed to appreciate the European "modern style." Scholarship of the display as the promotion of a style assumes that Dana had more than a cursory grasp of Werkbund products. Barry Shifman, "Design for Industry: The 'German Applied Arts' Exhibition in the United States, 1912–13," *Journal of the Decorative Arts Society* 22 (1998): 19–31; Pilgrim, "John Cotton Dana," 48–55.

56. The mission statement, point two of the Werkbund charter of 12 July 1908, used the word "propaganda." See *Jahrbuch des Deutschen Werkbundes 1913: Die Kunst in Industrie und Handel* (Jena: Diederichs, 1913), n.p., reprinted in Gillian Naylor, *The Bauhaus Reassessed* (London: Herbert Press, 1985), 18. The term "propaganda" was on the cusp of enormous change: by the 1920s it connoted biased communication, not the neutrality of publicity. See Paul Jobling and

David Crowley, *Graphic Design: Reproduction and Representation since 1800* (Manchester: Manchester University Press, 1996), 107–118.

57. Generally, Americans have perpetrated this generalization, and oddly enough the American Craft Museum elected to use the term "industrial design" to describe the 1912 show. See "John Cotton Dana," *Craft in the Machine Age, 1920–1945*, comp. Tara Leigh Tappert (New York: Harry N. Abrams in association with the American Museum of Craft, 1995), 232; Nicholas Maffei, "John Cotton Dana and the Politics of Exhibiting Industrial Art in the U.S., 1909–1929," *Journal of Design History* 13, no. 4 (2000): 301–317. For instance, the Newark Museum's 1910 exhibition of "modern American art pottery" featured Rookwood and Grueby, the country's premier gold-medal winners in world's fairs. See Ulysses G. Dietz, *The Newark Museum Collection of American Art Pottery* (Newark: Newark Museum, 1984), 7–10.

58. John Cotton Dana, "German Applied Arts Exhibition," 1912, typescript, NMEF. The tour was funded by each participating museum contributing two hundred dollars in addition to intercity freight. The Germans' estimated shipping costs were less than the actual costs, and the additional requests for money by the Newark Museum from its colleagues were rejected by all the other museums. The Newark Museum ended up covering a shortfall of two thousand dollars, an enormous expense at the time (half of Dana's annual salary) and created grounds for resentment among Dana's critics, trustees, and fellow institutions.

59. *Eighteenth Annual Report of the Board of Trustees of the Free Public Library* (1907), 36.

60. Popper, "Newark, N.J., 1870–1910," 53.

61. Kevin J. Smead, "An Intelligent, Respectable, Well-Dressed Body of Men: A History of Newark's Jewelry Workers, 1801–1945," in Ulysses G. Dietz, *The Glitter & the Gold: Fashioning America's Jewelry* (Newark: Newark Museum, 1997), 138.

62. "The Library's German Books," *Newark Evening News*, 8 June 1912, NPL Scrapbook, 1906–1913. The periodical collection at the Newark Public Library was impressive and included Austrian and German titles, including *Uber Land und Meer, Illustrierte Zeitung, Deutsche Rundshau, Fliegenda Blatter, Westermann's Monatschefte*, and *Zeitschrift des Allgemeinen Deutschen Sprachvereins*; as well as several other periodicals focused more exclusively on culture: *Deutsche Kunst und Dekoration, Innen Dekoration, Modern Kunst, Kunstwelt, Licht und Schatten, Die Kunst, Zeitschrift fur Bildende Kunst, Museum Kunde*, and *Jugend*.

63. "The Library's German Books," *Newark Evening News*, 8 June 1912, NPL Scrapbook, 1906–1913.

64. Ibid., 256.

65. *Sunday Call*, 24 June 1906, as quoted in Popper, "Newark, N.J., 1870–1910," 258.

66. Ibid.

67. In 1890, three theaters and four amusement halls in Newark were all built and owned by German Americans. Popper, "Newark, N.J., 1870–1910," 209.

68. A successful German brewing family also funded the Busch-Reisinger museum of German art established at Harvard.

69. Although dead by 1904, Louis Prang had been the most famous German to bring technical knowledge of lithography to America in the course of the nineteenth century. Michael Clapper, "Popularizing Art in Boston, 1865–1910: L. Prang and Company and the Museum of Fine Arts (Massachusetts)" (Ph.D. dissertation, Northwestern University, 1997); Katherine Morrison McClinton, *The Chromolithographs of Louis Prang* (New York: C. H. Potter, distributed by Crown Press, 1973). German immigrants dominated the printing industry from very early on in America. See Oswald Seidensticker, *The First Century of German Printing in America, 1728–1830* (Philadelphia: Schaefer & Koradi, 1893), for a euphoric analysis of the German American influences. For a more balanced view, see Albert Bernhardt Faust, *The German Element in the United States* (1927; New York: Arno Press, 1969).

70. On Gebrüder Jänecke, see William S. Peterson, *The Kelmscott Press* (Berkeley: University of California Press, 1991), 112–114, and Linda Parry, *William Morris* (New York: Abrams, 1996), 310–335.

71. See Daniel Rodgers's study of the transmission of disciplinary and institutional models across the Atlantic by Richard Ely, among others. German schools were thought to test "character more than information" and teach ideals of "brotherhood and cooperation." Daniel T. Rodgers, *Atlantic Crossings: Social Politics in a Progressive Age* (Cambridge, Mass.: Belknap Press, 1998), 22–87; Eileen Boris, *Art and Labor: Ruskin, Morris, and the Craftsman Ideal in America* (Philadelphia: Temple University Press, 1986), 30.

72. David Nasaw, *Schooled to Order* (New York: Oxford University Press, 1979), 123.

73. James Haney, "Art Teaching in German Schools" (1913), reprinted in Charles Richards, *Art in Industry* (New York: Macmillan, 1922), 87. Haney thought art would "help the many see art as something coming home to

them in their every-day existence." "Would Apply Art," *Baltimore Sun*, 10 November 1910, Florence Levy Papers, New York Historical Society Manuscript Collection. A 1913 issue of *Vocational Education* magazine contained one article and three book reviews admiring German pedagogy. See Edwin G. Cooley, "Professor Dewey's Criticism of the Chicago Commercial Club and Its Vocational Education Bill," *Vocational Education* 3, no. 1 (September 1913): 24–29. The books reviewed included Holmes Beckwith, *German Industrial Education and Its Lessons for the United States*, George Kerschensteiner, *A Comparison of Public Education in Germany and in the United States*, and Ralph C. Busser, *The German System of Industrial Schooling*.

74. Haney, "Art Teaching in German Schools," 87. In 1912, Haney traveled to the Fourth International Congress for the Promotion of Art Education and Art in Relation to the Industries in Dresden, and on his return he asked the New York City schools to emulate aspects of German education. "It is to these schools also that the American economist and manufacturer must look, if they would learn one of the secrets of Germany's advance in the race for commercial supremacy," Haney declared.

75. Dana, "German Applied Arts," 83.

76. "Newark will never regain what she lost in the last 20 to 40 years through her failure to provide free high school facilities." John Cotton Dana, *Newarker* 1, no. 3 (January 1912): 48.

77. See chapter 2, note 20. For a sense of the level of hysteria about the trade balance turning irrevocably in Germany's favor, see George B. Waldron, "Made in Germany," *Chautauquan* 35, no. 2 (May 1902): 127–133.

78. "Artisans' Periodicals Found in the Library," *Newark Evening News*, 12 June 1903, NPL Scrapbook, 1903–1905; Dana, "Modern German Applied Arts," 11. See also "Mechanics Now Using the Free Public Library," *Sunday Call*, 7 November 1909, and "Library's German Catalogue," *Newark Evening News*, 7 November 1908, NPL Scrapbook, 1906–1913.

79. By 1919, Dana was being vilified in newspapers for his refusal to remove German literature from the shelves of the public library. He resolutely argued that in the midst of war the librarian needed to separate the country's cultural achievements from its present government. In the periodical *The American City*, Dana wrote about "Training a City in Civics" and noted that "autocracy is, or has been a menace to mankind—the German Empire taught us that." See John Cotton Dana, "Training a City in Civics,"

American City 20, no. 3 (March 1919): 240. His denunciations of autocracy did not, however, extend to museum management, where Dana wrote "Centralize authority. A museum cannot be well managed by a board of directors. No business can." "Fundamental Notes" in Dana, *The New Museum* (Woodstock, Vt.: Elm Tree Press, 1917), 38.

80. "Artisans' Periodicals Found in the Library."

81. Dana's first contact in the Deutscher Werkbund was Annaline Schmidt, sister of Dr. Paul Ferdinand Schmidt, head of the department of graphic arts at the Kaiser Friedrich-Museums in Magdeburg, who then forwarded his request to the Werkbund. John Cotton Dana to Annaline Schmidt, 9 February 1911, NMEF; Schifman, "Design for Industry," 378.

82. See Sebastian Müller, "Das Deutsche Museum fur Kunst in Handel und Gewerbe," *Karl-Ernst Osthaus: Leben und Werk*, ed. Herta Hesse-Frelinghaus (Recklinhausen: A. Bongers, 1970), 296–300. Osthaus's lectures included "Die Kunst im Dienste des Kaufmann's" (Art in the service of the salesman), and "Zur Geschmackausbildung des deutschen Kaufman's" (Toward educating the taste of German salesmen). Heskett, *German Design*, 127.

83. Joan Campbell, *The German Werkbund: The Politics of Reform in the Applied Arts* (Princeton: Princeton University Press, 1978), 43.

84. William Leach, *Land of Desire* (New York: Pantheon, 1993), 164–169.

85. Frederic Schwartz, *The Werkbund: Design Theory and Mass Culture before the First World War* (New Haven: Yale University Press, 1996), 112.

86. Hermann Muthesius, "Wirtschaftsformen im Kunstgewerbe," *Die Werkkunst* 3 (1908): 230–231; "Library a Leveller," *Newarker* 1, no. 10 (August 1912), 184. See Laurie Stein, "German Design and National Identity, 1890–1914," in *Designing Modernity: The Arts of Reform and Persuasion, 1885–1945*, ed. Wendy Kaplan (New York: Thames and Hudson, 1995), 49–73.

87. John Cotton Dana, "Munich," manuscript, Dana Collection, NPL.

88. Frederic C. Howe, "City Building in Germany," *Scribner's* 47, no. 5 (May 1910): 601–614.

89. Ibid., 614.

90. *Newarker* 1, no. 4 (February 1912): 55.

91. Charles W. Eliot, *The Conflict between Individualism and Collectivism in a Democracy* (New York: Scribner's, 1910), 11–46. See also Isaac B. Berkson, *Theories of Americanization: A Critical Study* (New York: Columbia University, 1920).

92. David W. Noble, *Paradox of Progressive Thought* (Minneapolis: University of Minnesota, 1958), 55–77; Daniel M. Fox, *Discovery of Abundance: Simon N. Patten and the Transformation of Social Theory* (Ithaca: Cornell University Press, 1967), 64; Leach, *Land of Desire*, 240–243.

93. Simon Nelson Patten, *The New Basis of Civilization* (1909; Cambridge, Mass.: Belknap Press, 1968), 106–107.

94. Osthaus, "Introduction," in *German Applied Arts*, 4; Fritz Meyer-Schönbrunn, "Advertising Art," in *German Applied Arts*, 39. Meyer-Schönbrunn was an assistant at Osthaus's Deutschen Museum für Kunst in Handel und Gewerbe. On Osthaus, see also Michael Fehr, Sabine Röder, and Gerhard Storck, eds., *Das Schöne und der Alltag: Die Anfänge Modernen Designs, 1900–1914* (Köln: Wienand, 1997).

95. Behrens advocated abstraction on grounds of relationship to modern alienation: "Ornament should therefore always have something impersonal about it." Cited in Schwartz, *Werkbund*, 69.

96. See also Frederick Schwartz, "Commodity Signs: Peter Behrens, the AEG, and the Trademark," *Journal of Design History* 9, no. 3 (1996): 153–184; Jeremy Aynsley, *Graphic Design in Germany, 1890–1945* (Berkeley: University of California Press in association with Thames and Hudson, 2000), 76–85.

97. Meyer-Schönbrunn, "Graphic Art," 29.

98. Louise Connolly, "German Arts and Crafts Exhibit," *Newarker* 1, no. 6 (April 1912): 90.

99. *Pittsburgh Dispatch*, 23 February 1912, 6, NMEF. The *New York Sun* also considered "Advertising Art" the astonishing part of the show. *New York Sun*, 14 March 1913: n.p., NMEF.

100. *Newark Evening News*, 12 April 1912, NMEF.

101. Henry Louis Bullen to Dana, 23 April 1912, NMEF. Dana also received a letter of congratulations on the German printing in the show from Henry Louis Johnson, editor of *Graphic Arts*. See Henry Louis Johnson to John Cotton Dana, 26 May 1913, L255, Dana Collection, NPL.

102. *Newark Evening News*, 12 April 1912, n.p., NMEF.

103. "Germans Show How to Impress Art on Industry," *New York Herald*, 13 March 1913, NPL Scrapbook, 1906–1913.

104. *New York Sun*, 14 March 1913, n.p., NMEF.

105. Connolly, "German Arts and Crafts Exhibit," 90.

106. Karl With, "Ceramics," in *German Applied Arts*, 61.

107. Ibid.

108. On German stoneware, see David Gaimster, *German Stoneware 1200–1900: Archeology and Cultural History* (London: British Museum Press, 1997).

109. Hermann Muthesius, "Die Kunst Richard Riemerschmids," *Dekorative Kunst* 7 (April 1904): 254.

110. William Graham Sumner, *Folkways: A Study of the Sociological Importance of Usages, Manners, Customs, Mores and Morals* (Boston: Ginn and Company, 1906), 4–6; John Cotton Dana to the United States State Department, 6 December 1922, NMEF.

111. My interpretation for this understanding of early-twentieth-century design reform relies on Pat Kirkham, *Harry Peach* (Leicester, U.K.: Design Council, 1986), 47–69, and Alan Crawford, *By Hammer and Hand* (Birmingham, U.K.: Birmingham Museums and Gallery, 1984), 23–25. See also Julian Holder, "'Design in Everyday Things': Promoting Modernism in Britain, 1912–1944," in *Modernism in Design*, ed. Paul Greenhalgh (London: Reaktion, 1990), 123–144; 3–18; 2–25; Gillian Naylor, *The Arts and Crafts Movement: A Study of Its Sources, Ideals and Influence on Design Theory* (Cambridge, Mass.: MIT Press, 1971), 184–189.

112. Addams, *Spirit of Youth*, 122–123.

113. Ibid., 126–127.

114. Edward Robinson, director of the Metropolitan Museum, sent Dana a letter to that effect. He explained that numerous trade organizations had asked for exhibition space and "our hospitality to a German exhibition of the kind would call down unpleasant and possibly justifiable criticisms from those who have been disappointed. It would also undoubtedly cause embarrassment to our Trustees by bringing out a renewal of these and similar applications." Edward Robinson to John Cotton Dana, 28 September 1911. Dana, upset or merely looking to instigate discussion, wrote to the Museum's secretary and his long-time friend, Henry Watson Kent: "I did not know that the Metropolitan had adopted the policy of displaying the work of dead men only . . . really it makes me sick." John Cotton Dana to Henry Watson Kent, 2 October 1911, NMEF.

115. Director Wilson thought the exhibition was overly beneficial to German merchants and seemed to sanction the American predilection for European luxury imports to the detriment of American businesses: "Is it in the slightest interest of the German manufacturer? . . . If it has been arranged in such a way as to further the interests of American manufacturers without advertising German manufacturers, and for the purpose of stimulating our people in a better and more artistic line of production, then I believe I should like to take hold of it in Philadelphia."

William P. Wilson, Director of the
Philadelphia Commercial Museum, to John
Cotton Dana, 2 February 1912. Wilson and the
Commercial Museum contributed to the 1916
textiles exhibition at the Newark Museum,
lending some specimens of Japanese silk
weaving and dyeing. Newark Museum to
William P. Wilson, Commercial Museum, 30
August 1915, NMEF.

116. Marjary Gilson to Richard C. Jenkinson, 2
May 1912, Jenkinson scrapbook, NJHS.

117. Dewey spoke on March 28, 1912, and Blatch
on 17 June 1912 at the headquarters of the
Women's Political Union. *Women's Political
Union of New Jersey Campaign Yearbook,
1914*, Elizabeth Pope Collection, NJHS.

118. *Women's Political Union of New Jersey
Campaign Yearbook, 1914*. On the changing
use of publicity by the suffrage movement,
see Susan A. Glenn, *Female Spectacle*
(Cambridge: Harvard University Press,
2000), 129–136. On October 25, 1914, the city
witnessed a second large suffrage rally. The
streets and the exhibition booths were a stage
to conduct information campaigns and also to
lobby for specific definitions of industry that
recognized women.

119. "Splendid Art at the Exposition," *Exposition
News* 5 (17 May 1912): 1.

120. *Exposition Daily Recorder*, no. 1 (3 February
1913): 2.

121. Ibid.

122. See *Counter Currents*, Bamberger's house
organ. The most complete run is located in
the Rutgers University Library.

123. *Exposition Daily Recorder*, no. 4 (6 February
1913): 4.

124. Janet Zapata, "Whitehead & Hoag Co.," in
Glitter & the Gold (Newark: Newark Museum,
1997), 184–185.

125. See Roland Marchand, "Designers Go To
the Fair II: Norman Bel Geddes, The General
Motors 'Futurama,' and the Visit to the
Factory Transformed," *Design Issues* 8, no. 2
(Spring 1992): 22–40.

126. Hadley, *John Cotton Dana, A Sketch*, 56–57.

127. The city's other grand department store,
Hahne's, commissioned plates from the same
manufacturer, inserting its own façade in
place of Bamberger's as one of Newark's
seven wonders.

128. William James, *Pragmatism: A New Name
for Some Old Ways of Thinking* (New York:
Longmans, Green, 1907), 74, 86, 92; John
Dewey, "The Scholastic and the Speculator"
(1891–2), in *Early Works, 1882–1898*, 5 vols.
(Carbondale: Southern Illinois University
Press, 1967), 3: 150–154; John Cotton Dana,
*A Plan for a New Museum: The Kind of
Museum It Will Profit a City to Maintain*,
The New Museum Series, no. 4 (Woodstock,

Vt.: Elm Tree Press, 1920), 3; John Cotton
Dana, "The Cash-Value of Art in Industry,"
Forbes Magazine, 1 August 1928, 16–21.
See James Livingston, *Pragmatism, Feminism,
and Democracy: Rethinking the Politics
of American History* (New York: Routledge,
2001) for a recent examination of the
economic metaphors such as the "credit
system of truth" that Richard Hofstadter
decried in *Anti-Intellectualism in
American Life* (New York: Knopf, 1963).

129. "How the Library May Be Bettered,"
Newark Evening News, 20 March 1902,
NPL Scrapbook, 1901–1903. *Exposition
Daily Recorder* no. 6 (8 February 1913): 4.

130. John Cotton Dana, "The Salesman as
a Missionary," *Newarker* 2, no. 5 (March
1913): 275.

Four: Molding and Modeling
Civic Consumption

1. "Clay Industries of New Jersey" and "Clay
Products of New Jersey" were two distinct
exhibitions advertised under separate titles
and as a concurrent event, depending on
the context. "Industries" included historical
products, and "products" more contemporary
commodities. For the sake of consistency
with the textile exhibition of 1916, I use
the former.

2. "Mr. Dana's Notes on Exhibition of Clay
Products Industry of New Jersey," 1 August
1914, 6, NMEF.

3. John Cotton Dana, "Intellectual Life and
Free Libraries," *Newarker* 4, no. 3 (January
1915): 1. Later reprinted in John Cotton Dana,
Suggestions (Boston: F. W. Fox, 1921), 17.

4. Marion F. Washburne, "A Labor Museum,"
Craftsman 6, no. 6 (September 1904): 574.

5. Dana, "The Gloom of the Museum,"
Newarker 2, no. 12 (October 1913): 395. Dana's
patriotic sentiment was somewhat new
because only a year before he had inquired if
Stoke-on-Trent potters wanted to send over a
"carefully selected exhibition" of their wares.
See J. C. Dana to Herbert Baily, editor of
Connoisseur, 11 March 1914, NMEF.

6. See Chistopher Long, *Paul T. Frankl and
Modern American Design* (New Haven:
Yale University Press, 2007), 26; Rudolph
Rosenthal and Helena L. Ratzka, *Story of
Modern Applied Art* (New York: Harper,
1948), 165–166.

7. Louise Connolly, "Docentry Notes,"
typescript, 1, NMEF. Also see Holger Cahill
in *Louise Connolly* (Newark: Library and
Museum, 1928), 21.

8. Otis T. Mason, *Woman's Share in Primitive
Culture* (New York: D. Appleton, 1894), 17.
Also see "Evolution of a Housewife," *Newark

Evening News, 5 April 1909, NPL Scrapbook, 1906–1913. Several anthropologists were asking the same questions about cultural classifications. Frank Hamilton Cushing was one who especially focused on pottery and the potshard as a means of reading larger cultural values. His argument that each was a metonym for its genus and a synecdoche for a cultural habit disseminated similar conceptions of pottery as a serious gauge of culture and not a "decorative" art.

9. Charlotte Perkins Gilman, *The Man-Made World or Our Androcentric Culture*, 3rd ed. (New York: Charlton Company, 1914), 72.

10. *Year Book of the Contemporary of Newark, New Jersey, 1914–15* (Newark, 1915), 4.

11. Dana's interest in including grade school work in ceramics is documented in the correspondence between the museum and Eva Struble, art instructor at the Newark Board of Education, in January 1915. However, Struble informed Dana that no Newark schools used clay.

12. Dana, "Clay Industries of New Jersey," 80.

13. The museum asked such direct questions as "What is your approximate output?" to which John Maddock's responded, "10,000 toilets a year," and Mueller Tile gave economic information, forty thousand dollars per year.

14. Newark Museum Association to Thomas Maddock's Sons Co., 2 January 1915, NMEF.

15. Newark Museum Association to Mrs. G. R. Trall, 13 October 1914, NMEF.

16. *Fifth Annual Report, Newark Museum Association 1914–1915* (Newark: Newark Museum, 1915), 6.

17. Newark Museum Association to Mrs. G. R. Trall, 13 October 1914, NMEF.

18. John Cotton Dana, *A Small American Museum, Its Efforts toward Public Utility* Newark: Newark Museum, 1921), 19.

19. Ulysses Dietz, "Art Pottery as Contemporary Ceramics: The Collection of the Newark Museum," *Journal of the American Art Pottery Association* 12, no. 9 (July–August 1996): 15–18.

20. Americans imported seven million dollars worth of ceramics in 1894, and the total value of exported ceramic sanitary ware was approximately $135,000. See Chauncey DePew, ed., *1795–1895: One Hundred Years of American Commerce* (New York: Haynes, 1895), 292.

21. Samuel Harry Popper, "Newark, New Jersey, 1870–1910: Chapters in the Evolution of an American Metropolis" (Ph.D. dissertation, New York University, 1952), 411.

22. Dana, "Intellectual Life and Free Libraries," 1.

23. James B. Lane, *Jacob Riis and the American City* (Port Washington, N.Y.: Kennikat Press, 1974), 59.

24. The initiative was pioneering in applying a business method, the direct-mailing campaign, to schoolteachers. Self-addressed stamped postcards were used by the museum to facilitate teacher response. The postcards offered four choices of time slots, and teachers only had to check off a box and post the card.

25. Superintendent Ebenezer Mackey of Trenton's Board of Education also lamented that clay was not taught in his system except in the School of Industrial Arts, confiding that "clay . . . has met with very much opposition on the part of parents and school janitors." E. Mackey to Dana, 28 January 1915, NMEF.

26. Maud Mason to Newark Museum, 7 March 1915, NMEF.

27. Marc Jeffrey Stern, *The Pottery Industry of Trenton: A Skilled Trade in Transition, 1850–1929* (New Brunswick: Rutgers University Press, 1994), 25. Also see Neil Ewins, "'Supplying the Present Wants of Our Yankee Cousins . . . ': Staffordshire Ceramics and the American Market, 1775–1880," *Journal of Ceramic History* 15 (Stoke-on-Trent, UK: Stoke-on-Trent City Museum, 1997): 62; John Spargo, *Early American Pottery and China* (1926; Rutland, Vt.: Charles E. Tuttle, 1974), 237.

28. Charles Fergus Binns, *The Potter's Craft* (New York: Van Nostrand, 1910), viii.

29. Enoch Bourne to John Cotton Dana, n.d., NMEF.

30. Frank Frederick to John Cotton Dana, 26 January 1915, NMEF.

31. Dana, "A Museum of Service," 584.

32. Ibid.

33. *Exposition Daily Recorder* no. 4 (6 February 1913): 3.

34. Lewis T. Bryant, *Industrial Directory of New Jersey* (Paterson, N.J.: Bureau of Industrial Statistics of New Jersey, Department of Labor, 1918).

35. William Paul Gerhard, *The Water Supply, Sewerage and Plumbing of Modern City Buildings* (New York: John Wiley & Sons, 1910), 80, 109.

36. The stores targeted for participation, L. Bamberger and Company, L. S. Plaut and Company, and Hahne and Company, were the same ones that the library had served for ten years with branches dedicated to serve employees. See "Library Books in the Stores," *Sunday Call*, 12 August 1906, NPL Scrapbook, 1905–1906.

37. Connolly, "Docentry Notes," 2.

38. John Cotton Dana, "The Salesman as a Missionary," *Newarker* 2, no. 5 (March 1913): 275.

39. Richards lectured on seventeenth- and eighteenth-century French furniture, and his definition of "industry" evolved, as Dana's

did, from seeing no paradox between manual crafts and machine processes to elaborately differentiating the practices. *Metropolitan Museum of Art Bulletin* 9, no. 1 (January 1914): 27. For a comparison of the Met and Newark that is compelling for its politics but selective in its evidence, see Christine Wallace Laidlaw, "The Metropolitan Museum of Art and Modern Design, 1917–1929," *Journal of Decorative and Propaganda Arts* 8 (Spring 1988): 88–103. Laidlaw is not alone in championing the Newark Museum as anti-elitist and overlooking its intensely supportive embrace of capital and local commerce.

40. Simon Bronner calls this "an ideological double helix," an anachronism as a metaphor, but an insight into the conception of such a mutual dynamic. Simon J. Bronner, "Object Lessons," in *Consuming Visions*, ed. Bronner (New York: W. W. Norton, 1989), 255.

41. See Regina Lee Blaszczyk, *Imagining Consumers* (Baltimore: Johns Hopkins University Press, 2000), 118.

42. Stern, *The Pottery Industry of Trenton*, 108–114.

43. The overall trend in business in Newark was toward consolidation. The number of industrial establishments fell from 3,339 to 1,858, a 44.4 percent decrease between 1900 and 1910, while the population grew from 246,000 to 347,000. There was a concurrent increase of people in manufacturing, from 49,550 to 59,555. The annual increase in the value of products made by Newark industries rose from $127 million to $203 million, a 59.5 percent increase. See Popper, "Newark, New Jersey, 1870–1910," 52–63.

44. Tariffs rose 50–55 percent on imported plain and decorated goods in the first two decades of the twentieth century.

45. William Edward Leuchtenburg, *Perils of Prosperity, 1914–1932*, 2nd ed. (Chicago: University of Chicago Press, 1993), 3–17; Robert Higgs, *The Transformation of the American Economy, 1865–1914* (New York: Wiley, 1971), 111–127.

46. Isaac Broome sculpted the bust of Grant while on contract with Ott and Brewer to enrich their presentation at the Centennial Exposition of 1876. See Alice Cooney Frelinghuysen, *American Porcelain, 1770–1920* (New York: Harry N. Abrams and Metropolitan Museum of Art, 1989), 29–37.

47. Herbert Minton and Co. first used the term "parian" to market statuary in the 1840s, and after 1851 it was used in England and North America to refer to any unglazed porcelain statuary and busts. See Maureen Batkin and Paul Atterbury, "The Origin and Development of Parian," in *The Parian Phenomenon*, ed. Atterbury (Somerset, U.K.: Richard Dennis, 1989), 9–18.

48. Stern, *The Pottery Industry of Trenton*, 141.

49. Newark Museum Association to Thomas Maddock's Sons, 20 August 1914, NMEF. In contrast to Dana's pride of place, Tiffany and Co., which won the nation's first international gold medal in the applied arts, maintained its major factory in Newark and created a postal address to hide the fact. The address of "Forest Hill" obscured its location and disassociated it from Newark's many mid-market jewelry firms. Charles Venable, *Silver in America: A Century of Splendor, 1840–1940* (Dallas: Dallas Museum of Art, 1994), 114. Also see Dietz, *The Glitter & the Gold: Fashioning America's Jewelry* (Newark: Newark Museum, 1997), 48.

50. Stern, *The Pottery Industry of Trenton*, 5–12.

51. Ibid., 35, 92, 121–134.

52. Ibid., 78. Potters accepted only a limited "associationism to match corporatism."

53. Ibid., 110.

54. John Cotton Dana and Frances Doane Twombly, eds., *The Romance of Labor: Scenes from Good Novels Depicting Joy in Work* (New York: Macmillan, 1916).

55. Patricia E. Meola, *Summit* (Charleston, S.C.: Arcadia, 1998), 72.

56. The presentation of artifacts brought into the art museum some of the domestic practices of American material culture. See Kenneth L. Ames, "Meaning in Artifacts: Hall Furnishings in Victorian America," in *Material Culture Studies in America*, ed. Thomas J. Schlereth (1982; Walnut Creek, Cal.: AltaMira, 1999), 206–221.

57. J. Garrison Stradling, "Puzzling Aspects of the Most Popular Piece of American Pottery Ever Made," *Magazine Antiques*, 1 February 1997, 85.

58. Edwin AtLee Barber, *The Pottery and Porcelain of the United States* (1893; Watkins Glen, N.Y.: Century House Americana, 1971), 7–8.

59. The Walpole Society was established in January 1910, after Henry Watson Kent and Luke Vincent Lockwood traveled to Boston to purchase the collection of Eugene Bolles, which became the nucleus that developed into the American Wing of the Metropolitan Museum of Art in 1924. Kent claimed, "Realizing how few collectors of such things at that time knew one another, I proposed the organization of a society so that they might come together." Their first meeting was in Hartford on 21 January 1910. See Henry Watson Kent, *What I Am Pleased to Call My Education*, ed. Lois Leighton Comings (New York: Grolier Club, 1949), 161; Elizabeth Stillinger, *The Antiquers* (New York: Knopf, 1980), 179.

60. Dana, *Mr. Walpole's Friends in Boston, 1910* (Newark: Merrymount Press, 1911), 18; Barber, *The Pottery and Porcelain of the United States*, 7. American colonial silver went from being described as "curious, but ... [of] little artistic merit" in 1889 to being exhibited at the Boston Museum of Fine Arts in 1906 and deemed "of considerable artistic merit. of a time when American taste, if uninventive, was at least unvulgarized." *Harper's Weekly*, 27 April 1889, and *The Evening Post* (1906), as quoted in Stillinger, *The Antiquers*, 48, 126.

61. Stillinger, *The Antiquers*, 151; R.T.H. Halsey, *Pictures of Early New York* (New York: Dodd and Mead, 1899).

62. "The Production and Appreciation of Art in New Jersey," *Bulletin of the New Jersey State Federation of Women's Clubs* 1, no. 1 (15 November 1914): 3.

63. The first books on collecting emphasize patriotism and national tendencies in aesthetics, such as Annie Trumbull Slosson's *The China Hunters Club, by the Youngest Member* (New York: Harper, 1878),and Jennie J. Young, *The Ceramic Art* (New York: Harper, 1878). "Torchbearer" is apt imagery for these women because it conjures paradoxes, suggesting both militant firebrands and conventional tenders of the hearth. They were the first generation to call themselves feminists. Blair explains that her choice of words for the title of her book came from a contemporary favorite usage by sculptor Anna Hyatt Huntington, poet Anna Blake Mezquida, playwright Alice Archer James, and the Women's Christian Temperance Movement. Parallel representations by men include the Statue of Liberty. See Karen J. Blair, *The Torchbearers: Women and Their Amateur Associations in America, 1890–1930* (Bloomington: Indiana University Press, 1994), 5–7.

64. "The Production and Appreciation of Art in New Jersey," 2.

65. For a dynamic portrayal of women's clubs, see Karen J. Blair's *The Clubwoman as Feminist: True Womanhood Redefined, 1868–1914* (New York: Holmes and Meier, 1980) and *The Torchbearers*. An earlier, less critical appraisal is Mildred White Wells, *Unity in Diversity: The History of the General Federation of Women's Clubs* (Washington, D.C.: General Federation of Women's Clubs, 1957).

66. Blair, *The Torchbearers*, 8.

67. Slosson, *The China Hunters Club*.

68. Prime himself saw ceramics as embodying "civilizing" and "refining influences." William Cowper Prime, *Pottery and Porcelain of All Times and Nations* (New York: Harper, 1878), 17–18.

69. The Newark Society of Keramic Arts was praised as one of the most outstanding on the east coast in *Keramic Studio*. See Regina Lee Blaszczyk, "The Aesthetic Moment: China Decorators, Consumer Demand, and Technological Change in the American Pottery Industry, 1865–1900," *Winterthur Portfolio* 29, no. 2/3 (Summer 1994): 121–153; Cynthia A. Brandimarte, "Somebody's Aunt and Nobody's Mother: The American China Painter and Her Work, 1870–1920," *Winterthur Portfolio* 23, no. 4 (Winter 1988): 203–224.

70. Anne M. Cannon, "A Perfect Day in Historic Haunts," *Young Woman's Journal* 23, no. 8 (August 1912): 418.

71. Blair, *The Torchbearers*, 8.

72. Landon Storrs, *Civilizing Capitalism: The National Consumers' League, Women's Activism, and Labor Standards in the New Deal Era* (Chapel Hill: University of North Carolina Press, 2000), 15.

73. Blair, *The Torchbearers*, 84–85. Also see *American Art Annual* 6 (1907–1908): 163, and "Art Department," *General Federated Magazine* 12 (April 1914): 9–10; Joan Siegfried, "American Women in Art Pottery," *Nineteenth Century* 9 (Spring 1984): 12–18.

74. NMA to Antique Shop, 228 South 11 Street, Philadelphia, Pa., 15 December 1914, NMEF.

75. See David Goldberg, "Charles Coxon, Nineteenth-Century Potter, Modeler-Designer, and Manufacturer," *American Ceramic Circle Journal* 9 (1994): 44–49. The Ellsworth pitcher is attributed to Charles Coxon's (1805–1868) tenure at Millington, Astbury and Poulson.

76. "Here is a difficulty," Dana noted in a memo to Beatrice Winser, his second in command, "We will be asked to show things [by the women's clubs] that have nothing to do with New Jersey because they are ancient and rare." John Cotton Dana to Beatrice Winser, 15 December 1914, NMEF.

77. "Exhibition of New Jersey Pottery," *Sunday Call*, 31 January 1915, 2; Newark Museum Association to Mrs. G. R. Trall, 13 October 1914, NMEF.

78. John Cotton Dana, "An Industrial Exhibit in a Municipal Museum," *American City* 13, no. 1 (July 1915): 22.

79. John Cotton Dana to Henry B. Kümmel, the State Geologist of the New Jersey Geological Survey, 14 August 1914, NMEF.

80. "Woman's Club Gives Exhibit," *Sunday Call*, 29 March 1914, NPL Scrapbook, 1913–1916.

81. See "Traveling Collections of Art," *Illinois Club Bulletin* 4, no. 3 (1913): 30. On other women's art exhibitions, see *Bulletin of the Illinois Federation of Women's Clubs* 4, no. 3 (1916): 50; Alice Park, "Exhibition by Women and Women Organizers at the Panama Pacific

International Exposition," *Jus Suffragii*, 1 October 1915, 11–12; Blair, *The Torchbearers*, 5.

82. See Martin Eidelberg, "Myths of Style and Nationalism: American Art Pottery at the Turn of the Century," *Journal of Decorative and Propaganda Arts* 20 (1994): 85–111.

83. "Maud Mason and the Fawcett School," *Keramic Studio* 16, no. 4 (August 1914): 74–77. Also see "The Newark Society of Keramic Arts," *Keramic Studio* 13, no. 1 (May 1911): 58–62; and *Keramic Studio* 16, no. 2 (June 1914): 28–32.

84. See Cheryl Buckley, *Potters and Paintresses: Women Designers in the Pottery Industry, 1870–1955* (London: Women's Press, 1990), and Moira Vincentelli, *Women and Ceramics: Gendered Vessels* (New York: Manchester University Press, 2000).

85. *Women's Political World* 1, no. 20 (15 October 1913), Amelia Moorfield papers, box 1, NJHS.

86. Her father was still alive and provided the institution with a history of the firm, leading to the identification of two hound pitchers to the Salamander Works. See John Cotton Dana to Clara Poillon, 11 March 1914, NMEF.

87. Clara Poillon's art was noted and exhibited in many places by 1915: in 1897 in *Home Furnishings*'s review of a New York Keramic Society exhibition in the Waldorf ballroom (along with Adelaide Alsop, as yet unmarried to Samuel Robineau), in the 1904 Louisiana Purchase Exposition in St Louis (see *Transactions of the American Ceramic Society*), in a 1906 "Craftsman" exhibition in Helena, Arkansas, organized by a women's club, and in the 1907 National Society of Craftsmen exhibition; see *International Studio* 71 (1907).

88. Clara Poillon to Newark Museum, 13 March 1915, NMEF.

89. No mention was made of the fact that Poillon's "hand work [was] done by two skilled artist[s]." Clara Poillon to Newark Museum, n.d., NMEF.

90. "Mr. Dana's Notes on Exhibition of Clay Products Industry of New Jersey," 3–4.

91. Newark Museum Association to Thomas Maddock's Sons, 3 December 1914, NMEF.

92. *Plumber's Trade Journal, Steam and Hot Water Fitters' Review* (1 November 1917): G24. Also see Ellen Lupton and J. Abbott Miller, *The Bathroom, the Kitchen, and the Aesthetics of Waste: A Process of Elimination* (Cambridge, Mass.: MIT List Visual Arts Center, 1992); Ruth Schwartz Cowan, "The 'Industrial Revolution' in the Home: Household Technology and Social Change in the 20th Century," *Technology and Culture* 17, no. 1 (January 1976): 1–26; H. L. Miller, "A Social History of the American Bathroom" (Master's thesis, Cornell University, 1960); Alexander

Kira, *The Bathroom* (New York: Viking, 1976); Siegfried Giedion, *Mechanization Takes Command* (1948; New York: Norton, 1969), 682–712.

93. "Porcelain and China in the Bathroom," *Sanitary Pottery* 1, no. 2 (May 1909): 13.

94. John M. Gries and James Ford, eds., *Homemaking, Home Furnishing, and Information Services*, President's Conference on Home Building and Home Ownership, vol. 10 (Washington, D. C., 1932), 13, as quoted in Cowan, "The 'Industrial Revolution' in the Home," 6.

95. Holger Cahill, "John Cotton Dana and the Newark Museum," in *A Museum in Action* (Newark: Newark Museum, 1944), 25.

96. Roy Palmer, *The Water Closet: A New History* (London: Newton Abbot, David & Charles, 1973), 73.

97. *Sanitary Pottery* 8, no. 1 (May 1916): 12.

98. See Norbert Elias, *The Civilizing Process*, vol. 1, *The History of Manners*, and vol. 2, *Power & Civility*, trans. Edmund Jephcott (Oxford: Blackwell, 1994).

99. *New Jersey Clay* (Newark: Newark Museum, 1915), 4.

100. "The Pottery Exhibit," 5 [unlabeled newspaper clipping], NMEF.

101. The crucible figured in Israel Zangwill's play, *The Melting-Pot* (1909) when his protagonist, David, invokes a religious metaphor: "America is God's Crucible, the great Melting-Pot where all the races of Europe are melting and reforming! Germans and Frenchmen, Irishman and Englishmen, Jews and Russians—into the Crucible with you all! God is making the American." Zangwill dedicated his play to "the great reformer," Theodore Roosevelt.

102. Samuel Haber, *Efficiency and Uplift: Scientific Management in the Progressive Era, 1890–1920* (Chicago: University of Chicago Press, 1964), 62, 85.

103. Newark Museum Association to John Maddock's Sons, 23 January 1915, NMEF, notes the receipt of "one closet, one tank with hardware and cover" closet #455, china tank #429, . . . seat." At the time, toilets were called water closets. Another company wrote to the Newark Museum detailing their contribution: "We are sending you today carefully packed, by express prepaid, the old lavatory and pedestal, the Siwelclo Closet combination with tank and glass front all fitted and properly tested, and bone chinabracket, towel bar, toilet paper holder, mug, vase and soap holder with necessary brackets, all fitted with all screws so that they can be put up by any practical plumber in the course of a few hours . . . so that you can put them right under water." E. C. Storer to

Newark Museum Association, 29 January 1915, NMEF.

104. Stuart Galishoff, *Newark: The Nation's Unhealthiest City, 1832–1895* (New Brunswick: Rutgers University Press, 1988), 36–79.

105. *New York Times*, 14 November 1914, NMEF.

106. William B. M'Cormick, "Surely Useful and Purely Decorative: Both Have Their Place in Novel 'Art' Show," *New York Press*, 22 February 1915, NMEF.

107. Marcel Duchamp upstaged Dana's action when he submitted a urinal to the Society of Independent Artists in February 1917. Duchamp's piquancy relegated the earnest humanitarian aspect of Dana's action to obscurity. Curiously, both men posed a similar question to their audiences about the categorization of art and industry in terms of mechanization. Duchamp explained that whether the artist "with his own hands made [it] or not has no importance" in relation to the urinal's value. As Duchamp's work has been mythologized over the years as a conceptual and linguistic sleight of hand, the influential and innovative display of American commerce has become obscure. There is also a possibility that Duchamp arrived in New York in the summer of 1915, read of the Newark exhibition, and made his *Fountain* two years later as a direct parody. Stieglitz photographed the urinal for Duchamp, and, having visited the Newark Museum on several occasions, was aware of Dana's museum. The imaginative displays of sanitary ware retailers is noted in Kirk Varnedoe and Adam Gopnik, *High & Low: Modern Culture and Popular Art* (New York: Museum of Modern Art in association with Harry N. Abrams, 1990), 274–278.

108. Wood, "The Connection between Art and Bath Tubs," 8; Gillian Naylor, *The Bauhaus Reassessed* (London: Herbert Press, 1985), 37.

109. Adolf Loos, "Plumbers," *Spoken into the Void: Collected Essays 1897–1900* (Cambridge, Mass.: MIT Press in association with the Graham Foundation and the Institute for Architecture and Urban Studies, 1982), 44–48.

110. *New Jersey Clay* (Newark: Newark Museum, 1915), 10.

111. Barber, *The Pottery and Porcelain of the United States*, 1.

112. *Sanitary Pottery* (March 1916) back cover advertisement, n.p.

113. Ibid.

114. Newark Museum Association to Mrs. G. R. Trall, 13 October 1914, NMEF.

115. On the endurance of Ruskin's phrase from *The Seven Lamps of Architecture* (1857), see Paul Greenhalgh, *Modernism in Design* (London: Reaktion, 1990), 31–32.

116. John Cotton Dana to Hahne and Company,

Bamberger and Company, 9 February 1915, NMEF.

Five: Weaving the New into the Old

1. John Dewey, *The School and Society, Being Three Lectures*, 2nd ed. (Chicago: University of Chicago Press, 1900), 20. Newark's exhibition was open February 1 to March 19, 1916.

2. Michael Kammen, *Mystic Chords of Memory* (New York: Knopf, 1991), 270; Woodrow Wilson, *The New Freedom: A Call for the Emancipation of the Generous Energies of a People* (Englewood, N.J.: Prentice-Hall, 1961), 40.

3. William James, *Talks to Teachers on Psychology and to Students on Some of Life's Ideals* (1899; New York: Courier Dover, 2001), 48.

4. "Remarkable Textile Exhibition Opens in Library on Tuesday," *Sunday Call*, 30 January 1916, 5.

5. John Cotton Dana, "A Museum of Everyday Life," *Woman's Home Companion* 52, no. 1 (January 1925): 29.

6. The education of the immigrant excited fellow museum leaders Morris D. C. Crawford at the American Museum of Natural History, Stewart Culin at the Brooklyn Museum, and Robert Weeks de Forest, president of the American Federation of Arts and the Metropolitan Museum of Art. For examples of AFA programs, see Allen H. Eaton, *Immigrant Gifts to American Life: Some Experiments in Appreciation of the Contributions of Our Foreign-Born Citizens to American Culture* (New York: Russell Sage, 1932); Kristin L. Hoganson, *Consumers' Imperium: The Global Production of American Domesticity, 1865–1920* (Chapel Hill: University of North Carolina Press, 2007).

7. See Philip B. Scranton, ed., *Silk City: Studies on the Paterson Silk Industry, 1860–1940* (Newark: New Jersey Historical Society, 1985).

8. *Children at the Textile Exhibition* (Newark: Newark Museum Association, 1916), 10.

9. 50,089 attended, according to the museum's *Annual Report, 1915–1916*, 9.

10. Bamberger's ran their final Made in Newark exhibition in 1916, and it is worth speculating whether Bamberger's sensed that the spectacle of live craft and the metaphor of spiritualized materialism was losing power in the popular mind. Helen Christine Bennett, "Do the Wise Thing If You Know What It Is—But Anyway Do Something!" *American Magazine* 95, no. 6 (June 1923): 122.

11. *Children at the Textile Exhibition*, 5.

12. See Eileen Boris, *Art and Labor* (Philadelphia: Temple University Press, 1986), 123; Thomas

Carlyle, *Past and Present* (1843), as quoted in Daniel T. Rodgers, *The Work Ethic in Industrial America, 1850–1920* (Chicago: University of Chicago Press, 1978), xi.

13. *Children at the Textile Exhibition*, 8.

14. Laurel Thatcher Ulrich, "Wheels, Looms, and the Gender Division of Labor in Eighteenth-Century New England," *William and Mary Quarterly*, third ser., 55 (1998): 37–38; Laurel Thatcher Ulrich, "A Bedsheet in Beinecke," *Common-Place*, 2, no. 1 (October 2001).

15. Address by Jane Addams at the Organizational Meeting, 16 November 1906, at Cooper Union, New York. See "Proceedings of the Organizational Meetings," *National Society for the Promotion of Industrial Education Bulletin* 1 (January 1907): 41–43.

16. *The Museum* 1, no. 1 (1917): 7.

17. "Open Letter to Newark's Foreign Born," and "Welcome Extended to Foreigners by Newark's Public Library," *Sunday Call*, 17 March 1914, NPL Scrapbook, 1913–1918.

18. *Fifth Annual Report Newark Museum Association, 1916–1917*, 21.

19. *Children at the Textile Exhibition*, 11.

20. The relativism of measuring pluralism in Newark has perplexed some scholars. For instance, Nicholas Maffei's disappointment that Dana's pluralism did not extend to African Americans is explained by the fact that the minority population was a mere 2 percent prior to World War I. See Nicholas Maffei, "John Cotton Dana and the Politics of Exhibiting Industrial Art in the U.S., 1909–1929," *Journal of Design History* 13, no. 4 (2000): 312; Samuel Popper, "Newark, New Jersey, 1870–1910: Chapters in the Evolution of an American Metropolis" (Ph.D. dissertation, New York University, 1952), 341.

21. Robert Rydell, *All the World's a Fair: Visions of Empire at American International Expositions, 1876–1916* (Chicago: University of Chicago Press, 1984)

22. Robert Crunden, *Ministers of Reform: The Progressives' Achievement in American Civilization, 1889–1920* (New York: Basic Books, 1982), x; Renato Rosaldo, "Imperialist Nostalgia," in *Culture and Truth: The Remaking of Social Analysis*, 2nd ed. (Boston: Beacon Press, 1993), 68–87.

23. Horace Kallen "Democracy versus the Melting-Pot," *New Republic*, 25 February 1925, 219; David M. Kennedy, *Over Here: The First World War and American Society* (New York: Oxford University Press, 1980), 207.

24. See Amelia Peck, *Candace Wheeler: The Art and Enterprise of American Design* (New York: Metropolitan Museum of Art, 2001); Candace Wheeler, *The Development of Embroidery in America* (New York: Harper and Brothers, 1921).

25. See Alice Zrebiec, "The American Tapestry Manufactures: Origins and Development, 1893 to 1933" (Ph.D. dissertation, Institute of Fine Arts–New York University, 1980).

26. Theodore Roosevelt, "A Layman's Views of an Art Exhibition," *Outlook* (22 March 1913), reprinted in *Salon to Biennial—Exhibitions that Made History*, ed. Bruce Altshuler, 2 vols. (New York: Phaidon, 2008), 1: 169.

27. Harriot Stanton Blatch, "Weaving in a Westchester Farmhouse," *International Studio* 26 (October 1905): 102–105.

28. See Ellen Carol DuBois, "Working Women, Class Relations, and Suffrage Militance: Harriot Stanton Blatch and the New York Woman Suffrage Movement, 1894–1909," *Journal of American History* 74, no. 1 (June 1987): 34–58; Lisa Tickner, *Spectacle of Women: Imagery of the Suffrage Campaign 1907–1914* (Chicago: University of Chicago Press, 1988).

29. *Ladies' Home Journal* (September 1916): 34, as quoted in Jennifer Scanlon, *Inarticulate Longings: The Ladies' Home Journal, Gender, and the Promises of Consumer Culture* (New York: Routledge, 1995), 64.

30. Helen Perry, Newark Museum Association to Mrs. Carl Vail, 7 January 1915, NMEF.

31. *Year Book of the Contemporary of Newark, New Jersey, 1915–16* (Newark, 1916), 17.

32. Although Hazenplug is not a household name, his designs, mainly posters and chap books for the Chicago house of Stone and Kimball, are in the Museum of Modern Art and other collections. He awoke to art through the community center established by Jane Addams, who described "Hazen" as "a sort of errand boy of the arts, decorator, scene-painter, dancer, doer in an articulate fashion of all the odd jobs that turned up to be done in connection with the Hull House theater, hopelessly the esthete but never helplessly." His work embodied uplift through art, its vocational value.

33. Amelia Moorfield Papers, box 1, NJHS.

34. Ibid. A schedule of such events lists her on 10 June 1915.

35. "Objects to Treatment of Miss Connolly," *Sunday Call* (1 April 1917), NPL Scrapbook, 1913–1918.

36. The national leadership, the General Federation of Women's Clubs, supported the campaign to ratify suffrage when it was convulsing politics and homes in 1915. Neale McGoldrick and Margaret Smith Crocco, *Reclaiming Lost Ground: The Struggle for Woman Suffrage in New Jersey* (Trenton: New Jersey Historical Commission, 1993), 39.

37. Ibid., 69.

38. Ibid., 44.

39. Typed manuscript, undated, Louise Connolly

to "Ogden, for *NY Post*," NMEF.

40. "Newark's Saengerfest Begins in a Rainstorm," *New York Times*, 1 July 1906, 3.

41. Livingston, *Pragmatism, Feminism, and Democracy*, 117–136.

42. "Making Work Pleasant," *Saturday Evening Post* 185, no. 21 (23 November 1912): 24.

43. *Sunday Call*, 25 June 1916, NMEF.

44. Kallen, "Democracy versus the Melting-Pot," 218.

45. Mary Antin, *The Promised Land* (Boston: Houghton Mifflin, 1912), 211.

46. See "Dances of All Nations," *Hull-House Bulletin* 4 (Winter 1900): 3; Barbara Kirshenblatt-Gimblett, "Objects of Ethnography," in *Exhibiting Cultures: The Politics and Poetics of Museum Display*, ed. Ivan Karp and Steven D. Lavine (Washington, D.C.: Smithsonian Institution Press, 1998), 419.

47. Eaton, *Immigrant Gifts to American Life*, 34–38; *Cleveland Museum of Art Bulletin* 6, no. 3 (April 1919): 56.

48. See Barbara Kirshenblatt-Gimblett, *Destination Culture: Tourism, Museums, and Heritage* (Berkeley: University of California Press, 1998).

49. William James, *Pragmatism: A New Name for Some Old Ways of Thinking* (New York: Longmans, Green, 1907), 53.

50. Boris, *Art and Labor*, 114.

Six: A Parade of Civic Virtue

1. John Cotton Dana, "The Library and the Celebration," *Newarker* n.s. 1, no. 1 (November 1915): 17.

2. "Character: The Nation's Greatest Asset," *Newarker* n.s. 1, no. 9 (July 1916): 270. See also Bernd Hüppauf, "Spaces of the Vernacular: Ernst Bloch's Philosophy of Hope and the German Hometown," in *Vernacular Modernism*, ed. Maiken Umbach and Hüppauf (Stanford: Stanford University Press, 2005), 84–113.

3. LC (Louise Connolly), undated manuscript., Homelands Exhibition, NMEF.

4. "Pageants Better than Gunpowder," *Century Magazine* 58 (July 1910): 476. See also David Glassberg, *American Historical Pageantry* (Chapel Hill: University of North Carolina Press, 1990), 41–68; Naima Prevots, *American Pageantry: A Movement for Art & Democracy* (Ann Arbor, Mich.: UMI Research Press, 1990), 74.

5. Percy Mackaye, *The Civic Theatre in Relation to the Redemption of Leisure* (New York and London: Mitchell Kennerley, 1912), 51. See also Emma Goldman, *The Social Significance of Modern Drama* (Boston: R. G. Badger, 1914), 5–7; Jane Addams, "What the Theatre at Hull-House Has Done," *Charities*, 29 March 1902, 284, as quoted in Jean Bethke Elshtain, *Jane Addams and the Dream of American Democracy* (New York: Basic Books, 2002).

6. For details on the celebration, see Edward Hagaman Hall and the Hudson-Fulton Celebration Commission, *The Hudson-Fulton Celebration, 1909: The Fourth Annual Report of the Hudson-Fulton Celebration Commission to the Legislature of the State of New York*, 2 vols. (Albany: State of New York, 1910), 1: 70–72.

7. Henry Watson Kent, *What I Am Pleased to Call My Education*, ed. Lois Leighton Comings (New York: Grolier Club, 1949), 163. For a perspective on the Metropolitan's exhibition that focuses on the story of connoisseurship, see Elizabeth Stillinger, *The Antiquers* (New York: Knopf, 1980), 164.

8. *Bulletin of the Metropolitan Museum of Art* 6, no. 1 (January 1911): 11.

9. John Cotton Dana, "A Model Catalogue," *New-York Evening Post*, 12 November 1909, NPL Scrapbook, 1906–1913.

10. *New York Times Magazine*, 12 September 1915.

11. *Exposition News*, no. 1 (13 May 1912): 3; *Newark Can, Newark Will* (Newark: Newark Industrial Exposition, 1914), 6.

12. *German Advertising Art: An Exhibit in the Public Library, January 2–31, 1914* (Newark: Newark Museum Association, 1914), 3–4.

13. In addition to Dana, Price, and Wiener, the other judges were J. H. Bacheller, president of the Fidelity Union Trust Company and a member of the One Hundred, and Frederick J. Keer, museum trustee and co-owner of Newark's premier gallery of artistic furnishings.

14. C. Matlack Price, "The Newark Poster," *Newarker* n.s. 1, no. 2 (December 1915): 33–34; "Newark's Traveling Posters," *Newarker* n.s. 1, no. 2 (December 1915): 35.

15. Ibid. Dana discouraged such bookishness in *The Newarker*, claiming that the Newark Public Library's "knowledge is not what you used to call 'book learning,'" but "the kind you pick up in an office, shop, or store on the street corner." Dana, "The Library and the Celebration," 17. One illustration situated a powerful male mounted on a horse, and the judges saw it as too warlike, noteworthy because the Werkbund dismissed Peter Behrens's nude cavalryman on similar grounds, as an unsuitably martial image when war was a threat on the horizon. See Jeremy Aynsley, *Graphic Design in Germany, 1890–1945* (Berkeley: University of California Press in association with Thames and Hudson, 2000), 66–69.

16. Adeline Adams, *John Quincy Adams Ward, An Appreciation* (New York: National Sculpture Society, 1912), 34–36.

17. "Sanctions for Use of Robert Treat Design," *Newarker* n.s. 1, no. 6 (April 1916): 136.

18. *Newarker* n.s. 1, no. 6 (April 1916): 140.

19. Gutzon Borglum, "Individuality, Sincerity, and Reverence in American Art," *Craftsman* 15, no. 1 (October 1908): 3–9; Gutzon Borglum, "The Betrayal of the People by a False Democracy," *Craftsman* 22, no. 1 (April 1912): 3–9; Gutzon Borglum, "Art That Is Real and American," *World's Work* 28 (June 1914): 200. See also, Albert Boime, "Patriarchy Fixed in Stone: Gutzon Borglum's Mount Rushmore," *American Art* 5, no. 1–2 (Winter-Spring 1991): 142–167; Adam J. Lerner, "Gutzon Borglum's 'Conception,'" *American Art* 12, no. 2 (Summer 1998): 70–73.

20. *Newarker* n.s. 1, no. 4 (February 1916): 85–86.

21. "All Newark to See the Times Prizes," *New York Times*, 7 May 1916.

22. Dana wrote for the *School Arts Book*, loaned it to teachers, and exhibited Bailey's art in his institution. For information on Bailey's exhibition in the Newark Library, see *Seventeenth Annual Report of the Board of Trustees of the Free Public Library made to the Honorable the Board of Aldermen of the City of Newark, N.J. 1904* (Newark: Free Public Library, 1905), 50. For information on Henry Turner Bailey speaking to The Contemporary on 4 February 1913 see *Year Book of the Contemporary of Newark, New Jersey, 1912–13* (Newark, 1913), 16.

23. Henry Turner Bailey, "The First American Thanksgiving," *School Arts Book* (1906): 108. Exercises included drawing a Pilgrims' house, "Squanto," a still life of a sword, a pewter plate, and iron cooking pot. "Probably no other publication has been used as faithfully by as many teachers in the elementary schools as has *School Arts*," noted Frederick M. Logan. See Frederick M. Logan, *The Growth of Art in American Schools* (New York: Harper, 1955), 134.

24. *Newarker* n.s. 1, no. 6 (April 1916): 131.

25. Jane Addams, *The Spirit of Youth and the City Streets* (New York: Macmillan, 1909), 126.

26. David Riesman and Reuel Denney, "Football in America: A Study in Culture Diffusion," *American Quarterly* 3, no. 4 (Winter 1951): 309–325. Certain regulations, such as the use of helmets, sought to decrease violence, while organizing the game along the gridiron and controlling movement as precisely rehearsed timed sequences were industrial management techniques. Others included the two-platoon system of teams and the standardization of line formations to maintain a steady, fast pace.

27. "Thousands Cheer the Rival Teams," *New York Times*, 5 November 1911, C5.

28. *Newark Evening News*, 27 April 1916, 21.

29. Advertisement, *Newark Evening News*, 11 February 1916, 80.

30. Joseph Roach, *Cities of the Dead* (New York: Columbia University Press, 1996), 194. Also see, James Clifford, *Predicament of Culture* (Cambridge, Mass.: Harvard University Press, 1988), 338.

31. Van Wyck Brooks, "On Creating a Usable Past," *Dial* 64 (11 April 1918): 339. Also see, Warren I. Susman, "History and the American Intellectual: Uses of a Usable Past," *American Quarterly* 16 (Summer 1964): 243–263. For more information on therapeutic consumer culture in the Progressive era, see T. J. Jackson Lears, "From Salvation to Self-Realization: Advertising and the Therapeutic Roots of Consumer Culture, 1880–1930," in *Culture of Consumption*, ed. Richard Wrightman Fox and T. J. Jackson Lears (New York: Pantheon, 1983), 3–38.

32. On the moral dimensions of pageantry in the Progressive-era United States, see Robert Cantwell, *When We Were Good: The Folk Revival* (Cambridge, Mass.: Harvard University Press, 1996); David Glassberg, *American Historical Pageantry*; David Glassberg, "Restoring a 'Forgotten Childhood': American Play and the Progressive Era's Elizabethan Past," *American Quarterly* 32, no. 4 (Autumn 1980): 351–368; David Glassberg, "History and the Public: Legacies of the Progressive Era," *Journal of American History* 73, no. 4 (March 1987): 957–980; Martin Green, *New York 1913: The Armory Show and the Patterson Strike Pageant* (New York: Scribner's, 1988); Cathy James, "Not Merely for the Sake of an Evening's Entertainment": The Educational Uses of Theater in Toronto's Settlement Houses, 1910–1930," *History of Education Quarterly* 38, no. 3 (Autumn 1998): 287–311.

33. William Chauncy Langdon, *Book of Words: The Pageant of Darien* (New York: Clover Press, 1913), as cited in Glassberg, *American Historical Pageantry*, 69.

34. Prevots, *American Pageantry*, 49.

35. Thomas Wood Stevens, *The Pageant of Newark* (Newark: Committee of One Hundred, 1916), 95–102; John Collier, "The Lantern Bearers," *Survey* 36, no. 14 (1 July 1916): 347.

36. *Newarker* n.s. 1, no. 6 (April 1916): 139.

37. "Making Americans," *Newarker* 3, no. 2 (December 1913): 430–431. Also see Allen H. Eaton, *Immigrant Gifts to American Life* (New York: Russell Sage, 1932); Kristin L. Hoganson, *Consumers' Imperium: The Global Production of American Domesticity, 1865–1920* (Chapel Hill: University of North Carolina Press, 2007).

38. Collier, "The Lantern Bearers," 347.

39. Stevens, *The Pageant of Newark*, 129.

40. William James, "Pragmatism" (1907), lecture 2, "What Pragmatism Means," in *Writings 1902–1920* (New York: Library of America, 1987), 520–522. See also James Livingston, *Pragmatism, Feminism, and Democracy: Rethinking the Politics of American History* (New York: Routledge, 2001), 27, 117–136.

41. *Newarker* n.s. 1, no. 1 (November 1915): 13; *Newarker* n.s. 1, no. 3 (January 1916): 66.

42. *Newark Evening News*, 4 May 1916.

43. "Pageant House, a Hive of Busy Women," *Newarker* n.s. 1, no. 5 (March 1916): 126.

44. A similar idealization of American historic mercantilism occurred in the "Commercial Days," pageant sponsored by the House of Seven Gables Settlement Association in Salem, Massachusetts. There, twelve thousand predominantly Irish, Polish and Russian immigrants participated. See Patricia West, *Domesticating History: The Political Origins of America's House Museums* (Washington, D.C.: Smithsonian Institution Press, 1999), 47; Joseph A. Conforti, *Imagining New England: Explorations of Regional Identity from the Pilgrims to the Mid-Twentieth Century* (Chapel Hill: University of North Carolina Press, 2001), 257–262.

45. Arthur Wiener, "Willy Sesser," *The Poster* 4, no. 3 (November 1913): 22–28. See also Michele H. Bogart, *Artists, Advertising, and the Borders of Art* (Chicago: University of Chicago Press, 1995), 110–124.

46. John Cotton Dana to Augustus V. Hamburg, 17 July 1915, Dana Collection, NPL.

47. John Cotton Dana, "The Exposition of Our Newest Newarkers," typescript, NMEF.

48. "Solving Social Questions," *Newarker* 2, no. 2 (December 1912): 231.

49. "Secretary Baker Opens Exposition," *New York Times*, 14 May 1916. The words presage the way the Smith Hughes Act (1917) would configure a reductive ideal of industry in the public educational system.

50. "Jersey Old Guard Greet Roosevelt," *New York Times*, 3 June 1916.

51. Rabbi Solomon Foster, "Some Inspirational Values of the 250th Anniversary Celebration," *Newarker* n.s. 1, no. 2 (December 1915): 27–28.

52. *Fifth Annual Report Newark Museum Association, 1916–1917*, 20–21.

53. LC (Louise Connolly), undated manuscript, NMEF.

54. Kate Belcher to Louise Connolly, 14 April 1916, NMEF.

55. Frederica Howell to John Cotton Dana, 15 April 1916, NMEF

56. Alice Kendall to John Cotton Dana, 13 July 1916, NMEF.

57. "Benefits of Homelands Exhibition Trickle through Curtain of Heat," *Newark Evening News*, 26 July 1916, 8, NMEF.

58. *Newark Evening News*, 26 July 1916, NMEF.

59. Alice Kendall to John Cotton Dana, 13 July 1916, NMEF.

60. John Cotton Dana to Alice Kendall, 22 July 1916, NMEF.

61. Alice Kendall to Katherine Rummell, 15 November 1916, NMEF.

62. Dana, "A Museum of Everyday Life," 29; John Cotton Dana, *A Small American Museum, Its Efforts Toward Public Utility* (Newark: Newark Museum Association, 1921), 11.

63. *Eighth Annual Report Newark Museum Association, 1916–1917*, 12. More photographic than written documentation is extant in the NMEF.

64. John Cotton Dana, "Preface," in Della R. Prescott, *A Day in a Colonial Home*, ed. Dana (Boston: Marshall Jones Company, 1921), ix.

65. "The Colonial Kitchen," December 1915, addendum in *Newark Museum Association Seventh Annual Report, 1915–1916*, n.p. This suggests that the cult of domesticity did not die in the modern era, it just became more complicated and nuanced. See also Priscilla J. Brewer, *From Fireplace to Cookstove: Technology and the Domestic Ideal in America* (Syracuse: Syracuse University Press, 2000).

66. *Seventh Annual Report Newark Museum Association, 1915–1916*, 23–24.

67. See Laurel Thatcher Ulrich, *Age of Homespun* (New York: Knopf, 2001), 11–40.

68. John Cotton Dana, "A Municipal Exhibition," *Newarker* 4, no. 1 (November 1914): 4.

69. John Cotton Dana, "The Gloom of the Museum," *Newarker* 2, no. 12 (October 1913): 389.

70. Bamberger's production of faux-historical goods began quite early. The 1912 and 1914 Gustav Stickley Craftsman furniture catalogues took the "handmade" ideal so far as to advertise light fixtures with "hammered glass."

71. For analysis of the fireplace, see Katherine Anne-Marie Roberts, "Hearth and Soul: The Fireplace in American Culture" (Ph.D. dissertation, University of Minnesota, 1990); William Rhoads, "The Colonial Revival and American Nationalism," *Journal of the Society of Architectural Historians* 35, no. 4 (December 1976): 239–254; and Rodris Roth, "New England Kitchen Exhibits," in *Colonial Revival in America*, ed. Alan Axelrod (New York: Norton, 1985), 159–183.

72. John Cotton Dana, "A Museum of Everyday Life," *Woman's Home Companion* 52, no. 1 (January 1925): 29.

73. Dana most likely visited the Essex Institute in 1910, when the Walpole Society made a trip to Salem. A theatrical kitchen was the first of Dow's period rooms, in which he used living actors, a newspaper from 1800, a pair

of silver-horned spectacles, and maintained a fire burning in the hearth. George Francis Dow, *Annual Report of the Essex Institute*, 1 May 1911, 18; Dow, *Annual Report of the Essex Institute*, 6 May 1912, 16. See also, Glassberg, *American Historical Pageantry*, 214. On period rooms, see Dianne Pilgrim, "Inherited from the Past: The American Period Room," *American Art Journal* 10, no. 3 (May 1978): 4–23; Edward Alexander, "Artistic and Historical Period Rooms," *Curator* 7, no. 4 (1964): 263; James Deetz, "A Sense of Another World: History Museums and Cultural Change," *Museum News* 58, no. 5 (May-June 1980): 40–45; Charles Hosmer, *Presence of the Past: A History of the Preservation Movement in the United States before Williamsburg* (New York: Putnam's, 1965); Stillinger, *The Antiquers*, 130, 150–152.

74. Beverly Gordon, "Spinning Wheels, Samplers, and the Modern Priscilla: The Images and Paradoxes of Colonial Revival Needlework," *Winterthur Portfolio* 33, no. 2/3 (Summer-Autumn, 1998): 163–194.

75. "Old Colonial Rooms," *Camera Work* 32 (October 1910): 25. Similarly, in *Sesame and Lilies*, John Ruskin described the home as "a sacred place, a vestal temple, a temple of the hearth." John Ruskin, "Of Queen's Gardens," *Sesame and Lilies* (1864), as quoted by Gwendolyn Wright, *Moralism and the Model Home: Domestic Architecture and Cultural Conflict in Chicago* (Chicago: University of Chicago Press, 1980), 13.

76. "Old Colonial Rooms," 25. See Thomas Denenberg, *Wallace Nutting and the Invention of Old America* (New Haven: Yale University Press in association with the Wadsworth Atheneum, 2003). Denenberg suggests that photographs were a surrogate experience, using Miles Orvell's concept of the "real thing" (80), but they could also be seen as prescriptive. See Miles Orvell, *Real Thing* (Chapel Hill: University of North Carolina Press, 1989), 7.

77. Wright, *Moralism and the Model Home*, 115.

78. Carl Becker, "An Interview with the Muse of History," *Dial* 59 (11 November 1915): 336–338.

79. Prescott, *A Day in a Colonial Home*, 45.

80. Charles Wilcomb (1865–1915) erected Colonial kitchens at several expositions between 1896 and 1910 to represent the virtues of the American past and established permanent Colonial rooms in the Oakland Public Museum in 1910. Melinda Young Frye, "The Beginnings of the Period Room in American Museums: Charles P. Wilcomb, "Colonial Kitchens, 1896, 1906, 1910," in *The Colonial Revival in America*, ed. Alan Axelrod (New York: Norton, 1985),

217–240; Melinda Young Frye, *Natives and Settlers, Indian and Yankee Culture in Early California* (Oakland: Oakland Museum, 1979); Ira Jacknis, "Introduction: Museum Anthropology in California, 1889–1939," *Museum Anthropology* 17, no. 2 (June 1993): 3–6.

81. Carl Becker, "Detachment and the Writing of History," *Atlantic Monthly* 106 (December 1910): 524–536.

82. James Harvey Robinson, *New History* (New York: Macmillan, 1912): 24, as cited in Milton M. Klein, "'Everyman His Own Historian': Carl Becker as Historiographer," *History Teacher* 19, no. 1 (November 1985): 101–109. Also see Carl Becker, "Everyman His Own Historian," *American History Review* 37 (January 1932): 231–235.

83. Theodore Roosevelt, *History as Literature* (New York: Scribner's, 1913), 3–36. See also Richard Slotkin, "Nostalgia and Progress: Theodore Roosevelt's Myth of the Frontier," *American Quarterly* 33, no. 5 (Winter 1981): 608–615.

84. Dana, *A Day in a Colonial Home*, xi–xii.

85. Ibid.

86. John Dewey, "The School as Social Center," *Elementary School Teacher* 3, no. 2 (October 1902): 78. See also Shannon Jackson, *Lines of Activity: Performance, Historiography, Hull-House Domesticity* (Ann Arbor: University of Michigan Press, 2000), 256–258. In contrast to Dana, his fellow members of the Walpole Society, especially R. T. Haines Halsey, have been identified as proponents of elitism and paternalism. Halsey described the American Wing at the Metropolitan Museum in 1924 in relation to Americanization: "Many of our people are not cognizant of our traditions and the principles for which our fathers struggled and died. The tremendous influx of foreign ideas utterly at variance with those held by the men who gave us the Republic, threaten and, unless checked, may shake its foundations." See Wendy Kaplan, "R.T.H. Halsey: An Ideology of Collecting American Decorative Arts," *Winterthur Portfolio* 17, no. 1 (Spring 1982): 43–53.

87. "The Springfield Avenue Library: What One Branch Is Doing to Help Make Several Thousand New, Good, American Citizens," *Newarker* 1, no. 11 (September 1912): 177–179; "The Foreign Branch," *Newarker* 2, no. 10 (August 1913): 354; "The Foreign Newarker," *Newarker* 3, no. 1 (December 1913): 421–436; "Outsiders an Asset," *Newarker* n.s. 1, no. 8 (June 1916): 209.

88. Henry W. Wack, "The Civic and Spiritual Import of the Newark Pageant," *Newarker* n.s. 1, no. 8 (June 1916): 233–237. Dana's editorial had been were transferred to the

organization's director of publicity, Henry W. Wack, beginning in November 1915. *The Newarker* had attained a circulation of approximately twenty thousand after four years of library management, and the change was marked by the use of glossier paper to handle an improvement in the quality and number of photographic reproductions and a more informal and chatty tone. On the transfer of editorial duties in *The Newarker*, see *Newarker* 3, no. 11 (September 1914): 588. Publication abruptly terminated in December 1916.

89. Louise Connolly to Kate Belcher, 13 April 1916, NMEF

90. Frances Hays to Thomas Wood Stevens, January 1914, Thomas Wood Stevens Papers, Arizona State University Library, Box 33, Folder 6, as cited by Martin V. Minner, "Metropolitan Aspirations: Politics and Memory in Progressive Era Newark" (Ph.D. dissertation, Indiana University, 2005), 224.

91. Collier, "The Lantern Bearers," 346–347.

92. Ibid., 347, 349

93. John Cotton Dana, "The Newark Industrial Exposition from the Public Library's Point of View," NPL Scrapbook, 1913–16.

94. "Is Newark Penny-Wise and Pound-Foolish?" *Survey*, 13 May 1916, 173–174.

Conclusion: The Industrious Citizen

1. Louis Menand, *The Metaphysical Club* (New York: Farrar, Straus and Giroux, 2001), 318.

2. Menand, *The Metaphysical Club*, xi.

3. "Librarian Dana on the Joys of His Youth," *Newark Evening News*, 20 May 1914, NPL Scrapbook, 1913–18; "Biography—Notes for A Proposed Autobiography," ms. 58, Dana Collection, NPL.

4. Although Veblen used the logic of the machine to attack the Arts and Crafts movement as sentimental, his own utopic vision involved a rustic retreat into the "simple life." See Miles Orvell, *The Real Thing* (Chapel Hill: University of North Carolina Press, 1989), 162–163; and David E. Shi, *The Simple Life: Plain Living and High Thinking in American Culture* (New York: Oxford University Press, 1985), 180–181. For Dewey, "primitive" was a source for the "civilized." See John Dewey, "Interpretation of Savage Mind," in *John Dewey: The Middle Works, 1899–1924*, ed. Jo Ann Boydston, vol. 2 (Carbondale: Southern Illinois University Press, 1980), 40.

5. For a glimpse of Murphy's taste, see Ellen Denker, *Faces & Flowers: Painting on Lenox China* (Richmond: University of Richmond Museums, 2009), 15–16, 50–51.

6. Benedict Anderson, *Imagined Communities* (1983; London: Verso, 1991), 198; Carolyn Stedman, *Dust* (New Brunswick: Rutgers University Press, 2002), 38–57.

7. E. P. Thompson, *Customs in Common* (London: Merlin Press, 1991), 7.

8. "Woman as Librarian of Newark," *Royal Gazette and Colonist Daily*, 11 October 1929, Winser family papers, NJHS.

9. Federal Writers' Project of the Works Progress Administration, *New Jersey, A Guide to Its Present and Past* (New York: Viking Press, 1939), 314.

10. Chalmers Hadley, *John Cotton Dana*, 9–63; Philip Roth, "Topic: Reflections on the Death of a Library," *New York Times*, 1 March 1969, 30; Philip Roth, *Goodbye, Columbus and Five Short Stories* (1959; New York: Vintage, Random House, 1993), 30–38.

11. For contemporary discussions on museum and artistic community, see Grant H. Kester, *Conversation Pieces: Community and Communication in Modern Art* (Berkeley: University of California Press, 2004); Paul DiMaggio, "Are Art-Museum Visitors Different from Other People? The Relationship between Attendance and Social and Political Attitudes in the United States," *Poetics* 24, no. 2–4 (November 1996): 161–180; Mihaly Csikszentmihalyi, "Design and Order in Everyday Life," *Design Issues* 8, no. 1 (Autumn 1991): 26–34.

12. See Kenneth Frampton, "Towards a Critical Regionalism: Six Points for an Architecture of Resistance," in *The Anti-Aesthetic*, ed. Hal Foster (New York: New Press, 1983), 16–30; and Kenneth Frampton, "Epilogue: Critical Regionalism Revisited," in *Vernacular Modernism*, ed. Maiken Umbach and Bernd Hüppauf (Stanford: Stanford University Press, 2005), 193–197.

13. "To-Day at New Synagogue," *Sunday Call*, 8 November 1911, NPL Scrapbook, 1906–1913.

INDEX

Page numbers appearing in italic refer to illustrative material.